C0-AUG-352

UNIVERSITY OF WINNIPEG
LIBRARY
DISCARDED
515 Portage Avenue
Winnipeg, Manitoba R3B 2E9

Harriet Martineau

 Women and
Culture Series

The Women and Culture Series is dedicated to books that illuminate the lives, roles, achievements, and position of women, past or present.

Fran Leeper Buss
 La Partera: Story of a Midwife

Valerie Kossew Pichanick
 Harriet Martineau: The Woman and Her Work, 1802–76

VALERIE KOSSEW PICHANICK is a Hamilton Prize winner for 1978. The Alice and Edith Hamilton Prize is named for two outstanding women scholars: Alice Hamilton (educated at the University of Michigan Medical School), a pioneer in environmental medicine; and her sister Edith Hamilton, the renowned classicist. The Hamilton Prize Competition is supported by the University of Michigan Horace H. Rackham School of Graduate Studies and by private donors.

PR
4984
.m5 Z78
1980

Harriet Martineau

The Woman and Her Work, 1802–76

Valerie Kossew Pichanick

Ann Arbor / The University of Michigan Press

Copyright © by The University of Michigan 1980
All rights reserved
Published in the United States of America by
The University of Michigan Press and simultaneously
in Rexdale, Canada, by John Wiley & Sons Canada, Limited
Manufactured in the United States of America

Library of Congress Cataloging in Publication Data

Pichanick, Valerie Kossew, 1936–
 Harriet Martineau, the woman and her work,
1802–76.

 (Women and culture series)
 Bibliography: p.
 Includes index.
 1. Martineau, Harriet, 1802–1876. 2. Authors,
English—19th century—Biography. I. Title.
II. Series.
PR4984.M5Z78 1980 823'.8 [B] 80-15322
 ISBN 0-472-10002-4

for my daughter, Marcelle

Acknowledgments

I am indebted to the University of Massachusetts at Amherst and the Woodrow Wilson Foundation for supporting and encouraging my studies. I am particularly indebted to the Horace H. Rackham School of Graduate Studies of the University of Michigan and the Hamilton Prize and Women and Culture series editorial board of the University of Michigan who have made the publication of this work possible.

For permission to use letters and manuscripts in their collections, I wish to thank the University of Birmingham, Birmingham; the principal and librarian of Manchester College, Oxford; the master and fellows of Trinity College, Cambridge; Dr. Williams's Library, London; the Library of University College, London; the British Museum Library, London; Yale University Library; the Bodleian Library, Oxford; and the Fawcett Library at the City of London Polytechnic. I also quote and cite from papers by permission of the Houghton Library, Harvard University; by permission of the syndics of the Fitzwilliam Museum, Cambridge; and by courtesy of the trustees of the Boston Public Library.

The Richmond portrait of Harriet Martineau is reproduced by permission of the National Portrait Gallery, London.

Contents

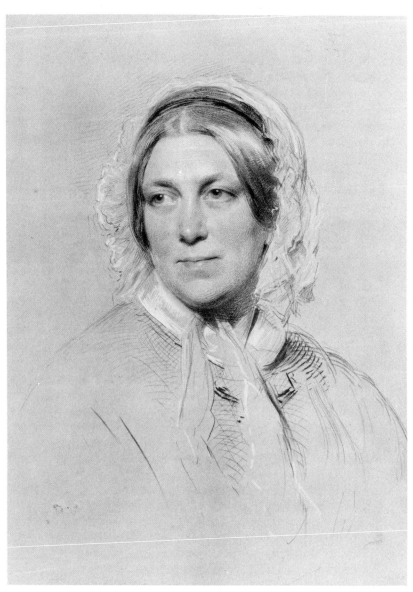

Portrait of Harriet Martineau by George Richmond, 1849.

A Human Mind
from the Very Beginning

No creature is so intensely reserved as a proud and timid child: and the cases are few in which the parents know anything of the agonies of its little heart. . . . It hides its miseries under an appearance of indifference or obstinacy, till its habitual terror impairs its health, or drives it into a temper of defiance or recklessness. I can speak with some certainty of this, from my own experience. I was as timid a child as ever was born.[1]

When Elizabeth Martineau gave birth to the sixth of her eight children on June 12, 1802, she entrusted the infant to the indifferent care of a wet-nurse. This was neither an actual nor a symbolic rejection of the child, for well-to-do middle-class mothers seldom nursed their own children. Yet the act of abandonment was significant, and it was repeatedly reinforced during the formative years of the young Harriet Martineau. Elizabeth Martineau gave her child few tokens of affection, and her seeming indifference was compounded by the frequency with which she sent the delicate and often difficult Harriet from home. The little girl's earliest recollections were not of mother and the comfortable brick house on Magdalen Street in Norwich, but of coarse sheets and an unfamiliar creaking bedstead in a distant rural cottage. As a child she

> . . . scarcely dared to look round from fear of lights on the ceiling or shadows on the wall, . . . started at the patter of rain, or the rustle of the birds leaving the spray, . . . felt suffocated by the breeze and maddened by the summer lightening, . . . trembled before a new voice or a grave countenance, and writhed under a laugh of ridicule. [*Household Education*, pp. 61–62; see also p. 58]

She suffered the agonies of loneliness, the pangs of sibling jealousy, and the fears of rejection. "I really think, if I had once conceived that any body cared for me," she later wrote in her *Autobiography,* "nearly all the sins and sorrows of my anxious childhood would have been spared me." Yet she confided her anxieties to no one, least of all to her mother. As Harriet Martineau herself conceded, "Cheerful tenderness . . . was in those days thought bad for children."[2]

Although Elizabeth Martineau scrupulously cared for her daughter's material and educational needs, she ignored her emotional wants. She gave her little girl no demonstrable tokens of her affection and failed to inspire that trust which is surely the first task of maternal care. If in maturity Harriet Martineau pleaded with parents to be an "unfailing refuge" for their children, it was partly because she herself had had need of a refuge and had failed to find it. Her mother had never invited Harriet's confidences and had never known the intensity of her child's need to love and to be loved. Instead of experiencing the warmth and security of shared affection, the young Harriet had known only the bewildering unreality of her own isolation.

Thomas Martineau, Harriet's father, was a manufacturer of textiles—bombazines and camlets—and an importer of wines in the old cathedral city of Norwich. Norwich had been a distinguished manufacturing town and a celebrated cultural center in the eighteenth century, but it was gradually becoming a casualty of the industrial revolution. As Harriet herself later described it:

> Railways, free trade, and cheap publications have much to do with the extinction of the celebrity of ancient Norwich, in regard to both its material and intellectual productions. Its bombazine manufacture has gone to Yorkshire, and its literary fame to the four winds.[3]

But the power looms of the north did not cast their shadow on the prosperity of the Martineaus and their city until a decade after the Napoleonic wars. In Harriet's youth Norwich had not yet become a cultural and commercial backwater. Heavily Nonconformist, intellectually vigorous, and economically prosperous, the city, like the Martineau family, owed much of its industrious competence and religious dissidence to its proximity to Europe. Waves of political and religious refugees had for centuries sought and found sanctuary in Norwich. Among them had been Gaston Martineau, a Protestant surgeon of Dieppe, who had fled France for East Anglia following the revocation of the Edict of Nantes in 1685. His descendants had

remained in the area, had prospered, and a century later were numbered among the first families of the city.

Thomas Martineau, although lacking self-assertion and without much personal distinction, belonged to an intellectual circle which included such literary figures as Mrs. Barbauld and Amelia Opie. He was a Unitarian and a political radical and he imparted these beliefs and values to his children. Little else is known about Thomas Martineau, and his daughter's mildly affectionate references to him were rare and unrevealing. It was Thomas's wife who dominated the household and ran the lives of the young Martineaus. Born Elizabeth Rankin, the daughter of a wholesale grocer and sugar refiner of Newcastle-upon-Tyne, she was a literate and intelligent woman, but her education had been limited. She loved poetry but understood no philosophy, spoke no French, and felt out of place among the cultural elite of Norwich. There may be some truth to the suggestion that her domestic tyrannies stemmed from her social inadequacies, but it is true too that the frugal efficiency and impersonal competence with which Elizabeth Martineau ran the house on Magdalen Street was characteristic of the nineteenth-century matriarch.[4] If she loved her children, she rarely permitted them to know of it, and if her aspect was sterner than her reality, if beneath the starched muslin kerchief, the buckram, and the stays she concealed a tender heart, then her daughter little suspected it. Her approbation was generally cautious, and her displeasure was much to be feared: the Martineau children were forewarned not to do anything stupid or clumsy before their mother if they "did not wish to be laughed at."[5] Years later a family friend recalled:

> [Mrs. Martineau] appeared to me to order everything and everybody right and left, and though by no means an indulgent mother, she was yet a proud one, and had confidence in the results of her own management and system of education. . . . It was the *setting-down way* she had, which was so terrible to sensitive young people, and which her own children felt. . . . When she was at the age of thirteen I saw much of Harriet. I remember *no* tenderness towards her, but the same severity and sharpness of manner, cleverness of management, and sarcastic observation of other people's management. I thought Harriet at that time a clever child, but an odd wise one. She used then, I remember, to be left much by herself, put aside, as it were. [*Autobiography*, 3:11–12]

Harriet was later to describe the type of maternal authority to which she was forced to submit as "a tyranny of the mind." Her mother demanded unquestioning obedience and Harriet passively

gave it. But subjection did not come easily to the child, and beneath her submissive demeanor "the interior rebellion" kept her conscience "in a state of perpetual torture." She was a "perservering" young person and likewise a stubborn one. Never in childhood did she own herself to be wrong.[6] She lied to her mother habitually, and when caught out in an obvious falsehood would cling obstinately to her story despite her mother's displeasure, and indeed perhaps because of it. She almost enjoyed being punished: it brought her attention, swelled her feeling of importance, and increased her sense of injustice.

> There was nothing to be afraid of in saying the truth, no reason why she should not. But she had a temper of such pride and obstinacy that she was aware of even enjoying being punished, as giving her the opportunity of standing out; while the least word of appeal to her affections or her conscience, if uttered before her temper was roused, would melt her in a moment. [*Household Education*, p. 106]

Praise was always preferable to blame and even as an old woman she could vividly recall her glowing sensation on the few occasions when her mother had expressed her grudging pleasure.

Harriet resented the domestic despotism of her elder siblings no less than she did that of her parent. The older Martineau children bullied and teased the younger ones, and both Harriet and her brother James suffered under this common persecution. It may have been this shared misery which drew the two together from their earliest years. James was born when Harriet was not quite three, and from his infancy she had entertained a very special devotion toward him. Friends remembered her as "the companion and caretaker of her younger brother." And to James, the object of her otherwise frustrated affections, she gave some of the love which she so craved herself.[7]

> All who have ever known me are aware that the strongest passion I have ever entertained was in regard to my youngest brother, who has certainly filled the largest space in the life of my affections of any person whatever. [*Autobiography*, 1:99]

Harriet's maternalism in the case of James was implicit; it was explicit in the case of her sister Ellen, the youngest of the Martineau children. Ellen was born in 1811 when Harriet was nine. Harriet and her sister Rachel had been sent to live in the country during their

mother's confinement. Harriet, as was her custom when away from her family, suffered the pangs of homesickness, and on learning of the birth of the latest member of the family, she longed more than ever for home.

> Homesick before, I now grew downright ill with longing. I was sure that all old troubles were wholly my fault, and fully resolved that there should be no more. Now, as so often afterwards (as often as I left home) I was destined to disappointment. I scarcely felt myself at home before the well-remembered bickerings began;—not with me, but from the boys being troublesome, James being naughty; and our eldest sister angry and scolding. *I then and there resolved that I would look for happiness to the new little sister, and that she would never want for the tenderness which I had never found.* . . . That child was henceforth a new life to me. I did lavish love and tenderness on her. . . . The passionate fondness I felt for her from that moment [the moment of first seeing her] has been unlike anything else I have felt in my life,—though I have made idols of not a few nephews and nieces. [Emphasis added][8]

She was not only emotionally attached to the baby, but honestly curious about it too. She told a stranger one day that she would now be able to see "the growth of a human mind from the very beginning," and several times a day she thanked God for that privilege. She spent every spare moment in the nursery and when she was not quietly observing the infant, she would get up from her stool and "devour the child with kisses." She agonized over its illnesses and triumphed over its progress and throughout her life kept a special place in her affections for her baby sister Ellen.

For Rachel, who was a year and a half her senior, Harriet harbored a very different passion. Not only did Rachel ape the patronizing attitudes which the oldest Martineau children adopted toward the youngest ones, but she had also become the object of Harriet's intense and secret jealousy. This jealousy may have begun earlier, but in her *Autobiography* she recounted an incident which occurred when she was five. A thoughtless family friend had singled out Rachel—prettier and seemingly brighter than the plain, plodding Harriet—for a special favor, and had taken Rachel off leaving Harriet alone on the street with "bursting heart, beating my hoop, and hating everybody in the world." Later when she observed, or imagined that she observed, her mother favoring Rachel too, her misery was boundless. Rachel was closest to Harriet in age and she represented her chief rival for their mother's limited attention. Because she was older, Rachel could accomplish the same tasks with considerably more skill than did her

younger sister. She came in for a greater share of her mother's praise
as a consequence, and to Harriet this seemed proof of their parent's
preference. Her resentment simmered for several years but she said
nothing until finally, surprised by her own temerity, she accused her
mother of partiality. It was, perhaps, the only time that she articulated
her torments, but Mrs. Martineau failed to recognize the depth and
urgency of the child's unhappiness and she did not choose to discuss
the problem. She sent the miserable and still defiant Harriet off to
bed, admonishing her to ask God's forgiveness for the outburst. But
Harriet was impenitent and she deliberately neglected to say her
prayers that night. It was the first time in her young life that she did
not pray before retiring.[9]

For Harriet childhood had been a burdensome experience,
plagued as it was by a guilty envy of Rachel and an anxious desire to
be rewarded by her mother. She was also, perhaps partly because of
these emotions, tormented by a "beggarly" digestive system, and it
may not have been entirely coincidental that digestive problems contin-
ued to trouble her until she was over thirty and secure in her own
identity.[10] As an infant Harriet had been deprived not only of mater-
nal care but also of adequate nurture. The wet-nurse hired to suckle
the child had concealed from Mrs. Martineau the fact that she had all
but ceased lactation. Fully three months elapsed before Harriet's
mother recognized the cause of the infant's diarrhea and otherwise
pitiable condition. Then Mrs. Martineau, thinking to make up for her
previous neglect, forced the child to consume abundant quantities of
milk each day. She made milk the staple of the child's diet and at
breakfast the little girl was given nothing else.[11] But though Harriet
hated milk, she could not bring herself to complain,

> . . . and so went for years having the feeling of a heavy lump in her
> throat for the whole of every morning,—sometimes choking with it,
> and sometimes stealing out into the yard to vomit; and worse than the
> lump in the throat, she had depression of the spirits for the first half
> of every day, which much injured the action of her mind at lessons,
> and was too much for her temper. [*Household Education*, p. 185]

These circumstances, together with her basic insecurity and her de-
sensualized relationship with her mother, were possibly related to
Harriet's claim that since birth she had had no sense of smell or
taste. Neither sensory deficiency is congenital, and when they occur
they are normally regenerative.[12] The fact that Martineau once in
adulthood briefly experienced the sensation of taste would strongly

suggest a psychological rather than a physiological explanation for her deficiency.[13]

Habitually miserable and withdrawn, the young Harriet was tormented also by the awareness that others thought her homely. She had never been guilty of personal vanity, but she had not thought of herself as ugly until one day she overheard a cousin say "how ugly all [her] mother's daughters were, Harriet in particular." The childish countenance had been unusually grave for one of her years, and it was dominated by a firm rather protuberant chin which underlined her obstinacy and gave her a somewhat sulky expression. Dark unruly hair grew low over her forehead and the large, rather fine blue eyes were usually red with weeping. Her family considered her dull, awkward, and difficult, and clearly she thought so too. What little positive image she had of herself was indirectly gleaned from her mother's rare and strangely oblique compliments. "Why Harriet!" her mother said on one occasion when she was trying to remove an insect from Harriet's eye, "I know you have resolution, and you must stand still till I get it out." At another time Harriet was weeping over some compulsory needlework while Rachel played outside with a young guest: "If you go on this way you will soon be the best needlewoman of us all." And when her tippet slipped askew before Sunday chapel and her mother had to pin it in place: "Superior book-knowledge will never make up for being troublesome."[14]

Deprived of faith and trust in her relationship with her mother, and perhaps without being able to clearly articulate these needs, Harriet nevertheless at an early age unselfconsciously sought and found a substitute faith in religion.[15]

> The religion was of bad sort enough, as might be expected from the urgency of my needs; but *I doubt whether I could have got through without it.* I pampered my vainglorious propensities by dreams of divine favour, *to make up for my utter deficiency of self-respect:* and I got rid of otherwise incessant remorse by a most convenient confession and repentance, which relieved my nerves without at all, I suspect, improving my conduct. [*Autobiography*, 1:12, emphasis added]

Although she was afraid of everyone, she was not in the least afraid of God. She constantly longed for heaven, and confided later that

> the temptation to suicide was strong. No doubt there was much vindictiveness in it. I gloated over the thought I would make somebody care about me in some sort of way at last: and as to my reception in the

other world, I felt sure that God could not be angry with me for making haste to him when nobody else cared for me, and so many people plagued me. [*Autobiography*, 1:18–19]

Once she went so far as to sneak into the kitchen for a carving knife, but mostly she fantasized about heaven and indulged in dreams of martyrdom. She imagined death at the stake and on the scaffold and had a great longing to be a Catholic and a nun so that she could "take heaven by storm." In chapel she sat staring at the windows "looking for angels to come for me, and take me to heaven in sight of all the congregation." At seven, Harriet, who was "only waiting for some influence to determine my life in that direction," came under the moral persuasion of an older, highly religious child who had come to live with the Martineaus. From that time her religious devotions became earnest: she prayed with punctilious regularity, she compiled a notebook of biblical commands for all occasions, and by the age of nine she had written a sermon.[16] Nevertheless, her experience of childhood remained "a painful and incessant longing for the future . . . a longing [she said in retrospect] . . . for independence of action."[17]

In order to achieve "independence of action," Harriet Martineau was to need not only her own formidable determination, but also the advantages of a good education. In this respect she was fortunate, for Thomas and Elizabeth Martineau were somewhat in advance of their time when it came to the education of their children. Although the elder Martineaus differentiated between the schooling they gave their sons and their daughters, they believed in providing all their children—regardless of sex—with an adequate learning experience. The education that the Martineau girls received was thus far deeper and more rounded than that generally obtained by the daughters of middle-class families.

Rachel and Harriet were educated for the most part—according to the Lancastrian monitorial system—by their older siblings. Elizabeth, the oldest and nine years Harriet's senior, taught them French; Thomas taught them Latin; and Henry taught them writing and arithmetic. In Harriet's view she received an adequate grounding in both languages, and as Latin was not usually taught to girls at all, her education was distinctly superior to most. But Elizabeth "expected too much from us both morally and intellectually; and she had not been herself carried on so far as to have much resource as a teacher." Henry, who was too young to play schoolmaster, inflicted a

"droll system of torture" on his younger sisters and made their lesson period "his funny time of day; and sorely did his practical jokes and ludicrous severity afflict us."[18]

Between 1813 and 1815, Harriet was unexpectedly given the opportunity of formal schooling. When several vacancies occurred in the Reverend Isaac Perry's school, Harriet, Rachel, and a dozen other daughters of Unitarian families were allowed to occupy the vacant places. The girls sat in the front desks from where they were unable to communicate with or see the boys in the seats behind them. They were given separate instruction but were taught in the same way and according to the same curriculum as the boys, studying Latin, French, composition, and arithmetic. Of the fourteen girls ranging in age from eleven to sixteen, Harriet was the youngest, and for her the experience was "delectable." She clearly enjoyed the challenge, and she was happy under the gentle supervision of the schoolmaster with his old-fashioned powdered hair and his grey eighteenth-century pantaloons. It was a mournful day indeed when financial difficulties overwhelmed the school in 1815 and Mr. Perry was forced to close its doors permanently.[19]

For the next two years Harriet and Rachel were taught by masters in Latin and French. The family also read a great deal of history, biography, and critical literature. An avid reader from the age of seven and her discovery of *Paradise Lost,* Harriet was seldom seen without a book in her pocket, under her pillow, or on her lap, even during meals. With the other daughters of the family she was also obliged to do a great deal of sewing and by the time she was a young woman she was making all her own clothes. She displayed a fine musical talent and was given private piano lessons by a superior musician. But her music teacher was an impatient and hard taskmaster, and instead of enjoying her gift, Harriet was reduced by her twice weekly music lessons to a state of nervous collapse.[20]

Musical performance, in any case, became increasingly difficult for Harriet. At twelve she began to notice a "scarcely perceptible" loss of hearing, and by the age of sixteen it had become quite pronounced and was causing her considerable personal agony and social distress. She felt now more than ever alone and excluded from the rest of the family and seems to have received very little sympathy from either her parents or the other Martineau children.[21]

Now and then some one made light of it; now and then some one told her that she mismanaged it, and gave advice which being inapplicable, grated upon her morbid feelings; but no one inquired what

she felt, or appeared to suppose that she did feel. Many were anx-
ious to show kindness, and tried to supply some of her privations;
but it was too late. She was shut up, and her manner appeared hard
and ungracious while her heart was dissolving in emotions. [*Household
Education*, pp. 83–84]

At first the family tried to ignore her deficiency. They blamed her
for not attending to what was said. Then when it became evident
that she really did not hear what had been said, they blamed her for
not asking. But Harriet was determined never to become a burden.
She remembered all too well what a jest her brothers and sisters
thought deaf acquaintances of the family were when they asked to
have everything repeated. She was determined never to become a
nuisance herself and so relied on friends to repeat pertinent infor-
mation unasked. Eventually when her little vanity succumbed before
necessity and she began using an ear trumpet in her twenty-eighth
year, she was able to reduce the barrier which her impaired hearing
had imposed between herself and the rest of the world.[22] In the
meantime, however, she came to realize that

> I must take my case into my own hands; and with me, dependent as I
> was upon the opinion of others, this was redemption from probable
> destruction. Instead of drifting helplessly as hitherto, I gathered my-
> self up for a gallant breasting of my destiny; and in time I reached the
> rocks where I could take a firm stand. I felt that here was an enter-
> prise; and the spirit of enterprise was roused in me. [*Autobiography*,
> 1:83]

At fifteen the combination of her deafness, her poor health, and
her unhappy disposition led her parents to once again send her
away from home. They told her that she was to visit her Aunt
Kentish, Mrs. Robert Rankin, who ran a school for girls in Bristol,
but they neglected to mention that her absence was to be a pro-
tracted one. When she discovered the deception, she felt contrite
and ashamed, blaming herself for having necessitated the subter-
fuge. However, the fifteen months which she spent in Bristol were
the happiest of her young life. In her Aunt Kentish, for the first
time, she found "a human being whom I was not afraid of," a
confidante at last. Her aunt and cousins received the unhappy girl
with a warmth which thawed the cold repellent protective wall
which she had erected about herself. They were accomplished and
scholarly and her association with them stimulated her own studies.

She also came under the influence of the Unitarian minister and educator, the Reverend Lant Carpenter, and became his devoted disciple, "living wholly in and for religion, and fiercely fanatical about it." Although her schoolfellows found her quiet and uncommunicative, they did not dislike her. They thought her clever, conscientious, but rather humorless. She laughed rarely and her plain passive face was usually expressionless—perhaps on account of her deafness as well as her personal reserve. The girls were accustomed to joke about all Norwich geese being swans, for Harriet missed home and spoke of her family frequently and in glowing terms in spite of her happiness in Bristol. She herself wrote:

> My home affections seem to have been all the stronger for having been repressed and baulked. Certainly, I passionately loved my family, each and all, from the very hour that parted us; and I was physically ill with expectation when their letters became due. [*Autobiography*, 1:92]

She was delighted when the time came to return to the familiar bickerings at 24 Magdalen Street. But this time she returned with a new assurance. Her aunt had taught her the beauty of reciprocated affection, she had stimulated Harriet's interest in intellectual pursuits, and she had shown her how to make the most of her appearance. Lant Carpenter had strengthened her already strong religious convictions. The Harriet who returned to Norwich came soon to be regarded with a new and surprising respect by her family.[23]

It was from Lant Carpenter that Harriet Martineau first learned about Locke, Hartley, and the principle of sensation. John Locke (1632–1704) believed that all knowledge was a product of experience. It was by experience and through the senses that an individual achieved identity and acquired perception. As a more or less passive recipient of life's impressions, a person learned by the association of pleasure and pain. More played upon than player, the individual was, simply, the effect of environmental causes. Locke's hypothesis that the human mind was devoid of preconceptions until influenced by experience and exposed to the environment emphasized the significance of the senses in the learning process and implied the importance of the educator in providing the necessary stimuli for the developing mind. In his *Essay Concerning Human Understanding*, published in 1690, Locke wrote:

> Let us then suppose the mind to be, as we say white paper, void of characters, without any ideas: how comes it to be furnished? . . . To this I answer, in one word, from experience. In that all knowledge is founded, and from that it ultimately derives itself.[24]

Locke proposed the concept of the tabula rasa by which eighteenth- and nineteenth-century educators comprehended the awesome power of Pygmalion which enabled them to breathe whatever life they chose into the human clay delivered into their hands.

In Europe Locke's ideas were taken up by the French encyclopedists and eventually through Rousseau were reintroduced to England in the eighteenth century by the English romantics. But in England Locke's ideas had already been preserved and elaborated upon by another school of English interpreters. One of the most significant of these was David Hartley (1705–57). Hartley restated the tabula rasa theory in his *Observations on Man* written in 1749. He added to Lockean philosophy the doctrine of association which recognized the causal character of ideas themselves: that ideas or impressions stimulate associated ideas. Hartley was largely unread in his own time, but his work was popularized later in the century, and it was chiefly through his disciples Joseph Priestley (1777–1804) and Jeremy Bentham (1748–1832) that Hartley came to influence English educational theory.

The schools of Bentham in England and Rousseau in France found in the tabula rasa an earnest commitment to the cause of education. They both believed that the environment was the principal element in the educative process, and although their methods and philosophies were different, they both sought to control that environment. In its purest form, Benthamism found expression in the carefully controlled atmosphere in which Jeremy Bentham's chief spokesman, James Mill, reared his famous son. James Mill created an environment from which all alien corruptions had been deliberately excluded and in which John Stuart's mind could receive only those impressions which his father permitted it to receive. John Stuart, as those familiar with his *Autobiography* know, was a prodigy who at twelve was knowledgeable about all the major classics, had learned differential calculus, and had already begun to study logic. His youthful experience was the very antithesis of that depicted by Rousseau for his fictional Emile. Rousseau all but banished books and looked instead to nature for his classroom. Rousseau's chief English disciple was William Wordsworth who extolled the symbiosis of childhood and nature, and in the *Prelude* converted his own child-

hood into a celebration of that experience. But Samuel Taylor Coleridge who had earlier embraced the concept of the tabula rasa came to query the basic Locke-Hartley premise and the passivity which the theory of sensation implied. Influenced by Kant, he began to place the emphasis on *eduction* rather than *induction*—on bringing something out of the child rather than on putting something into it. He substituted creativity for receptivity and differentiated between the reason of the creative mind and the understanding of the simply receptive mind. It was not, he thought, nature which instructed the individual mind, but the individual mind which gave meaning to nature.

Harriet Martineau was not reared according to any obvious educational theory, but as an adult she became familiar with current hypotheses. She drew upon these and on her own childhood experiences in her novels and in her children's books. But her most important and self-revealing statements about childhood were made in her posthumously published *Autobiography* (1877), and in *Household Education*, published in 1849, the year after her mother's death—as if deferring to her mother until death made deference no longer necessary. In her *Autobiography* she recounted her loveless and often distorted youth. In *Household Education* she used her knowledge of educational theory, as well as her own experiences and observations, to teach parents the importance of inspiring their children with love instead of fear, of preserving instead of destroying their confidence, and of understanding their keen sensibilities. *Household Education* was addressed not to philosophers of education but to literate and concerned parents of all classes: to the "well-conditioned artisan," as well as to the couple then rearing their growing family in the royal nursery at Buckingham Palace. It was written on the assumption that most nineteenth-century children never went to school, and that when they received any education at all, it was generally from their parents and not from professional educators.

Harriet Martineau accepted the precept that experience informed the human mind, but she did not ascribe all influences to the "aliment on which genius is nourished"; she did not endorse the concept of the passive mind. The mind, she conceded, created its own vision of the world. Though she failed to define Imagination in any Coleridgean sense, she gave prominent place to what she called "the highest of human faculties." And if she fell short of a truly conceptive vision of mind it was not because she was unacquainted with the works of Coleridge and Kant, but because she was of a more prosaic

cast of mind than they. She appreciated the difference between creative Imagination and passive receptivity, but she was so lacking in imagination herself that she could suggest that Imagination be taught by the inspiring example of those who achieved nobility of mind. Too much the environmentalist and the pedant to concede that anything could not be taught, Martineau was by nature and affiliation much closer to the school of experience than she was to the Coleridgean school. Despite her concessions to the latter, she believed that education depended primarily on the stimulation of the perception and the senses: the sensibilities of the student and his or her capacity for pleasure and pain. She managed to chart a careful course between the structured and the structureless, between the methods of James Mill and those of Rousseau.

> In preparation for the more serious work to come, the parent has chiefly to watch and follow Nature;—to meet the requirements of the child's mind, put the material of knowledge in his way, and furnish it with the arts necessary for the due use of its knowledge and nobler powers.

The chief aim of education as she saw it was to encourage each individual to achieve his or her fullest potential. The principal methods of education were to be by the stimulation of the perceptive faculties, and the provision of as varied an experience as could be obtained.[25]

An unfaltering belief in the perfectibility of humankind through education was implicit in Harriet Martineau's acceptance of the tabula rasa theory. It was a belief which remained the chief source of her inspiration: her idée fixe. Like a growing number, although by no means a majority, of her contemporaries, she celebrated childhood as a new innocence and substituted the concept of original virtue for that of original sin.

> The fatal notion that human beings are more prone to evil than inclined to good, and the fatal practice of creating factitious sins, are dreadfully in the way of natural health of conscience. Teach a child that his nature is evil, and you will make him evil. . . . It is a far safer and higher way to trust to his natural moral sense, and cultivate his moral taste: to let him grow morally strong by leaving him morally free, and to make him, by sympathy and example, in love with whatever things are pure, honest, and lovely . . . and, let it be remembered, man has no faculties which are, in themselves and altogether, evil.
> [*Household Education*, p. 116]

In *Household Education* she provided a manual of gentle, natural, and gradual instruction which emphasized the innocence and the individuality of the child. The more practical aspects of her theory owed a great deal to Richard and Maria Edgeworth's *Practical Education* (1798) and to the ideas which her teacher Lant Carpenter had expressed in *Principles of Education* (1820). Both the Edgeworths and Carpenter were Hartleyans, and both emphasized the importance of love in the administration of children—a recognition which the nineteenth century was generally slow to accept. But both Richard and Maria Edgeworth and Lant Carpenter wrote *for* parents *about* children. Their emphasis was on the educator rather than on the child. Carpenter, for example, spoke about the cultivation of children's affections "as a most important means of acquiring power over their minds." He admitted his chief aim to be "less to secure *affection* than to secure influence." In this one essential area Harriet Martineau differed from her old teacher and most contemporary educators. She did not think of love as merely the tool of parental discipline but saw it as essential to the security and happiness of the child itself. Her shift in emphasis was largely a product of her own experience, and her empathy for the child was perhaps the most original aspect of *Household Education* which was in some ways less an educator's manual than a plea for childhood: a *cri de coeur*. The frightened, lonely child whom Harriet Martineau had been never entirely disappeared from the consciousness of the assured woman whom she became.[26]

One would not have recognized in the Harriet Martineau who wrote *Household Education* the still tormented sixteen-year-old returning to Norwich from Bristol. But a barely perceptible change had begun to occur; emotionally and intellectually Harriet had cautiously turned an important corner in her life. She was no longer a difficult little child, and although much of her new outward show of assurance still masked her own private uncertainties, she was gaining new strength from her studies, her religion, and even the deafness which threw her increasingly on her own inner resources. She was still meekly obedient to her mother's will—forced, for example, to go to balls and parties although her deafness made such occasions an ordeal. She still dutifully took her place at the worktable when the women of the house were plying their needles and she reluctantly accompanied them on their social outings and decorous walks. But every moment

that could be stolen away from such compulsory activities was spent reading in the solitude of her own room. Most of her studying had to be conducted in private because it was considered improper for young ladies to study "too conspicuously." She read philosophy and scriptural commentaries, studied the Bible, learned Italian with Rachel, and before breakfast read and translated Latin with James.[27]

It had been Harriet's enthusiastic description of Lant Carpenter which persuaded her parents to send James to Carpenter's school for boys in Bristol. This circumstance had deepened the bond between the brother and the sister, and in the intervening years their relationship ripened into a close personal, religious, and intellectual affinity. It therefore came as a severe blow to Harriet when, in 1821, James left home for college and she was abandoned to her "widowhood." But James's new status, his new friendships, his new interests, and even his new love and future wife, Helen Higginson, did not sever the ties which bound them. Their correspondence continued frequent and affectionate, and one unforgettable summer the brother and sister shared the experience of a five-hundred-mile walking tour of Scotland. They took a steamer from London to Edinburgh, and then a coach to Perth, whence they proceeded on foot. Carrying their knapsacks and a handbasket, they walked fifteen miles a day across glen and through forest. For the two town-bred Martineaus it was a Wordsworthian experience. James later described it in these terms:

> To both of us it was a first free admission into the penetralia of natural beauty; and we walked everywhere with hushed feeling and reverent feet. We were perfectly at one . . . both intensely alive to the appeal of mountain forms and channeled glens, and the play of light and cloud with the forest, the corrie, and the lakeside. And in the fresh morning hours before fatigue had made us laconic, the flow of eager talk—as is usual with young people—ran over all surfaces,—even plunged into all depths,—human and divine; with just the right proportion of individual difference to prevailing accordance for the maintenance of healthy sympathy. That journey lifted our early companionship to a higher stage, and established an affection which, though afterwards saddened, on one side at least never really changed.[28]

James's departure in 1821 had threatened to leave an aching vacuum in Harriet's life, and it was he who suggested that she seek a diversion in writing. Her first literary publications made their appearance in the *Monthly Repository* in 1822 and 1823. It was surely no coincidence that both articles—"Female Writers on Practical Divinity" and "On Female Education"—revealed an intelligent awareness

of the subordination of women at precisely the time when she, the older sister, was being left at home while her already educationally advantaged younger brother went off to establish a career.

In the first of the articles, "Female Writers on Practical Divinity," she wrote of the "peculiar susceptibility of the female mind" for the promotion of religion and virtue. She pointed to successful female writers on divine and moral subjects who exemplified this special female calling. Religious as she then was, she probably identified with these women and saw herself as their likely successor. Although, for example, dissenting strongly from Hannah More's religious beliefs, she nevertheless associated herself significantly with certain aspects of Mrs. More's evangelicalism: with the task of bringing "the spirit of religion into company," and of teaching the finest aspects of Christian morality through personal example. Implicit in this first hesitant publication was Harriet Martineau's own intent: to teach by her writing. Implicit also was the belief in a superior female morality. It was a belief common and current throughout much of the nineteenth century, but Harriet Martineau's conformity was both qualified and ambiguous. Although prepared to argue female moral superiority in order to delineate an area of female vocation, in principle she was an egalitarian and sincerely opposed to the concept of sexually oriented mental differentiation.[29]

It was this latter principle which found expression in her next article, "On Female Education." In her second publication she launched out with greater self-confidence, and although she sought the shelter of a male pseudonym—"Discipulus"—in the second as in the first article, one can nevertheless sense in this work an early intimation of the mature journalist who would seek shelter from none. This was her first significant work on the position and education of women, and in sentiment and opinion it differed little from her later works on the subject.[30] Her views on female education were far in advance of contemporary opinion, and it would be helpful to know (though it is impossible to guess) to what extent these views were her own and derived from her own increasing independence, to what extent (if at all) they reflected the opinions of the family, and whether she was already (as she became later) familiar with the writings of Mary Wollstonecraft, who in *A Vindication of the Rights of Woman* (1792) had pleaded that

> women must be allowed to found their virtue on knowledge, which is scarcely possible unless they be educated by the same pursuits as men.[31]

In "On Female Education," Martineau addressed herself to the purported differences between male and female intellects. Hartleyan that she was, she attributed such differences as did exist between men and women not to innate qualities but rather to educational discrimination.

> In our own country, we find that as long as the studies of children of both sexes continue the same, the progress they make is equal. After the rudiments of knowledge have been obtained, in the cultivated ranks of society, (of which alone I mean to speak,) the boy goes on continually increasing his stock of information . . . while the girl is probably confined to low pursuits, her aspirings after knowledge are subdued, she is taught to believe that solid information is unbecoming her sex, almost her whole time is expended on light accomplishments, and thus before she is sensible of her powers, they are checked in their growth, chained down to mean objects, to rise no more; and when the natural consequence of this mode of treatment arise, all mankind agree that the abilities of women are far inferior to those of men. [P. 77]

Women, she concluded, were not deficient in natural ability but only appeared to be so because they were kept in ignorance from their earliest formative years. She argued earnestly for the education of her sex, but like other contemporary feminist thinkers, she never recommended that women neglect their domestic obligations in order to pursue knowledge. Martineau did not deny the role of homemaker, wife, and mother; she applauded domestic virtues and believed that they would be strengthened rather than diminished if female educational opportunities were extended.

> If the whole mind be exercised and strengthened, it will bring more vigour to the performance of its duties in any particular province. . . . If "great thoughts create great minds," what can be expected from a woman whose whole intellect is employed on trifling cares and comparatively mean occupations, to which the advocates of female ignorance would condemn her? [P. 78]

As mothers, women were responsible for the training of the young, and as wives, they had to be intellectual companions to their husbands. In both instances the cultivation of mind was imperative, and in neither would this cultivation lead to frivolity or the neglect of domestic duty. Women were only frivolous, she believed, because of their lack of intellectual opportunity and not because of their lack of intellect.

When woman is allowed to claim her privileges as an intellectual be-
ing, the folly, the frivolity, and all the mean vices and faults which
have hitherto been the reproach of the sex, will gradually disappear.
As she finds nobler objects presented to her grasp, and that her rank
in the scale of being is elevated, she will engraft the vigorous qualities
of the mind of man on her own blooming virtues and insinuate into
his mind those softer graces and milder beauties, which will smooth
the ruggedness of his character.[32]

The young author was herself of too independent a frame of mind
ever to agree to female subservience even when she was prepared to
concede a difference in the quality of male and female virtues. While
accepting as a fact of nineteenth-century life that middle-class boys
had to be trained for the professions and that middle-class girls had
to be taught domestic skills, she remained keenly sensitive to the
disparity between the education of boys and girls. A quarter of a
century after writing "On Female Education," she was still pleading
for the education of women and against the argument that homely
obligations precluded the cultivation of the female mind.

If it be true that women are made for these domestic occupations
then . . . no book study will draw them off from their homely du-
ties. . . . Every woman ought to have that justice done to her faculties
that she may possess herself in all the strength and clearness of an
exercised and enlightened mind, and may have at command for her
subsistence, as much intellectual power and as many resources as edu-
cation can furnish her with. Let us hear nothing of her being shut out,
because she is a woman, from any study that she is capable of pursu-
ing. [*Household Education*, pp. 156–58]

When Harriet Martineau published her first *Monthly Repository* arti-
cle, her oldest brother, Thomas, immediately recognized her writing
potential and enthusiastically encouraged his sister's literary ambi-
tions. In her childhood, Harriet had been in considerable awe of
Thomas, but she now established a warmer, deeper attachment to
the young physician and his new wife. The couple took the lonely
girl to their hearts and into their home and gave her at last a feeling
of security and belonging. But this happiness was fleeting; Thomas
was consumptive and his visits to Torquay and Madeira in search of
a cure proved futile. To the grief of the family on Magdalen Street,
and to the inexpressible distress of Harriet, Thomas died in 1824.[33]

Sorrows seldom come singly, and it was at precisely this time that the house of Martineau began to falter. Competition from the Yorkshire power mills was eroding the market of the small, older textile manufactories of Norwich, and in 1825–26 a national economic crisis dealt an additional crushing blow to Thomas Martineau's business interests. He managed to avert the bankruptcy which forced many other businesses to close in the panic, but only by extending his credit. Now his health began to fail too. He was suffering from what was diagnosed as an incurable liver ailment and on June 21, 1826, the elder Thomas Martineau followed the younger to the grave.[34]

Meanwhile James, now a seminarian at Manchester New College at York, had returned home after his first college term in August, 1823, bringing with him a fellow divinity student, John Hugh Worthington.[35] Worthington, as far as is known, was the only man ever to "stir hope" in the heart of Harriet Martineau, but the nature of her feelings for him remains unclear. Unfortunately the more detailed account which she gave of the episode in the original draft of the *Autobiography* was altered on the advice of her friend Henry Atkinson. We are therefore left to reconstruct the affair—if such it can be called—from James's transcription of Harriet's letters to him at the time, from her guarded statements in the final version of the *Autobiography*, and from James's defensive reminiscences of 1884 when he was in his eighties.

James's own role in the affair is ambiguous. Harriet claimed that Worthington's first visit resulted in an attachment which her parents had not discouraged, but which was initially thwarted through the "evil offices" of some third person, presumably James. James later denied ever having placed an obstacle in the young couple's path, although in his own transcription of Harriet's letter to him on October 1, 1825, he referred to "some apprehensions which I had expressed in my last letter." Subsequent events proved that James's hesitation to give the match his blessing were less "evil" than solicitous. Harriet herself revealed a remarkable ambivalence toward her suitor. True, her disclaimers may have been nothing more than a conventional coy modesty, but her insistence that she felt little more than friendship for Worthington had the ring of conviction. Most of her misgivings centered on the frailty of Worthington's precarious health, and when the couple eventually became engaged in 1826 her feelings seem to have been more of apprehension than of eager anticipation, and less of passion than of compassion.

I was at first very anxious and unhappy. My veneration for his *morale* was such that I dared not undertake the charge of his happiness: and yet I dared not refuse, because I saw it would be his death blow. [*Autobiography*, 1:130–31]

Her fiancé had suffered a physical and mental collapse before his engagement, and in December, 1826, not quite four months after their betrothal, the strain of his Manchester ministry proved too much for him. He lapsed into an insanity from which he never recovered and to which he succumbed a few months later. The shock overwhelmed Harriet when she first learned of his seizure, but, told that it was incurable, she pragmatically decided not to linger in hope. She succeeded almost instantly in diffusing her emotions, and indeed the abruptness with which she shut him from her mind seemed selfish and callous to Worthington's family who deeply resented her for it. But insulating herself against hurt was Harriet's only defense mechanism. She managed to convince herself that

the present sufferer . . . [is] not her John Hugh Worthington, but another existence, whose conscious experience has no relation [to] that of her beloved. For her, the real John Hugh Worthington *is* what he *was*, and he will be when they meet in Heaven; hence she is calm, and can wait till she is fit to join him.

She took comfort in the Bible which Worthington had given her, but she broke off the engagement and even refused to go to Leicester to see him. She so successfully divorced him from her life that when his death finally came she appeared to have been little affected by it.[36] In the instance of her broken romance, she demonstrated an extraordinary ability to desensitize herself, to untrammel the emotions, and to devote her energies completely to a life of the mind. She succeeded thereafter in making her professional rather than her emotional or personal life the undistracted focal point of her existence and she came to recognize that

my business in life has been to think and learn, and to speak out with absolute freedom what I have thought and learned. The freedom is itself a positive and never-failing enjoyment to me, after the bondage of my early life. My work and I have been fitted to each other, as is proved by the success of my work and my own happiness in it. The simplicity and independence of this vocation first suited my infirm and ill-developed nature, and then sufficed for my needs . . . and I long ago came to the conclusion that . . . I am probably the happiest single woman in England. [*Autobiography*, 1:133]

She was deaf, she knew herself to be plain, and with the family
fortunes tumbling at this time, she had further inducements to lower
any social expectations and sublimate any romantic inclinations. She
had no subsequent love affairs and considered her immunity a bless-
ing, but she had a fond nature and conceded that "there is a power
of attachment in me that has never been touched." Years later, look-
ing back at the events of 1826, however, she admitted to relief rather
than regret.

> If I had had a husband dependent on me for his happiness, the
> responsibility would have made me wretched. I had not faith enough
> in myself to endure avoidable responsibility. If my husband had *not*
> depended on me for his happiness, I should have been jealous. So also
> with children. The care would have so overpowered the joy,—the love
> would have so exceeded the ordinary chances of life, —the fear on my
> part would have so impaired the freedom of theirs, that I rejoice not
> to have been involved in a relation for which I was, or believed myself
> unfit. [*Autobiography*, 1:131–34]

In her grief over her father and brother and with the further
sorrow of her romantic disappointment, Harriet grew closer to her
mother. She at last felt "beloved at home," and, in spite of her
wretched health and emotional afflictions, she was happy.[37] In the
year following the deaths of her father and Worthington, she im-
mersed herself in writing. She began the life-long practice of send-
ing the first draft of her manuscripts directly to the publisher with-
out either rewriting or recopying. She decided what she had to say,
and then, in clear precise prose and a firm legible hand, she commit-
ted herself to paper. She composed religious works such as *Addresses
Prayers and Hymns* (1826), she wrote novellas such as *Principle and
Practice; or, The Orphan Family* (1827), and she composed her first
industrial stories *The Rioters* (1827) and *The Turn-Out* (1827). But the
short stories, essays, and tracts of the 1820s—apart, perhaps, from
the first two *Monthly Repository* articles—are of little interest today.
Their significance lies in the intimations they gave of what was to
follow: the dedication, the wide range of concerns, and the prolifi-
cacy. They were important milestones not only in the career of Har-
riet Martineau, but also in her life. Whereas in childhood she had
been plagued with frustrated passions and disappointments, in
young adulthood she was able to channel her energies into her work,
and a preoccupation with duty began to replace a preoccupation
with self.

It is not difficult to reconcile the resolute woman Harriet Martineau became with the frightened child she had been, for it was out of the crucible of loneliness and fear that she molded her independence. But although she resolved her youthful problems in her own unique way, her childhood experiences were not entirely singular. It was an age when an invisible but impenetrable barrier separated the generations, and when countless girls and boys endured torments similar to those which had scarred Harriet Martineau's first years. The terrors of the red-room in *Jane Eyre* (1847) and the subtle tortures which Maggie Tulliver suffered in *Mill on the Floss* (1860) were like echoes of Martineau's own unhappy childhood. Indeed, when it was first published, Martineau was taxed with the authorship of *Jane Eyre* by friends and relatives familiar with her youth. Later Charlotte Brontë told Martineau that reading those parts of *Household Education* which related to Martineau's own experience " 'was like meeting my own fetch,'—so precisely were the fears and miseries there described the same as her own, told or not told in 'Jane Eyre.' "[38]

Harriet Martineau eventually resolved the difficulties of her anxious childhood. Instead of defeating her, the isolation of her youth, her increasing deafness, and the bereavements of the 1820s combined to give her strength. The emotional poverty of her early years—which, perhaps, was in some way related to her inability to form close personal relationships of a sexual nature—led her to a determined self-dependence. She turned to a life of the mind for fulfillment and immersed herself in work. Her early attempts at authorship, even when lacking intrinsic merit, were an important step toward the realization of self, the emancipation of spirit, and the establishment of identity.

All Things Hold Their March

Beneath this starry arch,
 Nought resteth or is still;
But all things hold their march
 As if by one great will.
Moves one, move all;
Hark to the foot-fall!
On, on, for ever.

"Harvests of All Time" (1834)[1]

The Octagon Chapel which was just visible from the house on Magdalen Street symbolized for Harriet Martineau the Unitarian faith in which she was raised. Traditional Unitarians followed the teachings of Christ but denied his divinity, claimed to represent the original and undefiled essence of primitive Christianity, and looked to the Bible for their authority. Their biblicism differed from the bibliolatry of Evangelicalism in that it regarded the Bible not as the literal word of God but as the record of those who had been privileged to observe His revelations. This view liberated Unitarians from the confines of restricted fundamentalism and enabled them—on the pretext of weeding out later corruptions from the original Scriptures—to edit the Bible so that it would affirm their beliefs. But Unitarians coming under the influence of Enlightenment theories of natural law were finding even this accommodation between omnipotent authority and scientific law difficult to accept. These differences eventually split Unitarianism into two camps: those who accepted biblical command without questioning it, and those who tried to reconcile religious belief and scientific theory. It was a conflict analogous to the paradox of predestination and free will which had divided and perplexed theologians for centuries.

When she was only eleven Harriet Martineau happened upon the

contradiction implied by predestination and free will. How, she had then asked her brother Thomas, if God foreknew everything, could we be blamed or rewarded for conduct which had already been decided beforehand? Thomas, only eighteen himself, had no answers. But telling his sister that she was too young to understand did not make the question go away. She clung to the problem with all the tenacity which even then was characteristic of her. She endured in secret "horrors of doubt," and the obsessive guilt of knowing that such doubt was sinful. She wanted to pray and she wanted to praise but found herself incapable of doing either.

> I listened for the song of praise, and felt that I also would adore if I knew whither to refer my adoration, and if I could offer it unmixed. I was oppressed with a sense of the marvellous beauty of the face of things, and the immeasurable might of that which organized them. But what and where was this principle? Could it be reached; could it be worshipped?[2]

It was unlikely that at eleven Harriet Martineau was conscious of looking for a principle, but when she wrote those lines in 1831 she had found her answer in a principle: the principle of necessity. She credited James, when a young seminarian at York, with first defining the doctrine for her, but she was, by that time, familiar with Lant Carpenter's necessarian views and with the works of Priestley to which Carpenter had introduced her during her stay in Bristol. The doctrine of necessity which provided Harriet with a new certitude and enabled her to reaffirm her faith was, simply, the doctrine of causation: that everything is a necessary consequence of what has preceded it. In other words, there can be no effect without a previous cause, and as man himself is the effect of previous causes, his freedom of will is an illusion. His actions are dictated by a mind which has been predetermined by antecedent events and by present circumstances over which he has no control. Because even his motives are the effects of earlier causes, man's freedom of choice is circumscribed and even predictable. He inhabits a teleological universe whose course even God cannot alter. Although still considered the first cause, God, according to necessarian logic, is as bound as man by natural precedence. He cannot intercede; He cannot answer prayers; and He is, furthermore, without the arbitrary will which characterizes the God of the Old Testament.

Necessarian theory had its origins in empiricism and owed an important debt to the Lockean hypothesis that all knowledge was the

product of experience, but that knowledge of God was the result of revelation. In his otherwise empirical-causal universe, Locke conceded the existence of an inexplicable nonmechanistic deity. His disciple, Joseph Priestley, drew a similar distinction between the knowable world and the unknowable God, acknowledging the existence of a divine controlling mind even while he affirmed the law of causation. Priestley's philosophy explained that prayers were unanswerable because God was limited by the restraints of His own law, and it showed that the individual, despite an apparent lack of free will, was the active agent by whose efforts new effects were created and a continuum of causation perpetuated. Yet Priestley could still abide in the certainty that God was the first cause, and that from Him all things emanated for the greatest good of humankind. Above all, Priestley perceived God as infinite and His purposes as benign.

This was precisely the philosophy which spoke to Harriet Martineau's needs at this period of her life. It obviated her doubts and strengthened her faith. Although at first reluctant to abandon the concept of a "special Providence," she grasped eagerly the idea of an inexorable law inspired by a divine first cause.

> God not only instituted all the principles on and by which man works,—He also gives the sagacity to discern, and the impulse to act. He disposes the circumstances, he molds the will, he confers the power, he offers the result. It is all of him, and through him, and to him.[3]

But the fallacy of the Locke-Priestley argument lay in the arbitrary assumption that there were two kinds of knowledge: the revelatory and the empirical. By accepting the former and the scriptural verifications of it along with the latter, Priestley, and with him Martineau, were guilty of intellectual inconsistency. As Leslie Stephen was to point out:

> Priestley caricatures the ordinary English tendencies to make a compromise between things incompatible. A Christian and a materialist . . . abandoning the mysterious and yet retaining the supernatural elements of Christianity . . . he flashes out at times some quick and instructive estimate of one side of a disputed argument, only to relapse at the next moment into crude dogmas and obsolete superstitions.[4]

The religion which Priestley, Martineau, and other necessarians affiliated with the Unitarian church professed was an uneasy accommodation between rationalism and biblicism. As Martineau herself

later admitted, Unitarianism took what liberties it pleased with the revelation it professed to receive. Unitarianism, she said,

> ... made its own choice what to receive and what to reject, without perceiving that such a process was wholly incompatible with the conception of the Scriptures being a record of divine revelation at all. . . . Unitarianism is a mere clinging, from association and habit, to the old privilege of faith in a divine revelation, under an actual forfeiture of all its essential conditions. [*Autobiography*, 1:37–40]

This observation, written in 1855, was more than a product of her later religious disillusionment. In *The Victorian Church*, Owen Chadwick describes nineteenth-century Unitariansim as "a wobble between confident faith and confident scepticism."[5] In the 1820s and early 1830s, Harriet Martineau herself "wobbled" somewhere between the biblical Unitarians in whom "revelation controlled reason," and the deistical Unitarians in whom "reason controlled revelation." She took, as she later admitted, "monstrous liberty with the Gospel," selecting those aspects of it which answered her purpose, and rejecting those which failed to do so. For example, she refused to acknowledge the divinity of Christ, but she accepted his resurrection; she rejected spiritual pre- or postexistence, but she believed in the afterlife; and while dismissing parts of Christian doctrine as the products of a later corruption, she nevertheless "took all the miracles for facts, and contrived to worship the letter of the Scriptures."[6]

Martineau's argument that Christianity was unitarian in its original form followed closely along Priestleyan lines.[7] It relied on the Bible for its authority and rejected the Trinity, the divinity of Christ, vicarious atonement, the immaculate conception, arbitrary predestination, and the apostolic succession as accretions which had been superimposed on the primitive church by later interpreters. Her essays in the *Monthly Repository* supported the belief that the ideology of Unitarianism was in essence the religion of the first Christians. When in 1830 the British and Foreign Unitarian Association established an essay competition aimed to argue the superiority of Unitarianism, and to prove the misconceptions of Catholicism, Mohammedanism, and Judaism, Harriet Martineau entered the competition and won the prizes in all three categories.[8]

The essays addressed to Mohammedans and Jews made almost as much of a plea for Christianity as they did for Unitarianism, but the Catholic essay was addressed specifically to the question of unity: the credo basic to the Unitarian faith. In this essay, *The Essential Faith of*

the Universal Church, Martineau argued that the earliest Christians had been converts from the monotheistic Hebrew faith; that they had accepted Christ as the messiah but had not supposed him to have been divine. To have assumed Christ divine would have been to have assumed more than one god, and this the converts from Judaism would not have done. It was the later adherents to Christianity, those who came from polytheistic faiths, who corrupted the original unitarian concept. The first of these, she believed, were the Gnostics who converted to Christianity some twenty years after the death of Christ. It was they who first embraced the concept that Christ was a god. Subsequent converts made additional elaborations, conceiving the divinity of Mary and a panoply of saints and martyrs. But the first followers of Christ had not found it necessary to pray through the intercession of Mary, the saints or even Christ himself. They worshipped " . . . not through the ministrations of inferior spirits but face to face in the sanctuary of his presence."

> By the unity of God we understand not a unity of substance connected with a variety of persons, or a unity of persons accompanied with a division of attributes; but a concentration of attributes of Deity in one eternal, indivisible substance.[9]

The purpose of Christianity was not, she insisted, to worship Christ, but to comprehend his divinely inspired message and to understand that the significance of his life had been in his godly example and in his resurrection. It was by the resurrection that God had revealed to mankind the hereafter which till then had not been comprehended by Mosaic law. And it was in the resurrection that Christianity chiefly differed from Judaism, as she pointed out in her companion essay, *The Faith as Manifested through Israel*, a piece inspired largely by Lessing's *Hundred Thoughts on the Education of the Human Race* which she had just reviewed in the *Monthly Repository*.[10]

Like Priestley, Harriet Martineau believed unquestioningly in the resurrection while denying the world of the spirit. Priestley had persuaded himself that a mechanistic, physical interpretation of the resurrection was possible. Resurrection, he said, was a recomposition of the body from the elements out of which it was first made: that which had been decomposed, he reasoned, could be recomposed by the being who had composed it. Martineau was not prepared to accept this rationale. She rejected the concept of recomposition and in "Physical Considerations Connected with Man's Ultimate Destiny" she wrote:

The caravan of the desert leaves no trace of its perished thousands when the moist and the dry, the jackal and the carrion bird, have done their work. The sunken vessel with all that it contained of human or in-animate, is dissolved into its elements before the neighbouring coral reef has been built up to the surface. And what is to be said of cannibalism, where one human frame is immediately incorporated with another? The resurrection of each entire human body is manifestly impossible.[11]

How then could she account for the resurrection and the hereafter if she denied Priestley's argument and rejected the concept of soul? It was imperative that she affirm the doctrine of the afterlife because she considered it central to Christianity, but the ratiocinative process by which she did so was largely semantic. Attempting to differentiate between "spiritualization" and "etherealization," she claimed that although there was no soul, an etherealized body could, after death, evolve from a material body. How the "spritual essence" in which she *did* believe differed from the spirit or soul in which she professed *not* to believe it is impossible to say. But the ambiguity of her argument was illustrative of that awkward position which she and other rationalists of her faith were forced to occupy. She could not discard the resurrection without destroying a fundamental aspect of Christianity, but she could not explain it without resorting to explanations which could not logically be accommodated by a rational philosophy.[12]

It was necessary for Harriet Martineau at this stage of her life to believe that "death is only an eclipse, and not an extinction." The little girl who had imagined that the angels would descend upon the congregation of the Octagon Chapel and take her to heaven, and who had fantasized about an afterlife happier than that which she had known on earth, needed, in early adulthood, to believe in the hereafter. She permitted herself to contemplate what was in fact the spiritual world, and in a flight of fancy imagined her own ethereal postexistence.

It is my hope to be permitted, in the days of my immortality, to overtake the planets at will: and, while thrilled with the perception of the perfect fitness of their frame, to look back on worlds in the process of formation. But more vivid is my expectation that I shall pass hither and thither in the *spiritual* universe, empowered to apprehend truth after truth; and, on the way, to discern from afar how the elements of the moral creation are gathered together, and organized and vivified by creative power, as they are sent forth on their everlasting way. [Emphasis added][13]

The diverting thought of Harriet Martineau flying about the heavens replete with ear trumpet like a female Gabriel should not dis-

tract us from recognizing that at this time in her life her faith was strong enough to overcome her rational objections, and to reconcile her to what could not have been a logically satisfying compromise. As John Henry Newman claimed:

> In the presence of faith reason bows and retires; or rather in words already quoted, faith is itself *the reasoning of the religious mind*. Such a mind holds the gospel to be probable because it has a strong love for it, even when the testimony is weak.[14]

In its search for origins, Martineau's Catholic essay, *The Essential Faith of the Universal Church*, owed little to the continental tradition of biblical criticism—it was much less sophisticated, for example, than the Unitarian Charles Hennell's *Inquiry Concerning the Origin of Christianity* (1838)—and was much more a Unitarian polemic than it was a scholarly textual analysis of the Scriptures. But it exemplified that interest in historicity which put Unitarians in the vanguard of nineteenth-century biblical scholarship. Unitarians did not fear biblical analysis because they believed in the spirit rather than in the letter of the Bible. Necessarians in particular appeared to be proof against the challenges of the nineteenth century. Their belief in a divinely inspired natural law, instead of being antithetical to faith, was an affirmation of it. The more one knew of the mysteries of God's universe the more, they believed, would one appreciate the splendor of God the Creator.

> A world of truth is before us. We cannot help desiring to explore it; and we know of no interdiction which need exclude us from any part of it. We ought, therefore, to disregard mistaken advice and impotent threats which would deter us, and press forward to the limits of science, determined to ascertain for ourselves where we must stop, and to heed no prohibition but that of Nature, or of Him who constituted nature.[15]

Harriet Martineau needed to believe, and even the ambiguities in her rationale could not undermine the apparent security of a faith which rested on the twin pillars of Unitarianism and necessarianism.

In 1829 it was worldly rather than religious problems which pressed upon the Martineau family. In that year the final collapse of the Norwich manufacturing house of Martineau occurred. Harriet had been left a small sum in her father's will, but it was not enough to

sustain her even living at home, and she was faced with the problem of having to contribute to her own support. Hitherto the tracts and stories published by Houlston had produced only trifling amounts and her *Monthly Repository* contributions had been gratuitous. On learning of her predicament the new editor, the Reverend William Johnson Fox, offered to pay her what he could. This sum was small and still inadequate to her needs, however, and other sources of income had to be found. Governessing, the traditional occupation for young ladies without means, was closed to her on account of her deafness, but when both Rachel and Ellen went out to teach, Harriet concocted a novel scheme of teaching by correspondence. She sent out a prospectus but received not a single response and it was decided by the family that she should supplement her income by sewing. She was to stay at home with her mother, her Aunt Lee, and her somewhat erratic brother Henry, in whose hands the family manufactory had met its final demise.

Harriet continued to write at night after toiling with her needle all day. In spite of the family decision, she had elected her own calling.

> I have determined that my chief subordinate object in life shall henceforth be the cultivation of my intellectual powers, with a view to the instruction of others by my writings. On this determination I pray for the blessing of God. . . . I believe myself possessed of no uncommon talents, and of not an atom of genius; but as various circumstances have led me to think more accurately than some women, I believe that I may so write on subjects of universal concern as to inform some minds and stir up others . . . of posthumous fame I have not the slightest expectation or desire. To be useful in my day and generation is enough for me.[16]

With this purpose no doubt in mind, she went to London in the winter of 1829. There, staying in the home of an aunt and uncle, she spent the daylight hours obediently poring over fancy-work, and in the evenings she retired to her room to write—sometimes until the early hours of the morning. But she found no buyers for her literary efforts, and except for the offer of a job proofreading, her only possibility of income remained her needlework and the fifteen pounds she was getting from Fox. This would have sufficed, but in the meantime, without her knowledge, her aunt had written to Mrs. Martineau advising that Harriet had much better content herself with earning a certain living by the needle rather than indulge her vainglorious ideas of success in the masculine world of literary Lon-

don. Her mother immediately upon receipt of this missive ordered
Harriet's return to Norwich. Despite her mature twenty-seven years,
the would-be author returned meekly home. The old habit of obedi-
ence prevailed, but beneath it there burned a deep resentment at
being remanded "to a position of helpless dependence, when a ca-
reer of action and independence was opening up before me." Her
mother received her kindly, however, and Harriet was able to ex-
tract from her the promise that she could spend at least three
months of every year in London so that without "deserting home
duties," she would be able to keep in touch with literary society
there.[17]

The most important intellectual influence on Harriet Martineau
at this time was the Reverend William Johnson Fox who had become
sole editor of the *Monthly Repository* in 1828. When Harriet made her
first contribution to the *Monthly Repository* in 1822, the journal was
primarily a vehicle for Unitarianism, edited and owned by the Rev-
erend Robert Aspland who had founded it in 1806. Harriet Marti-
neau was to describe Aspland as "the formidable prime minister of
his sect." But despite his religious purpose, his journal, as Francis E.
Mineka points out in *The Dissidence of Dissent*, had a much wider
social and political conscience than did other contemporary religious
publications. The Unitarians were, in fact, considered by their oppo-
nents to be "a political rather than religious sect—radical to a man."
And it was therefore not uncommon to find radical expressions in
Aspland's *Monthly Repository*. The journal had always pleaded the
cause of reform, defended the spirit of both the American and
French revolutions, lamented the perfidy of the Lake Poets when
they rejected their earlier more revolutionary convictions, and had
even, in 1821 and 1823, given qualified support to Owenism. In
general the platform of the *Repository* was one with which Harriet
Martineau sympathized: she supported reform, and she opposed
legal inequities, slavery, and the established church and government.
She spoke out against the wrongs of war, and spoke in favor of the
rights of women: her "On Female Education" set the tone which the
journal would follow on this question.[18]

The *Monthly Repository* under Aspland was therefore far from be-
ing a narrowly sectarian publication, although in 1826 it looked as if
it might become so when the newly formed British and Foreign
Unitarian Association acquired it from Aspland with the intention of
making it an official organ for Unitarianism. In 1828 Fox, who had
been on the original editorial board of the new series, became the
sole editor, and three years later he bought the journal outright

from the association. He broadened the outlook and the appeal of the *Repository*, extending its circulation and increasing its literary contributions from outside the Unitarian circle. Eventually he liberated it from its religious moorings completely. It became a vehicle for liberal thought and radical idealism and lost all connection with Unitarianism. Although retaining many of its readers and some of its old contributors, it now lost large numbers of its former supporters by openly espousing radical causes, for many Unitarians, in common with other middle-class Dissenters, were by the 1830s becoming satisfied with the extent of national reform. They had seen repeal of the Test and Corporation acts and the achievement of political and municipal reform, and were becoming part of the ruling class by assuming positions of prominence in cities all over the country. Because Unitarians on the whole were reformers and not revolutionaries, their aims had been to displace the Establishment and not to foster a popular movement. Now confident that they had at last arrived, many of them joined with "Finality John" Russell in proclaiming that reform had gone far enough.[19]

Those Unitarians who remained faithful to a radical ideology continued to support the *Monthly Repository*. Among the holdovers from the first series was Harriet Martineau, who, in the view of Mineka, became the *Repository*'s leading writer from 1829 to 1832. She contributed some original stories and poems, but most of her articles were reviews of books—mainly on religion, philosophy, morals, and biography. She had made her initial second series contributions in reply to an advertisement which Fox had placed when he became editor in 1828. Now, at fifteen pounds a year, she became the *Repository*'s only paid contributor. Her labors for this small sum were prodigious, especially during 1830, which Fox's biographer Richard Garnett described as the *"annus mirabilis* of her connection with the *Repository*, which would have fared badly without her aid."[20] By her own account, she produced fifty-two separate items for Fox in that year. This was in addition to the fancy-work which continued to be her chief means of support, and in addition to the three prize essays for the Unitarian Association, an essay on baptism for which she won third prize, *Five Years of Youth*,[21] *Traditions of Palestine*,[22] and seven tracts for her old publisher Houlston. Of the fifty-two items, thirty-five were reviews, but the custom of the time allowed reviewers to go beyond the books under consideration and use the opportunity to express their own opinions. Harriet Martineau was no exception, and most of her views on religious and philosophical questions found expression in such articles. In the next year she wrote another

thirty-three reviews from a total of thirty-seven items. But in 1832 she became involved in her political economy series and her contributions dropped off.[23]

Harriet Martineau's association with Fox was, by her own admission, "unquestionably the occasion, and in great measure the cause, of the greatest intellectual progress I ever made before the age of thirty." She believed that, next to her brother James, Fox understood her better than anyone. She had not yet, she said, emerged from that sullenness which had made her so disagreeable and ungracious in her youth, and she was, furthermore, still "strictly sabbatarian and subject to many prejudices." Yet Fox and his friends had welcomed her to their circle with the utmost kindness and patience. She had soon become a companion to Fox, his wards the Flower sisters, and the other distinguished members of their literary community. She warmed to the unaccustomed experience of friendly social intercourse and was in great measure assisted in this by the gift of an ear trumpet from her Aunt Lee. In fact her emergence from the silent and lonely shadows in which she had so long abided can be attributed both to the ear trumpet which helped her to communicate with the hitherto silent world, and to the tender ministrations of Fox and his friends. She wrote happily of the latter to James, describing the intimacy of the circle, their honest evaluations of one another, and their mutual confidences.[24] But James did not echo her enthusiasm.

> The whole process of self-analysis and mutual admiration and criticism appears to me unhealthy and repulsive, and not without a considerable taint of indelicate freedom. The account confirms rather than lightens my impression of the questionable tone of their free-thinking and free-living clique.[25]

This comment tells us more about James than about Harriet, but it is impossible to say whether he communicated his feelings at this time or whether he only made the comment when he transcribed his sister's letters several years later.

Harriet Martineau's friendship with Fox had begun during the winter of 1829 before her recall to Norwich. She had spent hour after hour in his study and he had closely supervised her work. Although there was no "trace of sentiment" in their relationship according to Garnett, she provided Fox with a needed and enlightened companionship.

His intellectual relations with [Harriet Martineau] were in one respect closer than those with Eliza Flower, their objects had more in common. . . . With Harriet Martineau's wide range of topics . . . he was perfectly at home.[26]

Furthermore, Garnett added, her letters to Fox at this time revealed a desire to bestow sympathy and affection and to receive it in return.[27] Despite the intellectual and platonic nature of the relationship, it was not without warmth, and Harriet may have come as close to a dependency as she was ever to do. Her gratitude to Fox and the Flowers long survived the friendship itself and did not "wait on principle" as R. K. Webb alleges. When she came to write her *Autobiography* in 1854 she recalled that "their gentleness, respect and courtesy were such as I now remember with gratitude and pleasure," and even personal and religious differences later did "not lessen my sense of obligation to them for the help and support they gave me in the season of intellectual and moral need"(1:148).

In 1830 Fox was forty-four with, according to Carlyle, "a tendency to pot-belly and snuffiness."[28] He was, however, at the peak of his influence and popularity both in the pulpit and in the press. He had started life as the son of an impoverished East Anglian farmer, and after earning his living for a while as a bank clerk in Norwich, had turned to the ministry. Originally a Calvinist, he had, after much inner turmoil, converted to Unitarianism. An early and tepid romance had been blighted by his gloomy financial prospects, but when he began to succeed in the ministry, and with the decline in her own family's fortunes, Eliza Florance returned to his life and presuming upon his earlier intentions made him feel obligated to marry her. By this time (1820) whatever passion he may have once felt for her had long since faded, but he felt honor-bound to marry the lady, and so marry her he did. It was an action he regretted almost immediately.

Very soon after my marriage I found I had made a blunder; and though a moderate share of comfort, and disposition to help me in my exertions, at least some sympathy with these . . . would have pretty well contented me, I did not find even these.[29]

The strain of his loveless marriage occasioned a mental breakdown in 1822 and to add to his domestic trials, the eldest of the three children of the union was a deaf mute whom his mother constantly abandoned to Fox's care. He was an extremely sensitive man with an obvious need

for companionship, of which his marriage provided him none. He sought not subservience in a wife, but equality and friendship. "Man has crippled female intellect and thereby enfeebled his own," he said. "In training a dependent he has lost a companion."[30]

It is not surprising that Fox should have turned elsewhere for the affection and encouragement he needed. Eliza Flower was the older of the two daughters of Benjamin Flower, a longtime friend of Fox's. Flower was an uncompromising radical who, in his early days as editor of the *Cambridge Intelligencer*, had been sentenced to six months in Newgate by the House of Lords for his outspoken opposition to the established order. Immediately upon his release from prison he had married Eliza Gould, a woman of like mind and integrity. She had risked dismissal as a school mistress rather than give up her subscription to the *Intelligencer*, and, although previously unacquainted with Flower, she began visiting him faithfully in Newgate. It was from this union that Eliza and Sarah Flower were born.

Benjamin Flower's wife died in 1810 and he had reared his daughters himself. Their education was far from orthodox. Although there were masters in the village whom Flower employed from time to time, most of their schooling was received from the hand of their eccentric and peripatetic father. He did not cultivate in them the traditional feminine and domestic virtues but rather informed their minds by drawing upon life with eclectic catholicism. Both were—even allowing for the artist's flattery—delicately beautiful. They were also musically gifted, Eliza in particular having a genius for musical composition.

When Flower died in 1829 the two young women became wards of William Johnson Fox and it soon became evident that Eliza was supplying the place in his affections which his wife had forfeited so early in their marriage. Eliza Flower—whom Fox called Lizzie in order to distinguish her from his wife and daughter of the same name—became his amanuensis, used her considerable musical gifts to write hymns for his services, and provided the spiritual support which his wife had failed to supply. Mrs. Fox, not surprisingly, became more than ever estranged from her husband and in 1834, unable to endure the situation any longer, she carried her objections to two members of her husband's congregation. In the ensuing furor a large minority walked out of Fox's congregation, the Unitarian ministers of London denounced their colleague, and Fox, as a result, dropped his affiliation with the Unitarian church. He stopped using the title "Reverend" but continued to serve the remaining congregants at South Place Chapel.

After his severance from official Unitarianism, Fox became more and more rationalist in his attitude toward religion. Accommodating more and more to the evolving scientific revolution, he stated an abhorrence to both the ritual and the "prostration of the understanding" which a submission to the authority of priesthood implied. As he came to devote himself more and more to literary and, later, parliamentary duties, his clerical functions became fewer. He also had to give up the *Monthly Repository* in 1836 because the journal had become too much of a financial drain on his limited funds. First Richard Henry Horne and then Leigh Hunt assumed the responsibility for the journal, but it was impossible to keep the ailing *Repository* afloat, and in March of 1838 its final issue was published. Fox himself had by this time become a member of the daily press writing for the *Morning Chronicle* and the *True Sun*.[31]

In 1835 Fox and Eliza Flower set up a separate establishment in Bayswater and by this open avowal of their affections estranged many of their oldest friends. Among them was Harriet Martineau, who, until the time of Fox's actual separation from his wife, had been convinced that the relationship between Fox and Eliza Flower was an innocent one. In fact, in 1834, just before the couple began living together, Harriet had descended upon Lizzie and presuming upon their close friendship had asked for and received an explanation. Apparently satisfied, she told Fox that

> Lizzie has done what was due to my friendship to her and told me all. You are aware that I must be more grieved than surprised. You know too what my opinion has been throughout, and you know me. What follows? That, *no change having taken place in either of you, my respect and friendship are precisely what they were before*. [Emphasis added][32]

She did not at first suspect the platonic nature of the Fox-Flower situation.[33] She knew of the couple's devotion to one another but acted to sever her social connection with them only after they committed the impropriety of setting up a separate establishment together. Harriet probably considered the action a denial of the assurances which Lizzie had given her. She could understand their love and their grief and as long as "no change" had taken place in their actual situation, her feelings toward them could remain unaltered. But the mores of a society which brooked no indiscretions were such that the couple had forfeited respectability by their action, and now Harriet Martineau joined to decry their open avowal. Untouched as she was by experience of physical passion or a need for dependency,

she showed them little sympathy, and in a letter written several years later to Richard Monckton Milnes, she said:

> Mr. Fox, who has left his (very disagreeable) wife, and loves another openly can't forgive me my belief in the remediableness, through the practice of duty, of a moral mistake. Because *I think love, like other passions, guidable by duty*, he pities me as an unfeeling person. [Emphasis added][34]

Although all social contact between Harriet Martineau and Fox ended, they resumed their correspondence in 1838 and continued it until 1857. They wrote on matters of common interest: reform, women's rights, abolition, the corn laws, India, etc. Their correspondence survived the chilly first years after the estrangement, Fox's disapproval of Harriet's 1844 cure by mesmerism, and her injunction at the time to have her letters destroyed. Although Fox's letters to her were full of the same old affection and appreciation as before, the mutual regard of the earlier years could not but have been affected. In spite of Fox's pleadings, Harriet remained adamant in her disapprobation. He wrote:

> The language of your great work [*Society in America* (1838)] is that of the paramount worth of thorough sincerity, and the right of all to act upon their own principles. And yet towards myself, and that purest and noblest of beings with whom I am identified, and whom you recognise as such, your position is one of practical condemnation.[35]

The impact which the lovely Flower sisters had on the plain, lonely, and provincial young Harriet Martineau survives in her fiction: in *Five Years of Youth; or Sense and Sentiment* published in 1831, in the *Monthly Repository* story "Liese," and in *Deerbrook*, her three-volume novel of 1839 (which will be discussed in a later chapter).[36] *Five Years of Youth* is a slight novella patterned on the early life of Benjamin Flower's daughters. As the subtitle would indicate, Harriet Martineau tried to recreate an Austen-like domestic novel. It is, however, a trivial work lacking the perception which was becoming apparent in her better review articles of the period. She was then and continued to be at her weakest when she wrote fiction. Her fiction lacked personal commitment, she neither developed character nor evoked realism, her dialogues were wooden and didactic, and she relied upon the narrative to carry the action along. In *Five Years* even the plot is without merit. It is the story of the two Byerly sisters

brought up, like the Flowers, by their widowed father. Their musical talent, their beauty, their obviously disordered youth closely paralleled what Harriet Martineau knew of the Flowers' childhood. She even succeeded in weaving into the tale the story of Benjamin Flower's imprisonment, but here it is depicted as having taken place in his old age with his daughters and not the faithful Eliza Gould visiting him in his prison cell.

An underdeveloped and superficial work, *Five Years* is of greater interest for what it tells us about Harriet Martineau herself than for what it relates about the well-publicized youth of Eliza and Sarah Flower. It hints at her admiration for them, and because of the unequal treatment of the two sisters, it also suggests that she may have preferred Eliza to Sarah. There may also have been a barely conscious parallel between the relationship of the Byerlys and her own experiences with her sister Rachel. But the most important aspect of *Five Years* is what it tells us about the intellectual change of focus which was becoming apparent in Harriet Martineau's outlook. She said later in her *Autobiography* that her prize essays, written the year before *Five Years*, marked her final connection with official Unitarianism.

> This last act in connexion with the Unitarian body was a *bona fide* one; but all was prepared for that which ensued,—a withdrawal from the body through those regions of metaphysical fog in which most deserters from Unitarianism abide for the rest of their time.... I had now plunged fairly into the spirit of my time,—that of self-analysis, pathetic self-pity, typical interpretation of objective matters, and scheme making, in the name of God and Man. [1:157]

Were it not for *Five Years of Youth*, this statement could be interpreted as merely the hindsight of a disillusioned cynic, but the novella bears out her claim. It reveals that she was, in fact, at this time emerging from her earlier religious orthodoxy into a region of "metaphysical fog." For in *Five Years* she descanted on organized religion and spoke of God and worship not in Unitarian but in pantheistic terms. At the same time, she did not permit the "fog" to engulf her completely; she came to realize that her religion till then had been largely a self-serving preoccupation with her own religious conscience. She began to see religion more and more in terms of her duty toward humanity. *Five Years of Youth* reveals the start of her transition from preoccupation with religion to preoccupation with society. She had begun to realize, as Mill was to do in *On Liberty*, that Christianity should be not a "doctrine of passive obedience," but an "energetic Pursuit of Good."

UNIVERSITY OF WINNIPEG
LIBRARY
515 Portage Avenue
Winnipeg, Manitoba R3B 2E9
DISCARDED

In *Five Years* she began to pound away on those arguments of political economy which were to become her new gospel.[37]

"Liese" is of greater importance for the study of Harriet Martineau than is *Five Years of Youth*, for although the heroine of the tale, Liese, bears a superficial resemblance to Eliza Flower—for whom she was obviously named—she bears a strong, if perhaps unselfconscious, resemblance to Harriet Martineau herself. It is, perhaps, the only identifiable self-portrait in Martineau's fictional work. The story is set in Reformation Germany just after the issuance of the decree for the dissolution of the monastic orders. Liese, a nun forced to leave the sanctuary of her sisterhood and to reenter the world from which she had escaped many years earlier, was accepted into the home of a family who had embraced Luther's new faith. Because she remained steadfast in her old beliefs, she was isolated even among these friends, but as she opened her mind to Luther's creed and gradually came under the influence of the reformer himself, she emerged from her self-centered, self-imposed solitude. She began to look outward and to dedicate herself to serving others. She joined Luther's household, assisted him as a scribe and wrote hymns which inspired the converts to his new churches—in fact did all the things for Luther which Eliza Flower was then doing for the Reverend William Johnson Fox. The parallel between the two couples has not been lost on readers of the tale, but what has not been remarked is the less obvious parallel between Liese and Harriet Martineau herself. The Liese who had shut herself into a convent in order to escape to a place where "new griefs could not reach her," bore a more than passing resemblance to the Harriet Martineau who only a short time earlier had shut herself into a quiet world in which only religion had sustained her. Liese's progress from her narrow religious preoccupation toward a new sense of purpose and a fulfillment which she had not known in the old self-contemplating days echoed the author's own emergence from the silent insularity of her lonely deaf world. Like Liese she had been "wretched in her loneliness of soul," but now she warmed to the kindly considerations of friends who, like Liese's, had the patience to wait out her prejudices.[38]

Her association with the South Place Chapel set marked a turning point in Harriet Martineau's life. The friends who had known her before that time, she said in later years, scarcely recognized her afterward.

> The frown of those old days, the rigid face, the sulky mouth, the forbidding countenance, which looked as if it had never had a smile

upon it, told a melancholy story which came to an end long ago: but it was so far from its end then that it amazes me now to think what liberality and forebearance were requisite in the treatment of me by Mr. Fox and the friends I met at his house, and how capable they were of that liberality. . . . They saw that I was outgrowing my shell, and they had patience with me till I had rent it and cast it off. [*Autobiography*, 1:148]

As Harriet was learning from Fox, so the fictional Liese began to learn from Luther. Liese warmed to her new companions, she studied, she communed with nature, and she performed deeds of piety.

She was happier than formerly, and more useful, more beloved, and her devotions therefore had more of praise in them, and less of penitence; there was full employment in the present for all her faculties of mind and soul, and she therefore looked back into the past but seldom, and contemplated the future more in the realities before her, than in the visions which floated afar.[39]

Relinquishing her old religious rites and devotions, Liese now found renewal through nature and duty and "watched, with wondering consciousness, the expansion of her own intellect, and the affections which thence arise; an intellect more shackled than weakened by former influences, and affections which only needed scope to become as divine as earthly existence allows."

From her burgeoning renaissance Liese was suddenly and rudely summoned by her old abbess in much the same way as Harriet had been recalled from London by her mother. The comparison is forced upon the reader by the use in both the *Autobiography* and "Liese" of the word "peremptory" to describe the summons. Just as Liese's friends pressed upon her the need to assert her independence and return to them and her new life, so too did Fox insist that Harriet Martineau return to London and a career of letters. Like Harriet in whom "the instinct and habit of old obedience" prevailed, Liese was conditioned by her old obediences and returned—temporarily—to the abbess. But neither the cruel abbess of fiction—whose depiction is surely telling—nor Mrs. Martineau in fact prevailed. Harriet Martineau broke loose from her maternal moorings and dedicated herself to the "cultivation of [her] intellectual powers, with a view to the instruction of others by [her] writings." In the same way Liese "cultivated her intellect and her tastes, as husbanding a possession common to society."[40] Liese now learned to love God more than she had done when, as a nun, her whole life had been supposedly dedicated to

loving him. She was immersing herself in a religion of nature. So too was Harriet Martineau.

Necessarianism was basically consistent with pantheism—as Coleridge had found before he shifted to greater orthodoxy—and Harriet Martineau was becoming persuaded that "the highest condition of the religious sentiment is when . . . the worshipper not only sees God everywhere, but sees nothing which is not full of God." She expressed herself thus in her *Monthly Repository* articles of the period, and in the introduction to the collected articles when they were published in *Miscellanies* in 1836. Religion, she stated in the introduction of 1836, advances through three stages. The first is simply obedience to form. The second is a self-inquisitorial search for God. The third and final stage—the one which she later categorized as "metaphysical fog"—is reached when God is found to be present in all things: in the "glories of the sunrise, the sublimity of the stormy ocean, [and] the radiant beauties of the night."[41]

Her *Monthly Repository* articles were redolent with Wordsworthian sentiments. In nature she saw symbolic expression of her faith. She wrote, for example, of the sea as a triumphant affirmation of her own belief.

Now may I be freely wrought upon by sound and motion, stimulated and soothed by influences which man can only interpret to me, and not originate. Thou rolling sea: thou shalt be my preacher. Of old was that office given to thee. Wisdom was in her native seat before the throne of God when thy bounds were fixed; and from her was thy commission received to be the measure of time, a perpetual suggestion of eternity, and admonition to "rejoice ever before Him." Thine is the old unwearied voice: thy sound alone hath not died away from age to age: and from thee alone is man willing to hear truth from the day that his spirit wakes to that when his body sleeps forever. By the music of thy gentle lapse [*sic*] it is thine to rouse the soul from its primal sleep among the flowers of a new life: blossoms whose beauty is unseen, whose fragrance unheeded, till at thy voice all is revealed to the opening sense. . . . Every other voice utters, and is again silent: men speak in vain and are weary: if they are regarded they still become weary. The nightingale that sings far inland, nestles in silence when the moon goes down. These winds which tune their melodies to thine, pause that thou mayest be heard; and yonder caverns which sing a welcome to the winds as they enter, are presently still. But if thou shouldst be hushed, it would be as if Wisdom herself were struck dumb; . . . If at noon day thou shouldst be stilled, men would look up to the sun to see it shaken from its sphere: if midnight, all sleepers would rise to ask why God had forsaken them. . . . How oppressive

would be the silence, how stifling the expectation, how hopeless the blank if we should call upon thee and find no answer.[42]

Similarly, in "Sabbath Musings II" she wrote of retiring to the sanctuary of the poplar grove in order to communicate with God.

> Perhaps, [as] the cowled devotee retired hither to pay his debt of devotion, to transfer his prayers from his girdle into the care of his saint. Perhaps, as he stood beneath this shelter, some wandering breeze came to sweep aside the foliage, and give him a glimpse of the wide champaigne studded with hamlets, speckled with flocks and herds, and overspread with the works of man's busy hands. Perhaps he crossed himself, and thanked heaven that he was not like these busy men, destined "to fret and labor on the plain below," but rather withdrawn into the stillness of retreat, where the songs with which the reaper cheers his toil could never come to disturb the orisons of the devout.[43]

But although Harriet Martineau could contemplate retreating on the sabbath to worship God through nature she could not retreat permanently from the world or from duty to humanity. It is the imagery and not the sentiments which force a comparison with Matthew Arnold's "Stanzas from the Grande Chartreuse":

> Oh, hide me in your gloom profound,
> Ye solemn seats of holy pain:
> Take me cowled forms and fence me round,
> Till I possess my soul again;
> Till free my thought before me roll,
> Not chafed by hourly false control:[44]

Where Arnold would have bade the banners pass, Harriet Martineau was prepared to do no such thing; her pantheistic retreat and her adoration of God through nature were preliminary to shouldering her social conscience and her duty toward those who suffered on the "darkling plain." God-consciousness was not consciousness of self but mindfulness of humanity: "the service of life."[45]

Martineau's *Monthly Repository* articles of the period revealed a growing certainty that there should be harmony between the life of the spirit and the life of the flesh. Without "man-ward sympathy," a "God-ward sympathy" was without meaning. Christ himself had not been an anchorite but had walked among men and had reconciled the worship of God with service toward man. A religion which nourished only itself was not enough.

I hear an universal acknowledgement of the obligation to do good to the souls as well as the bodies of men: and yet, what comes of it? Some are too indolent to give, others too proud to receive instruction. Some are too selfish to inquire, others too timid to reveal. Men meet to worship God, and separate without trying to do his work upon each other.... They thank God for the honor of being his viceregents, and then compose themselves to sleep at their posts.... When I see a physician ministering to the soul as tenderly as to the body of his patient, when I see a preacher of the gospel discoursing more eloquently by his life than by his lips, when I see a student gathering together the treasures of wisdom only to distribute them with increase ... I rejoice to see how the will of God is done on earth as in heaven.[46]

The dedication to service and good works which Harriet Martineau advocated was as much a part of the Unitarian as it was of the Evangelical code. Although the Evangelicals may have emphasized the spiritual rather than the physical salvation of suffering humanity, and may have interpreted good works and devotion to duty in terms of their own personal salvation, they shared with their Unitarian and German-romantic contemporaries that dedication to duty, philanthropy, and principle which was an essential part of the nineteenth-century work ethic. It is no coincidence that both Harriet Martineau and Thomas Carlyle, writing within a few years of one another and as yet unacquainted, should have independently selected as their text the line from Ecclesiastes (14:10): "Whatsoever thy hand findeth to do, do it with thy might." Harriet Martineau used it in "On the Agency of Feelings in the Formation of Habits," in the *Monthly Repository* of 1829, and Thomas Carlyle used it in *Sartor Resartus* published in *Fraser's Magazine* between November 1833 and August 1834. Martineau first read *Sartor Resartus* in the 1836 Emerson edition and was herself instrumental in getting it published in book form in England after her return from the United States. The "Everlasting Yea" which Carlyle was affirming in *Sartor* appealed to that part of Harriet Martineau which cried out for affirmation: action upon principle, a vindication of truth, and an assertion of human rights.[47] It appealed too to the inflexible determination with which she invariably confronted that which she interpreted as her duty. She doubtless gave her emphatic approval to Carlyle's invocation:

Fool: the Ideal is in thyself, the impediment too is in thyself: thy Condition is but the stuff thou art to shape that same Ideal out of: what matters whether such stuff be of this sort or that, so the Form thou give it be heroic, be poetic?

Produce! Produce! Were it but the pitifullest infinitesimal fraction of a Product, produce it, in God's name: 'Tis the utmost thou hast in thee: out with it then. Up, up: *Whatsoever thy hand findeth to do, do it with thy whole might.* Work while it is called Today; for the Night cometh, wherein no man can work. [Emphasis added][48]

Carlyle's words echoed her own earlier more prosaic appeal:

We should not wait till some object of misery presents itself to our gaze, to awaken the sensibility which has hitherto been the spring of our actions; but, remembering that *what our hand findeth to do we are to do with all our might,* we should relinquish our inactive meditations, exclude selfish regrets, and hasten to the performance of some active duty. [Emphasis added][49]

It was no mere semantic exhortation; it was becoming the rule by which Harriet Martineau would live her life.

Chapter III

A Sign of This Country and Time

The "greatest happiness" principle, like the doctrine of necessity, depended on causation: by avoiding pain and seeking pleasure individuals could achieve their own happiness and increase the sum of all human happiness. The concept, generally associated with Jeremy Bentham, was current in the eighteenth century before Bentham articulated it, and it was Joseph Priestley—the most direct influence on Bentham—who first used the felicitous phrase, "the greatest happiness of the greatest number," in his *Essay on the First Principles of Government.*[1] The social implications of the theory were not lost on Priestley, but Bentham converted the philosophy into an instrument of social change and thereby put his own personal stamp upon it. Out of the greatest happiness principle—which he first called utilitarianism in 1802—Bentham conceived a philanthropic legal and political program which aimed, as John Stuart Mill later defined it, to *educate* individuals to understand what their and society's best interests were, and to associate their happiness with the happiness of the social whole.[2]

Benthamite utilitarians placed a Hartleyan reliance on education, but recognizing the fallibility of human nature, they realized that even when educated, people might be subject to selfish motivation and might require the reinforcement of prescribed sanctions. In his *Introduction to the Principles of Morals and Legislation* (1780), Bentham said that, stimulated as they were by pleasure and pain, individuals should be *induced* to act in a manner which would benefit the general good. Private interests should be made to coincide with public welfare by the employment of legal, moral, physical, and—though a skeptic himself—religious sanctions. Benthamites expressed qualified faith in individualism but their laissez faire did not mean *no* government, it meant *good* government. They sought to destroy old governmental forms, in their place proposing new legal codes and

46

new institutions. Those closest to Bentham himself—the Mills at India House and Chadwick in public health, for example—came to champion a greater rather than a lesser degree of administrative supervision, and to represent something other than the laissez faire associated with free trade liberalism and the Manchester School.

Free trade was the economic complement of the greatest happiness theory and classical political economy was the economic corollary to utilitarianism. As a legislator and jurist Bentham thought in terms of administrative change. Adam Smith, using the same philosophic elements, thought in terms of economics. Smith's *Inquiry Concerning the Wealth of Nations* (1776) was therefore more than a blueprint for free trade; it was a classic statement of the greatest happiness principle. He sought to end inequities perpetuated by ancient privilege and entrenched monopoly and to leave individuals free to seek their own best interests. According to his theory, the happiness of each individual contributed to the total quantum of human happiness because unless all members of society were happy, none could be so. He called this theory "identity of interests," and used it to justify the argument for personal as well as international freedom of competition. Adam Smith had a more sanguine opinion of human nature than did Bentham, and Benthamite political economists, especially with the rising star of David Ricardo, substituted Ricardian pessimism for Adam Smith's optimism: John Stuart Mill's mature rejection of complete social, political, and economic laissez faire was representative of the evolving mind of utilitarianism. But Adam Smith's free trade followers had confidence that, left alone, individuals would act for the good of society as well as themselves. Because Smith believed that there was an identity of interests, and because of an optimistic necessarian view of the ultimate benificence of untrammelled natural law, he and his disciples in political economy embraced unqualified laissez faire as the means to the greatest happiness. But as this is a world in which only the fittest survive, they have come to be identified with selfish individualism, with self-help, with the interests of the middle-class merchant and manufacturer, and with the exploitation of the working classes.

Other than the few classic interpreters of each school, utilitarians and laissez fairists tend to defy strict classification. Like most of her contemporaries, Harriet Martineau was difficult to categorize. She was generally more closely allied with the school of Adam Smith and the identity of interests principle: in 1832, for example, she was telling her *Monthly Repository* readers that

every man knows his interests best, and as the interest of the public is that of congregated individuals the part of justice and benevolence is to interfere with none in the direction of their own concerns.[3]

Nevertheless she was also in harmony with many aspects of the less individualist Benthamite interpretation of the greatest happiness principle. An enthusiastic supporter of public education as a means of social improvement, she endorsed most of the Benthamite reform proposals of the 1830s. When in *Harriet Martineau: A Radical Victorian*, R. K. Webb denies that Martineau was a Benthamite, his reasons and his definitions are not quite clear. He admits that Harriet Martineau sympathized with the "criterion of utility," and that she admired Benthamite social reforms, but he concludes that "she was a better revolutionist than administrator."

> An optimistic perfectibilist, she would enforce and reinforce inevitable change. It was not only that things could be done, but that things would be done. Because she knew where society was heading—her thinking was teleological not instrumental—she was capable of revolution (or of talking it) in almost the wildest Jacobin sense. Not for nothing is one reminded from time to time in reading her of Karl Marx. Not in programme, to be sure, but in spirit. Hers was a clean manifestation of the radical temper.[4]

One of the chief difficulties of trying to label Harriet Martineau is that, like almost everyone else, her ideas changed with time. Harriet Martineau's opinions on utilitarianism and laissez faire altered considerably during her lifetime and it is therefore hazardous to classify her as one thing or another without specifying the period to which one is referring. In 1832 she agreed with doctrinal aspects of both utilitarianism and laissez faire. Although she modified her liberalism and came to regard Benthamism more critically in later years, she never denied the pervasive importance of the greatest happiness theory.[5] "We are all," she wrote at mid-century, "living and acting under the influence of [Bentham's] aspiration for the 'greatest happiness of the greatest number.'"[6]

In 1832 she certainly believed that it would be by the application of the theories of the utilitarians and the political economists that a more equitable society would be attained. Her interest in the "dismal science" was primarily in its social application and she was interested in the commercial and fiscal aspects of political economy mainly insofar as the national economic prosperity was basic to the welfare of the society. In other respects her concern with the pecu-

niary aspects of political economy—the free trade concept excepted—was largely academic. Having read *The Wealth of Nations* she agreed with Smith that the society could not prosper while the rich surfeited and the poor starved. She agreed with Smith's conclusions and with his methods for alleviating the national ills by encouraging individuals to seek their own best interests. It seemed to her that the truths of political economy were basic and simple, and like the truths of necessarianism, were ultimately dependent on the unimpeded functioning of natural law. But she oversimplified, and there is some justification to John Stuart Mill's accusation that she reduced the laissez faire system to "an absurdity."[7] It was an accusation which Mark Blaug in *Ricardian Economics* (1958) considers "less than fair," for Blaug describes hers as "a perfectly standard treatment of the proper scope of government."[8] On the other hand, however, Blaug criticizes her for accepting Smith's interpretation of economics as the final word on the subject, and Smith's view of political economy as complete. But here it is Blaug who is "less than fair," for although when she wrote her *Illustrations of Political Economy* in 1832[9] Harriet Martineau believed classical political economy to be a "complete science" which provided all the answers to the nation's socioeconomic problems, Blaug should have acknowledged that, to her credit, she later owned this earlier conclusion to have been wrong.

> The pretended science is no science at all, strictly speaking . . . so many of its parts must undergo essential change, that it may be a question whether future generations will owe much more to it than the benefit of establishing the grand truth that social affairs proceed according to general laws, no less than [do] natural phenomena of every kind. [*Autobiography*, 3:245]

Harriet Martineau never laid claim to the title of economist and she was aware that she was merely the popularizer of other people's ideas.[10] Her knowledge of economics was superficial, impressionistic, and often ill digested. John Stuart Mill, with perhaps unwarranted acerbity but not without justice, called her a "mere tyro."[11] And she, realizing her own inadequacies as a political economist, admitted to Lord Brougham that she suffered from "a sense of helpless ignorance," and felt panic at the thought of "stereo-typing a hundred blunders with each number." Nevertheless, upon her contemporaries she exerted an extraordinary degree of influence, an influence which in Blaug's assessment was dangerous. "New ideas," he writes,

"are not likely to be welcome when everyone is already furnished with easy answers to difficult questions."[12]

It is in the reading public's ready acceptance of Martineau's pat answers that the *Illustrations of Political Economy* assume significance for the twentieth-century historian. Harriet Martineau's little volumes were extremely popular and they furnished an exceptionally large number of readers with the elements of political economy as she understood them. By 1834 the series was selling ten thousand monthly copies while by contrast John Stuart Mill's *Principles of Political Economy* (1848) sold a mere three thousand copies in four years. Although Martineau was to declare in 1855 that "After an interval of above twenty years, I have not the courage to look at a single number,—convinced that I should be disgusted by bad taste and metaphysics in almost every page,"[13] she nevertheless took pride in the influence which the series had exerted.

> [Political Economy] was never heard of outside of the Political Economy Club, except among the students of Adam Smith; but the "series" made it popular, aided as it was by the needs and events of the time. [*Autobiography*, 3:401]

It was to a large extent Harriet Martineau's sense of timing which made the series an instant success. In the early 1830s reform was in the air, and Martineau recognized a latent interest in a subject which hitherto had attracted the attention of only an inner circle of devotees. The public at large was ignorant of the principles of political economy, and Harriet Martineau saw it as a duty to "my great pupil, the public" to fill the void.

> These are times for testifying, as much as the old times of religious reformation. There is as much religion in our political reformations as there ever was in the theological,—and as much more as the glory of God is more involved in the happiness of his children than in the framing of creeds.[14]

She first learned the basic principles of political economy herself in the *Globe,* the Martineau family newspaper, "which, without ever mentioning political economy . . . taught it and viewed public affairs in its light." In 1827, she read Jane Marcet's *Conversations on Political Economy,* and, influenced by Mrs. Marcet's arguments, derived the idea of teaching the principles of political economy by narrative illustration.[15]

Mrs. Marcet's *Conversations,* published in 1816, enjoyed a modest success (seven editions in the next twenty years), but its appeal was somewhat limited. It was addressed primarily to young people and predated James Mill's much more formal treatise to the young, *Elements of Political Economy,* by four years. *Conversations* was a dialogue between a teacher, Mrs. B., and her pupil Caroline. In it the author set out to prove how

> Political Economy treats of the formation, the distribution, and the consumption of wealth; [how] it teaches us the causes which promote or prevent its increase, and their influence on the happiness or misery of society. [P. 18]

Mrs. Marcet was far from believing that political economy would encourage a materialistic devotion to riches.

> Political Economy tends to moderate all unjustifiable ambition, by showing that the surest means of increasing national prosperity are peace, security, and justice; that jealousy between nations is as prejudicial as between individuals; that each finds its advantage in reciprocal benefits; and that far from growing rich at each other's expence, they mutually assist each other by a liberal system of commerce.[16]

She quoted at length from Smith's *Inquiry Concerning the Wealth of Nations* to prove the efficacy of the division of labor, and to stress that an identity of interests bound capitalist and laborer. She quoted from Malthus's *Principles of Political Economy,* and revised the second edition of *Conversations* after reading Ricardo's *Principles of Political Economy* which had not yet been published when her first edition went to press. As with Martineau, Mrs. Marcet's ideas were not her own. She aimed only to popularize and to a certain extent she succeeded.

Where Mrs. Marcet had limited her audience to young people of the middle and upper classes, and James Mill had intended his *Elements* as a primer for students of the subject, Harriet Martineau addressed the "mass of the people."

> We do not dedicate our series to any particular class of society, because we are sure that all classes bear an equal relation to the science, and we much fear that it is as little familiar to the bulk of one as of another.[17]

Every member of the community, she believed, needed to understand the elements of political economy if the condition of England was to be improved.

Unless the people will take pains to learn what it is that goes wrong, and how it can be rectified, they cannot petition intelligently or effectually.[18]

There had already been some positive response from working-class readers to her two early tales *The Turn-Out* and *The Rioters* which Houlston had published in 1827. Two years later in a letter to Fox, she expressed the intention of setting forth those questions of political economy which she felt it important for the working people to know. Her plan was to write twenty-four monthly volumes, each one illustrating a specific aspect of political economy, and, despite her growing journalistic commitment to the *Monthly Repository,* she began writing her first number, *Life in the Wilds,* in 1831. The publishing houses showed no interest in the idea when she wrote from Dublin where she was visiting James. Her letters from Norwich after her return home drew as little response, but Harriet was not to be daunted. She determined to go to London herself, and with her mother's somewhat hesitant blessing on her solitary venture, she packed her bags that "foggy and sleety" December of 1831 and set off for the metropolis. London was gripped by the fever of reform agitations and in the throes of a cholera epidemic. In the uncertainty of the times no publisher was willing to take a chance on an obscure provincial authoress, and Harriet became despondent and discouraged. At last William Johnson Fox made a proposal on behalf on his brother, Charles, then first setting up as a publisher. Because of his own financial vulnerability the terms which Charles Fox proposed were somewhat harsh, and Harriet accepted his contract with a little reluctance. She had to guarantee five hundred subscribers, and even then if fewer than a thousand copies had sold by the end of two weeks, Fox would be relieved of the obligation of publishing more than the first two numbers. At that time and for that period a thousand copies in so short a time must have seemed to her an utter impossibility. In addition, the prospect of having to solicit subscriptions was thoroughly disagreeable. It was therefore without much hope and in wretched health that Harriet Martineau returned to Norwich and the unpleasant and onerous tasks of appealing to potential subscribers and completing her monthly volumes.[19]

The first number was published in February, 1832, and within ten days the entire first edition of 1,500 copies had been sold. By the end of the year she was telling her brother James that Fox had released her from the subscription clause, and that sales for each number had reached a daily total of one hundred.[20] Miss Harriet

Martineau was obscure no longer. This time when she packed her bags for London, she left Norwich for good.

> I fully expect [she wrote to her mother from London] that both you and I shall feel as if I did not discharge a daughter's duty, but we shall both remind ourselves that I am now as much a citizen of the world as any professional *son* of yours could be. [*Autobiography,* 3:91]

The simplicity and ease of Martineau's style was one of her greatest assets, and it accounted in part for her success as a journalist. Nevertheless, it is difficult for the modern reader to readily appreciate the reasons for the success of her *Illustrations*. The moralistic little stories, with one or two notable exceptions, were dull and often overdrawn. Her characters were generally two-dimensional and she belabored much of the message by means of wooden, didactic, and unrealistic dialogue. She herself acknowledged that the chief difficulty of the *Illustrations* was the necessity of having to introduce a "discourser" to explain the theory. Nevertheless, meticulously basing her diligent little volumes on the principles set out in James Mill's *Elements of Political Economy* and on standard works like *The Wealth of Nations* and Malthus's *Essay on Population,* she conscientiously included in her narratives every aspect of her subject. She utilized government blue books and the library of the House of Commons, and she relied on the advice of friendly experts like Francis Place, Joseph Hume, and William Tait.[21]

Each number dealt primarily with a particular aspect of political economy. After ascertaining and summarizing the main points which she wished to illustrate, she decided upon a setting for her story, researched the topography of the locale, outlined the chapters, and once having erected this skeletal framework, "all the rest was easy . . . and the story went off like a letter."[22] Once she had committed a word to paper she never changed it. Her technique of not recopying her manuscripts for her publishers accounted in large measure for her prolific output and explained Jane Welsh Carlyle's sarcastic comment that

> Harriet Martineau used to talk of *writing* as such a *pleasure* to her. In this house we should as soon dream of calling the bearing of children "such a pleasure"—but betwixt *writing* and *writing* there is a difference, as betwixt the ease with which a butterfly is born into the world and the pangs that attend a man-child.[23]

The series, as Empson accurately pointed out in the *Edinburgh Review,* was uneven in quality.[24] This can be attributed mainly to the haste with which the twenty-five volumes were written, as well as to Harriet's uncertain health at the time, and to her family obligations. She was unable to shed her duties as a daughter, for her mother and aunt came to live with her in London and she was responsible for their continued comfort in their new home on Fludyer Street. Another reason for inconsistency was the fact that some aspects of the subject held less interest for her than did others. The banking, currency, and commercial tales, for example, lacked the impact of those stories which dealt more primarily with social issues. Of these latter, *A Manchester Strike* stands out and ought to be considered a precursor to the industrial novels of the succeeding decades. Harriet Martineau was probably one of the earliest of English nineteenth-century writers to perceive that

> the true romance of human life lies among the poorer classes; the most rapid vicissitudes, the strongest passions, the most undiluted emotions, the most eloquent deportment, the truest experience are there. These things are marked on their countenances, and displayed by their gestures; and yet these things are almost untouched by our artists; be they dramatists, painters, or novelists.[25]

However, where most of the later industrial novelists—Dickens and Disraeli, for example, but not Mrs. Gaskell—viewed industrialization with gloomy foreboding, Harriet Martineau was optimistic about "perpetual progress." Instead of a nostalgic conception of a golden past, she described contemporary difficulties as a product of a corrupt aristocratic past. The Sir Thomas More of her tale *The Three Ages* was not a "Tory" like the More of Southey's *Colloquies* (1829) but a "Benthamite" with a lusty contempt for corruption in government and a deep sympathy for the suffering peasant farmer. Where the industrial novelists tended to blame laissez faire and utilitarianism for what they took to be the worsening condition of England, Harriet Martineau saw a solution to this condition in the theories of political economy. But she was not complacent about the present. Like the industrial novelists she had learned the gruesome truths about the social standards of the working poor from government reports. She realized, as she later explained, that even the blue books told little of the "awful interior history of the time," and she had attempted to convey some of the horror and the tragedy of that "awful interior" in tales like *Ireland* and *A Manchester Strike.*[26]

We will not here be concerned with the individual tales so much as with the social theory which emerged from the *Illustrations* as a whole.[27] It was a theory based primarily on Bentham's greatest happiness principle, Smith's laissez faire doctrine, Malthus's *Essay on Population,* and Ricardo's attack on the Corn Laws. It was Harriet Martineau's vision of society as she perceived it in 1832, it was the philosophy with which she familiarized her reading public, and it was a viewpoint which began to elicit growing support in nineteenth-century England.

David Ricardo wrote his *Principles of Political Economy* in response to the Corn Laws of 1815. It was he who identified the corn monopoly as a basic cause of the unhappy condition of England, and it was he who, departing from Smith's identity of interests principle, first claimed that the artificially high price of protected corn benefited only the landlords. Because the price of corn was high, he argued, more and poorer quality land was placed under cultivation. This had the effect of increasing the rents of the landlords, and of making them the only segment of the community deriving any advantage from the Corn Laws. The farmer who paid the rents and grew the corn did not benefit because he had to pay higher production costs on the inferior soils. These higher costs were passed along to the manufacturer who had to pay his workmen higher subsistence wages, and who, in consequence of the higher wage packet, increased the price of his product. The worker therefore paid more for manufactured goods, still expended the same proportion of his income on bread—estimated at from 40 to 60 percent of his weekly wage—and therefore did not improve his position despite the increase in his wages. The sole beneficiary of the system was the landlord whose rent rolls increased as inflation spiralled upward. "Corn is not high because rent is paid," Ricardo concluded, "but rent is paid because corn is high."[28]

According to Ricardo's theory, the Corn Laws which kept the price of grain high had to be abolished if Britain's other economic ills were to be solved. It was an argument which proposed a simple solution to complex national problems, and Harriet Martineau, who had a penchant for seemingly simple solutions, ethusiastically joined the anti–Corn Law forces. Free Trade, and the repeal of the Corn Laws in particular, became her panacea for the national condition and it was probably her dogmatism on this question which gave rise to J. S. Mill's charge that she reduced laissez faire to "an absurdity." In the thirties she drove the argument home in the *Illustrations,* and

in the forties she became a publicist and pamphleteer for the Manchester School.

Martineau followed the Ricardian model in *For Each and for All,* where she attributed the fall of profits and of real wages to "the inequality in the fertility of the soils." In *Ella of Garveloch* she quoted Ricardo almost verbatim, "A rise in prices, therefore, creates and is not created by rents." But in *Sowers not Reapers,* although arguing against the cultivation of inferior soils, she departed from Ricardo and James Mill by including the landlords among the casualties of corn protection.[29] With fidelity to the identity of interests principle she concluded that what was bad for one segment of the economy would in the long run be detrimental to all segments, and argued that the cultivation of inferior soils would beggar the tenant farmer who would not be able to keep up his payments to the landlord; therefore, the landlord would also become a victim of the pernicious system which he had created.

She summed up the anti–Corn Law position in her *Monthly Repository* article of 1832, "A Summer's Dialogue between an Englishman and a Pole." A nation, she said, should not bury its resources in its "own bad soils."

> This country is destined, by nature and circumstance, to be a commercial rather than an agricultural country; and it would in no wise trouble, but rather rejoice me to see her supplying every region of the world with her manufactures, and receiving, in return, from east and west, the produce of wider and more fertile fields than she can boast.[30]

It was an argument which critics of laissez faire could use to justify their accusation that the repealers were acting in behalf of the manufacturing interest, supporting the repeal of the Corn Laws merely because they wished to lower the cost of subsistence and increase their profits. But to Harriet Martineau an increase in profits would not serve the selfish interests of the manufacturers alone. A growth of capital, she said, meant a directly proportional growth in the wage fund, and this meant more jobs or more wages, depending on the number of workers in the labor market. "The interests of the two classes of producers are therefore the same; the prosperity of both depending on the accumulation of CAPITAL."[31]

Because its opponents identified political economic theory with the manufacturing class, it is important, if we are not to dismiss Harriet Martineau as merely the propagandist for the manufacturing lobby, to understand that as a convert to Adam Smith's identity

of interests premise she believed completely in the interdependence of all segments of the society. Labor was the basis of all production; without it capital could not be built; and without the productive investment of capital new labor could not be created. Therefore labor and capital had to cooperate in order to perpetuate a prosperous continuum. It followed that operatives and employers had to be taught the principles of political economy if they were to understand their symbiotic relationship; for without a knowledge of these principles Martineau rather feared that men of commerce and industry might become "the money grubbers of the community." Properly instructed, however, all segments of the economy would function in their own and each other's best interests.[32]

Martineau's undaunted optimism was based on an idealized perception of human capabilities, and on a faith in the beneficence of an unimpeded natural law. While acknowledging that it precluded complete equality, she nevertheless wholeheartedly endorsed the competitive system. Each individual, she believed, had the right to compete for the pie, but none could demand, or had the right to expect, an equal share of it. She considerably softened her opinion later, but in 1832 she was an outspoken opponent of Owenite socialism. When she spoke of equality it meant "an open field and fair play to everyone," and a right to the product of one's labor did not mean the right to an equal share in production. She had serious reservations, in any case, about the economic feasibility of the socialist scheme. And, using an argument which was to become popular later in the century, she voiced doubt that the type of self-sufficient communal society which Robert Owen proposed could in the long run prosper. She feared that it would make too many demands on the diminishing resources of the soil because men would not be impelled to limit the size of their families or migrate to labor-shy areas if they knew that the community would provide.[33] She had no faith that the greatest happiness of the greatest number could be achieved without the motivation of individual needs and desires. The only types of cooperative venture which she ever wholeheartedly endorsed were those like the Rochdale Pioneers which relied on individual participation and proportional benefits. She modified her earlier blanket condemnation of Owenism later, however, and some twenty years after writing her antisocialist tale *For Each and for All* was to say of it:

I cannot recal [*sic*] that story, more or less; but I know it must have contained the stereo-typed doctrine of the Economists of that day.

> What I witnessed in America considerably modified my views on the
> subject of Property; and from that time forward I saw social modifica-
> tions taking place which have already altered the tone of leading
> Economists and opened a prospect of further changes which will prob-
> ably work out in time a totally new social state. If that should ever
> happen, it ought to be remembered that Robert Owen was the sole
> apostle of the principle in England at the beginning of our century.
> [*Autobiography*, 1:232]

Harriet Martineau in 1832, however, was happier leaving the direc-
tion of society to natural law rather than to Owenite paternalism.

Even in 1832 Martineau was prepared to make exceptions to the
extreme laissez faire position. Besides allowing for the military and
judicial obligations of the state, she conceded other important areas
of legitimate government concern: education, public works, and the
administration of the Poor Law were, for example, too important
and too complex to be left to individual initiative. In the *Illustrations
of Political Economy* tale *The Three Ages* she drew attention to the fact
that the same government which had been killing British trade with
overregulation had been sadly deficient in the area of education and
public works. She listed in order government spending priorities as
she perceived them: education, public works, government and legis-
lation, law and justice, diplomacy, defense, and, finally, running a
poor last, the dignity of the sovereign. She noted wryly that in terms
of existing government spending the order was almost completely
reversed. More than half the annual peacetime budget was devoted
to military expenses and to servicing a national debt which was the
legacy of war. Like Bentham and Smith she opposed war because it
disrupted peaceful trade, but she also believed that an impoverished
people should have the right to consent to a war for which they and
their future generations would be taxed.[34] The glories of war, the
pomp of the court, and the extravagances of the state church were
luxuries which a nation could not afford when its social ills were still
so pressing. It was especially immoral, she thought, to tax a hungry
people in order to perpetuate a state church which did nothing to
educate them and which catered to the religious needs of only a part
of the population. In the *Illustrations of Taxation* tale *The Tenth Hay-
cock* her economic arguments against the Established Church were
given added vigor by her nonconformist opposition to that church.
She opposed government expenditures which did not serve the com-
monweal and she was against all inequitable forms of taxation. While
adverse to all taxes of a mercantilist nature, she was particularly

against the taxing of essential commodities, less because of the effect of such revenue raising on trade than because such impositions caused undue harships for the poor. But she recognized that a government had to levy taxes in order to function, and she supported the idea of a graduated income tax and a tax on property. Once collected, however, she believed that such public monies should be expended only for the benefit of the people.

> Government does not earn the wealth it spends; and each act of waste
> is an injury to those who have furnished the means, and an insult to
> every man who toils hard for scanty bread.[35]

Although she later made exceptions to certain forms of child and female labor, Martineau remained dogmatically opposed to the principle of factory legislation. Not behindhand in joining the chorus of dismay which greeted the 1832 Sadler Committee Report on the condition of child labor in the factories and mills of the nation, and despite drawing attention to the plight of young factory workers in *A Manchester Strike*, she nevertheless refused to be ambivalent on the question of regulating labor even when it was the labor of children.

> Legislation *cannot* interfere effectually between parents and children
> in the present state of the labour market. Our operations must be
> directed towards proportioning labour and capital, and not upon re-
> stricting the exchange of the one for the other,—an exchange which
> *must* be voluntary, whatever the law may say about it.[36]

In 1849 she sounded the same note when, in her *History of the Peace*, she questioned the feasibility of legislating between parents and children, "in defiance of the great natural laws which regulate the operation of labour and capital." Recalling the factory legislation agitation of the 1830s she said:

> People who thought only of the children's instant welfare, and not of
> the considerations of justice and of actual practicability with which the
> case was complicated, clamoured for a law which would restrict the
> hours of labour and determine the wages of the persons who should
> be employed in the cotton and silk mills. Economists showed how vain
> had always been, and must ever be, laws to regulate labour and wages.
> Statesmen knew how vain it was to interfere by law with private regu-
> lations: and the mill owners complained of the injustice of arbitrarily
> raising wages; while this was exactly the prospect which delighted the
> operatives. They began to see before them a long perspective of legal

protection and privilege, by which they as well as their children should obtain the same wages for less and less work, while too few of them perceived that *any law which should deprive them of the free disposal of their own labour would steal from them their only possession, and be in fact a more flagrant oppression than any law had inflicted on their order for centuries.* [Emphasis added][37]

Martineau's were the standard laissez fairist arguments, but even allowing for her adherence to principle, it is difficult to see how anyone with her humanitarian concerns could have so lightly dismissed the "children's instant welfare." Many of the political economists were prepared to yield on this point: John Stuart Mill, James McCulloch, and even Nassau Senior, the most consistent opponent of the Ten Hours Bill on economic grounds, conceded that in the case of child labor there ought to be regulation.[38] Harriet Martineau, however, championed the people's right to dispose of their labor, opposed any infringement on this right, and remained steadfast in her objection to factory legislation. She was one of Lord Ashley's most determined critics and she bowed to his persuasions only in the case of women and children in the mines. Even here, she cautioned in the *History of the Peace*,

> the great permanent objection remained, of the disastrous consequences of interfering with the labour market. The great majority of the nation [meaning those who shared Harriet Martineau's views] however felt that it was better to have the burden thrown on the parishes for a time than to let such abuses continue. [2:555]

It should be remembered that mines were generally on the estates of large landowners and the exception which Martineau made in this case may have been influenced by this awareness along with the special brief which she carried for the working woman. Generally, however, Martineau preferred to sacrifice short-term humanitarianism in favor of the long-term benefits of political economy. She was far from being oblivious to the privations of the poor, but she genuinely believed that charitable expedience was detrimental to the future happiness of the greatest number.

Her attitude can be explained in part by her confidence in the benevolent intentions of the manufacturing class. Her knowledge of industrial relations came primarily from the smaller manufactories of Norwich and Birmingham where employer-employee relations had not yet become as impersonalized as they had in large industry. She herself was not familiar with the large factories of Lancashire,

and Francis Place warned her that she would be unable to "form a correct opinion of the monstrous iniquity of our factories . . . they are too scandalous and too infamous to be told, even to a searcher after truth like you."[39] Nevertheless Martineau was able to obtain the written testimony of the operatives themselves, and in *A Manchester Strike* she used this material to paint a sympathetic portrait of suffering factory workers and to show that when factory owners were ignorant of the correct principles they could be appallingly selfish. But where some observers denounced, in Carlyle's words, "the brutish empire of Mammon" and its emphasis on production, and where even moderate opponents of industrialization ventured the opinion that it had done little to advance the position of the working class, Harriet Martineau remained convinced that, despite the sometimes appalling conditions of labor, the situation of the operative had actually improved in the three decades since the turn of the century. Her claim that "the factory people are better off than any others of our labourers," is not without some merit. In the never quite ending debate among economic historians on the condition of the laboring class, it is now generally conceded that it was the condition of the domestic worker—the pieceworker for example—rather than that of the factory worker which deteriorated in the nineteenth century. The most recent quantifiers have quite convincingly shown an increase in the value of real wages as the nineteenth century progressed; and Martineau, looking back at the first decades of the century in her *Introduction to the History of the Peace* (1851), certainly believed this to have been the case.[40] In line with the generally accepted rationale of the classical political economists, she saw the industrializing process and the increase in productivity as beneficial to society as a whole. According to this theory, mechanization would increase production, lower prices, stimulate further production and consequently enlarge the number of employment opportunities while at the same time it increased the buying power of the workers.[41] Like Adam Smith, Martineau viewed technical advance as a stimulant to the economy which rather than displacing the worker would actually assist him.

In *Life in the Wilds*, *Briery Creek*, and *The Hill and the Valley*, Martineau argued forcefully for the industrializing process, claiming that it would not only increase capital and therefore proportionately increase the wage fund, but that it would also relieve the workers of the more mechanical aspects of their labor and give them more leisure time for creative occupations. As far as the latter was concerned, Martineau failed to appreciate that labor could conceivably

become more rather than less mechanical; and as far as the former
was concerned, she failed to see that despite an increase in the wage
fund, there could be, following the introduction of new machinery,
an initial period of disorientation and unemployment. Along with
the majority of economists (David Ricardo and a small following
excepted) she saw only the long-term benefits which would be de-
rived from mechanization. She was therefore, as a matter of course,
a critic of Luddism in all its manifestations. She failed to appreciate
the fine distinction between unskilled workers who actually bene-
fited by industrialization, and skilled artisans—the Luddite core—
whose craftsmanship was suddenly outmoded, and whose jobs were
threatened by the machines they sought to destroy.[42]

Like most members of her class Harriet Martineau probably felt
threatened by violence, but the reasons which she gave for deploring
disruptive action were mainly pragmatic. Machine breaking and
strikes, she said, drove less profitable establishments out of business
and reduced the capital of those businesses which survived. Because
the wage fund declined in proportion to the decline in capital, the
end result of strike action would inevitably mean either fewer jobs or
lower wages. This was the burden of her tale in *A Manchester Strike*,
and she further elaborated on the subject in an 1834 pamphlet pub-
lished at the request of Lord Durham, entitled *The tendency of strikes
and sticks to produce low wages, and of union between masters and men to
ensure good wages.*

> The question is whether masters and men shall bear one another up
> till a favourable change comes . . . or whether the men, by demanding
> higher wages, shall knock up the poorer masters, and destroy their
> own chance of getting wages at all.[43]

In *A Manchester Strike* Martineau engaged the reader's sympathies
for the union leader and his men while arguing the futility of strike
action. She did not, as Dickens did in *Hard Times*, blame strikes on
outside agitators, nor did she try to minimize the conditions which
drove the workers to strike. Indeed, she even supported the concept
of combinations.

> It is necessary for labourers to husband their strength by union, if it is
> ever to be balanced against the influence and wealth of capitalists. A
> master can do as he pleases with his hundred or five hundred work-
> men, unless they are combined.[44]

But she nevertheless denied workers' combinations the only form of
action by which they could obtain redress. She refused to endorse

strike action because strike action was detrimental to the "identical interests" of the manufacturer and the worker. She believed, along with James Mill and the other political economists that "the rate of wages depends on the proportion between Population and Employment, in other words, Capital,"[45] and that because strikes would deplete capital without changing the ratio of population to employment, they would either drive up unemployment or drive down wages.

In spite of her opposition to strike action Martineau treated her fictional strikers in *A Manchester Strike* with sensitivity and evident compassion. But in the two years between writing *A Manchester Strike*, one of the first of the *Illustrations of Political Economy*, and completing the five volumes of the supplementary series, *Illustrations of Taxation* (1834), her attitude underwent a change, and in *Scholars of Arneside* she treated unions and union leaders without a trace of sympathy. Her new severity probably owed a great deal to the industrial unrest of 1834, and to the poor press which unions received at that time. The establishment of the Grand National Consolidated Trades Union (GNCTU) must also have posed a threat of a new and frightening trade monopoly. Although the GNCTU was shortlived, the events of the thirties were sufficient to arouse Martineau's permanent opposition to unionization and union leadership. In her retrospective comment on the thirties in her *History of the Peace* she patly repeated all the allegations which had been made by union opponents in 1834: that the union leaders brutally intimidated their fellow workers, that they were responsible for the wanton destruction of property and the disruption of industry, and that they misappropriated union funds. Indiscriminately tarring all combinations with the same brush, she described trade unions as "the greatest danger" then facing the United Kingdom.[46]

Harriet Martineau placed the responsibility for almost all aspects of the workers' welfare squarely on their individual shoulders. She believed especially that an uncontrolled increase in population would diminish the prospects for all workers because the benefit derived from the wage fund by each worker depended on the number of workers by which the fund had to be divided. Only by the personal efforts of each worker could the ratio of population to employment be kept in favor of the operatives. But in the late eighteenth and early nineteenth centuries it was becoming apparent that the population of Britain was rising sharply (between 1801 and 1851 the total population had doubled), and the increase, though attributable to a declining death rate and especially to declining infant mor-

tality, was seen by contemporaries as evidence of a rising birthrate. For Harriet Martineau and her era, Malthus's *Essay on Population* became an article of faith, expressing as it did

> . . . the all-important fact which lies at the bottom of the poverty of society—that the number of consumers naturally presses on the means of subsistence; and that while numbers and the means of sub-sistence are not proportional to each other by the exercise of enlight-ened prudence, poverty and misery must always exist. . . . human families expand in numbers while cornfields do not expand in size.[47]

Notwithstanding the fact that the increase in population was viewed as a threat to the nation's limited resources, few dared suggest birth control as the logical alternative. The question was certainly not thought to be the proper subject for the consideration of an unmar-ried young woman, and it was therefore not without an inner struggle that Harriet Martineau faced up to her moral and social obligations as she saw them.[48] Broaching the subject cautiously, she skirted the issue and her recommendations were not very specific. She suggested in *Weal and Woe in Garveloch* that because "the happi-ness of the people does not depend on the total amount of wealth, but on its proportion to those who are to enjoy it," it was necessary to limit the size of the population. She hinted that the imprudent indulgence of love would increase impoverishment, but she sug-gested no more stringent palliative than late marriage and pru-dence.[49] She was criticized for her timidity by Empson in the *Edin-burgh Review*, [50] and by Francis Place, who was an active supporter of birth control. Place, a publicist and pamphleteer on the subject of contraception, recognized the inadequacy of her recommendations in *Weal and Woe in Garveloch*. He wrote her a gentle remonstrance:

> Can or will the people refrain from producing children in such num-bers? I answer not by those [methods] suggested by you and others—not by delayed marriages. It is utterly useless to preach abstinence . . . chastity and late marriages are as much opposed as any two things can be. . . . The consequences of delayed marriages are dissolute prac-tices. . . . You can form nothing like a correct opinion of these evils, no respectable woman can do so.[51]

Nevertheless Place commended her "excellent tales" for bringing the matter to the public's attention, and sent her a book on the subject of birth control by Robert Dale Owen, "the son of my old and some-what crazy friend Robert Owen." Her later more practical position

on birth control and on the question of delayed marriage probably owed a great deal to the influence of Francis Place.

Most of the criticism of *Weal and Woe* and its author came from those who, rather than being upset by her timidity, were shocked that she should have broached the subject at all.

> It is quite impossible not to be shocked, nay disgusted, with many of the unfeminine and mischievous doctrines on the principles of social welfare, of which these tales were made the vehicle. . . . A little ignorance on these ticklish topics is perhaps becoming a young unmarried lady. But before such a person undertook to write books in favour of the preventive check; she should have informed herself somewhat more accurately upon the laws of human propagation. Poor innocent! She has been buzzing over Mr. Malthus's arithmetical and geometrical ratios for knowledge which she should have obtained by a simple question or two of her mama.[52]

The review in the *Quarterly* was written by George Poulett Scrope, an economist of some distinction although generally out of sympathy with the classical political economists. According to Harriet Martineau, the "insulting" remarks were later "interlarded" by John Wilson Croker and by John Gibson Lockhart, the *Quarterly*'s editor. She never forgave either of the latter gentlemen and years later had a belated revenge when she wrote their obituaries in the *Daily News*.[53]

The question of overpopulation had a remedy less controversial than that of birth control, and in *Homes Abroad* Martineau offered this alternative. A worker, she said, could keep the ratio of labor to wage fund favorable either by migrating to a part of the country where there was no unemployment, or by emigrating to the colonies. She did not consider the latter to be a desertion of the homeland but rather the patriotic duty of those who were numbered among the surplus population.

> After all, a state is made up of individual members; and, therefore, whatever most benefits these individuals must benefit the state. Our duty to the state and our duty to ourselves are not opposing duties. . . . On the contrary, a man's duty to his country is to provide honestly and abundantly, if he can, for himself and his family; and when this cannot be done at home it is a breach of duty to stay and eat up other men's substance.[54]

Under the influence of Edward Gibbon Wakefield she made emigration and colonization yet another exception to laissez faire, arguing

for subsidized and supervised emigration in both *Homes Abroad* and *Ireland*. But she was in no way an imperialist. True to the creed of Adam Smith she opposed mercantilism and favored the ripe fruit theory: "The States of America are a source of much greater wealth and power to Great Britain than when she had a ruler in each of them." She deplored the exploitation of colonies, and noted the irony of sending missions to convert the heathen or of trying to impose a veneer of civilization while simultaneously robbing a country of its natural resources and depriving its natives of the means to a civilized standard of living. But despite this opposition to colonies of exploitation, she had quite a different opinion of colonies of settlement. The latter, she thought, would benefit by the influx of British immigrants, would provide a market for British manufactures, and would help solve the overpopulation question. She did not mean by this that colonies should be dumping grounds for the unwanted. She especially opposed the concept of penal settlements, not only because of the detrimental influence which a large body of criminals would have on a young settlement, but because she thought it unfair to leave the honest worker to starve at home while giving the criminal the opportunity to benefit as a consequence of his crimes. Using Wakefield's theory, she argued for a balanced emigré community which would duplicate in microcosm the economic structure—minus the aristocratic element—of the mother country. She understood the danger of denuding the homeland of its able-bodied young people, but nevertheless thought it wise to encourage the young to emigrate where they could build a new society and where their offspring would people an underdeveloped land rather than overpopulate the British Isles.[55]

By means of birth control, labor-migration, and emigration the poor had the opportunity, it was thought, to ameliorate their present condition and to influence their future. Indigence was therefore neither understandable nor forgivable, and almost without exception nineteenth-century political economists believed that the permanent pauper who was neither sickly nor disabled was either idle, dissolute, or foolish. They were unable to comprehend a condition of permanent unemployment: "If there are human beings capable of work," wrote John Stuart Mill in *Principles of Political Economy*, "they may always be employed producing something."[56] Political economists insisted that relieving the indigent would only serve to perpetuate poverty. They acknowledged that it was not possible to eradicate poverty but it was their fixed resolve to discourage indigence. They would not condone charity and were determined in

their opposition to private or local charitable organizations. Making one of their earliest exceptions to the laissez faire rule, they argued for the regulation of relief by government agency and for the amendment of the old Poor Law. It was thought that under strict state control the reliance on relief could be minimized and outdoor assistance—which they considered the most pernicious aspect of the old Poor Law—eliminated. The Speenhamland system of supplemental wages became therefore their chief target, and so frequently did they fulminate on the subject that Southey described their outpourings as a "diarrhoea of the intellect."

The campaign to amend rather than repeal the old Poor Law was an acknowledgment that poverty could be diminished but not eliminated. It was peaking when Martineau came to write her *Illustrations*, but she still naively hoped for the total extirpation of poverty and of the Law that governed it. Believing that relief was the chief cause of indigence, she advocated, in *Cousin Marshall*, the gradual reduction of assistance. This, she predicted, would lead to an end for Speenhamland and to an emptying of the poorhouses. She dragged up all the classic arguments against guaranteeing a subsistence wage: that it encouraged idleness; that it fostered the attitude that the community would provide and therefore encouraged profligacy and increased the birthrate; that it drove up the poor rates; that it added the small farmers who could not afford to pay the poor rates to the ranks of the "rate-receivers"; and that it thereby increased poverty and added to the burden on the community.

> It is rather hard on the poor . . . that we should complain of their improvidence when we bribe them to it by promising subsistence at all events. Paupers will spend and marry faster than their betters as long as the system lasts.[57]

Her arguments against Speenhamland were specific. She recounted the history of the system and concluded that in the southern counties of England where it was practiced, "the most deplorable misery prevails." She did not take into account the fact that, the southern Speenhamland counties being almost wholly agricultural, the lack of industrial alternatives made seasonal unemployment and suffering inevitable, and some kind of relief imperative.

Harriet Martineau believed along with Poor Law reformers in general that "every diminution of the inducements to indigence is necessarily an increase of the inducements to independence." It was one of the basic arguments against supplementary wages that they

rewarded the idle at the expense of the industrious and therefore
discouraged industry. The new Poor Law commissioners, with this in
mind, set out to eliminate outdoor relief and to ensure that public
charity would in no way provide a better standard of living than that
secured by the very meanest independent worker.[58] As John Stuart
Mill put it:

> If the condition of a person receiving relief is made as eligible as that
> of the labourer who supports himself by his own exertions, the system
> strikes at the root of all individual industry and self-government. . . .
> But if, consistently with guaranteeing all persons against absolute
> want, the condition of those who are supported by legal charity can be
> kept considerably less desirable than the condition of those who find
> support for themselves, none but beneficial consequences can arise.[59]

The poorhouse was therefore to become the only alternative to self-
support, and it was to be so designed and governed that it would act
as a deterrent to indigence and as an incentive to work. In Edwin
Chadwick's words, it would serve as "a cold bath—unpleasant in
contemplation but invigorating in its effects."[60]

Harriet Martineau's four dreary tales *Poor Laws and Paupers* further
elaborated on the theme set out in *Cousin Marshall*. They were com-
missioned by the Society for the Diffusion of Useful Knowledge
(SDUK) and were used in the campaign which preceded the amend-
ment of the old Poor Law.[61] She was furnished with volumes of mate-
rial by the Poor Law commissioners and the bias of her tales followed
the bias of the commission which had set out to prove the pernicious
effect of the outdoor system, and which argued that the workhouse
had to act as an incentive to work and not as an encouragement to
indolence. Her main theme was the theory, now discredited accord-
ing to Mark Blaug, that pauperism so burdened the rate-paying yeo-
manry that they became paupers themselves and gradually disap-
peared as a class.[62]

It is impossible to say whether or not Martineau's Poor Law tales
influenced the easy passage of the Poor Law Amendment, but the
fact that Lord Brougham turned to her as a publicist for the cam-
paign was an indication of the esteem which the *Illustrations* had
brought her. Of the *Illustrations* Lord Chancellor Brougham had
said:

> They are of the highest merit, and indeed are of very great impor-
> tance. It is difficult to estimate the good they are likely to pro-

duce.... She is as prolific as Scott ... and she has the best feelings and, generally the most current principles of any of our own political economists.[63]

Brougham had besieged her with requests to transfer publication of the *Illustrations* to the SDUK, but unwilling to break her contract with Charles Fox, she had accepted instead a commission to write *Poor Laws and Paupers*. In spite of his radicalism, Brougham was a member of the Whig cabinet, and at the time William Johnson Fox had warned Martineau, via the medium of a *Monthly Repository* review article, that her new association might be construed as an alliance with Whiggism and would make her "a less efficient, because less trusted, national instructor." She felt called upon to defend the purity of her radicalism and to deny any association with the Whigs, but Fox's timely criticism had put her on her guard and she thereafter refused to affiliate with any political party and even refused all offers of a government pension.[64] Her favor and assistance were nevertheless courted by many prominent public men of Whiggish persuasion. Chancellor of the Exchequer Lord Althorp asked her advice on the question of direct taxation.[65] Lord Durham became her intimate friend and invited her to stay at Lambton Castle while she wrote the Poor Law tales. Her friendship with the Lambtons was to outlast Lord Durham's premature death and to extend to the very edge of Martineau's own grave. With Brougham, however, Martineau's association was brief: they quarreled over remuneration for the Poor Law tales, and the unhappiness generated over this incident was further embittered by Brougham's enmity toward Lord Durham.[66]

Whiggish gentlemen of the press, the *Edinburgh* reviewers Jeffrey, Smith, and Empson, were also constant visitors to the house on Fludyer Street. Empson acknowledged that since the publication of the *Illustrations*, "We have heard more political economy ... than we believe was ever before heard outside the Political Economy Club." But he nevertheless told *Edinburgh* readers that it was highly presumptuous of Harriet Martineau, a mere woman, to claim to "legislate for mankind anew on its most complicated institutions." He was an as yet unconverted Whig who disagreed with many of the theories of the economists, and much of his criticism of the *Illustrations* was aimed at political economy rather than at Harriet Martineau. "The excellences are her own," he wrote, "and ... the defects are, in some degree, those of other people." He admired her descriptive talents but criticized her inconsistencies; her support for public edu-

cation, for example, he found to be contrary to "the universality of her principle." He observed also that the later *Illustrations* were of lower quality than the first more successful volumes, and he singled out *Ella of Garveloch*, *Weal and Woe in Garveloch*, and *A Manchester Strike* as "so beautiful in their poetry and their painting, and so important in their moral, that, were we to begin to praise them, we should not know where to stop."[67]

The Tory journals were considerably less kind. William Maginn in *Fraser's Magazine* was upset by Martineau's "tirade" against charity, her denunciation of the Poor Law, and the "disgusting" dissemination of the "topic of generation."[68] But it was the *Quarterly Review*, not *Fraser's*, which Martineau thought the least charitable of her critics. Like *Fraser's* it denounced her for thinking "child-bearing a crime against society," and deprecated her opposition to alms. It examined the individual tales, generally came to conclusions which differed from hers, and summed up its opinion thus:

> There is, we admit, much which it is impossible not to admire in Miss Martineau's productions—the praiseworthy intention and benevolent spirit in which they are written,—and the varied knowledge of nature and society, the acute discrimination of character, and remarkable power of entering into, and describing the feeling of the poorer classes, which several of her written narratives evince. But it is equally impossible not to laugh at the absurd trash which is seriously propounded by some of her characters, in dull didactic dialogues, introduced here and there in the most clumsy manner, and what is worst of all, it is quite impossible not to be shocked, nay disgusted, with many of the unfeminine and mischievous doctrines on the principles of social welfare, of which these tales are made the vehicle.[69]

After the vindictiveness of the Tory journals and the lukewarm praise of the *Edinburgh* Martineau must have found the appreciation of those who supported the principles of political economy very comforting. John Stuart Mill was kind in the *Monthly Repository*.[70] On a more personal level Francis Place was consistently encouraging. He told her that she delighted well-informed people with the able and "enticing manner" in which she elucidated difficult subjects. He found the tales exhilarating and no work "so practically valuable" as the summarizing story, *The Moral of Many Fables*. If he were a rich man, he said, he would have endowed every library and book club with copies of her stories.

It is not easy for me to express to you the admiration I feel, on reflecting that you—a woman—should have excelled them all, that you should have set at naught the odium which has palsied almost everyone else.[71]

In *The Moral of Many Fables*, Martineau summarized the arguments and conclusions of the preceding twenty-four volumes. She renewed her call for the interdependence of capital and labor, for mechanization, for repeal of the Corn Laws, and for free trade. She repeated her arguments against strikes and against charity. And she stressed the importance of population control and emigration. She acknowledged that British society was still imperfect, but she believed it to be perfectible and saw it as making "a prodigious advance." With her confidence in perpetual progress she had no doubt that the greatest happiness of the greatest number could be achieved. Much of her optimism was founded on the theory that natural resources and man's ingenuity were inexhaustible.[72] She failed to appreciate the discrepancy between this argument and the logic of the Malthusian belief in the diminishing returns of the soil. She did not question that progess would be anything but beneficial, nor did she ask where it ultimately tended.

To Harriet Martineau at this time political economy offered a happy prospect and she saw it as "a positive obligation on every member of society who studies and reflects at all, to inform himself of its leading principles."[73] She reinforced the chief doctrines of the "science" in many of her subsequent writings. *Dawn Island* (1845) and *Forest and Game Law Tales* (1845 and 1846) were written specifically on behalf of the Anti–Corn Law League. Her *History of the Peace* can logically be called the laissez fairist's interpretation of early nineteenth-century British history. Even in her novels and children's stories the message of political economy was seldom absent. Except for *Forest and Game Law Tales*, however, she did not repeat the experiment of teaching by illustration, and the concept was not revived until 1874 when Millicent Garrett Fawcett wrote *Tales in Political Economy* with apologies to Harriet Martineau "for my plagiarism of the idea."

A quarter of a century after writing the *Illustrations* Martineau was to say of the competitive principle:

If . . . [a man] were perfectly honourable and generous, he might find it impossible to trade or labour on the competitive principle, and might thus find himself helpless and despised among a busy and wealth-gathering society. [*Household Education*, p. 23]

But in 1832 she was the unhesitating champion of individualism. She did not appreciate the ambiguities inherent in her philosophy, and failed to understand that laissez faire and the greatest happiness principle were fundamentally incompatible; that individual freedom could become synonymous with personal greed and private interest; and that it was too often antithetical to social responsibility. She believed that by teaching the rules of political economy to a society its individual members would be induced to act in behalf of the greatest happiness of their greatest number. In this—despite the exceptions she made in the case of education, public works, and the Poor Law administration—she was closer to being a free trade liberal than to being a Benthamite utilitarian. She had a sanguine view of human nature and unlike Bentham and his immediate disciples who knew the importance of reinforcing sanctions, she opted for a reliance upon individual virtue based on a knowledge of the correct principles. She chose to believe in the finest rather than the meanest attributes of human nature, and it was upon the rock of her naive and undaunted optimism that her philosophy foundered. For all its defects, however, the *Illustrations of Political Economy* made its author a celebrity, filled a significant void, and spoke both to and for its era. In John Stuart Mill's words, Harriet Martineau and her political economy tales "are surely a sign of this country and Time."[74]

Chapter IV

The Retrospective Traveler

Of Slaves, Women, and Democracy in America

When the sailing ship the *United States* left Liverpool harbor in August of 1834, Harriet Martineau and her traveling companion Louisa Jeffreys were aboard. Martineau had completed the *Illustrations* and was escaping the literary commitments, the social obligations, and the increasing demands and tensions of the house on Fludyer Street. A few weeks later when the ship docked in New York she was in a state of high excitement, her spirits in a "holyday dance." In the two years she was to spend in the United States she proved to be an indefatigable tourist, acutely observant, and serenely oblivious to the discomforts of nineteenth-century travel. She sailed up the Hudson. She went to Niagara Falls twice. She sailed the Great Lakes. She visited the grave of Joseph Priestley. She had dinner at the White House with President Jackson whom she did not much like despite his laissez faire antimonopolist philosophy and because of his attitude and actions toward the Indians and the slaves. She stayed with former President Madison whom she did like, and except for the question of slavery got along famously with the old statesman. She visited Capitol Hill and attended debates in the Senate which she considered an unrepresentative, Southern-dominated, and aristocratic body—she was unable to comment on the membership and debates in the House because the acoustics of the chamber made it difficult for her to hear. She journeyed south from Washington through the Carolinas and Georgia to New Orleans and then sailed north up the Mississippi. She visited Tennessee, Kentucky, and Ohio, and made several trips to New England where she toured the Connecticut Valley with the historian George Bancroft, climbed the White Mountains, and attended a Harvard commencement. She stayed at the home of Dr. William Channing, the Unitarian divine,

and met the Garrisonian abolitionists and embraced their cause. She visited prisons, asylums for the insane, and schools for the handicapped. She went to industrial centers in the North, and plantations in the South. She spent time in the major cities, and enjoyed the unspoiled beauty of the frontier regions. The list of celebrities she met was so prodigious that it does not bear repeating. She was in her own words "lafayetted"—the best homes were open to her, carriages were sent for her, attentions were showered upon her, and she basked in "one bright sunshine of goodwill" from the moment she disembarked in New York until the dark specter of slavery cast its shadow across her path.[1]

She went to America, she said, for rest and recreation and denied that her tour was ever a premeditated "book-making expedition."[2] Despite her denials, the prospect of writing about her experiences could never have been far from her mind. Originally the idea of going to America was suggested to her by Lord Henley who said that

> whatever else may or may not be true of the Americans, it is certain that they have got at the principles of justice and mercy in the treatment of the least happy classes of society which we should all do well to understand. Will you not go and tell us what they are? [*Autobiography*, 1:270]

It was a suggestion which was bound to appeal to Harriet Martineau's didactic instincts. Although she declined the advance offers of publishing houses, and publicly denied any ulterior purpose in her journey—probably for the benefit of her American hosts who would otherwise have been put on their guard—she nevertheless kept copious journals of her itinerary and her experiences, and admitted privately as early as 1833 that

> if I am spared to come back, this country shall know something more than it does of the *principles* of American institutions. I am tired of being kept floundering among the details which are all that a Hall and a Trollope can bring away; and it is urged upon me by some of our philanthropists, that I should go and see for myself.—What I have said seems presumptuous. But the thing should be done, and I will do it, as far as in me lies.[3]

It was an ambitious if not a "presumptuous" proposal, but in it lay the germ of modern sociology.[4]

Martineau realized that it was important to make an objective study of the political and social institutions of a nation before passing judg-

ment upon it. En route to New York she had outlined a primitive sociological methodology which was later published as *How to Observe Morals and Manners*.[5] Determined to avoid partiality herself, she advised would-be travelers not to judge foreign lands by their own countries or to censure manners or customs because they were strange or differed from those to which they were used. She had been forewarned by the example of Frances Trollope's *Domestic Manners of the Americans* which was published in 1832. Mrs. Trollope had come to America from England in 1827 to join Frances Wright at the Nashoba settlement, but despite this early brush with radicalism, she was neither a reformer nor a democrat. She was proud rather than critical of her own country, and she regarded with impatience any deviation from the standards and morals to which she was accustomed. Unlike Martineau, who was prepared to adopt the manners and accept the habits of the natives, Mrs. Trollope was unwilling to adapt to the conditions of the country. She commented with unremitting frequency upon the "want of refinement" which everywhere affronted her. She described with acid humor the tediousness of social evenings where women talked of nothing but their illnesses and critically eyed each other's clothes while men discussed politics and spat—she was particularly disturbed by the American habit of spitting. Plainly offended by the familiarity of those she considered her social inferiors, she portrayed Americans at their most ignorant and crude, and she concluded her book with the promise that should her American readers ever "embellish" their lives with the arts and graces, she would return and write a different sort of book.

> If refinement once creeps in among them, if they once learn to cling to the graces, the honours, the chivalry of life, then we say farewell to American equality, and welcome to European fellowship one of the finest countries on earth.[6]

Mrs. Trollope's prejudices and preconceptions were those of the English establishment. Unlike her contemporary traveler Alexis de Tocqueville, she was appalled rather than impressed by the "equality of condition" which she found among Americans. Harriet Martineau noted with amusement that Americans, still smarting from Frances Trollope's criticisms, had been forewarned before her own arrival not to chew tobacco or praise themselves in her presence "under penalty of being reported in London for these national foibles."[7] In her two American books—*Society in America* (1837) and *Retrospect of Western Travel* (1838)—she was generally careful to avoid Mrs. Trol-

lope's particular aversions even when she observed them, but she could not resist the occasional comment about spitting and complained somewhat pettishly about a disquieting national partiality for rocking chairs. She found it unsettling to watch ladies "vibrating in different directions, and at various velocities"; perhaps there was a relationship between this discomfort and the childhood fear of magic lanterns and terror of rythmic echoes.[8] By and large, however, she bore her experiences with good humor, and unlike Mrs. Trollope, who refused to associate with those she did not consider her social equals, Martineau was conscious of the danger of associating exclusively with those who *were* her social equals and of therefore having only a "partial intercourse with the nation." So although fêted by the famous, she made a point of meeting ordinary Americans too. Over the two year period of her stay in the United States she traveled some ten thousand miles. She journeyed by Mississippi riverboat, by canal barge, by railway, on horseback, and by stage. She lived during that time in private homes as the guest of the illustrious, but she also lived in boardinghouses and met with the common people. She endured with considerable stamina, especially for one so recently in poor health, the rigors of travel: the stranding of her boat on the Lakes, the near-overturning and miring of her carriage, and the endless delays and wearying overnight journeys in creaking, jolting carriages which bumped their unceremonious way along primitive corduroy roads. All the time she meticulously noted her impressions in her journal. Nothing escaped her keen observing eye, but while losing nothing in private conversation, she admitted that her deafness was a handicap and that she missed "the casual conversation of all kinds of people, in the streets, stages, hotels &c." She acknowledged regretfully that "the lights which are thus gathered up by the traveler for himself are far more valuable than the most elaborate accounts of things offered to him with an express design." Nevertheless, she more than compensated visually for her aural deficiency, and her enthusiastic portrait of America in the 1830s is as vibrant today as it was when she wrote it. Where the *Illustrations* had demonstrated the weaknesses of her fictional prose, Martineau's American volumes illustrated her strengths as a journalist. Although conscious of the importance of objectivity, she was more partial than she realized, for she came to the United States armed with expectations. She believed herself to be

> as nearly as possible unprejudiced about America, . . . [but] with a
> strong disposition to admire democratic institutions, [and] an entire

ignorance how far the people of the United States lived up to or fell below their own theory.[9]

Coming from an intensive study of the condition of human happiness in England where the society had not yet shaken off the burden of ancient aristocratic dominion, she came to America with high hopes that in this new republic at least the people would be living up to the ideals of humanity manifested in their own Declaration of Independence. She therefore arrived with eager preconceptions which could not but have colored her final judgment of the United States and its people. The value of her observations was far from being obscured by her expectations. Martineau achieved maturity as an author in her American books, and her work derived strength from her new independence and stature as an individual.[10]

After her two years among the Americans, Martineau returned home, and in the following year, 1837, she published *Society in America*. She divided the book into three sections: the first dealt with America's political structure, the second with its economy, and the third, "Civilization," with various aspects of its social mores. As a sociological study the work is uneven in quality. Perceptive observations are interspersed with untidy rambling anecdotes and tangential personal reminiscences which, although interesting enough in themselves, detract from the purpose of an objective survey of society. It was unfortunate that Harriet Martineau wrote *Society in America* before she wrote *Retrospect of Western Travel*, published in the following year. If the order of writing had been reversed she would have been less tempted to digress from her expressed aim in *Society in America*. *Retrospect* professed to be nothing more than a book of travel, and although it was not without some social commentary, it was an unpretentious work with serious considerations clearly subordinated. In its coherence and in its structure *Retrospect of Western Travel* was superior to the earlier work and was considered so by many of her contemporaries. She herself later described it as "more creditable to her mood, and perhaps to her powers, than the more ambitious work."[11] When he read it, even Carlyle was "vehement" in his delight.[12] It captured much of Martineau's infectious enthusiasm, and her most hostile American critics were prepared to concede the excellence of her descriptions. Nevertheless, for the student of nineteenth-century America *Society in America* remains the more impor-

tant publication. More than half a century after its composition John Morley was to say of it, and of *Retrospect*:

> We do not suppose that they are worth reading at the present day, except from a historical point of view. But they are really good specimens of a kind of literature which is not abundant, and yet which is of the utmost value—we mean the record of the sociological observation of a country by a competent traveller, who stays long enough in the country, has access to the right persons of all kinds, and will take pains enough to mature his judgments. It was a happy idea of O'Connell's to suggest that she should go over to Ireland, and write such an account of that country as she had written of the United States. And we wish at this very hour that some one as competent as Miss Martineau would do what O'Connell wished her to do.[13]

In *Society in America* Martineau proposed to implement the sociological theories which she had outlined in the as yet unpublished *How to Observe Morals and Manners*. But her purpose was also "to compare the existing state of society in America with the principles on which it was professedly founded; thus testing Institutions, Morals, and Manners by an indisputable, instead of an arbitrary standard." She was quite aware of the danger "of not fully apprehending the principles on which society in America is founded; and of erring in the application to these of the facts which came under my notice" (*Society in America*, 1:viii). Alexis de Tocqueville had just made a similar examination of American institutions and democratic principles in *Democracy in America* which was published in 1835 while Martineau was still abroad. Both writers were therefore simultaneously and independently engaged in studying American society and examining applications of democratic theory in the new republic. But where Tocqueville was concerned primarily with democracy as a practical expedient, Harriet Martineau used the principles of democracy as a criterion of judgment.

> The inalienable right of all the human race to life, liberty, and the pursuit of happiness, must control the economical, as well as the political arrangements of a people; and . . . the law of universal justice must regulate all social intercourse. [*Society in America*, 1:5–6]

When Harriet Martineau came to the United States in 1834 there were twenty-four states and Andrew Jackson was President. She came from the old world to a new one in "the process of world-making." Pioneers were still extending the frontier into the diminishing

wilderness and even the eastern cities were still in embryo. It was a causal universe in which history was being created, and Martineau sensed the dramatic importance of the moment.

> The present . . . is an age in which societies of the whole world are daily learning the consequences of what their fathers did, the connexion of cause and effect being too palpable to be disputed.[14]

She perceived America as suspended between the past and the future "with many of the feudal prepossessions of the past mingled with the democratic aspirations which relate to the future." A necessarian and latent Comtean, Martineau believed that a society grew out of the national experience and was therefore infinitely mutable.[15] But the principles of justice upon which the United States had been founded should, she insisted, remain immutable. She expected to find the spirit of 1776 incarnate in America and her expectations were only partially fulfilled. America compared well with England where the individual was exalted in theory but still despised in the mass. There was no "hereditary humbug" in the United States, and "the English insolence of class to class"—except in the reprehensible case of black Americans—had not been reproduced on American soil. For those Americans who considered themselves "Exclusives" because of wealth or family position, Martineau had nothing but contempt. The natural aristocracy of the country, she believed, was to be found "not only in Ball-rooms and bank parlours, but also in fishing-boats, in stores, in college chambers, and behind the plough." Unlike Fanny Trollope who hardly knew how to receive the "uncouth advances" of her poorer neighbors, Harriet Martineau welcomed the leveling effects of republican equality.[16]

To Martineau, furthermore, the United States appeared to exemplify and substantiate the theories of political economy.

> One remarkable effect of democratic institutions is the excellence of the work turned out by those who live under them. In a country where the whole course is open to every one; where, in theory, everything may be obtained by merit, men have the strongest stimulus to exert their powers, and try what they can achieve. [*Society in America*, 2:352–53]

She was nevertheless disquieted by evidence of materialism in American society. Because she wished to deny that the free enterprise system encouraged a "sordid love of gain," she was unhappy to find it, and despite her loyalty to the principle of individual competition

she could not ignore that the mercenary spirit existed. She made the precipitous and melancholy discovery that economic laissez faire and individual liberty were not always compatible, for one individual's freedom to achieve too often encroached on the freedom of another. In *Society in America* she therefore amended her old uncritical acceptance of individualism and generously—albeit temporarily and inconsistently—endorsed instead the essential principles of socialism.[17] Despite all her fulminations against Owenism in the *Illustrations*, and particularly in *For Each and for All*, in *Society in America* Martineau wrote:

> . . . there is no way of securing perfect social liberty on democratic principles but by community of property. [3:39]

To those who knew her, her about-face came as a complete surprise. "How long have you been an Owenite?" exclaimed her brother Robert on reading the manuscript of *Society in America*.[18] But Harriet Martineau was neither an Owenite nor a communist. She never endorsed an arbitrary equalization of property, and she never entirely relinquished her faith in the competitive principle. But in America she became aware of the obsessive nature of economic individualism.

> If money, if success, apart from the object, could give happiness, who would be so happy as the merchants of America? In comparison with merchants generally, they are happy: but in comparison with what men were made to be, they are shackled, careworn, and weary as the slave. . . . Are the mechanic and farming classes satisfied? No: not even they . . . there must be something wrong in a system which compels men to devote almost the whole of their waking hours to procure that which, under a different combination of labour, might be obtained at a saving of three-fourths of the time. Whether their thoughts have been expressly turned to this subject or not, almost all the members of society are conscious that *care for their external wants is so engrossing as to absorb almost all other cares; and that they would most thankfully agree to work in their vocation for the community for a short portion of every day, on condition of being spared all future anxiety about their physical necessities.* [*Society in America*, 3:46–49, emphasis added]

Forgetting momentarily her earlier imprecations against communal societies in a new almost Marxian concern about leisure time, she ignored her previous rationale that communal responsibility enervated initiative, eroded progress, and was the nemesis of personal responsibility and endeavor. Instead, she acknowledged Godwin's

claim that "leisure [was] the birth-right of every human being," and she despaired that without "community of property" it could ever be secured to everyone. She conceded that the majority of Americans would be opposed to an equalization of property, but she did not think that they were beyond the pale of reclamation and she hoped that the false steps which they had taken in imitation of the old world could be retraced. She was confident that the time would come when Americans would recognize where their own best interests lay, but for her own society she had no such expectations. She thought the English too mired in the past, and too enmeshed in the intricacies of ancient property claims to easily find their own rescue. It is ironic that two world wars and a century later exactly the converse proved to be true!

Martineau's softened—indeed altered—attitude toward Owenism may have been influenced by her visit to Rapp's communist community at Economy, Pennsylvania, or merely by her disquieting observation that Americans were preoccupied with material success. Although she never fully endorsed either Owenism or communism, Martineau's concession toward socialist theory was significant, especially from one who continued to be numbered among the laissez fairists. For the student of Martineau this comment on individualism and the American economy is the most intriguing aspect of the section in *Society in America* devoted to the American economy, a section otherwise the least impressive part of the three-volume work and that which would have most benefited if *Retrospect of Western Travel* had been written first. Instead of providing a critical commentary on the economic fabric of the United States she gave impressions of the economy as she saw it functioning. She did not consider the geographical ignorance of her English readers and skipped from one part of the country to another with alarming inconsistency. Nor did she adequately consider her economist friends who doubtless would have welcomed a more scientific analysis of the United States economy. But perhaps the reader expecting to find a professional assessment of the American economy expects too much; after all, Martineau herself acknowledged that she was not an economist.

Martineau was on the whole more disturbed by American subservience to public opinion than she was by American materialism. Public opinion in America was something more than a convenient Benthamite sanction for the curbing of antisocial behavior; it had become a major obstacle to independence of thought and action. She saw the pressure to conform as ominous, and realized that as long as

opprobrium was attached to the minority view, the influence of the majority would remain oppressive: as long as "the will of the majority decides all public affairs, there is a temptation to belong to the majority." Therefore, instead of finding freedom of expression in America, she found a "deficiency of moral independence" which fed upon bigotry and intolerance and which mocked the spirit of democracy.[19] She admitted that the tyranny of a democratic majority could be as vicious as any aristocratic tyranny of the past had been, but she nevertheless refused to regard this as anything but a temporary phenomenon. Her faith in the ultimate triumph of democracy remained unshaken, and she believed—as she believed in the case of political economy—that the principle would be vindicated when the people were properly educated to an unselfish dedication to the greatest happiness of the greatest number.

> The majority eventually wills the best; but in the presence of imperfection of knowledge, the will is long in exhibiting itself; and the ultimate demonstration often crowns a series of mistakes and failures. [*Society in America*, 1:32–33]

Tocqueville had also noted American subservience to public opinion, and said he knew of no other country where there was "so little independence of mind and real freedom of discussion as in America." He saw in America a leveling down rather than a leveling up and he was less optimistic than Martineau about the majority ever willing the best.

> In the United States . . . the majority . . . exercise a prodigious actual authority, and a power of opinion which is nearly as great; no obstacle exists which can impede or even retard its progress, so as to make it heed the complaints of those whom it crushes in its path. This state of things is harmful in itself and dangerous for the future.[20]

Tocqueville's critique of democracy may well have sown in the mind of John Stuart Mill the seeds of doubt which blossomed in *On Liberty*, for it was Mill who reviewed *Democracy in America* for the *London and Westminster Review* in 1835 when the first volume was published.

Democratic theory presumed that the majority was a more reliable basis for authority than the minority and that it therefore selected the best measures and elected the best leaders. But Martineau found that in the United States, at least, the actuality lagged behind the theory. She discovered that elected officials in national and state

governments were not the most honest nor the ablest men, but usually those who were best able to propitiate public opinion.[21]

> It has become the established method of seeking office, not only to declare a coincidence of opinion with the supposed majority, on the great topics on which the candidate will have to speak and act while in office, but to deny, or conceal, or assert anything else which it is supposed will please the same majority. The consequence is, that the best men are not in office. [*Society in America*, 1:14]

Politicians, she noted, courted the people with lies, flattered them from the rostrum, and generally and inevitably accommodated themselves to expediency. Skeptical and apathetic, the constituents therefore had little faith in their elected officials, and a disquietingly large percentage of the electorate failed to perform its duty at the polls. By their omission, American voters abused those democratic privileges which the English radicals had so recently—if restrictedly—sought to achieve.

> If it were only borne in mind that rulers derive their just powers from the consent of the governed, surely all conscientious men would see the guilt of any man acquiescing in the rule of governors whom he disapproves, by not having recorded his dissent. Or, if he should be in the majority, the case is no better. He has omitted to bear his testimony to what he esteems the true principles of government. He has not appointed his rulers; and, in as far as he accepts their protection, he takes without having given, he reaps without having sown; he deprives his just rulers of a portion of the authority which is their due— of a portion of the consent of the governed. [*Society in America*, 1:158]

As usual she was optimistic that democracy would ultimately triumph and that the majority would eventually be right.

> The experiment of the particular constitution of the United States may fail; but the great principle which, whether successfully or not, it strives to embody,—the capacity of mankind for self-government,—is established. [*Society in America*, 1:158]

Martineau believed America to have been founded upon the right principles, but she perceived a failure not only to implement those principles but also to correctly define them. The leadership of the United States and the edicts of its government would not, she thought, reflect the will of the true majority of the people as long as

slaves and women were excluded from citizenship. The existence of human bondage, and the almost equally intolerable political nonexistence of women were unrepublican and undemocratic. It was to these two particular anomalies that Harriet Martineau expressly addressed herself in *Society in America.*

Harriet Martineau had embraced the antislavery cause before her visit to the United States. She had written on the subject in the *Illustrations of Political Economy* tale *Demerara,* in which she had been as much concerned with the economics as with the immorality of slavery. She had contributed two antislavery articles to the *Monthly Repository:* "West India Slavery," and "Liberia."[22]

> It is most painful to think on the condition of our Negro brethren; of their tortured bodies, their stunted intellects, their perverted affections, their extorted labour, their violated homes.[23]

Her unambiguous repugnance for the institution of slavery was well known, and the captain of the *United States* had doubted the wisdom of permitting her to disembark in New York where there had recently been antiabolitionist riots. He had taken her companion, Louisa Jeffreys, aside in order to ascertain Miss Martineau's position on slavery and had only consented to allow her ashore when assured that although "an abolitionist in principle" she had come to America "to learn and not to teach."[24]

Her first lessons had come from those of the middle and southern states who opposed the abolitionists and thought them a violent radical group whose disruptive methods were injuring rather than helping the cause of emancipation. Personal acquaintance with the abolitionists was to give her a quite contrary estimation. Her most lasting and important lesson on the subject of slavery was learned from William Lloyd Garrison and his disciples, and so closely did her subsequent arguments follow the Garrisonian line that it is impossible to say where Garrison leaves off and Martineau begins. Garrison had at first supported the concept of gradual emancipation and had therefore initially supported the American Colonization Society. The Colonization Society, founded in 1817, had the endorsement of Clarkson, Wilberforce, and other English champions of the antislavery cause who had themselves earlier been involved with a similar experiment—the Freetown, Sierra Leone, settlement of free blacks

and black loyalists. The Colonization Society proposed to transport fifty-two thousand liberated blacks annually from America to Liberia. As this number represented the approximate yearly natural increase in the slave population, it was hoped that by these means slavery would gradually be eliminated. However, there was a serious discrepancy between the society's intentions and its achievements. When Garrison realized this, he withdrew his support from the society, and by 1830 had begun to press for immediate abolition instead of the gradual emancipation which the society purported to endorse. Martineau had fervently embraced the cause and lauded the aims of the Colonization Society in both *Demerara* and "Liberia," but in *Society in America,* written after the Colonization Society had been in operation for twenty years, she pointed out that the society had succeeded in transporting only two to three thousand persons—a pitiable fraction of the two and a half million slaves and three hundred and sixty-two thousand free blacks living in the United States. The scheme was in her words "a miserable abortion," and she no longer saw it as a solution to the problem of slavery but merely as a convenient conscience salver to society members, many of whom were slaveholders themselves.

Garrison had been stung by the hypocrisy of a society which professed to have the interests of black Americans at heart but which in reality denied that the coexistence of black and white Americans was possible: the transportation concept was basically an admission that free blacks would not be easily integrated into the society, and that they should be transferred to the continent from which they originally came. Garrison aimed therefore not only to emancipate black slaves but also to integrate them. He realized that the North was as guilty as the South in this respect. Martineau also was to comment upon the intolerance of slaveholders in the South and of northerners who locked free blacks out of their schools; closed church pews to them; and excluded them from their colleges, their restaurants, their municipal offices, their professions, and even their literary and scientific associations.[25] Like Tocqueville who discovered that

> slavery is fatally united with the physical and permanent fact of color. The tradition of slavery dishonors the race, and the peculiarity of the race perpetuates the tradition of slavery,[26]

Martineau came to realize that in the minds of Americans race and slavery were inextricably associated. Former President James Madison, president of the American Colonization Society and a slave-

holder, had privately admitted to her that if he could make all the
blacks white he would "do away with slavery in twenty-four hours."
The significance of the admission was not lost upon her. She
acknowledged

> . . . that all the torturing associations of injury have been connected
> with colour, that an institution which hurts everybody and benefits
> none, which all rational people who understand it dislike, despise and
> suffer under, can with difficulty be abolished, because of the hatred
> which is borne to an irremovable badge.[27]

For William Lloyd Garrison slavery made a mockery of the pious
protestations of northerners, of the Colonization Society, and of
Christianity itself. Northern clergymen had closed their doors to him
when he sought to preach the gospel of universal freedom from
their pulpits, and when he brought his antislavery message to New
England in 1830 even Lyman Beecher and William Channing, who
later supported abolition, refused to underwrite his cause. With a
few exceptions like Martineau's friend, the Unitarian minister, the
Reverend Samuel May, leaders of the organized religions remained
aloof and disapproving. The only religious community to offer Gar-
rison a platform in those first pioneering days was not the Christians
but the deists of the First Society of Free Inquirers. Gradually, how-
ever, from these beginnings the New England and American Anti-
Slavery Societies were founded, and by 1833 each of the New En-
gland states had its own antislavery society. Yet organized religion
remained aloof, and a disenchanted Garrison withdrew his alle-
giance from the forms and orthodoxies of religion.[28]

To all appearances Harriet Martineau still conformed to the Uni-
tarian creed when she arrived in the United States. Although neces-
sarianism was not an accepted doctrine among American Unitarians,
Martineau as the author of the three prize essays was welcomed as
something of a religious authority by the American Unitarian com-
munity. But except for her friends May, Follen, and Channing—the
latter had by this time issued a statement in support of abolition—
the Unitarian clergy, like the clergy of most other denominations,
remained unmoved by Garrison's crusade. Martineau was dismayed
by the apparent hypocrisy of their position and she proclaimed them
"too destitute of the apostolic spirit to be adequate to the needs of
the time."

> They [the clergy] all *say* (in private) that Slavery is demoralizing, and
> that the duty of clergymen is to advocate good morals. Well then, if

they have done anything,—preached,—written,—opened pews to coloured people, supported their charities, and treated them like brethren, by all means let us know it. If not—where's the use of praising them for their private sentiments?[29]

Describing Christianity as "the root of all democracy, the highest fact in the Rights of Man," she condemned American Christianity as a "spurious offspring of that divine Christianity."[30] When in June, 1837 the General Association of Massachusetts Clergymen took a stand against the growing female participation in the cause of abolition, and even used the Bible to justify the subordination of women as southern clergy were using it to justify slavery, her disillusionment was complete. She continued to profess Christianity for another decade, and even in a later comment described this as "the highest point of the metaphysical period of her mind."[31] But her American experience sowed the seeds of her eventual skepticism, and in *Society in America* one sees the earliest intimations of what was to follow.

> The clerical profession is . . . too much opposed to the spirit of the gospel, to outlive long the individual research into religion, to which the faults of the clergy are daily impelling the people. [3:295]

Harriet Martineau, the necessarian, was not originally in total agreement with Garrisonian thought. Garrison rejected necessarian causation because he believed that it tended to exonerate the slaveholders as "creatures of circumstance." He took the position that people were individually culpable for their actions and that neither upbringing nor environment could be used to justify or excuse slaveholding. Martineau, on the other hand, and especially while still journeying in the South prior to her acquaintance with the abolitionists, had first regarded slaveholders as victims of their circumstances, and her letters and journals of 1835 evidenced a willingness to exculpate them on this account. Exposed to Garrison's rationale, however, she was prepared to deviate from causal dogma: she was never too immured in principle to deny justice when she saw it miscarried. She conceded that the same circumstances which had produced the slaveholder had also produced the Grimké sisters who left their comfortable southern estates to become abolitionists; and she concluded from this that the same causes could differently affect different individuals and that each was therefore responsible for his or her own actions. This concession notwithstanding, in the case of the slaves themselves she could in all conscience remain Hartleyan. She believed in the essential equality of human beings and was convinced

that only their circumstances had reduced the slaves to a "brutish" condition and that only circumstances—freedom and education— would restore them to a position of dignity. She noted with unmixed horror the awful hypocrisy of an Alabama law which fined masters five hundred dollars for teaching slaves to read, and only two hundred dollars for torturing them! Southerners, she remarked, were perfectly secure as long as their slaves were ignorant and docile, but they became suspicious and fearful if their slaves exhibited the traits of rational human beings.[32]

Although southerners insisted that slaves were contented with their lot, Martineau's own observations convinced her to the contrary. She had seen "dehumanized" beings trudging home from the fields like so many beasts of burden. She had witnessed the unspeakable condition of slave quarters. Most depressing of all, she had gone to the Charleston slave market and had felt a humiliation which "might stagger the faith of the spirit of Christianity itself." Only those could be content with the condition of their servitude, she concluded, who had been utterly demoralized and degraded.

> Slaves are more or less degraded by slavery in proportion to their original strength of character or educational discipline of mind. The most degraded are satisfied, the least degraded are dissatisfied with slavery. The lower order prefer release from duties and cares to the enjoyment of rights and the possession of themselves; and the highest order have a directly opposite taste. The mistake lies in not perceiving that slavery is emphatically condemned by the conduct of both.[33]

To Martineau's uneasy conscience slaves were "deeply injured fellow-beings," and she felt awkward and embarrassed in their presence because she bore the guilt of the society which had injured them.

Her first conscious contact with a slave was in Washington, and the occasion made an indelible impression.

> She was a brighteyed merry-hearted child; confiding like other children, and dreading no evil, but doomed, hopelessly doomed, to ignorance, privation and moral degradation. When I looked at her and thought of the fearful disobedience to the first moral laws, the cowardly treachery, the cruel abuse of power involved in thus dooming to blight a being so helpless, so confiding, and so full of promise, a horror came over me which sickened my very soul.[34]

The horror lingered in Martineau's consciousness and weighed upon her conscience, so that when some time later in New Orleans

she met Ailsie, she decided to adopt her. Ailsie was eight years old. She served her white mistress by dressing her hair and by fanning flies from the dinner table with a huge brush of peacock feathers. As a slave her future was too bleak to contemplate and thus Harriet Martineau, spinster, decided to have her sent to England as her adopted child. Ailsie, however, never arrived in England. She changed ownership and was lost to Martineau and to posterity. The relationship between Martineau and little Ailsie never really began and so it is impossible to guess what it might have become. But it would be fairly safe to conclude that Martineau was motivated less by maternal than by paternalist instincts. She wanted to give Ailsie a chance in a free society, and she planned to train her for domestic or industrial employment in England: she thought of Ailsie less as a daughter than as a kind of apprentice. Were her ambitions for Ailsie so modest because she was black? Would she have contemplated another training and another future for the child if Ailsie had been white? Was there then more than a modicum of hypocrisy in her protestations of human equality? These are questions all but impossible to answer. Martineau approved miscegenation and condemned social discrimination, but why, one cannot help wondering, did she think of Ailsie as her probable servant rather than as her possible child? Was it because of an unacknowledged prejudice? Were her considerations purely practical? Was it only her conscience and not her heart which had been stirred? The answer remains elusive. Martineau should rather be applauded for her intentions than condemned for her shortcomings. For an unmarried English woman of her time and place her commitment was generous and her gesture was superb.[35]

Harriet Martineau, beginning her tour in New York and then traveling south, had made many personal friends in the southern states and had enjoyed the generosity of southern hospitality. Because her southern hosts had led her to think of the abolitionists as anarchic revolutionaries, she had, despite her antislavery sympathies, been disinclined to receive abolitionist overtures when she first arrived in New England. But she had come to the United States as a professedly impartial observer and she was eventually persuaded therefore to attend a meeting of the Boston Ladies' Anti-Slavery Society. Since a meeting of the group had been mobbed earlier that year (1835), Martineau's attendance involved a serious risk of physical danger, but she refused to be intimidated by warnings or even by the ominous presence of hooting boys at the entrance to the meeting place. Clothed in objectivity she felt unafraid

and even a little skeptical. But her immunity was not to prove inviolable. While seated in the audience she was handed a pencilled note requesting that she address a few words to the meeting on behalf of the cause. She knew that her compliance would be a commitment, and she foresaw that every house in Boston but those of the abolitionists would be closed to her. She had sensed the omnipotence of public censure and knew that her endorsement of an unpopular cause would condemn her in the eyes of her friends and turn her triumphal tour into something less than cordial. However, personal consequences had never deterred Harriet Martineau from speaking her conscience, and as an opponent of slavery she could make only one choice.

> The case was clear as daylight to my conscience. If I had been a mere stranger, attending with a mere stranger's interest to the proceedings of a party of natives, I might and ought to have declined mixing myself up with their proceedings. But I had long before published against slavery, and always declared my conviction that this was a question of humanity, not of country or race; a moral, not a merely political question; a general affair, and not one of city, state, party, or nation. Having thus declared on the safe side of the Atlantic, I was bound to act up to my declaration on the unsafe side, if called upon. I thought it a pity that the call was made, though I am now very glad that it was.[36]

Her social fears were largely realized. She now had no callers in Boston except for those who were known to sympathize with the abolitionists, and during her remaining months in America

> she was subjected to insult and injury, and was even for some weeks in danger of her life while travelling where the tar-barrel, the cow-hide, and the pistol were the regimen prescribed for and applied to abolitionists, and threatened especially in her case.[37]

But the bond forged with the abolitionists that day in Boston was to last throughout her lifetime. She carried on their fight on the other side of the Atlantic until their cause was won. She wrote on behalf of emancipation not only in her two American books and in articles in the New York *National Anti-Slavery Standard,* but, endorsing the Garrisonian principles of immediate abolition and racial integration by peaceful apolitical methods, she also addressed English readers in the *Edinburgh Review,* the *Westminster Review* and the *Daily News.* She was convinced that abolition would not be achieved by the demo-

cratic process despite her adherence to the cause of democracy and her support for democratic principles. As it operated in mid-nineteenth-century America she had scant faith in the majority system, and pointed out that the small white southern electorate had an unequally large voice in Congress. With equal states' representation in the Senate, with the connivance and compromises of northern politicians, and with the accretion of new slave territories, the South, she believed, would be able to maintain its sectional interests. She did not yet see abolition and union as incompatible, nor at that time did she despair of the union. She described the threat of dissolution as a red herring designed to obscure the slavery question.[38]

> Those who threaten the dissolution of the Union, do it in order to divert towards this impracticable object the irritation which would otherwise, and which will ere long, turn against the institution of slavery.[39]

Despite her characteristic long-term optimism, Martineau did not minimize the difficulty of achieving emancipation. In *The Martyr Age of the United States* which was republished in America from the *Westminster Review,* she compared the task of the American abolitionists with that of the English reformers attempting to overthrow the aristocratic system.

> Slavery is as thoroughly interwoven with American institutions—ramifies as extensively through American society, as the aristocratic spirit pervades Great Britain. The fate of Reformers whose lives are devoted to making war upon either one or the other must be remarkable. [P. 4]

Her comparison was perspicacious. Slavery—the "solitary feudalism" of the South—appeared to be the only apparently enduring institution in the changing society of early nineteenth-century America. She understood that the caste system and the feudal notions it engendered in America were as pernicious and even more difficult to overthrow than was the English system of class. Nevertheless, she was encouraged by the vigor of the abolitionist struggle.

> You [the abolitionists] are strengthening us [the English] for conflicts we have to enter upon. We have a population in our manufacturing towns almost as oppressed, and in our secluded rural districts almost as ignorant as your negroes. These must be redeemed. We have also negroes in our dominions, who, though about to be entirely surrendered as property, will yet we fear, be long oppressed as citizens, if

the vigilance which has freed them be not as active as ever. I regard
the work of vindicating the civil standing of negroes as more arduous
and dangerous than freeing them from the chain and the whip.[40]

She did not underestimate the difficulty of this undertaking, but as
usual she was convinced that eventually "the natural laws which
regulate communities" would remove the curse of slavery and would
restore "the universality of that generous attachment to their com-
mon institutions which has been, and will again be, to the American
people, honour, safety, and the means to perpetual progress" (*Society
in America,* 1:108–9; 2:123, 137).

Harriet Martineau's efforts on behalf of abolition won deep re-
spect from her American colleagues in the movement. Her articles
were eagerly reprinted in the United States, and her American cor-
respondence and her American friendships never flagged. In 1838
she was made an honorary member of the Massachusetts Anti-Slav-
ery Society, and in 1840 she was elected as a delegate from Mas-
sachusetts to the London Anti-Slavery Convention. When in 1856
she was thought to be dying, Garrison proposed a resolution to the
annual meeting of the American Anti-Slavery Society expressing to
her "while yet there is time, our deep, affectionate, and reverential
gratitude for the benefit of her labours, the honour of her friend-
ship, and the sublime joy of her example." Privately he wrote to her
saying:

> Twenty years ago . . . words of sympathy and approval . . . you gave
> me . . . at the risk of social outlawry, popular contempt and indigna-
> tion, and pecuniary loss. . . . [You] have ever since been the unflatter-
> ing championess of justice, humanity and freedom on a world-wide
> scale.[41]

Anti-Slavery Society meetings began with a solemn reading of a Dec-
laration of Sentiments which was based upon the Declaration of
Independence. Martineau may well have been inspired by the iro-
nies implicit in the Declaration of Independence to compare the
realities of American society with the principles it had proclaimed in
1776. In the decade following Martineau's tour of the United States,
the women's movement in America also observed a ritual reading of
a Declaration of Sentiments at its conventions. But even before the
start of the conscious feminist movement, Martineau observed a par-

allel between the enslavement of blacks and the subjection of women. She noted that both made a mockery of democratic idealism in America, and in *Society in America* she wrote a chapter entitled: "Political Non-Existence of Women," which is a too much neglected early manifesto in the women's rights campaign. To Martineau it seemed intolerable that

> governments in the United States have power to tax women who hold property; to divorce them from their husbands; to fine, imprison, and execute them for certain offences. Whence do these governments derive their powers? They are not "just," as they are not derived from the consent of the women thus governed. [1:199]

Both in England and in America women's interests were represented by adult male voters. As Martineau pointed out, even supposedly radical thinkers like Thomas Jefferson in the United States and James Mill in England concurred in this opinion. But Martineau for her part would not accept surrogate representation.

> I, for one, do not acquiesce. I declare that whatever obedience I yield to the laws of the society in which I live is a matter between, not the community and myself, but my judgment and my will. Any punishment inflicted on me for the breach of the laws, I should regard as so much gratuitous injury; for to those laws I have never, actually or virtually, assented. [1:204]

As a little girl growing up in early nineteenth-century England, Harriet Martineau was more educationally advantaged than most. Even so, she was early aware of the limitations of female education and of female prospects. Her first contributions to literature and to the feminist cause, it will be remembered, were made when James went off to college and a career and left her at home. As a regular reviewer on the *Monthly Repository* a few years later, her feminism was further reinforced by William Johnson Fox and his like-minded circle. As a female radical in the era of reform, Martineau admitted to a compulsion "to do something with the pen, since no other means of action in politics are in a woman's power."[42] She resented her inferior status and the subjection of women generally and confided to Francis Place, "I would fain treat of Woman . . . for there is much to be said upon it."[43]

In England the women's movement advanced with the utmost restraint. Mary Smith's 1832 petition to enfranchise women was totally disregarded by the Reform Parliamentarians. A female enfran-

chisement clause in the first draft of the Charter did not appear in the final version. The first pioneering efforts in female education were not made until the 1840s. And it was not until the 1850s—with the modest exception of the 1839 Infant's Custody Act—that the first cautious assaults were made on the marriage laws. In America in 1834, however, the feminist movement already existed in embryo. American women became involved in the antislavery movement, the temperance societies, and the peace crusade. Women had been present at the first meeting of the American Anti-Slavery Society; they had organized their own branches of the society; they raised funds; and they wrote for the cause. Initially they acted as auxiliaries of the male leaders of the organization, but it soon became apparent that women were not playing a subordinate role in the movement. The Grimkés and other female abolitionists were among the most popular speakers on the antislavery circuit. In 1837, the year after Martineau's departure from the United States, the Massachusetts clergy felt compelled to issue their Pastoral Letter condemning these women for their unfeminine behavior: using biblical texts to support their charges, they contended that women belonged at home and not on public rostrums.

The Massachusetts clergy made feminism an issue in the antislavery campaign and split the abolitionist movement. Those abolitionists who were not in sympathy with the feminist cause harkened to the clerical admonition and formed their own branch of the antislavery movement—the National Anti-Slavery Society—in which female participation was subordinated. The Garrisonians of the American Anti-Slavery Society, however, upheld the rights of women to equality although they kept the question secondary to that of abolition and were less dedicated to feminism than were others, like Susan B. Anthony and her followers, who made women's rights their first priority. Nevertheless, both organs of the American Anti-Slavery Society, the *Liberator* and the *National Anti-Slavery Standard,* supported the women's fight and regularly reported the Women's Rights Conventions. Garrison in particular became a champion of the feminist cause.

> As our object is Universal Emancipation to redeem woman as well as man from a servile to an equal condition—we shall go for the Rights of Woman to their fullest extent.[44]

When the World Anti-Slavery Convention meeting in London in 1840 refused to seat two female delegates, Garrison absented him-

self from the main body of delegates and joined the women in the gallery saying, "After battling so many long years for the liberties of African slaves, I can take no part in a convention that strikes down the most sacred rights of all women." Martineau, herself too ill to attend as an honorary delegate for Massachusetts, could only admire the greatness of Garrison's gesture.

> Garrison was quite right, I think, to sit in the gallery at the Convention. . . . It has done much for the woman question, I am persuaded. You will live to see a great enlargement of our scope, I trust, what with the vices of some women and the fears of others, it is hard work for us to assert our liberty. I will, however, till I die, and so will you; and so make it easier for some few to follow us than it was for poor Mary Wollstonecraft to begin. [*Autobiography*, 3:233]

Harriet Martineau was never slow to applaud those who acted upon their principles, and never hesitated to do so herself. She had acted on principle when she tackled the awkward matter of birth control in *Weal and Woe in Garveloch*. She had acted on principle when she accepted the abolitionists' invitation to speak in Boston in 1835. And she was to act on principle again: when she affronted public opinion with her endorsement of mesmerism; when she disavowed the Christian faith in *Letters on the Laws of Man's Nature and Development* (1851); and when she took up the fight against the Contagious Diseases acts in the 1860s. It is thus not surprising to find her, in *Society in America*, acknowledging the courage of female abolitionists who defied the social conventions which would have robbed them of their freedom of speech.

> The incessant outcry about the retiring modesty of the sex proves the opinion of the censors to be, that fidelity to conscience is inconsistent with retiring modesty. If it be so, let modesty succumb. [*Society in America*, 3:110–12]

Nevertheless, most men and women were effectively silenced by social prohibitions, by the effect of the Pastoral Letter, and by the biblical injunctions of the clergy.

Religion, as Martineau observed, played a very large part in the lives of a majority of American women. She attributed their excessive piety to the fact that outside marriage and the family women had little to occupy their minds; they allowed their religion to become a substitute for boredom.

> The way in which religion is made an occupation by women, testifies
> not only to the vacuity which must exist when such a mistake is fallen
> into, but to the vigour with which the religious sentiment would prob-
> ably be carried into the great objects of life, if such were permitted.[45]

Falling out of the religious way herself, she believed that, given the
opportunity, women would apply their misdirected energies to "the
great objects of life." But in America as in England, female educa-
tion was superficial, professionalism was frowned upon, and except
for those women who were forced by circumstance to support them-
selves, the lives of most women were vacuous.

> While woman's intellect is confined, her morals crushed, her health
> ruined, her weaknesses encouraged, and her strength punished, she is
> told that her lot is cast in the paradise of women: and there is no
> country in the world where there is so much boasting of the "chival-
> rous" treatment she enjoys. That is to say,—she has the best place in
> stage coaches: when there are no chairs for everybody, the gentlemen
> stand: she hears oratorical flourishes on public occasions about wives
> and home, and apostrophes to woman: her husband's hair stands on
> end at the idea of her working, and he toils to indulge her with
> money: she is at liberty to get her brain turned by religious excite-
> ments, that her attention may be diverted from morals, politics, and
> philosophy; and especially her morals are guarded by the strictest
> observance of propriety in her presence. In short, *indulgence is given
> her as a substitute for justice.* Her case differs from that of the slave, as to
> principle, just so far as this; that the indulgence is large and universal,
> instead of petty and capricious. In both cases justice is denied on no
> better plea than the right of the strongest. [*Society in America*, 3:106,
> emphasis added]

Because of what Harriet Martineau described as the "chivalrous
taste and temper" of Americans, it was made almost impossible for
women to earn their own livings. The only respectable employments
for women of the middle class were teaching (it was in the nineteenth
century that women began to replace men as teachers in the United
States), sewing, and the keeping of boarding houses. But the women
of the New England operative class had more opportunities for em-
ployment than their more affluent sisters. New England was without
slaves and had a surplus female population. Therefore, with the
growth of the manufacturing industry in the early nineteenth cen-
tury, women became the major employees in the mills of Waltham
and Lowell; in Lowell women numbered 70 percent of the labor
force. Unlike their English counterparts these operatives were coun-
try rather than urban women; their period of employment was usu-

ally temporary; and their condition of employment was fairly good. They worked long hard hours, but they earned enough to save. They stayed in a company town, lived in company-provided housing, had the use of a community library, attended lectures in the community lyceum, and listened to sermons in the community church. Like most nineteenth-century Britons who toured the United States—Fanny Trollope excepted—Harriet Martineau visited the model town of Lowell. And despite its paternalism she was so impressed by what she saw there that she suggested the trial of similar experiments in Great Britain. Recent scholarship paints a less than impressive picture of Lowell, and apparently the period of its success and prosperity was transient, but in 1835 Martineau did not know this. She saw an orderly community where women of the operative class living in reasonable surroundings could achieve independence albeit beneath the umbrella of company paternalism and in defiance of the strictest interpretation of laissez faire. She inferred from the Lowell experience that it might be possible for women of all ranks to burst the bonds of prejudice which had hitherto restricted them to economic inequality if not outright dependence.[46]

The sphere of woman, Martineau concluded, had been narrowly defined for her by man when it ought to have been circumscribed only by her own natural abilities. She opposed female acquiescence to the limits which had been set on woman's social role and political position.

> The truth is that while there is much said about "the sphere of woman," two widely different notions are entertained of what is meant by the phrase. The narrow, and, to the ruling party, the more convenient notion is that sphere appointed by men, and bounded by their ideas of propriety;—a notion from which any and every woman may fairly dissent. The broad and true conception is of a sphere appointed by God, and bounded by the powers which he has bestowed. . . . That woman has power to represent her own interests, no one can deny till she has tried. . . . The principle of the equal rights of both halves of the human race is all we have to do with here.[47]

Like most contemporary feminists, Martineau saw no conflict whatever between homely duties and intellectual or professional attainments. But without denying the importance of domestic accomplishments she nevertheless would not accept that woman's sole aim or her only place was marriage. Unlike Tocqueville, who believed that equality of the sexes would degrade both men and women, and who approved the American application to the sexes of "the great principle of political economy which governs the manufactures of

our age, by carefully dividing the duties of man from those of woman in order that the great work of society may be better carried on."[48] Martineau emphatically denied woman's exclusion from any occupation for which she was physically suited. But Tocqueville, while approving the intellectual improvement of women, still believed that they should be restricted to a peculiarly feminine sphere of influence. Most American women would have agreed. Catherine Beecher, whom Martineau met in Cincinnati, supported and even led the drive to improve the quality of female education in America. But while she encouraged the training of women teachers, Beecher did not condone other forms of female professionalism or activism. She opposed the feminists who sought to play public roles, and she spoke for the majority of her contemporaries when she did so. In common with Tocqueville she perceived women not as the equals of men but only as the source of their moral and domestic inspiration. This special elevated view of the role of woman was as common in nineteenth-century England and France as it was in nineteenth-century America. Tennyson, confronting the issue of equality in *The Princess,* acknowledged that there were innate differences which made women somehow gentler and more moral than men.

> Yet in the long years like must they grow;
> The man be more of woman, she of man;
> He gain in sweetness and in moral height,
> Nor lose the wrestling thews that throw the world;
> She mental breadth, nor fail in childward care,
> Nor lose the childlike in the larger mind
> Till at last she set herself to man,
> Like perfect music unto noble words.[49]

But like Mary Wollstonecraft, who described women as "exalted by their inferiority,"[50] Martineau saw the seeming elevation of her sex as false and degrading. In America she was affronted by that chivalry, particularly in the South, which seemed to her to substitute condescension for respect.

> I have seen, with heart-sorrow, the kind politeness, and gallantry, so insufficient to the loving heart, with which the wives of the south are treated by their husbands. . . . I know the tone of conversation which is adopted towards women; different in its topics and style from that which any man would dream of offering to any other man. [*Society in America,* 2:338]

She denied that there were hardy masculine virtues and different gentle feminine ones, but she recognized that such an opinion ex-

isted. There was, she said, a "prevalent persuasion that there are virtues which are peculiarly masculine, and others which are peculiarly feminine," and that such a "separate gospel" for men and women implied higher expectations of morality for women than it did for men and reinforced the existing and insidious double standard (*Society in America*, 3:115).

As a single woman and a successful professional she thought it reprehensible that woman's prospects should be confined to matrimony, especially since marriage, in America as in England, usually concerned itself with status rather than affection. A woman was therefore seldom able to find satisfaction in marriage and was not permitted to seek intellectual, professional, or romantic gratification outside it as her husband was able to do. As one who enjoyed independence of thought and action, Harriet Martineau could readily understand and sympathize with the limitations and frustrations suffered by those women trapped in unhappy marriages. She did not believe that the marriage vows were indissoluble, and she became, as a consequence, a supporter of and an advocate for divorce, in which, as in other things, she saw and deplored an invidious double standard (*Society in America*, 3:128;119 ff.).

As a critic of marriage, a proponent of divorce, and a supporter of the equally reprehensible demand for women's rights, Martineau stood outside the mainstream. She was known to embrace these unpopular views and therefore received more than one warning to say nothing in *Society in America* regarding the position of women because of "the unacceptableness of the topic." But instead of persuading her to remain silent this implied censorship only challenged her. Martineau was never one to step aside when her duty seemed clear, and opposition only served to fire her determination. She appeared to have rather enjoyed her temerity, and probably derived as much secret satisfaction from the adverse criticism of her opponents as she did from the praise of her supporters. In the weeks prior to publication she had no regrets about her decision, and would have regarded the suppression of her convictions as a "damning sin." Nevertheless she was uneasy as she sat "in the calm, and awaiting the storm of criticism." When the storm eventually burst she was consoled by the warm appreciation of her friends and appeared unaffected by the condemnation of the more hostile elements of the press which she described as "so completely a matter of course, so temporary, and . . . so absurd, that it does not trouble me more or less."[51]

Her books were received in America according to the persuasions of the readers, and both praise and blame were abundantly meted out to her. The antislavery press was predictably enthusiastic. The *Liberator* described *Society in America* as "perhaps the most remarkable work ever written by a foreigner on the United States, for its extent of information, its freedom, its sincerity, and its affectionate, yet judicious appreciation of our institutions and people."[52] But the more numerous antiabolitionist reviewers whose criticisms were directed as much against Martineau's philosophical allies as against her own pronouncements were equally uniform in their condemnation. The *American Quarterly Review* described her tour as an "espionage" and her criticisms as an "insolence," and ostentatiously thanked heaven that it knew of no women who would "get up at a public meeting and make an abolition, an amalgamation, or a Malthusian speech."

> Excepting it be Fanny Wright or Harriet Martineau there is not a sane woman in the world, much less in the United States, who has a desire to enlarge her sphere of action beyond the limits of her domestic home.[53]

The *New York Review* expounded in similar vein, attacking her Unitarianism along with her abolitionism and her feminism. But it was especially the latter which shocked her critics, and the American press pejoratively called her "masculine," and "Amazonian" along with such epithets as "incendiary," "radical," "amalgamationist," and "pitiless." The *American Monthly Magazine*, which conceded the excellence of her observations and the judiciousness and candor of her expression, nevertheless thought her views on woman to be "absurdities." One anonymous reviewer inferred that as the author under review was neither a wife nor a mother, she had failed to fulfill woman's *natural* role and therefore had no *natural* rights to demand.[54]

Martineau herself had obviously expected more blame than praise even in England. She confessed to William Tait that except for the hostile review—for which she was sure he was not responsible—in his *Edinburgh Magazine*,

> the reception of my book has taken me wholly by surprise. I fully expected it would ruin me, and the writing of it was, I think, the most solemn act of my life. I hope I shall never again want faith in the sympathies of my readers, for never can I put their generosity to a

severer test than I have now done, and I have met with nothing but the most entire trust and generous sympathy (with the single exception of this review) from all kinds of readers.[55]

She pointedly ignored the less than cordial reception which the Tory press gave her book and referred in this instance to the more liberal reviewers. In the *London and Westminster,* then under the proprietorship of John Stuart Mill, *Society in America* was described as "incomparably the ablest and most instructive" work on the subject of the United States, and it called her book "a work which deserves the highest encomiums for the boldness and freedom of thought which it displays, and the many important truths which it inculcates and helps to diffuse." The *Edinburgh Review* described her as impartial, tolerant and entertaining if a little too "rectified" in her Jacobinism. And William Johnson Fox was naturally laudatory in the *Monthly Repository.* But conservative critics like *Fraser's* called her a "female Quixote" whose utopian, unrealistic visions had succeeded only in proving the impracticability of democratic institutions. She was, it said, as manifestly wrong in assuming that all men were created equal as she was in assuming that men and women could ever be equal. It described her as one who "has grown old [she was then thirty-five] in single-blessedness" and was therefore incapable of appreciating the joys of feminine dependency.

> She allows herself to indulge in ascetic reflections upon the tyranny of man, in denying woman that independence which woman, as a class, would refuse if it were offered to her, as being inconsistent with her nature; and affects to look down upon and despise, as incompatible with the existence of the intellect, that softness and tender susceptibility which is the chief charm of the sex, but which incapacitates alike her body and mind for independent action. . . . If Miss Martineau, therefore, or any other maiden malcontent, should again venture to assert the equality of man and woman, our only advice to whomsoever that lady may be, is to turn, before sitting down to her task to the book of Genesis.[56]

Benjamin Disraeli, reviewing *Society in America* in *The Times* noted that Miss Martineau, instead of enlightening her English readers with accurate descriptions of America, was intent upon "her own impracticable schemes for what she esteems the amelioration of the species and the emancipation of her sex."

> Armed only with the absurd axioms of an arbitrary scheme of verbiage which she styles philosophy, and which appears to be a crude

mixture of Benthamism, political economy, and sans cullote morality,
she hurries over the vast regions of the United States . . . analyzing,
resolving, defining, subdividing, and mapping out "the morals" of
America . . . not as they appear . . . but as they ought to figure accord-
ing to the principles which she imbibed before her visit.[57]

He perspicaciously observed that while she stubbornly persisted in
the conviction that the majority is always right, her evidence had
pointed to a quite contrary conclusion.

Although refusing to admit the fallibility of the democratic princi-
ple, Martineau had indeed to concede the failure of democracy in
the United States. She concluded that as long as slaves were ex-
ploited, Indians systematically dispossessed, and women subordi-
nated, American democracy would remain a hollow theory, and her
attacks on these inequities were nothing less than an admission of
this failure. She regretfully acknowledged that "the civilization and
morals of Americans fall far below their principles." Even so, she
recognized that compared with the English and the Europeans,
Americans had made considerable advances: they had achieved self-
government and they admitted democratic principle. Despite their
subservience to public opinion, their racial and religious intolerance,
and the tyrannies of the majority, they made no obeisance to a
hereditary aristocracy and she therefore did not doubt their ultimate
progress. The mere fact that there were in America those who
fought to secure the just exercise of those fundamental truths upon
which the nation had been founded was sufficient to sustain her in
the conviction that "the national heart" was sound.[58]

Unlike her review articles in the *Monthly Repository* and the *Illustra-
tions,* both of which commented upon or explained the ideas of
others, *Society in America* was the product of Martineau's own
thoughts and experiences. Its philosophical pronouncements were
sometimes inconsistent but its factual observations were generally
accurate, and its fundamental issues—democracy, abolitionism, and
feminism—were essential questions which nineteenth-century Amer-
ica was yet to resolve, and which would continue to preoccupy Marti-
neau in the years ahead. *Society in America* was good journalism and it
made a considerable contemporary impact. As a vehicle of reform
propaganda it disquieted conservative forces on both sides of the
Atlantic, and succeeded in stirring sleeping consciences and publiciz-
ing the needs of the hour. It is worth recording Maria Weston Chap-
man's 1877 assessment of the work in the *Memorials* to Martineau's
Autobiography.

"Society in America" is not only by far the best book of travels in that country, in the judgment of the best qualified Americans and Englishmen, but it needs remain of permanent value as a picture of the United States towards the middle of the nineteenth century. . . . Its fairness, its largeness and accuracy, the truth and beauty of its impartial reprehension of all that was bad and its sympathetic admiration of all that was good, are not only universally acknowledged among intellectual Americans at the present time, but they were so at the very period of publication, when moral opposition was at its hottest. [*Autobiography,* 3:168–69]

Although an abolitionist, a close friend, and a consequently less than impartial critic, Maria Weston Chapman was essentially correct on at least one count: Harriet Martineau's three-volume work on America "needs remain of permanent value as a picture of the United States towards the middle of the nineteenth century."

Chapter V

Suddenly into Summer

Harriet Martineau's independence was unusual in a woman of the nineteenth century. It owed something to the peculiarities of her personality, something to the circumstances of her childhood, something to her professional acceptance by the literary world, and more than a little to her own acceptance of her hearing disability.

Modern psychologists of the deaf agree that the hearing-afflicted are subject to severe psychological stresses, and are prone to grave emotional disturbance unless they are prepared to adjust to their condition. It is common for those with a hearing deficiency to be more introverted, more isolated, more detached, and at the same time more dependent than are individuals with normal sensory perception. The most severe cases of emotional disturbance are usually found among children who are congenitally deaf, or who become deaf before they are old enough to acquire the mechanics of language. Nevertheless, an acquired deafness is an acquired deprivation and it carries its own special psychological burdens. Progressive deafness is generally accompanied by progressive fear: fear of losing a vital link with one's environment, fear of failure, and fear of ridicule. To be deaf is to be vulnerable, hypersensitive, and suspicious— sometimes even to the point of paranoia. These emotional pitfalls can be avoided only if there is a general acceptance of the handicap by the individual and by his or her family and friends.[1]

It is fairly common for the family of the progressively deafened to ignore the reality of the situation and to attribute the child's behavior to inattentiveness, stupidity, or disobedience. This type of avoidance or blame increases the emotional burden which the child already bears by adding to it a sense of guilt and resentment. In the case of Harriet Martineau, as we have noted, there was just such an initial reaction by her family. It was not until they accepted the inevitability of her affliction that she was able to completely adjust to

it herself. In her *Letter to the Deaf* in 1834 she lectured against such avoidance—"When every body about us gets to treat it as a matter of fact, our daily difficulties are almost gone"—and stressed the need to minimize dependence.[2] She instinctively appreciated the importance of compensating for her handicap visually, intellectually, and professionally; she thereby naturally sought those avenues to a healthy adjustment which are recommended by modern therapists. In a sense then, Harriet Martineau's achievements as a writer may not have been despite her deafness but perhaps because of it. At fifty-two, after almost forty years of deafness, she admitted:

> Yet here I am now, on the borders of the grave, at the end of a busy life, confident that this same deafness is about the best thing that ever happened to me; the best in a selfish view, as the grandest impulse to self-mastery; and the best in the higher view, as my most peculiar opportunity of helping others, who suffer the same misfortune without equal stimulus to surmount the false shame and other unspeakable miseries which attend it. [*Autobiography*, 1:78]

There is not sufficient evidence to ascertain the origin or even the true extent of Harriet Martineau's deafness. Her hearing loss could have been the result of any number of childhood illnesses; it could have been caused by a trauma, or it could have been psychogenic. The first two of these are fairly common causes of acquired deafness. The third, which is of a hysterical nature in which an evident dysfunction occurs without there being any physiological abnormality, is extremely rare. Although the possibility of this having occurred should not be ruled out—especially considering Martineau's other sensory losses—it would be fruitless to speculate on the subject without more evidence than is available.

Because Martineau's hearing loss was acute in one ear but only partial in the other, it would be accurate to describe her as hard of hearing rather than as deaf. We know that she was able to communicate on a complex intellectual level even before she acquired an ear trumpet, at age twenty-eight, and that once able to amplify sound, she was able to adjust almost normally to social intercourse. She was not able to hear peripheral sounds and was most comfortable in intimate discourse, but her deafness apparently did not impose a serious social barrier and few if any of her friends ever complained of communication problems in their correspondence about her. Her own observations on her deafness indicated a fluctuation in her aural responses. Thomas Malthus, for example, whom other people had difficulty

understanding because of his cleft palate, she could hear without amplification. But William Wordsworth she could only hear when he addressed her directly: especially if he was not wearing his teeth! In the Senate in Washington she could distinguish the quality of Daniel Webster's "beautiful" voice, but in the larger chamber of the House she could not hear at all. We know that she went to the theater and the opera, and that she could hear the "intolerably delicious" sound of musical boxes when she placed them directly on her head. In 1827 her hearing temporarily improved after trying Galvanism, which was a form of electrical shock treatment. In 1844 after mesmeric treatment she spoke of being "less deaf than for twenty years past." In the dry atmosphere of Egypt in 1846 she was briefly able to hear without the use of her trumpet. And after an illness during which she suffered from earache and aural discharge, she told Joseph Toynbee, the noted physician and father of Arnold Toynbee, that she had recovered her "modicum of hearing,—and somewhat more. I heard my clothes again today, and the towel upon my skin."[3]

Apart from the psychological problems associated with a hearing deficiency, there is the dual strain of trying to hear and of constantly modulating one's own unheard voice so as not to be misunderstood. As Martineau explained:

> Life is a long, hard, unrelieved working-day to us, who hear, or see, only by express effort, or have to make other senses serve the turn of that which is lost. When three out of five are deficient, the difficulty of cheerful living is great, and the terms of life are truly hard. [*Autobiography*, 1:74–75]

Harriet Martineau had from the start refused to allow her hearing loss to become a burden on others. She consciously compensated for this loss by seeking out "impressions and influences," and she substituted acute visual perception for her other sensory limitations. In the intensity of her intellectual labors and in her dedication to her duty, as she perceived it, she sought avenues of escape from what would have been isolation and withdrawal had she made a less concerted effort to "breast her destiny."

Upon first meeting Harriet Martineau in 1837, Henry Crabb Robinson—a Unitarian, a barrister, a founder of University College London, and the correspondent and acquaintance of almost everyone of

any importance in nineteenth-century England—found her to be "agreeable in person and manners . . . not old maidish and not offensively blue in the colour of her conversation."[4] Her countenance had two years earlier impressed Maria Weston Chapman as being serene, with "self-sufficing dignity" and with "much light and sweetness in its play of feature"(*Autobiography*, 3:135–36). And although one has to make allowances for the prejudices of friendship, the portrait of the period by Richard Evans, now in the National Portrait Gallery in London, bears out this impression. It delineates a slim, tall, not unattractive young woman with dark shiny hair, a mouth a shade too generous, and a slightly prognathus, determined chin which seems to belie the extraordinary benevolence of the fine blue eyes.

The contradiction revealed in Martineau's features was not placed there at the whim of the artist. The obstinacy underlying the gentleness and calm, which emerged not only in the determination with which she tackled her professional and moral obligations, but also in the dogged and sometimes arrogant resolution with which she pursued her convictions, was still as much a part of her personality as it had been in childhood. Harriet Martineau could be kind, playful, generously affectionate, and good natured, as her letters attest, but she could also be blunt and probably ungracious when crossed or affronted. Her normal good humor seldom survived any particular imposition or gaucherie. She often gave offense herself by indulging in gossip: "Amongst her good qualities," said George Eliot of her, "we certainly cannot reckon zeal for other people's reputation. She is sure to caricature any information for the amusement of the next person to whom she turns her ear-trumpet."[5] When she believed herself to be betrayed, her resentment could be implacable. But her wrath was fairly infrequent, and though not all her friendships survived the vicissitudes of her religious and philosophical fluctuations, most of her friends remained loyal for life. The image of her irascibility in Webb's *Harriet Martineau: A Radical Victorian* is certainly quite misleading.

> If one will make an omelette, they say, one must break eggs. Miss Martineau broke friendships. Her servants and lesser people, her nieces and nephews remained fervently loyal, but of her own class and generation she seems to have quarrelled or drifted away from almost everyone.[6]

Friendship, especially in the relatively narrow circles of literary society in nineteenth-century London, was often a fragile thing, and

one has only to look at the social relationships of Martineau's contemporaries to realize how ephemeral friendship could be. Among those for whom Martineau's affections cooled were, for example, John Stuart Mill who isolated himself behind the barrier of social disapproval, and Thomas Carlyle who alienated almost everyone.[7] Carlyle had become Martineau's good friend after her return from the United States. It was she who chiefly promoted the publication of a one-volume edition of *Sartor Resartus* which had formerly been published only in separate numbers of *Fraser's Magazine*. It was she, acting in concert with other of his admirers, who sought to ease his financial distress by organizing a series of lectures for him in 1837. At this time Jane Welsh Carlyle described Harriet Martineau in the warmest terms. She was, Mrs. Carlyle said, "distinctly good-looking, warm-hearted even to a pitch of romance, witty as well as wise, very entertaining and entertainable in spite of the deadening and killing appendage of an ear-trumpet, and, finally, . . . very fond of me." Harriet Martineau was then one of Carlyle's "host of lady admirers" and Mrs. Carlyle described her as presenting her husband with her ear trumpet—which appears to have repelled Jane Welsh Carlyle more than it did most—"with a pretty blushing air of coquetry, which would almost convince me out of belief in her identity." But the admiration on both sides soon paled. When Martineau took ill in 1839 Carlyle's comment was one of relief that "her meagre didacticalities afflict me no more." And by 1849 Jane Welsh Carlyle was calling Harriet Martineau "foolish" and writing about a "feud" which is nowhere properly explained and which though eventually patched up seems never to have been properly resolved.[8]

John Stuart Mill described Carlyle as turning on all his friends, but Mill's own experience was similar. He cut himself off from the early friends of the days of Philosophical Radicalism—the Austins, the Grotes, John Roebuck and Harriet Martineau—and even from members of his own family, including his mother, whose depiction in his *Autobiography* may owe more to this estrangement than has hitherto been suspected. Mill's association with Mrs. Taylor was the cause of these alienations. Although Michael St. John Packe believes that Mill's disassociation from the old school was basically philosophical, it is surely more than a coincidence that Mill's erstwhile intellectual confrères should have been the very same friends who knew of and gossiped unforgivably about his association with Harriet Taylor.[9] Among these was Harriet Martineau, who had been present at the couple's first meeting, and who tirelessly regaled her friends about the occasion to the undying annoyance of both Mill

and Mrs. Taylor. When in 1837 Mill, as the proprietor of the *London and Westminster Review*, rejected a Martineau article on the young Queen, she attributed the rejection to personal reasons. Mill had turned down the article over the objections of John Robinson, the editor of the *Review*, who had encouraged Martineau's contribution in the first place. She had earlier confided to a friend that the proprietors of the *London and Westminster* had been "seized with a sudden desire that I should do all I can for them since the appearance of my book [*Society in America*] has shown that I am still a radical." She was therefore angered when her article was refused, but although she told her brother James that she would make no further contributions to the journal "under its present management," Packe exaggerates the effect on Martineau of this 1837 rejection. She made substantial contributions to the *Review* during Mill's tenure as proprietor, and she continued to do so until 1858. Her personal feelings toward Mill were, however, never thereafter very cordial.[10]

Martineau had many constant friends and correspondents of all ages and both sexes. Among her closest female friends were Maria Weston Chapman; Lady Byron, the widow of the poet; Elizabeth Jesser Reid, the benefactress of Bedford College for Women; Mrs. Elizabeth Ker, wife of the Member for Norwich; and Julia Smith, the aunt of Barbara Leigh Smith Bodichon. Except perhaps for Julia Smith, who was known more for her personal charm than for her strength of mind, they were all women of extraordinary ability, concerned about the causes of women, and of humankind in general.[11] It is not surprising that Harriet Martineau should have been drawn to them, nor they to her. But evidence that Harriet Martineau had such close friends does nothing to support R. K. Webb's allegation of her "latent homosexuality."[12] There is no evidence that Martineau herself was aware of or demonstrated lesbian inclinations nor that any of her friends ever observed such tendencies. The matter would appear therefore to be irrelevant, but as the issue has been raised it ought to be examined.

Webb believes that Martineau's friendships with women and especially her unalloyed admiration for Maria Weston Chapman provide evidence of "latent" lesbianism. But in a society which considered women inferior to men, female friendships were especially important, and the deep affectionate friendships of women in the nineteenth century were more often than not innocent of sexual implication. There certainly is no evidence in the correspondence between Martineau and Chapman to indicate the contrary. Martineau's en-

thusiastic descriptions of Maria Weston Chapman were doubtless
little more than the effusions of a plain woman for a lovely one and
of a new recruit to the abolitionist movement for one of its leaders.
In fact, her perhaps exaggerated opinion of Chapman's gifts found
ready echo. Chapman's antislavery colleague, William Lloyd Garri-
son, who knew her as well as anyone, described her as having "ge-
nius, intuition, farsightedness, moral heroism, and uncompromising
philanthropy as well as . . . rare literary taste and culture"—encomi-
ums which if anything exceeded Martineau's own.[13]

Besides pointing to Martineau's female friendships, Webb further
supports his thesis by suggesting that Martineau was susceptible to
female mesmerizers. This contention takes no account of a suscepti-
bility to mesmerism itself rather than to its practitioners, and it reads
a sexual content into Martineau's mesmeric experience of which
there is no evidence. Webb also cites as possible proof of her sexual
deviance Martineau's disapproval of the Fox-Flower, Mill-Taylor,
and Eliot-Lewes liaisons. But in so doing he exaggerates what was
probably little more than Victorian prudery and intolerance: these
couples were deserted by their closest friends. In looking only at
Martineau's disapproval of illicit alliances Webb ignores her hearty
endorsement of happy legitimate unions. Similarly, in looking only
at the lack of romance in Martineau's own life he ignores the fact
that she felt herself possessed of "a power of attachment . . . that has
never been touched" (*Autobiography*, 1:133). Webb cites two instances
as evidence of Martineau's apparent lack of interest in men: her
rational acceptance of the loss of Worthington, and her instant recoil
from the advances of an American host, the Reverend Ezra Stiles
Gannet. But Worthington was hopelessly insane and it was easier
and more sensible to rationalize his loss than to mourn it. And Gan-
net, besides being Martineau's host and a clergyman, was a married
man.[14] Her actions in the first instance were prompted by self-
defense, and in the second they reflected little more than her sense
of propriety and her sexual timidity and immaturity. Indeed it
might, perhaps, be more accurate to describe Harriet Martineau as
latently sexual than as latently homosexual.

With the success of the first volumes of *Illustrations of Political Econ-
omy* in 1832 Harriet Martineau had gone to London and taken lodg-
ings in Conduit Street. In London she had immersed herself in a
giddy round of strenuous labor and exhausting social activity. At

seven-thirty each morning she was at her desk, her pen in hand, her windows "open to the freshly watered streets, and shaded with summer blinds, and the flower-girls stationing themselves below—their gay baskets of roses still wet with dew"(*Household Education*, p. 184). She worked from seven-thirty until two and then there were callers to entertain and calls to be made. In the evening she was generally invited out to dinner, and between midnight and two in the morning she devoted her attention to the voluminous post which she received each day. In spite of her growing celebrity, however, her head was not noticeably turned by the attentions she received. As Sydney Smith of the *Edinburgh Review* said of her, "She has gone through such a season as no girl before ever knew, and has kept her own mind, her own manners, and her own voice. She is safe" (*Autobiography*, 3:80).

In August of 1833 Harriet was joined by her mother and Aunt Lee. Together they rented a small house on Fludyer Street which, if disconcertingly close to the dusty windows and curious clerks of the neighboring Foreign Office, had the advantage of being adjacent both to Downing Street and Saint James's Park.[15] But although the location was eminently suitable, the domestic circumstances proved as difficult as Harriet had suspected they would. She knew that her literary commitments and social obligations would prevent her from undertaking the "undivided companionship" which her mother required, and it was she who originally suggested that either Rachel or her aunt accompany her mother to London. Mrs. Martineau had been unwilling to expose Rachel to the glare and competition of Harriet's "distinguished reputation," and thus it was Aunt Lee, Harriet's father's sister, who was selected to complete the family circle.

Mrs. Martineau proved difficult to please, and she especially resented playing a role inferior to that of her daughter.

> My mother who loved power and had always been in the habit of exercising it, was hurt at the confidence reposed in me, and distinctions shown, and visits paid to me; and I with every desire to be passive and being in fact wholly passive in the matter, was kept in a state of constant agitation at the flux of distinctions which I never sought.[16]

Harriet's mother found the little house on Fludyer Street unsatisfactory and constantly worried her daughter to move to more fashionable quarters. But Harriet was without pretension and unwilling to "mortgage her brains" for the sake of social vanity. She therefore

endured while refusing to submit to her mother's displeasure. At the same time she performed her share of the normal domestic duties; participated in the life of London society; and completed her monthly volumes for Charles Fox. The strain told on her health, and by the end of the series she was writing her volumes propped up in bed and dosed with sal volatile. It is little wonder that she found independent travel in America a welcome change after the domestic, professional, and social demands of London. It was nevertheless to these demands that she returned from America in 1836, and it was under these same conditions that she completed *Society in America*, *Retrospect of Western Travel*, and *How to Observe Morals and Manners*.

R. K. Webb describes the period between Martineau's return from the United States and her tour of the continent in 1839 as one "without an outstanding accomplishment."[17] But in the brief space of three years she completed, in addition to her two American books and *How to Observe Morals and Manners*, three volumes for *The Guide to Service* commissioned by the Poor Law authorities for the purpose of training girls for domestic service.[18] She wrote articles for the *London and Westminster Review* and the *Penny Magazine*. And she was offered but did not accept the editorship of a proposed sociological journal which Saunders and Otley intended publishing.[19] In addition to all this literary activity she started her three-volume novel *Deerbrook* in June, 1838 and had completed it by February of the following year.[20]

All this time she was subject to mounting domestic worry and irritation. Her brother Henry had been a cause of concern for some years. It was he who had taken over the family business and had managed its affairs during its last distressful years. At the time he had earned the gratitude and respect of his family, but since then his behavior and his personal habits had deteriorated: he kept late hours, he gambled, and he drank. He still had charge of the Norwich wine importing business which had survived the collapse of the other Martineau interests in 1829, but which in 1838 was also dissolved. Through Harriet's connections a position as clerk was found for Henry at Somerset House, and he therefore joined the three women in London.[21] His arrival at Fludyer Street served only to compound Harriet's domestic difficulties. Aunt Lee, of whom she was very fond, was old and frail and had to be protected from worry. And her mother was clearly a trial. Harriet and Mrs. Martineau shared an obstinacy of character and friction inevitably resulted from their conflict of wills and differences of opinion. A single entry in Harriet's diary of January 14, 1838, tells the story all too plainly.

Kept up too much talk about the Pictorial Bible and Prayerbook with my mother. I should have let her prejudice pass with a simple protest.... How difficult, in such a case, to reconcile truth, respect, and peace! [*Autobiography*, 3:216]

Mrs. Martineau's continued inability to reconcile herself to her daughter's social precedence still made enormous demands on the resources of Harriet's tact. As Mrs. Martineau got older and became increasingly blind, Harriet's anxiety about her mother's well-being added to the already overcharged atmosphere of the small house.

My mother was old, and fast becoming blind; and the irritability caused in the first place by my position in society, and next by the wearying trial of her own increasing infirmity, told fearfully upon my already reduced health. My mother's dignified patience in the direct endurance of her blindness was a really beautiful spectacle: but the natural irritability found vent in other directions and especially was it visited upon me. Heaven knows I never sought fame; and I would thankfully have given it all away in exchange for domestic peace and ease: but there it was: and I had to bear the consequences. [*Autobiography*, 2:150]

It was not a happy time for Harriet Martineau.

I am not near so happy as I was. I want inner life. I must take to heart the "Ode to Duty," and such things, and do without the sympathy I fancy I want. If I am not happy what matters it? But I am happy, only less so than I have been. [*Autobiography*, 3:220]

This unusual ambivalence was possibly the product of generally poor health and the strain of the enormous commitments and demands which were imposed on Harriet's time and patience. The hectic pace of the "hackney-coach and company life" was also wearying, and it was at this time that she wrote her denunciation of "Literary Lionism" in the *Westminster Review*.[22] For although Harriet enjoyed the intimate intercourse of friendship, she abhorred the "lionizing" to which she as a celebrity was continually subjected. Her deafness made large social gatherings a strain. Writing to the Reverend William Ware after her return from the United States she conceded that

on coming back, I find so much more difficulty in society from this cause [her deafness] than before, that I rather think I shall go out less than I did,—for my sake and others,—tho' I mean to do brave battle

with all antisocial inclinations. But when recreation becomes irksome and laborious, I think it is perfectly fair to reduce its proportion to solitary employment and enjoyment.[23]

But life in London between 1836 and 1839 was far from solitary for Harriet Martineau; everyone came to call at 17 Fludyer Street. There were the radical politicians, Charles Buller, John Roebuck, and "that glorious man," Lord Durham. There was Robert Owen, still under his grand "delusion." There were the men of science Charles Babbage, Charles Lyell, and Erasmus Darwin who introduced Harriet to his brother Charles. There was the actor Macready who thought Miss Martineau a "fine-minded woman," except on the subject of women's rights which he did not at all comprehend. And there were many of the chief literary figures of the day: Robert Browning who came to talk about his poetry, Thomas Carlyle with a "terrible deal of the spirit of contempt," Empson and Smith of the *Edinburgh Review*, and Leigh Hunt and Richard Henry Horne who succeeded William Johnson Fox at the *Monthly Repository*.[24]

At the time she was writing *Deerbrook*, Martineau felt that she had begun to "sink under domestic anxieties, and the toil which is my only practicable refuge from them" (*Autobiography*, 2:109). But although she was undeniably under considerable physical and emotional stress, the novel should be seen neither as the product of this stress nor as its mirror. It is true that Martineau turned to the writing of fiction in 1838 as a release: "a relief to many pent-up sufferings, feelings and convictions" (*Autobiography*, 2:113). But it was intended as an escape from stress, and unlike the *Autobiography* and *Household Education*, the novel was in no sense confessional or autobiographical. It is difficult to credit Robert Lee Wolff's hypothesis that Martineau turned to fiction "perhaps in an effort to relieve some of her aggressive feelings by saying in a novel what she could otherwise never say at all."[25] Martineau's first subject for her proposed novel, the life of the black Haitian revolutionary, Toussaint L'Ouverture, would in no way have provided the opportunity for a catharsis. The plot she eventually decided upon was taken from fiction; it bore no relationship to her own life, and the characters, if we are to believe Martineau herself, were not real. "More or less suggestion from real characters there certainly is; but there is not one, except the hero, (who is not English,) that any person is justi-

fied in pointing out as 'from life.' "[26] Wolff's claim that the three chief female characters in *Deerbrook* may "safely" be regarded as "different aspects of Martineau herself," and that the unpleasant Mrs. Rowland, whom she in no way resembled, represented Martineau's mother, is little more than what Martineau herself would have called literary "fancy-work." In oversimplifying Martineau's psychological complexities, in placing them under the convenient umbrella of the term "neurosis," in claiming that from 1835 Martineau was "neurotically ill," and in accepting Webb's categorization of this period in Martineau's life as one "without accomplishment," Wolff has leapt to dramatic conclusions which should be examined with grave reservation. For although *Deerbrook* reflected Martineau's philosophical biases and preoccupations, it revealed very little of its author's inner thought processes.

Martineau set out to write a novel as pragmatically as she had set out to write the *Illustrations of Political Economy:* she researched for a plot, and she studied the style and methods of Jane Austen. *Deerbrook* was a conscious imitation of the Austen model, and contemporary reviewers were quick to note the resemblance.

> It is a village tale, as simple in its structure, and unambitious in its delineations, as one of Miss Austen's: but including characters of a higher order of mental force and spiritual attainment, than Miss Austen ever drew—save, perhaps, in "Persuasion."[27]

In the *Westminster* and the *Edinburgh* Martineau was favorably compared with Austen, and *Blackwood's*, though admitting that no one had yet equalled Jane Austen, concluded that "Miss Martineau in her late novel *Deerbrook*, has nearly approached her, and has added to her graphic and happy sketches of society, an analysis of the affections worthy of Madame De Stael."[28]

Instead of setting her work in the urban-commercial environment of her own experience, Martineau selected rural surroundings strongly reminiscent of those in Austen's work. The two matrons of the village, Deerbrook, were rather like good- and bad-natured versions of Mrs. Bennet: slightly vulgar, socially pretentious, decidedly trivial, and indubitably interfering. Their respective husbands, like Mr. Bennet, were sensible, bluff, and good tempered. The main protagonists, like their Austen precursors, were undeniably superior young people, discreet in their sentiments and elevated in their morals. Where Martineau broke with Austen and with literary tradition—to the displeasure of many of her readers and critics—

was in drawing her characters out of her own middle-class background.[29] Martineau's heroes were not taken from the ranks of the landed gentry: Edward Hope was a country surgeon who earned his living without access to either patronage or private fortune, and Philip Enderby, though a man of means, entered the bar and achieved dignity through personal endeavor. Hester and Margaret Ibbotson—reminiscent of Martineau's sisters in *Five Years of Youth*—were Dissenters from middle-class Birmingham. And Maria Young, crippled in body but not in spirit, was governess to the children of Deerbrook's leading citizens.

Before she started work on *Deerbrook*, Martineau had commented that in Austen "the story proceeds by means of the dialogue" (*Autobiography*, 3:218). And it was by means of the dialogue—vastly improved since the *Illustrations of Political Economy* but without Austen's superior style—that Martineau's three-volume work wended its sometimes laborious way. It was the story of a man who was obliged by an unfortunate accident of circumstance to marry the sister of the woman he loved. Although the situation which Martineau thus contrived was redolent with possibility, she failed to exploit the drama inherent in it. In Hope she created too moral a hero; his feelings for Margaret, the sister he loved but did not marry, were discreetly smothered by his rectitude and he was not permitted to let passion overcome his sense of honor. Martineau, innocent of passion herself, still thought, as she had in the case of Eliza Flower and William Johnson Fox, that love was "guidable by duty." These sentiments were not peculiar to Martineau, or even to maiden ladies; they were clearly in tune with Victorian times: the *Westminster Review* considered Hope's devotion to duty an "admirable quality," *Blackwood's* liked the uniformity with which the reader was led to "observe and admire the simple performance of duty," and the *Edinburgh Review* was similarly approving. What may strike modern readers as anticlimactic and sentimental evidently appealed to the more proper tastes of their Victorian predecessors.[30]

Although Martineau could not avoid preaching her favorite gospels even in a novel, *Deerbrook* was not intentionally didactic. It was a romance: love was the chief preoccupation of its characters, and marriage was the chief event of the plot. Hester and Margaret Ibbotson, Edward Hope, and Philip Enderby were the subjects of the romance. Mrs. Grey was the meddling matchmaker and the instrument by whom Hope was compromised into marrying Hester instead of Margaret. Philip Enderby's sister, the malevolent and ambitious Mrs. Rowland, like Bingley's sisters in *Pride and Prejudice*,

sought to frustrate the expectations of Margaret Ibbotson because she considered her family connections unsuitable. Finally there was the governess, Maria Young, standing apart from the action of the plot, and suffering from an anguished and humiliating unrequited passion for Philip Enderby because "there are no bounds to the horror and disgust, and astonishment expressed when a woman owns her love to its object unasked."[31]

Martineau had decided, even before she planned *Deerbrook*, to write about a fictional governess in order to show how bad at best the system was. Maria Young, however, represented more than this potential end; she symbolized the wider frustrations of nineteenth-century womanhood.

> For an educated woman, a woman with the powers which God gave her religiously improved, with a reason which lays life open before her, an understanding which surveys science as its appropriate task, and a conscience which would make every species of responsibility safe,—for such a woman there is in all England no chance of subsistence but by teaching, which can never countervail the education of circumstances, and for which not one in a thousand is fit.[32]

Maria Young, of all the *Deerbrook* characters, was most representative of the novel's author. It was through Maria that Martineau voiced her own sentiments and opinions on the position of women. But despite a superficial resemblance—both the character and the author were single independent women with physical afflictions—Maria Young was far from being a self-portrait. Though solitary, without love, and having a "peremptory vocation, which is to stand me instead of sympathy, ties, and spontaneous action," Maria lacked a calling.[33] She bore her independence as a reluctant burden and not with the sense of duty or cheerful determination with eventually made Martineau describe herself as "the happiest single woman in England." Maria symbolized the plight of the woman without means; thrust out of necessity into an occupation for which she had little vocation. She was the conduit for those opinions on the subject which Martineau felt bound to express; but she did not reflect the psyche of her creator. Like the other characters in the novel, Maria's chief preoccupation was love, albeit frustrated love. And Martineau, since the Worthington episode, had been in her own words "free from all idea of love affairs." Indeed, it was in great part this freedom from romantic passion which made her depiction of the emotion stylized and unrealistic in *Deerbrook*. Although in 1838 she was

"less happy than I have been," her need for sympathy was related to her domestic circumstances and there is no evidence whatsoever of a sublimated affair of the heart. Her inner loneliness may have found a slight echo in the solitary figure of the governess, but the resemblance ended there.

Because Martineau confessed her jealousy of Rachel in her *Autobiography*, Robert Lee Wolff has chosen to interpret Martineau's depiction of jealousy in Hester, the older sister, as further evidence that *Deerbrook* was a neurotic self-portrait. But Martineau's treatment of Hester was unsympathetic rather than empathetic, and Hester's jealousy was unrealistically drawn. There was little internalization of the passion: Hester talked rationally about her jealousy but did not subjectively experience it. It was as if Martineau consciously avoided introspection and deliberately refused to relate Hester's jealousy to her own. This avoidance was indicative of Martineau's general intention to abjure any identification with her characters. She did not choose to examine her personal emotions through the medium of the novel, nor could she be said to have written it in order to "relieve some of her aggressive feelings," as Wolff contends. It might be more accurate to interpret her disinterested and at times even antipathetic treatment of Hester's jealousy as symptomatic less of neurosis than of healthy adjustment. After all, she was no longer the overshadowed younger sister; she no longer needed to envy Rachel; and she could stand back and examine the emotion with detachment.

Martineau probably identified more closely with the gentle Margaret than she did with the jealous Hester, but even here the identification was superficial. Martineau could realistically depict Margaret's life with Hester and the physician Hope after their marriage because she herself had been an unattached younger sister in the homes of her physician brother Thomas, and of her older sister Elizabeth and her husband Dr. Thomas Greenhow. Margaret's childhood thoughts of suicide were also taken directly from Martineau's experience. Here the author used an incident from her own life—as she used others in this work—more or less out of context. It is almost as if she thought the story was worth telling for its own sake, and she failed to integrate it with the background and personality of her character. She used none of her own childhood torments to illuminate Margaret's suicidal intentions for she was perhaps not yet ready to do so. After all, her mother was still alive, and she did not make public her youthful resentments until after the old lady's death, first in *Household Education*, and then later in the *Autobiography*. *Deerbrook* was not the vehicle she chose "to relieve some of her

aggressive feelings by saying in a novel what she could otherwise never say at all." Nor was Margaret's submissiveness a Martineau trait—Robert Lee Wolff to the contrary. Submissiveness may have been expected of her as a daughter, but her submission was never meek. She never paid lip service to docility as a convention of female behavior and it would have been uncharacteristic for her to have wished to emulate the "virtue." We cannot conclude that Martineau wilfully or even wistfully attempted a self-portrait in Margaret. Nor did she provide any meaningful clue to her own feelings and emotions in any of her other female characters.

All writers draw on their personal experiences and, to some extent, there are aspects of all writers in their characters. But the literary critic and the historian are hard put to find much that is significantly autobiographical in Martineau's works of fiction. *Deerbrook*, a rather dull novel, adds very little to our knowledge of its author. The characters are not flesh and blood creatures but idealized creations. Although Martineau claimed—in *Deerbrook* itself— that a novel should be "of the mind . . . not of the mere events of life," *Deerbrook* was little more than a tale.[34] Martineau substituted monologue for introspection and failed utterly to penetrate the subconscious of her characters. Unlike Brontë or Eliot who succeeded her, she was concerned less with character development than with character delineation. Instead of becoming more complex and interesting with the evolution of the plot, her characters stood fully revealed from the first. They were superficial, two-dimensional, and almost allegorical. Their chief preoccupation was love but the portrayal of that love was as idealized as the portrayal of the characters themselves. It is little wonder that, some time later, Charlotte Brontë's *Villette* should have stunned Harriet Martineau "with an amount of subjective misery which we may fairly remonstrate against."[35] Martineau's lovers did not love with a passion. They paled and pined and were painfully smitten in a manner which appealed to those Victorians who read *Deerbrook*, but which strikes the modern reader as lifeless and sentimental. It should be observed, however, that our judgment is doubtless influenced by our acquaintance with the superb new generation of fictional works which *Deerbrook* preceded: *Oliver Twist* was only then appearing in monthly numbers, the Brontës and Thackeray did not publish until the following decade, and Eliot's first works of fiction did not appear until the late 1850s. *Deerbrook* was not in the category of these works. It was not a work of genius. Its chief importance was in breaking with the silver-spoon tradition and in giving the middle-class hero a place

in English literature. Otherwise it was in the narrative genre of the eighteenth century: pleasant, contemporaneously popular, and even influential, foreshadowing "the best work of the great novelists who followed."[36] But its success was fleeting, best described by John Morley, writing in 1886, who said of it: " . . . this is one of the books that give a rational person pleasure once, but which we hardly look forward to reading again."[37]

The contemporary reviews were almost uniformly complimentary. The *Athenaeum* had some reservations about the "idealized" characters, but nevertheless regarded *Deerbrook* as a book which "opens, elevates and humanizes the mind," and by and large the other journals joined a generally admiring chorus. Martineau's friends and acquaintances in the literary world—Carlyle excepted—were enthusiastic: John Sterling, Charles Knight, Henry Crabb Robinson, Richard Henry Horne, Richard Monckton Milnes, and Lord Jeffery of the *Edinburgh Review* all liked *Deerbrook*. And later, when she achieved fame of her own, Charlotte Brontë writing as Currer Bell said that

in his mind "Deerbrook" ranks with the writings that have really done him good, added to his stock of ideas, and rectified his views of life.[38]

After completing *Deerbrook*, in 1839, Martineau sought escape from the accumulated strain of her London life. She and some female companions crossed to Rotterdam with the intention of sailing down the Rhine to Switzerland and then going on to Italy. However, when they reached Venice Martineau became so ill that her brother James and her future brother-in-law Alfred Higginson (who became Ellen's husband in 1841) were sent for to escort her home. She was suffering a general failure of vitality, but in addition she was having frequent menses and irregular discharges; there was a membranous protrusion from the vagina; she was experiencing sharp pains in the uterine area; and there was a severe tenderness which centered in the left groin, extended to her back and legs, and made walking difficult. On her arrival in England she placed herself immediately under the care of her sister Elizabeth's husband, Thomas Greenhow, who practiced medicine in Newcastle. She was not inhibited by any "becoming" modesty, and had already written to Greenhow from Italy describing her symptoms in some detail. On reaching Newcastle she submitted to intensive and frequent examinations, and was found to have an enlarged and retroverted uterus. Her brother-in-

law removed a small polyp from the cervix, but suspected that the main problem was caused by a second and larger tumor. He prescribed carefully administered doses of opiates for her general discomfort and leeches for the pain in the groin.[39] Martineau was convinced of the malignancy of the tumor and thought herself to be dying.[40] She was well aware of the physical nature of her illness, but because she attributed its cause to "the extreme tension of nerves under which I had been living for some years while the three anxious members of my family were, I may say, on my hands" (*Autobiography*, 2:150), Martineau must to some extent be held responsible for the theory that her illness was psychologically induced. She probably shared the conventional Victorian belief that nervous and intellectual strain harmed the reproductive organs. But even if she herself attributed the cause of her illness to psychogenic reasons the symptoms of the disease were real enough, and any motives she may have had to malinger—if such had indeed been her intention—disappeared in the first year of her confinement: her mother moved to Liverpool where Ellen and James and their families now lived, her aunt died, and Henry emigrated.[41]

R. K. Webb has already referred to Cecil Woodham-Smith's contention that Martineau's illness was motivated by a need to escape from family responsibilities.[42] But although Webb has pointed out the very real medical nature of Martineau's symptoms, he has not effectively refuted Woodham-Smith. Woodham-Smith appears to have been unfamiliar with the existing and detailed medical reports, and she woefully misrepresented the facts: she confused the symptoms of Martineau's final illness with those of her earlier one; she ascribed the *Daily News* leaders to the period after her Tynemouth confinement when Martineau was well, instead of to the period of her final illness; and she mistook Martineau's moral responsibility for the other members of her household for a financial one. In implying the hypochondria of Martineau and other notable Victorian invalids, Woodham-Smith underplayed the very real illnesses which plagued them. It is true that Victorians were preoccupied with their health; but it is less than accurate to ascribe their physical symptoms entirely to psychological causes. Genuine ill health was common. At a time when medical knowledge was primitive at best, and when sanitation was bad and diets poor, consumption, rheumatism, and digestive ailments were chronic, and the cures were often worse than the disorders. One has only to read the letters of Jane Welsh Carlyle, or Thomas Robinson's letters to his brother Henry Crabb Robinson, or Martineau's own correspondence, particularly

with Elizabeth Barrett, Florence Nightingale, and John Chapman, to realize that the morbid interest in unpleasant symptoms and the often histrionic sense of martyrdom which accompanied invalidism were mostly associated with extreme and genuine discomfort. This is not meant to imply that there were no psychosomatic disorders, but merely that Victorian ill health has too often and too lightly been attributed to hypochondria and hysteria.

Hysteria was thought to be a female disorder which originated in the uterus. It counterfeited many illnesses and disorders including loss of smell, taste, and hearing. Although hysteria cannot be ruled out in the case of Martineau's sensory deprivations, it was clearly not the cause of the disease which laid her low in 1839. Both Greenhow's *Medical Report* of 1845 and the discussion of Martineau's case in the *British Medical Journal* in 1876 and 1877 provide definitive evidence of the clinical nature of her problem.[43] Martineau, in any case, did not fit the profile of the hysterical type. According to Carroll Smith-Rosenberg, the nineteenth-century medical definition of the hysterical woman was

> ... a "child-woman," highly impressionable, labile, superficially sexual, exhibitionistic, given to dramatic body language and grand gestures, with strong dependency needs and ego weaknesses.[44]

Martineau was none of these. However psychologically opportune her illness may have been, it was inspired neither by a hysterical need for attention, nor by the escapism suggested by Woodham-Smith.

Because retirement was the preferred cure for female disorders, Martineau spent the next five years "between couch and bed." She was offered the guest room at her sister's home in Newcastle but she characteristically refused dependency and declined to impose her illness on a healthy household. Instead she retired to lodgings at nearby Tynemouth, an unfashionable seaside town on the estuary of the Tyne. There she felt she would "enjoy the feeling of giving no trouble, and, as Carlyle says, 'consuming one's own smoke.'" She chose accommodations on the beach and a room which had a view of the sea and the downs. There, like Tennyson's Lady of Shalott, but with a telescope which Mrs. Reid had given her instead of a mirror, she could observe life outside her window. She became acquainted with the North Sea in its many moods, and with the rocky, wreck-lined strand where a lone sycamore braved the east wind. She could see the lighthouse and could watch ships seeking shelter in the harbor inlet. On the downs she could see cows grazing, farmers making hay, boys flying kites, and washer-women carrying their large bun-

dles from the farmhouses to the village. She could see farms, pad-
docks, dairies, a colliery, and a windmill. She had a partial view of
the railroad and enjoyed watching trains gathering speed on the
level ground and then laboring up the incline. With the aid of her
telescope she could almost forget that she was merely a distant ob-
server and not a participant in the life outside, and when night shut
her off from the visible world she could take solace in the stars and
could watch the sun rise across the sea.[45]

Her two-room apartment was never without the rarest hothouse
fruits and flowers, and, except for the long winter months when
visitors were rare, Martineau was seldom alone. At times the Tyne-
mouth lodgings must have been reminiscent of the Fludyer Street
drawing room, and it was often a question of too much rather than
of too little company. All the faithful friends—Mrs. Reid, Julia
Smith, Lady Byron, Milnes, Crabb Robinson, Erasmus Darwin, and
even the Carlyles—made the pilgrimage to Tynemouth. Govern-
ment commissioners and political notables, like Cobden, came to
consult. Her mother came up from Liverpool to visit, and other
relatives were also frequently in attendance.[46]

Martineau preferred to have company when she was not in pain.
She had, she said, "a great dread of exciting more compassion (and
yet more sympathy) than my circumstances require." She only saw
her friends when she was "well-opiated," and they were, therefore,
sometimes surprised by her appearance of vitality. Henry Crabb
Robinson was amazed to find her "hardly . . . an invalid [*sic*]" and
her conversation to be "very animated and agreeable." Jane Welsh
Carlyle reported that Harriet Martineau had exhausted her in
"every particle of intellect, imagination, and common sense."[47] But
although she enjoyed her visitors, the pressure of the tumor on her
spine and on parts of her abdomen caused her increasing discom-
fort. Her bowel and bladder functions were affected, and she was
subject to nausea and constant headaches.[48] In the autumn she bade
the last of her summer guests farewell with a sense of relief.

> My winter (that is my season of silence and solitude) began on Thurs-
> day,—the last of my friends having left me. Now for about seven
> months, (if I live) my days will pass in the deepest repose that can be
> had in this world by any but hermits. I shall see scarcely a face but those
> of my Doctor and maid, till June . . . this loneliness is altogether a mat-
> ter of choice. I have at last persuaded my friends to indulge me in it.[49]

She derived strength from her period of self-imposed solitude
and rest, but she could not even in ill health afford to indulge in

idleness. In spite of its success her writing had not made her wealthy and she could not have paid for the necessary services of a maid during her Tynemouth confinement if it had not been for the generosity of her Uncle Peter Martineau. Because illness was undermining her ability to support herself, her friends became concerned, and in 1843 Erasmus Darwin organized a Martineau testimonial which realized thirteen hundred pounds. The income from this she felt would be sufficient for her needs, and that year, with some relief, she was able to decline any further contributions from her uncle, to renounce her future share of her mother's estate asking that it be divided among her three sisters and her brothers James and Robert, and to announce her retirement as an author.[50]

Although Martineau gratefully accepted the testimonial offered her by her friends, she had earlier declined to consider receipt of a government pension despite the fact that it was customary to thus reward writers and artists. Prime Minister Grey had offered her a pension in 1832 when she was writing the *Illustrations*. She had contemplated accepting the honor but as it came from the Whigs she had felt the need to ask the opinion of radical colleagues Brougham, Fox, McCulloch, and James Mill. They offered no great objections to the award but she was nevertheless effectively discouraged from receiving it by her brother James. He told her that her recompense should come from the reading public and not from a political party, and won over by this compelling argument, she declined the offer. She was to do so again when Prime Ministers Melbourne in 1842 and Gladstone in 1873 renewed the government's offer of a pension. Her attitude toward pensions became a matter of faith, and she argued that she did not want to compromise her objectivity by accepting favors from a political party, nor did she wish to receive emoluments which were derived from the taxes of the unrepresented poor. It was a noble self-denial and quite consistent with her political principles, but it did not meet with much approbation. Her action was a criticism of the system, and her statement that "there can be no peace in benefitting by the proceeds of an unjust system of taxation," met with scornful rejoinders from the supporters of that system.[51] "What does the poor good woman mean?" quizzed one critic, who quite missed her point.

> Every officer of or under the crown then, every salaried man in the state, every paid magistrate, every soldier and sailor . . . is a thief who preys on the vitals of the poor. . . . I have no doubt that some of Miss M's radical admirers would gladly tie the noose for them all.[52]

In the first years of her illness Martineau completed her Haitian novel, *The Hour and the Man*, and wrote the four children's stories of the *Playfellow* series. Then, despite her expressed need for "rest from the pen," and despite the fact that the testimonial relieved her financial stress, she began work on a new publication, the initially anonymous *Life in the Sick-Room*. At the same time the invalid was concerned with the strategy of the Anti–Corn Law League, she was involved in correspondence with Peel and Cobden; she was assisting a government commission then preparing an education bill; and she was actively opposing Lord Ashley's factory legislation. She had proofs to read. She was sent manuscripts from strangers who wanted her advice. She spent hours on fancy-work which she donated to antislavery causes and to local Newcastle public works projects. She had voluminous correspondence: "My own large family incessantly and reasonably needing 'just a line' to say how I am:—a multitude of friends ditto." And there were always numerous personal demands on her time: " . . . clothes to be made and mended and a poor capricious sinking body to be opiated and indulged."[53]

The Hour and the Man was published in 1841, but the idea of writing a novel based on the life of the hero of the Haitian revolution had been germinating since 1838 when Martineau first contemplated writing a novel. On her aborted tour of Europe in 1839 she had slipped across the border from Switzerland to France in order to see the Castle Joux where Toussaint had been incarcerated by the French, and where in 1803 he was supposed to have died. She had read whatever literature was available on the subject in English and French. She had studied the geography of the island. She was familiar with Wordsworth's sonnet on the black hero. And doubtless she had also read John Greenleaf Whittier's "Toussaint L'Ouverture," which was published in Garrison's *Liberator* of June 30, 1837. In Toussaint she found not only a fascinating subject for a historical romance, but a means of promoting antislavery and amalgamationist causes.[54]

The Hour and the Man, though lacking depth as a novel, succeeded in capturing the impassioned spirit of late eighteenth-century French colonial Haiti. The story was about the island's struggle for independence from white domination, and in it Martineau probably came closer to endorsing revolution than at any other time. Toussaint was the symbol of black liberty. He knew that for his people the choice was either "slavery or self-defence,"

and that by his own eventual overthrow only the trunk "of the tree of negro liberty is laid low.... It will shoot again from the roots, they are many and deep." But although she sympathized with the problem of black bondage, Martineau was not personally familiar with black Haitians, and her characters lacked ethnic authenticity. She was interested primarily in promoting the cause of emancipation and racial equality, and if her urbane, philosophical Toussaint more than slightly resembled Shakespeare's noble Moor, it was probably because she wanted to convince her white readers of the essential dignity of the black man. She made Toussaint larger than life: too virtuous to recognize villainy, too honest to flinch from the execution of impartial justice, and generally so idealized that she afterwards wrote in self-defense and in defense of the original Toussaint:

> People will suppose Toussaint himself to be the fictitious part of the book: whereas I solemnly believe him to have been what I have represented; *and the sayings which are called the finest in the book are his own.* . . . I am uneasy at having credit of originating what a dead hero thought and said.[55]

If her readers had been perturbed by her choice of a middle-class hero in *Deerbrook*, they were even more so by her choice of a black one in *The Hour and the Man*. In the *Athenaeum*, for example, she was told, "Do the negro justice, we say, by all means; but keep him, for half a century at least, out of our imaginative literature." *The Hour and the Man* did not enjoy the success of *Deerbrook*, but it nevertheless went into several editions, and the author derived a good deal of satisfaction from the writing of it.[56]

Much more popular than the Haitian novel was Martineau's *Playfellow* series of four children's books published between 1841 and 1843. To the modern reader the stories seem morbid and moralistic, but Martineau's contemporaries of all ages enjoyed the *Playfellow* stories enormously. These were not her first venture into children's literature; her earliest children's fiction—the obscure *Principle and Practice; or, the Orphan Family*—having been published in 1827 anonymously. In this early novella, five orphaned children survived heroically under the guidance and influence of the eldest who "has had so much to do and bear, that she has learned not to look from side to side in hope and fear, but to go on, straight forwards, in the road to duty, whether an easy one or not."[57] This same sentiment pervaded all the *Playfellow* stories except *The Prince* which was based on

the tragic life of the young dauphin of revolutionary France and which was the only nonfictional tale of the four. The other three stories were all about children who succeeded in overcoming enormous odds without any significant adult assistance. The Robinson Crusoe element—so popular in the nineteenth century, especially with the middle class—was especially strong in *Settlers at Home* and to a lesser extent in *Feats on the Fiord*, where resourceful children were pitted against the elements and forced to cope with hazards which threatened their very survival. *The Crofton Boys*, the most popular of the tales, was much closer to the experience of the average middle-class Victorian child. It was one of the earliest of English boarding-school stories, predating *Tom Brown's Schooldays*, which was not published until 1857.

Martineau had been driven to write her *Illustrations of Political Economy* by conviction as well as necessity, but her *Playfellow* stories seem to have been inspired mainly by necessity. Although at the time she regarded them as her final contribution to literature, she did not use them for any significant final radical gesture. In fact, it was probably because she was relying upon the income which she would derive from them that she chose to write in the conventional genre of the children's story and to express the conventional sentiments. In spite of her earnest social consciousness she did not choose, as Dickens was doing, to write about the underprivileged or abused child. Though she was concerned about the rearing of children and abhorred the still prevailing eighteenth-century convention of treating children like little adults, it was precisely as little adults that she depicted her boys and girls. Her small heroes and heroines bore premature responsibilities, were expected to act with the propriety of their elders, and were made to mouth proper and pious cant. Her necessarian logic and embryonic skepticism did not prevent her from expressing the usual religious dogmas and the belief in traditional prayer. Nor did her concern about the unequal role of women effect any concessions toward the conventional depiction of her little girls. The boys were the real heroes of her stories; the girls were simply passive bystanders or at best helpmeets. It was almost as if she went out of her way to avoid controversy and to give the public what it liked and expected.

After she had concluded the last tale, *The Crofton Boys*, and despite her announced retirement, she immediately took up the pen again. By the end of 1843 she had completed *Life in the Sick-Room*, inspired not by a commercial motive but rather by that sense of duty and personal commitment with which she had written "Letter to the

Deaf" in 1834. She felt that her illness had taught her the uses of
suffering and she wanted to share the lesson. While denying that
pain was divinely inflicted for some good, Martineau nevertheless
used her experience of illness, as she used all her experiences, to
instruct others.

> You know, as I do, how useful it is to human beings to have before
> them spectacles of all experiences; and we are all alike willing, having
> worked while we could, now to suffer as we may to help our kind in
> another mode.[58]

As with her advice to the deaf, the chief burden of her instruction
was that the invalid give little trouble to others, and that the friends
of the sufferer accept and speak the truth and forebear false conso-
lation. She offered ideas about visiting hours and sickroom proce-
dures and made practical suggestions similar to those which Flor-
ence Nightingale was to make in *Notes on Nursing* in 1859.

In *Life in the Sick-Room* Martineau partially revealed the extent of
her own suffering and, unfortunately using tantalizing generalities,
described the pangs of conscience which tormented her solitary
hours:

> . . . the invisible array which comes thronging into the sick-room
> from the deep regions of the past, brought by every sound of nature
> without, by every movement of the spirit within; the pale lips of dead
> friends whispering one's hard or careless words, spoken in childhood
> or youth—the upbraiding glance of duties slighted and opportunities
> neglected—the horrible apparition of old selfishness and pusillanimi-
> ties—the disgusting foolery of idiotic vanities. [P. 34]

She could not avoid sentimentalizing her mournful subject or laps-
ing into triteness or a self-dramatization of her own martyrdom. She
wrote of aspiring to attain "a trusting carelessness as to what be-
comes of our dear selves," but the very act of writing *Life in the
Sick-Room* was a denial of that "carelessness." Throughout the pages
of the self-righteous little volume there breathed a self-conscious air
of noble suffering. However, to do her justice, she herself later
denounced this offspring of her Tynemouth confinement as

> the magnifying of my own experience, the desperate concern as to my
> own ease and happiness, the moaning undertone running through
> what many people have called stoicism. [*Autobiography*, 2:172]

Life in the Sick-Room rapidly went into extra editions, which says as much about the Victorian frame of mind as it does about the author's. The anonymity of the author was very quickly penetrated and Henry Crabb Robinson became the recipient of all manner of compliments on Harriet Martineau's behalf. He was told, for example, that at Rydal Mount the Wordsworths "have been quite charmed, affected, and instructed by the Invalid's volume."[59] Elizabeth Barrett, who was at first suspected of being either the anonymous author or the "fellow-sufferer" to whom the book was dedicated, was quite flattered by both suggestions. Barrett and Martineau had not met but they had corresponded from their sickbeds, and in December 1844 Elizabeth Barrett wrote:

> With all my insolence of talking of her as my friend, I only admire and love her at a distance, in her books and in her letters, and do not know her face to face, and in living womanhood at all.[60]

Elizabeth Barrett regarded Harriet Martineau as "the most logical intellect of the age, for a woman." She shared Martineau's letters to her with her friends. In her room she hung a portrait of Harriet Martineau along with those of Browning, Carlyle, Wordsworth, and Tennyson. She staunchly defended Martineau against Robert Browning's criticisms, the early friendship that had existed between Browning and Martineau having developed into something like a mutual and cordial antipathy. So high an opinion did Elizabeth Barrett have of Martineau as an author and literary critic that when a package containing some poems Martineau had read for her arrived she was "so fearful of the probable sentence that my hands shook as they broke the seal." It is no wonder then that Elizabeth Barrett should have been flattered by the suggestion that she was thought to be the author of so acclaimed and popular a volume as *Life in the Sick-Room*.[61]

Early in 1843 Martineau reached the nadir of her condition, and it was then that she, apparently contemplating death and conscious of posterity, demanded that her correspondents burn her letters. She wrote in April of 1843 of her hopeless condition. "My weariness of life—my longing to be non-existent—is indescribable: the oppression of life grows heavier, almost from day to day . . ." But she was simultaneously becoming aware that "the sufferings from nervous

horrors and from bodily sickness are less than they were,"[62] and by
the middle of the year her condition apparently altered somewhat
for the better. Mrs. Reid arrived in July to find her much improved,
and by April of the following year Greenhow was able to note a
slight change in her general state of health. Her menses were resum-
ing their normal cycle, her nausea was ceasing, the activities of her
bowel and bladder were becoming easier and more regular, and
although it was still enlarged, there was more flexibility in the
uterus.[63] These changes were probably associated with a shift in the
position of the tumor so that it no longer oppressed the abdominal
organs. But because these physical improvements were the first en-
couraging signs in five long years, and because they coincided with
Martineau's first mesmeric treatment, she quite naturally ascribed
her cure to mesmerism.

Mesmerism was a "scientific" version of medieval exorcism: it re-
lied on physical rather than spiritual properties. The Austrian An-
ton Mesmer (1734–1815), who founded the mesmeric school, based
his theory on animal magnetism. He believed that because each indi-
vidual possessed a magnetic fluid, one individual could magnetize
another. By this means, and using passes of the hands, a mesmeric
practitioner could draw pain from the body of a patient. One of
Mesmer's disciples brought the mesmeric treatment of pain a step
further when he discovered an ability to induce a magnetic sleep or
artificial somnambulism during which he could elicit the patient's
symptoms and prescribe a cure: in 1843 this practice was given the
name "hypnosis." As a therapeutic technique mesmerism had only a
small following among serious medical practitioners in England, and
the English medical establishment on the whole remained aloof. But
the subject attracted considerable comment in the press. The *Athe-
naeum,* from approximately 1838, gave it a great deal of critical
attention. And *Blackwood's,* in an article entitled "Mesmeric Mounte-
banks," allied it with necromancy and its practitioners with Friar
Bacon and Friar Bungay.[64] Mesmerism, after all, attracted a variety
of cranks and quacks, and somnambulism was a short step away
from clairvoyance.

Martineau's chief interest in mesmerism began with her "cure,"
but she had been aware of the concept before she actually experi-
enced it. In *Life in the Sick-Room* she had written:

Who looks back upon the mass of strange but authenticated narratives
which might be explained by this agent [mesmerism], and looks, at the
same time, into our dense ignorance of the structure and function of

the nervous system, and will dare say that there is nothing in it? Whatever quackery and imposture may be connected with it, however its pretensions may be falsified, it seems impossible but that some new insight must be obtained by its means, into the powers of our mysterious frame. [P. 83]

In a sense, it was Martineau's sophistication—she recognized, as many did not, "our dense ignorance of the structure and function of the nervous system"—and her genuine interest in furthering science that led to her involvement with mesmerism. She was not a superstitious woman. The mysteries of the mind as she saw them were physically, not spiritually, resolvable. Her brother-in-law, Liverpool physician Alfred Higginson, had successfully performed an operation during which a patient had been placed in a mesmeric sleep. Some of Martineau's friends were already converts to mesmerism and had urged her to attempt a cure by its means, as all other treatments had apparently failed. Though Greenhow himself was somewhat skeptical, he was persuaded to meet and introduce a noted visiting mesmerist, Spencer Hall, to his sister-in-law. The meeting between Harriet Martineau and Mr. Hall took place on June 22, 1844, and on that occasion the mesmerist by passing his hands over her head from behind succeeded in producing a sensation which she described as "a clear twilight" in which objects dissolved before her wide open eyes, and a languor affected her limbs. After the effect of the haziness wore off she felt a hot oppression, but in subsequent sessions she experienced only a "delicious sensation of ease" and "the indescribable sensation of health, which I had quite lost and forgotten." She continued to be treated, first by Hall and then by Mrs. Wynyard, and in the interim between the departure of Hall and the arrival of Mrs. Wynyard, by her own maid who relieved her mistress's symptoms by imitating Hall's gestures.[65]

Martineau gradually gained strength and by October felt well enough to give up her dependence on opiates. She had her drugs hidden so that she would not be tempted to turn to them, and supported by mesmerism she began her "scramble out of the pit." It was a struggle, she said, "which can be conceived only by those who have experienced . . . a case of desperate dependence [on opiates] for years." But between June and October she so far regained her health that she could go outside for the first time in years. She basked on the rocks, took walks, and began planning excursions. She told Milnes:

The fresh amazement at the feeling of health does not go off at all, though I have now been well for half a year. I do not in the least become familiarized yet with the wonder of day to day passed without pain, or fear or anxiety.[66]

In December, 1844, she was walking fifteen miles a day. In January Henry Crabb Robinson reported that

Miss M's health in appearance at least is such as I never saw before— Her complexion is become beautiful—and her whole air is that of happiness.[67]

And though less flattering than Robinson, Jane Welsh Carlyle who saw her a year later was no less impressed by Harriet Martineau's "rude weather-beaten health."[68]

Whatever the true cause of her recovery, Martineau was convinced that it had been achieved through mesmerism, and as with all her other lessons, she hastened to educate the rest of society too. She published her "Letters on Mesmerism" in the *Athenaeum* in 1844 in obedience to duty and in the full knowledge that she risked the opprobrium of the uninitiated. It was, however, less the facts of her cure than her naive attempt to link mesmerism with the suspect question of clairvoyance that provoked adverse comment. She had been misled into believing that her landlady's niece and her sometime servant, Jane Arrowsmith, was a somnambule and a clairvoyant and although she was soon after to be undeceived and to admit her error, at the time of the *Athenaeum* letters she was insisting not only on the curative but also on the visionary powers of mesmerism. It was this latter aspect of her tale that her critics pounced upon. Her credulous description of Jane's miraculous powers met with sharp rejoinders from the *Athenaeum* critic Charles Wentworth Dilke, and an angry correspondence between the two ensued in the pages of the *Athenaeum*.[69] Even Martineau's friends, who may have been prepared to accept the evidence of her recovery as a testimonial to the forces of mesmerism, were on the whole skeptical about Jane. Henry Crabb Robinson was led to say that "everybody joins in ridiculing her [Harriet Martineau]. And I am hard put to, not to join with the multitude—She may have confidence in the Somnambulism of her Servant, but she can't properly communicate her faith to others." However, for a time at least Henry Crabb Robinson remained loyal. He even dutifully attended a seance and found himself in "a state of humble uncertainty—Not daring to deny, and yet unable to as-

sent."[70] The reaction from others was mixed. Robert Browning was utterly unwilling to accept Harriet Martineau's testimony, but Elizabeth Barrett remained faithful and wistfully wondered whether Miss Martineau's "apocalyptic housemaid" could tell if her dog Flush had a soul.[71] Jane Welsh Carlyle commented with her accustomed acerbity that "Harriet Martineau expects that the whole system of Medicine is going to be flung to the dogs presently, and that henceforth, instead of Physicians, we are going to have Magnetisers!"[72] William Johnson Fox, with whom Martineau was still in correspondence, and who still shared a philosophy compatible with hers, could not sympathize at all on the subject of mesmerism.[73] And William Wordsworth thought that doubtless Harriet Martineau's imperfect hearing had misled her, that she jumped too quickly to conclusions and that it was hardly safe "for anyone's wits to be possessed in the manner this extraordinary person is by one subject be it what it may."[74]

Thomas Greenhow, however, was personally offended by Harriet's mesmeric cure and by the publicity which it received through the publication of the *Athenaeum* letters. He felt that his professional reputation had been impugned, and it was in defence of his reputation that he hastened to write his *Medical Report of the Case of Miss H—— M——*. Most of the report contained his accurate day to day observations, and it provides a valuable record of Martineau's condition, but his conclusions should be read in the knowledge that he was writing after his sister-in-law's recovery, and in his own defense.

> Knowing well that no symptoms of malignant disease of the affected organ existed, I always believed that a time would arrive when my patient would be relieved from most of her distressing symptoms. . . . She never willingly listened to my suggestions of the probability of such prospective events and seemed always best satisfied with anything approaching to an admission that she must remain a secluded invalid. . . . During *the last year or two* . . . I had frequent opportunities of observing the increased ease and freedom with which she moved about her sitting-room . . . the condition in December is but the natural sequel of progressive improvement *begun in,* or *antecedent to, the month of April.* . . . the time had arrived when a new and powerful stimulus only was required, to enable the enthusiastic mind of my patient to shake them [the symptoms] off.[75]

Nineteenth-century medicine was not sophisticated enough for Greenhow to have been sure that no malignancy existed, and indeed his certainty of her recovery was nowhere expressed before his sister-in-law's actual cure. In the first year of her illness Sir Charles

Clark had pronounced Martineau's condition incurable, and as Greenhow then noted a concurrence in diagnosis, it may not be too rash to assume that the two physicians had also concurred in their prognosis. Spencer Hall recalled that on the occasion of his first meeting with Greenhow, the doctor had given no indication "that a cure of Miss Martineau's disease had already commenced (as his pamphlet now states it had) two months before."[76] But there was, according to Greenhow's notes and to Martineau's observations to Henry Crabb Robinson in 1843, a gradual improvement in her physical condition prior to the mesmeric treatment.[77] Greenhow could not claim that he had all along suspected a recovery but he was probably correct, once having noted an improvement in his patient's condition, that all she then needed was a psychological stimulus to shake off her illness. His claims to an earlier preknowledge that she would fully recover cannot however be fully credited and they probably stemmed from his damaged ego and not from any definite medical expertise. When R. K. Webb accepts Greenhow's claim that he had all along assured his patient that her disease was not fatal, he fails to take into account the fact that Greenhow's medical observations revealed no change in the actual condition of the uterine area until April of 1844. Furthermore, Webb makes no allowances for the possible prejudices of a doctor who considered his medical reputation to have been slighted. Webb therefore concludes that Martineau was "not so ill as she insisted." He denies the reality of her medical symptoms, ignores the possible ill effects of her five-year dependency on drugs, and suggests that she exaggerated her condition because she enjoyed the drama of martyrdom. To support his thesis he cites her admiration for those who suffered heroically and he even goes back to an early *Monthly Repository* article in which she wrote of a submission "to inevitable misfortune with humble acquiescence," and of welcoming "the dispensations of Providence, whatever they may be, to derive spiritual vigour from every alteration of joy and sorrow, to perceive the end for which those alterations are appointed, and to aid in its accomplishment." It is my belief that Martineau *was* as "ill as she insisted," and that even after her physical condition slightly improved she was still suffering from the morbidity which accompanied her disease, and from the prolonged effects of the drugs to which she had become habituated. Mesmerism filled an important psychological need, and may also have been an effective face-saving device for someone who had been claiming mortal illness. But although Greenhow was correct in this one aspect, his other claims should not be used to support a contention that the

period at Tynemouth was one of self-inflicted martyrdom. Green-how, we must remember, still used leeches and his medical opinion should not be accepted without question.[78]

Martineau's friends considered Greenhow's *Medical Report* a scandalous violation of professional propriety and gentlemanly conduct. He had, it is true, asked her permission to publish a report of her case, but she gave her consent thinking that he would write it in the conventional Latin and would publish it in a medical journal. She was horrified to discover that instead he had published "in a shilling pamphlet—not even in Latin,—but open to all the world!" The details which Greenhow revealed in his account of her case were of a very intimate nature and even today might have caused a public figure considerable embarrassment. It is not at all surprising therefore that she should have been deeply incensed. She severed all connections with the Greenhows, and because her mother, Rachel, and James also chose to interpret the publication of the "Letters on Mesmerism" as an affront to the personal and especially the professional integrity of Greenhow, she found herself isolated from most of the rest of the family. Only her brother Robert and her sister Ellen remained loyal.[79]

The relationship between Harriet and James had been deteriorating for some years. The brother and sister no longer occupied precisely the same philosophical territory: Harriet was still a necessarian and still professed to uphold the basic Unitarian tenets but her enthusiasm for religion had waned while James's had increased. He had moved away from necessarianism and in the direction of greater spiritualization. He was not fully sympathetic to some of his sister's more ardent personal causes: he did not condone either abolitionism or republicanism. Although in 1837 and 1838 she was still describing James as a "glorious personage . . . wiser, serener, more religious and merry than ever," and as "gentler, more moderate and noble than one often sees any men," by 1841, according to James, "Harriet's tone of epistolary address to me" had altered from "the superlative 'dearest brother' to the positive 'dear brother' which commenced with September 6, 1841." James went to Europe to fetch his sister when she was taken ill, but he did not visit her in all the five years of her confinement in Tynemouth. And when Harriet decided to have her correspondents destroy her letters in 1843 in order to prevent their posthumous publication, James refused to submit to the injunction. Thereafter her letters to him became, in his words, "ever more far between, limited to matters of fact, comparatively dry and cold," till they totally ceased a few years before the appearance

of the Martineau and Atkinson *Letters on the Laws of Man's Nature and Development* in 1851. Harriet discreetly bypassed the quarrel with James in her *Autobiography* and it was only in Maria Weston Chapman's *Memorials,* which constitute the third volume, that the matter was discussed at all. According to Chapman's notes for the memorial volume it was James who had inflamed Harriet's mother against her when the controversy over her mesmeric cure erupted. Harriet's nieces told Mrs. Chapman that the conduct of the family toward their aunt had been "all jealousy of her superiority." It is indeed quite possible that James's attitude toward his famous sister may have been inspired by envy; Harriet apparently thought so. She had privately told George Eliot that "from the beginning of her success [James had been] continually moved by jealousy and envy towards her." Though it was James who first suggested that his sister write, he became less encouraging with her increased success in the *Monthly Repository.* He had criticized her intimate connection with her editorial colleagues on the *Repository;* he had discouraged her acceptance of a Government pension; he had been jealous of her American friendships; and he had advised her against becoming editor of Saunder's and Otley's proposed sociological journal in 1838, although she would have been the first Englishwoman to be afforded such a journalistic distinction. It was between 1839 and 1844—the years of her illness—that the breach between the brother and sister widened, and when he sided with the Greenhows in their quarrel with Harriet, the damage done to their hitherto close relationship was all but irreparable. Though Harriet made up with her mother shortly before the old lady's death in 1848, with James the break was complete.[80]

Harriet Martineau was an obstinate woman, and the opposition of her brother and the criticisms of her family and friends during the mesmerism controversy served only to reinforce her own convictions. She was able—as in the case of Worthington—to exclude from her life those to whom she did not wish to attend, and to seclude herself behind the wall of her own certitude.

After the first stab of every new insult, my spirits rose, and shed forth the *vis medicatrix* of which we all carry an inexhaustible fountain within us. I knew, steadily, and from first to last, that we were right,—my coadjutors and I. I knew that we were secure as to our facts and innocent in our intentions: and it was my earnest desire and endeavour to be no less right in temper. How I succeeded, others can tell better than I. I only know that my recovery and the sweet sensations

of restored health disposed me to good-humour, and continually re-
minded me how much I had gained in comparison with what I had to
bear. [*Autobiography*, 2:200–201]

Martineau's recovery in 1844 ushered in a decade which she de-
scribed as "worth all the rest of her life."[81] In January of 1845 she
left Tynemouth for the Lake District and from there went on to
Birmingham where she spent ten "most happy" weeks with her
brother Robert and his family. She had intended returning to Tyne-
mouth, but during her absence the storm over the *Medical Report*
broke, and there now seemed little point to resuming life in a town
where the main attraction had been the proximity of her sister's
family. The Lake District had meanwhile cast a spell upon her and
she decided to return there and build her own home. No sooner was
the decision made than it was acted upon with her customary dis-
patch, and the walls of her new home rose so quickly that Mrs.
Wordsworth was led to exclaim: "Surely she must have mesmerized
her workmen, for our builders are never so alert."[82] Harriet Marti-
neau had spent her entire life either in her parent's home or in
lodgings, and her decision to build "The Knoll," as her home came
to be called, fulfilled a need for domesticity.

> I have a horror of mere booklife; or a life of books and society [as in
> London]. I like a need to have some express and daily share in some-
> body's comfort: & trust to find much peace and satisfaction as a house-
> keeper in making my maids happy, and perhaps a little wiser—in
> receiving overworked or delicate friends and relations to rest in my
> paradise, & in the sort of strenuous handwork *which I like better than
> authorship*. [Emphasis added][83]

There is an exquisite irony in this last confession, for Harriet Marti-
neau, if we recall, had elected authorship over her mother's express
desire that she spend her life as a needlewoman!
 "The Knoll" was situated near the village of Ambleside which
nestled between Lake Windermere and the surrounding hills. It was
a wooded valley which abounded in wild flowers, and the garden of
"The Knoll" was lovingly planted with foxglove, wood-anemones,
ferns, pansies, and primroses which Martineau gathered on her
many rambles. The house was a simple two-storied stone residence
covered with rambling vines and climbing roses. It boasted of indoor

plumbing, but was otherwise unpretentious and not especially large. Upstairs there were three bedrooms including one for the maids whom Martineau treated like daughters—one of her maids was Jane of Tynemouth who was apparently forgiven her deception and remained with her mistress until 1852 when she emigrated to Australia. Below there was a kitchen, scullery, a sitting room, and a large study with a bay window which overlooked the terraced garden. On her two-acre lot she kept cows, pigs, and poultry. She had an orchard and a vegetable garden, and there was a cottage for the Norfolk farmer and his wife who ran her small self-sufficient agricultural experiment, which in its turn produced *Our Farm of Two Acres,* a short book which soberly explained the practical aspects of small-scale domestic farming.[84]

Although many of her new neighbors were suspicious of her obsessive interest in mesmerism, they soon warmed to her on other counts. "It is," said Henry Crabb Robinson, "no slight proof of the kindness of her disposition that she seems to be not in the least offended by the opposition so generally raised against her." Her tolerance "even of intolerance" made friendly intercourse with the other Lake District residents, and especially Wordsworth, possible. She and the poet laureate actually agreed on very little, and she admitted that "I feel a growing love and tenderness for him but cannot yet thoroughly connect—compact—incorporate him with his works. Cannot yet feel him to be so great as they." For Mary Wordsworth she had a great fondness, as she did for Mrs. Thomas Arnold, and the feeling was cordially reciprocated in both cases. But except for these and a few friends with houses in the vicinity, she did not visit much in the neighborhood. She was proud of her home and happy when she was able to share it with her aunts, cousins, nieces, nephews, and numerous acquaintances.[85] Charlotte Brontë was among those who visited Harriet Martineau at Ambleside and she offered her sister Emily this description:

> I am at Miss Martineau's for a week. Her house is very pleasant both within and without; arranged at all points with admirable neatness and comfort. Her visitors enjoy the most perfect liberty; what she claims for herself she allows them. I rise at my own hour, breakfast alone . . . I pass the morning in the drawing-room, she in her study. At two o'clock we meet, talk and walk till five, her dinner-hour,— spend the evening together, when she converses fluently and abundantly, and with the most complete frankness. I go to my room soon after ten, and she sits up writing letters. She appears exhaustless in strength and spirits, and indefatiguable in the facility of labour: she

is a great and good woman; of course not without peculiarites, but I have seen none as yet that annoy me. She is both hard and warm-hearted, abrupt and affectionate. I believe she is not at all conscious of her own absolutism. . . . I have truly enjoyed my visit here. . . . Miss Martineau I relish inexpressibly . . . and though I share few of her opinions, and regard her as fallible on certain points of judgment, I must still award her my sincerest esteem. The manner in which she combines the highest mental culture with the nicest discharge of feminine duties filled me with admiration; while her affectionate kindness earned my gratitude.[86]

George Eliot, visiting "The Knoll" in October, 1852, gave an equally enthusiastic description of her hostess. "Miss M is quite charming in her own home—quite handsome from her animation and intelligence. She came behind me, put her arms round me in the prettiest way, this evening, telling me she was so glad she had got me here." She was, said George Eliot, a tonic, "with her simple energetic life, her Building Society, her winter lectures and her cordial interest in all human things."[87]

The Building Society and the winter lectures which George Eliot mentioned were two of Martineau's attempts to elevate the Ambleside working class. The Building Society was a somewhat limited effort to improve the quality of working-class housing and to enable the "workies," as Martineau somewhat condescendingly called them, to possess their own homes. But as no more than fifteen cottages were built and as the tenants were carefully selected and not typical of most members of the working class, the endeavor had only a limited success.[88] Her winter lectures, which included subjects ranging from English and American history to sanitation and local geography, were given two or three times a week to a working-class audience. These lectures, together with support for the local Mechanics Institute, were attempts to make self-improvement possible for the workers through education, but there is unfortunately no way of evaluating whether or not these efforts achieved any degree of success.

Besides her civic conscientiousness, her domestic occupations, and her rigorous walks—Wordsworth, himself an energetic pedestrian, was led to exclaim when he met her walking with Henry Atkinson, "Take care! take care! Don't let *her* carry you about. She is killing off half the gentlemen in the county!"—Martineau did not neglect her literary labors. Her day at Ambleside began at six. She had walked, bathed, and breakfasted by seven-thirty, and from that hour until two she remained at her desk. In the decade which followed her

recovery she wrote *Dawn Island, A Tale* (1845) to raise funds for the Anti–Corn Law League; *The Forest and Game Law Tales* (1845–46) at the urging of John Bright who was campaigning against the ancient Game Law privileges of the landed classes; she compiled more than one guide to the Lakes; she went to Egypt in 1846 and after her return wrote *Eastern Life Present and Past* (1848); *Household Education* was written in 1849; *The History of England during the Thirty Years' Peace* was researched and written in 1849 and 1850; in the following year she wrote *Introduction to the History of the Peace*, and with Henry Atkinson collaborated on *Letters on the Laws of Man's Nature and Development;* between 1851 and 1853 she translated and condensed the six volumes of Auguste Comte's *Positive Philosophy;* and she simultaneously contributed to the *Westminster Review, Household Words, The Leader,* and in 1852 began a long association with the *Daily News.*

Her activity seemed almost compulsive but she was happy: "the gayest of the gay, and perfectly well."[89]

> My life is now (in this season) one of wild roving, after my years of helpless sickness. I ride like a Borderer,—walk like a pedlar,—climb like a mountaineer,—sometimes on excursions with kind and merry neighbours,—sometimes all alone for the day on the mountain.[90]

Her energies amazed her Ambleside acquaintances, and even those like Edward Quillinan who were critical of her eccentric opinions conceded that "her manner [was] so pleasing, and friendly, that if I disliked some portions of her writings ten times more than I do I could not help liking *her*."

> Miss Martineau's intellectual activity shames all to idleness. Besides her contributions to I know not how many publications of the day . . . she finds time for much social service in various ways and gives evening lectures once or twice a week on political and household economy, etc. etc. to the labouring classes. I am told by those who have heard them that they are very good. . . . I confess that the [*sic*] Harriet Martineau is, all book writings apart, in herself and her own good natured and good hearted way, an agreeable neighbour, *much* to be *liked*.[91]

For all her earnestness, her formidable industriousness, and the obstinacy of her pride, she was a very warm, sociable, garrulous, and generous-hearted human being. She had a fresh and amiable laugh and enjoyed "laughable stories." She loved and was beloved by children. She inspired affection in others and needed it herself. In

America she had been described as "a lively, playful, child-like, simplicity-breathing creature," and in the summer of her content these qualities ripened. "I am very merry," she wrote in 1852, "It is curious that one so solemn in youth should be growing merry in her 50th year."[92]

Nathaniel Hawthorne, on a visit to the Lakes at this time, saw her as

> . . . a large, robust, elderly woman; but withal she has so kind, cheerful, and intelligent a face that she is pleasanter to look at than some beauties. Her hair is a decided grey. . . . She is the most continual talker I ever heard . . . very lively and sensible too. [*Autobiography*, 3:275]

The pleasing Richmond portrait of 1849 testifies to the serenity of her expression and to the handsomeness of her countenance. She was happy in her independence. She had achieved a rare prominence and stature. She enjoyed her work and her life. She was at the pinnacle of her professional career. If some considered her a political and religious pariah it apparently did not bother her. She was secure in her own convictions and had the ability of shutting out the voices she did not wish to hear. She felt impregnable in her opinions, self-reliant in her resources, and at last mistress in her own home. She now asked to be addressed as *Mrs.* Harriet Martineau, and the title was symbolic of more than her recognition that she was no longer either young or marriageable.[93] It was symbolic of her now unchallengeable independence: she had come into her own. In the happy years which followed her Tynemouth confinement she emerged from the shadow of her mother, she shed the religious crutch which had been her support since childhood, and she produced some of the most significant of her literary and journalistic work. It is to these writings, *The History of England during the Thirty Years' Peace, Eastern Life Present and Past, Letters on the Laws of Man's Nature and Development*, the translation of Comte's *Positive Philosophy*, and her later journal articles that we shall turn our attention in the remaining chapters of this work.

A History of Her Own Times

The History of England during the Thirty Years' Peace 1816–1846

As a journalist rather than a historian Martineau was singularly well-suited to chronicling her own times. "There are few living authors," wrote a reviewer in the *Athenaeum*, "who may be so implicitly trusted with the task of writing cotemporary [*sic*] history as Miss Martineau."[1] But though the reviewer thought the *History of the Peace* "as impartial a contemporary history as could be hoped from any pen," to the modern historian Martineau's objectivity is somewhat more questionable. Indeed, her *History of the Peace* becomes important as much for her patently obvious biases as for her contemporaneity. As a political economist looking back on her own era, Martineau had from the outset every expectation of enjoying "not a little writing of the gains we have made in freedom through peace and its attendant influences."[2] Progress through freedom and peace was an essential dogma to the classical political economist, and *History of the Peace*, concluding with the year of Corn Law repeal, was in a sense a celebration of those laissez faire ideals which Harriet Martineau had sought to propagate more than a decade and a half earlier: in *History of the Peace* she was able to provide an epilogue to the *Illustrations of Political Economy*.

Harriet Martineau undeniably wrote about progress, but she was not in Herbert Butterfield's sense a Whig historian. She did not write in the tradition of her contemporary, Thomas Babington Macaulay, who "brought all history to glorify the age of which he was the most honoured child."[3] Because Macaulay in the Whig historical definition was, or appeared to be, content with his age, he was inclined to judge and justify the actions of the past as they related to

the evolution of an evidently satisfactory present.[4] He did not believe in limitless progress or all-embracing democracy, and thought that by its extension to the middle class, democracy had gone far enough. He could feel satisfied that by the mid-nineteenth century the ends of progress had been achieved. But in spite of Britain's progress in the direction of liberalization and democratization, and in spite of the implementation of many of the legislative proposals which she had agitated for in the past, Martineau was forced to recognize that her England was not yet utopia. Though she did not despair of the ultimate vindication of the philosophy she espoused, she was dismayed by the fact that it had thus far produced so little change in the condition of England. As Elie Halévy—using Martineau's *History of the Peace* as a source for his own history of nineteenth-century England—recognized, Harriet Martineau, despite her reputation for being "nothing but a popularizer of orthodox utilitarianism in its most commonplace form," viewed the era which saw the triumph of laissez faire with less than equanimity.[5] For all her middle-class prejudices, she could not be satisfied with the achievements of reform: she could not regard the revolution as complete.

Martineau's earlier optimism had tempered but she did not despair of her society. As a necessarian and an embryonic Comtean she was able to regard her age as a period of "transition": as a part of the evolutionary process, a "partial advance towards the grand slow general advance which we humbly but firmly trust to be the destination of the human race" (*History of the Peace*, 2:707). Her old insistent optimism had lingered as late as 1843.

> We see that large principles are more extensively agreed upon than ever before—. . . . We see that the dreadful sins and woes of society are the results of old causes, and that our generation has the honor of being responsible for their relief. . . . We see that no spot on earth ever before contained such an amount of infallible resources as our own country at this day, so much knowledge, so much sense, so much vigor, foresight, and benevolence, or such an amount of external means.[6]

Eighteen forty-three had been a bountiful year in England: the country had weathered a six-year period of depression; it had already achieved a measure of parliamentary and social reform; under Prime Minister Peel it was headed (Martineau was certain) for the long-sought repeal of the Corn Laws. Then, hard on the heels of this respite from want and worker unrest, had come the disastrous crop failures of 1845, 1846, and 1847; the famine in Ireland; and

the Chartist protests and continental revolutions of 1848. Martineau's confidence was shaken. She could no longer be naively optimistic. The prescribed solutions had seemingly failed to achieve the desired results and the question of the condition of England remained unresolved.

> The tremendous Labour Question remains absolutely untouched.... If it be true, as some say, that the labourer's life-long toil demands a return, not only of sufficient food, and domestic shelter for his old age, but of intellectual and spiritual culture, what can we say to the working classes? ... we ought to put ourselves in their place, ... and then we shall understand how suspicious they must be of promises of unseen and future good [precisely the sort of promises she had made in the *Illustrations*] when it is offered as better than the substantial good which they see others enjoying, and feel to be their due. ... they will not acquiesce while they see that those who work less are more comfortable; and they are not told why. This is what remains for us to do;—to find out the why, and to make everybody understand it. [*History of the Peace*, 2:715–16]

Perplexed for an answer, and less than complacent about the condition of contemporary England, Harriet Martineau was nevertheless encouraged by the measurable progress which had been made. For besides expressing her nagging doubts, her *History of the Peace* also reflected a pride in the achievements of the age. Indeed, it mirrored the ambivalence of her own attitude.

The Harriet Martineau who set her hand to the writing of the history of her times was not the inexperienced author of the *Illustrations*. Her professional skills had improved immeasurably, and her attitude had significantly broadened. Even so, the undertaking was formidable and, in her words, *History of the Peace* was "the bulkiest of her works and the most laborious." She wrote it at the request of Charles Knight who, as publisher of the Society for the Diffusion of Useful Knowledge, disseminated informative, reasonably priced publications intended primarily to help the less prosperous members of society improve their lot and their understanding.[7] Knight had started writing the *History of the Peace* himself with the intention of making the events of their own time comprehensible to the same middle- and artisan-class readers who subscribed to his other publications. His plan had been to issue the work in monthly numbers and he had begun work on the first of these in 1846. Other commitments had forced him to set it aside after completing the initial installment, the history of the period from Waterloo(1815) to Peterloo(1819). His

subscribers had been more or less abandoned and the project neglected until 1848 when he was able to persuade Martineau to continue from where he had left off. He gave her a bountiful quantity of reference materials, which she later carefully acknowledged in marginal notation, and with her usual determination, but somewhat oppressed by the magnitude of her task, she began her work.[8]

The *History of the Peace* consisted initially of six books of which Martineau wrote all but the one completed by Knight. In 1849 and 1850, after the last of the monthly installments had been issued, the entire work was republished in a two-volume edition and it was so immediately successful that Knight suggested extending the work at both ends.[9] In the following year Martineau had *Introduction to the History of the Peace: from 1800 to 1815* ready for publication.[10] This introductory volume was primarily a narrative account of a period which she barely remembered, and her writing lacked the immediacy and personal bias which gave the original volumes their contemporary significance. Knight did not publish the final volume in the series because he was so disturbed by the apostacy of the Martineau and Atkinson *Letters on the Laws of Man's Nature and Development* when it was published in 1851 that he sold the rights to the series. The final chapters of the *History of the Peace* were not completed until an American edition of the entire work was published a dozen years later. This publication, *The History of England from the Commencement of the XIXth Century to the Crimean War* (1864), was an enlarged version of the entire work, which was not essentially revised but to which was added a final volume. Though briefer and less meticulously wrought than the preceding volumes, the concluding chapters nevertheless have an intrinsic interest, for they provide insight into Martineau's latest thoughts on some of the issues she had raised in the earlier portion of the work.

The sources for the *History of the Peace* were the *Annual Register,* Hansard, leading political memoirs and biographies, and the most important current journals and newspapers. In it she catalogued the political confrontations and parliamentary proceedings which accompanied the enactment of reform legislation. She wrote about the nation's economic fluctuations. She drew attention to social problems, especially as they affected the working class. She discussed British foreign and imperial policy and commented on the leading personalities of the period. She noted the irreversible phenomena of industrialization and urbanization, and described cotton manufacturing as a "leading social event," for with it had come the dramatic demographic shifting of thousands from the agricultural to the

manufacturing sector, and a new balance between town and coun-
try.[11] Although noting this process, she did not, unfortunately, in-
vestigate its impact on the society. She barely alluded to the urban
conditions which so appalled de Tocqueville and Engels.

The original two volumes of the *History of the Peace* dealt with
many of the more important questions of the period: it was not
simply a narrative. As the reviewer in the *British Quarterly Review*
pointed out:

> The tendency of the author is not to tell the *story of England* during the
> thirty years, but to collect from the records of that story certain politi-
> cal events, and round them to group the rest as best she may.[12]

There are two main focal points in Martineau's *History of the Peace:*
the democratization of the old aristocratic legislative process which
culminated with the Reform Act of 1832; and the liberalization of
the ancient commercial monopolies which culminated with the re-
peal of the Corn Laws in 1846. For Martineau both events symbol-
ized progress, and her treatment of them was indicative of her atti-
tude toward that progress. But she also recognized the dark descant
side to the story: the obtrusive question of Irish unrest and poverty
and, closer to home, the nagging question of working-class suffering
and working-class protest.

> The history of the Thirty Years' Peace painfully obtrudes . . . upon
> our notice . . . the most striking and universal advance in political
> knowledge and popular tendencies; and we are forced to reflect that
> this advance has not been accompanied by any adequate increase of
> comfort to the operatives, but rather by a gradual depreciation of
> labour.[13]

The troubles in Ireland and of the working class in England which
punctuated the years and penetrated the political, social, and eco-
nomic fiber of Britain darkened the pages of the *History of the Peace*
too. It is to these troubling aspects as well as to the more positive
achievements of the period and of the *History of the Peace* that we
shall turn our attention.

Martineau's *History of the Peace* began where Knight had left off,
with the years which followed Peterloo. The massacre at Saint
Peter's Fields symbolized for Martineau the end of an era and the

beginning of the reform process. The old advocates of protest had been Tory radicals like Cobbett who resisted the industrialization of a disappearing rural England. The new reformers came from the middle class. They supported change and opposed the ancient privileges of old landed and commercial aristocracies which the past had represented. As early as the 1820s their laissez faire ideology had filtered into the lofty antique halls of government where the Sidmouths and the Eldons were gradually being displaced by more moderate, liberal voices. From her perspective of two decades, Martineau had been able to discern the trend to reform, and to identify those who became agents of laissez faire in the economy, and of liberalism in domestic and foreign policy. She credited Huskisson for seeing "furthest into the nature and necessity" of free trade and eulogized Canning as the chief architect of a liberalized political philosophy in government. But she succumbed completely to the radical anti-Castlereagh proganda of the day, identifying Castlereagh with the repressive policies of Sidmouth, and failing to attribute to him the earliest of Britain's liberal policies abroad.[14]

Martineau believed that in the 1820s "men were going unconsciously into the great change which the next twenty years were to accomplish" (*History of the Peace*, 1:432–33). She viewed this period of British history in necessarian and Comtean terms, as a time of peace and "organic change" in which

> the individual will succumbs to the workings of general laws. The statesman can no longer be a political hero, overruling influences and commanding events. He can only be a statesman in the new days who is the servant of principles—the agent of the great natural laws of society. [*History of the Peace*, 1:317–18]

Though writing of the 1820s, Martineau clearly had the Peel of 1846 in mind, and she may also have been referring obliquely to the philosophy of Carlyle who put his faith in men rather than principles. For Martineau, in spite of the occasional "hero" in her *History of the Peace*, saw all men as the functionaries of irresistible natural laws, and because of this, was able to appreciate the capacity of the Liverpool ministers to "reconcile themselves to the changes which they had found themselves compelled to make" (*History of the Peace*, 1:277–78). Unlike Disraeli, who described Liverpool as "the Arch-Mediocrity himself,"[15] Martineau commended Liverpool for his ability to reconcile the disparate elements in his cabinet. He was, she wrote,

a good balance wheel when the movements of parties might otherwise be going too fast.... His highest ability was that of choosing and conciliating men.... Nobody quarrelled with him: and he set his weight against his colleagues quarrelling with each other. [*History of the Peace,* 1:432–33]

For although in essence the old Tory party had disintegrated by the 1820s, its survival in that decade owed, in Martineau's opinion, a great deal to Liverpool's willingness to compromise with the ideas of change. When the party eventually failed at the end of the decade it was because it had compromised too much for its traditional supporters and too little for the liberal wing of the party.

Martineau recognized the 1820s as a turning point in the nation's history: as a time "requiring for its administration a new order of men." In the *History of the Peace* she selected the funeral of the Duke of York in January of 1827 to symbolize the passing of the old order.

If those who attended that funeral could have seen their own position between the past and the future as we see it now, it would have so absorbed their thoughts as that the body might have been lowered into its vault unseen, and the funeral anthems have been unheard. A more singular assemblage than the doomed group about the mouth of that vault has seldom been seen. In virtue of our survivorship, we can observe them now, each one with his fate hovering over his uncovered head. [*History of the Peace,* 1:428–30]

The Duke of York had been the rallying point of repressive conservatism but his successor as commander-in-chief, the Duke of Wellington, would preside over a Tory cabinet which would yield the privileges which had been so long and jealously preserved. Wellington's government would repeal the Test and Corporation Acts which had disabled the Dissenters, and would pass the legislation which would at last emancipate the Catholics. The Duke of Clarence, the chief mourner at the funeral in the absence of George IV who was lingering himself, would be the monarch "in whose reign was to occur that vital renovation of our representative system." Liverpool, Canning, and Huskisson—the essence of Tory liberalism—were doomed to follow the Duke before the end of the decade. Also in attendance at the funeral was that staunch upholder of the church and last supporter of the ancient constitution, the Tory Lord Chancellor, Lord Eldon. He was, wrote Martineau, utterly unaware of the symbolic importance of the moment, and so preoccupied with the fear that he might catch

cold that he had stood "upon his hat to avoid chill from the flags." For Martineau, Eldon represented that aristocratic spirit which she hoped to see supplanted "in all its manifestations." He was the archetypal reactionary: "the grand impediment in the way of improvement—the heavy drag upon social happiness in the country he professed to love so well." Her depiction of Eldon was hardly without bias, but she paid careful if somewhat ironic attention to the Lord Chancellor's opinions and described him with a light, almost Gilbertian touch. By making his obfuscations seem a little ridiculous, she reduced them from the sinister and at the same time made the reformers appear by contrast all the more earnest.[16] Eldon and the other mourners had stood on that cold January day,

> . . .within the curtain of the future, seeing nothing but the vault at their feet, and the banners of the past waving above their heads. . . . But what they saw not, we, as survivors see; and what they heard not, we hear. . . . The summons of death and the popular will, and of individual conscience, are still audible to us,—not in their first stunning crash, but as funereal echoes to which those banners float. [*History of the Peace*, 1:428–30]

The decade of the twenties saw the erosion of old religious privileges. The thirties would be the decade of parliamentary reform. Martineau had grown up in the reigns of the last Georges. Her family had had little reverence for the royal incumbents or for the aristocratic parliamentary oligarchy and she came quite naturally by democratic and republican sentiments. Although she went to Victoria's coronation in 1837 hopeful that the young girl who had wept over her *Illustrations* would reassume responsibility for her people and restore the obligations of monarchy, her expectations had been disappointed. She was to look back at Victoria's coronation as an occasion which had

> . . .strengthened instead of relaxing my sense of the unreal character of monarchy in England. The contrast between the traditional ascription of power to the sovereign and the actual fact was too strong to be overpowered by pageantry, music, and the blasphemous religious services of the day. After all was said and sung, the sovereign remained a nominal ruler, who could not govern by her own mind and will; who had influence but no political power.[17]

Martineau interpreted the Bedchamber Question of 1839 not as evidence of the reassertion of political power by the Queen, but

rather as a political ploy by a dying Whig administration to mislead the young sovereign and to frustrate the formation of a Tory government. The crown, she concluded, had "no longer any power but for obstruction."

National power had passed from the hands of the crown, but in Parliament the aristocratic dominion remained, and Harriet Martineau herself, when a neophyte journalist writing for the *Monthly Repository,* had thrown her weight behind the movement pledged to transfer national leadership from the country's most ornamental members to its most productive ones. Her "Reform Song" (set to the music of "Scots, wha hae,") had been sung at political union meetings and monster rallies.

> Now's the day, and now's the hour!
> Freedom is our nation's dower,
> Put we forth a nation's power,
> Struggling to be free!
>
> Raise your front the foe to daunt!
> Bide no more the snare, the taunt!—
> Peal to highest heaven the chaunt,—
> "Law and Liberty!"[18]

Martineau was a confident supporter of democratic solutions, and she used the pages of the *History of the Peace* as much to describe the achievement of democratic reform in 1832 as to polemicize its further extension, and to counter the arguments of those who feared it.

> A representative system is worse than a despotism for a nation which has no ideas to represent—no clear conception of its political duties, rights and privileges—no intellect and no conscience in regard to social affairs. The opponents of both Parliamentary and Municipal Reform feared the ignorance and the self-will of the mass of the people; and not without reason. . . . The question was how to deal with it. Either the people must be governed without participation from themselves—that is England must go back into despotism; or the people must be educated into a capacity for being governed by themselves, through the principle of representation. The only possible education for political, as for all other moral duty, is by the exercise of the duty itself. [*History of the Peace*, 2:239–40]

She did not appear to fear the leveling spirit which was abroad and she had scant sympathy for the selfish fears of those who did.

The fearful by nature would compose an aristocracy, the hopeful by nature a democracy, were all other causes of divergence done away.... Men who have gained wealth, whose hope is fulfilled, and who fear loss by change, are naturally of the aristocratic class. So are men of learning, who unconsciously identifying learning with wisdom, fear the elevation of the ignorant to a station like their own. So are men of talent, who, having gained power which is the fit recompense of achievement, dread the having to yield it to numbers instead of desert. [*Society in America*, 1:12–13]

Martineau saw democracy as inevitable, and appeared to view the prospect with evident relish. In 1842, at the time of the Plug Riots and the Chartist Protests, she had calmly warned Richard Monckton Milnes:

Are you prepared, if you live to be old, to part with a good many of your social privileges? It is coming to that, depend upon it. We are not far from such a bouleversement as will throw every man of you on his manliness.... The smuggest of you will be shaken out of your nests and happy those who can fly, and not flutter or droop, in such a tempest as is driving up. We may get over this year quietly; but not thirty years,—nor twenty,—in my belief.[19]

Martineau was under no illusions about the Reform Act of 1832. She saw it as nothing more than a token gesture toward democracy which had left Parliament still aristocratic in tone and corrupt in electoral practice. She believed that its significance lay, not in its immediate effect upon the representativeness of Parliament, but rather in its promise of "achievement hereafter of a real representation." Though the middle class had been the chief beneficiaries of the act, they had gained less than their proportionate share of representation, and the artisan class remained without a voice at all in the halls of government. Martineau had always been a champion of the artisan class; it was to them, the most educable members of the industrious class, that she addressed many of her writings, and it was in them that her hopes for democracy rested. They had been ignored by the Reform Act because of upper-class fears which Martineau considered groundless.[20]

The strongest Conservative power of a country like ours resides in the holders of the smallest properties. However much the nobleman may be attached to his broad lands, and his mansions and parks, and the middle-class manufacturer or professional man to the station and pro-

vision he has secured for his family, this attachment is weak, this stake is small, in comparison with those of the artisan who tastes the first sweets of property in their full relish. He is the man to contend to the last gasp for the institutions of his country, and for the law and order which secure to him what he values so dearly. The commonest complaint of all made by the restless and discontented spirits of any time is that their former comrades become "spoiled" from the moment they rise into possession of any ease, property, or social advantage; and they truly thus become "spoiled" for any revolutionary or disorderly purpose. [*History of the Peace*, 2:28]

Martineau had confidence that a transition to democracy would be orderly, for in the months preceding passage of the Reform Bill there had been little actual disturbance, and by their sober conduct the people had, she thought, demonstrated their capacity for self-government by "making a satire on the then existing system of representation." Nevertheless many of those aristocratic members of the House who voted for reform had done so out of fear of the violence which might ensue if they resisted the demand for change. Indeed, the Radical Reformers had consciously employed the threat if not the actuality of violence in order to obtain passage of the reform legislation. Martineau was in all probability aware of these radical tactics.[21]

In the two years which preceded the Reform Act a climate of fear undeniably existed. Not only were there agitations in England, but on the Continent there had been effective revolutions. There has been much historiographic debate about the effect of the 1830 French revolution upon the British election of that year. It was Halévy's theory that the French revolution which overthrew Charles X and the repressive Polignac regime in 1830 directly influenced the English electors who, suspecting Wellington of being in sympathy with Polignac, failed to give his royally designated ministry an elective majority.[22] Norman Gash in his essay, "English Reform and French Revolution in the Election of 1830," and more recently Michael Brock in *The Great Reform Act* (1973), have attacked the Halévy hypothesis. Both Gash and Brock claim that most of the borough returns were decided prior to receipt of the news from France.[23] Martineau's contemporary estimate is therefore of more than passing interest in the light of these differences, especially because of her influence on Halévy. In the *History of the Peace* she placed considerable emphasis on the events which preceded the French revolution of 1830. She described the interest with which observers in England read reports of the repressive policies of Polignac, and she evidently

considered the eventual overthrow of the Bourbon regime, just days before the English politicians took to the hustings, as but the final scene in a long drama. In her opinion, the *preliminaries* to the French revolution of 1830 had had an immeasurable impact on political attitudes in England, especially as the English had, however wrongly, identified the government of Wellington with that of Polignac. It was, she thought, this popularly held misconception rather than the coup d'etat itself which had helped to overthrow the Tories at the polls. It was not Martineau's claim that the 1830 French revolution had directly influenced the British election of that year, but she thought that events in France may have stimulated or accelerated demands for reform. Necessarian that she was, she believed that change was inevitable and that a reform movement would have occurred in England without "the awakening of any new sympathy with foreign people." Even conservative reaction against continental revolutions would not, she was sure, have stemmed the tide of reform. But those "who were in any degree on the liberal side in politics," spoke to each other, she said, "in high exhilaration, of the bearing of these French events upon their own political affairs . . . and . . . saw that now was the time to secure that Reform of Parliament which was a necessary condition of all other political reforms."[24]

Despite the Reform Act, however, Martineau realized that "the real battle for the Reformation" was yet to be won, for "a vast proportion of the people—the very part of the nation whose representation was most important to the welfare of the state—were not represented at all." She embraced Carlyle's argument that Parliament was no representative body at all because it held no spokesmen for "that great dumb toiling class which cannot speak."[25] For Harriet Martineau, who began writing the *History of the Peace* in the year of the best organized of the Chartist protests, it was difficult to assess either the nature of Chartism or the direction the movement would take. She was not to know that Chartism's largest protest was to be its final one. She did not pretend to properly understand the phenomenon or to be able to fully explain it except as "another name for popular discontent—a comprehensive general term under which are included all protests against social suffering."[26] She chose to interpret the Charter as a political expression of what had begun as a social problem: a demand for representation by a laboring people who had struggled through a succession of poor harvests and industrial unemployment. She denied that anyone could speak for the working class but themselves, and, in 1848, had turned down an invitation by

Charles Knight to contribute to a proposed new "working-class" journal, *The Voice of the People*. Martineau did not feel that she could participate in a venture inspired by Whig officials who intended to employ as writers "friends of their own, who knew as much of the working classes of England as those of Turkey," and whose chief intention was to lecture the workers in a "jejune, coaxing, dull, religious-tract sort of tone" (*Autobiography*, 2:298–99).

These sentiments notwithstanding, Martineau had little sympathy for the working-class press. Even while deploring the four-penny stamp on newspapers as an "iniquity restraining the intercourse of minds in society," in the *Illustrations of Taxation* tale *Scholars of Arneside* she condemned the "revolutionary" tone of the illegal press. Although she had welcomed repeal of the stamp in 1836, she had not objected to the retention of a one-penny tax despite the principle involved. As she explained in the *History of the Peace*, the remaining duty made the risk of illegality too great at the price and as a consequence "a vast quantity of trash" had been driven off the market (*History of the Peace*, 2:327). She utterly failed to appreciate the political importance of the War of the Unstamped, and did not connect the leadership in the early newspaper struggle with that of Chartism a few years later.

If she did not always applaud their methods, Martineau had approved the aims of the Chartists and had supported their struggle for a voice in the nation's council. Yet when the final chapters were written in the 1864 American edition of the *History of the Peace*, and Chartism had died without achieving its aim, she did not seek to analyze its failure. Her original sympathy for its democratic goals had faded because her democratic zeal had waned. Events abroad—particularly in France where Louis Napoleon had usurped a throne despite the trappings of democracy—seemed to offer proof that universal suffrage was "no security for liberty." She had become reconciled to the idea of gradualism: "The proposal now," she wrote in *History from the Commencement*, "is for an expansion of the suffrages, gradual, and in some fair proportion to the improving intelligence of the people."[27]

In the *History of the Peace* Martineau upheld the franchise claims of artisans, operatives, Dissenters, and Jews, but on behalf of her own unrepresented sex she remained silent.[28] Her private feelings on the subject were unequivocal but the question of the enfranchisement of women was barely raised in 1832. Possibly because it had received no attention at the time—Mary Smith's petition on behalf of women's political rights was ignored during the Reform Bill de-

bates—it could not, perhaps, in all historical conscience have been included in the *History of the Peace*. Nevertheless, the question was one that deeply troubled her. It was the one aspect of James Mill's democratic theory with which she emphatically disagreed. Women, she had written in *Society in America*, could *not* be represented by their fathers or their husbands—"no person's interests can be, or can be ascertained to be, identical with those of another person"(1:202). The fact that she herself was a taxpayer and responsible citizen with no vote at elections she considered "an absurdity, seeing that I have for a long course of years influenced public affairs to an extent not professed or attempted by many men" (*Autobiography*, 1:402). Yet these sentiments found no echo in the *History of the Peace*. The ideal of female enfranchisement was not popularly admitted: it was a concept whose time had not yet arrived.[29]

After the Reform Act of 1832, the Poor Law Amendment Act of 1834 and the Municipal Corporations Act of 1835, the Whig-Radical alliance had seemingly dissolved. Instead of continuing to operate on principles, Martineau observed, they had each become entrenched in their own political camps. The word "reform" had become mere cant, and the Whigs had become as conservative as their predecessors in government had been. It appeared to Harriet Martineau that they had conveniently forgotten their earlier ideals; had shelved the liberal policies espoused during their long years in exile from office; and, after their assumption to power, had become as intransigent as the Tories before them had been. Martineau particularly considered Prime Minister Melbourne "out of his place as the head of a Reforming Administration, from his inability to originate, and his indisposition to guide." Among the Radicals there was a growing conviction that Melbourne and his party were clinging to power for the sake of office. But the influence of the Radicals themselves had become diffused. They were, Martineau noted, unable to merge their differences and could neither "regenerate nor supersede the Whigs, nor keep out the Conservatives."[30] At this time there was a general sense of disillusionment in the Radical camp, and Martineau probably arrived at the conclusions she did through her continued association with the Philosophical Radicals. Molesworth, for example, told Harriet Grote in 1836 that the Radicals were losing their influence because of a lack of unity, and because the Whigs, now secure in their position of authority, no longer felt the same need for Radical support as before. And George Grote described the frustration of having to attend Parliament in order to sustain "Whig *Conservatism* against Tory *Conservatism*."[31]

By the time of the 1841 election Martineau had come to believe that
all hope of a Whig-Radical coalition was extinct; that the discontent
and unrest among the laboring classes was so deep that "nothing
could avert revolution sooner or later"; and that until the workers
could be politically educated, it was

> desirable to have the strongest government that can be had; the gov-
> ernment *wh.* commands most of the support of the nation. This,
> events have clearly shown to be a tory Government, which is respected
> above the Whig, not so much, perhaps, on account of its principles, as
> on account of its efficiency in business.[32]

Martineau made a note of these impressions of the 1841 political
scene in an undated manuscript which was not intended for publica-
tion. In it she expressed the view that, "Peel . . . is now full as liberal
as the Whigs were when they came in, and more so than the three
tories of their company, Melbourne, Palemerston and Glenelg." She
accurately predicted that the strong Tories would separate from Peel
"and form an angry and helpless, but rather mischievous party." She
anticipated with some optimism a regrouping of politicians "on a
fresh set of principles," and looked upon the period as a "troublous
passage to better times."[33] But in spite of her confidence in Peel as
an administrator, Martineau's faith still rested in principles rather
than in men. In *Life in the Sick-Room* she wrote of

> the present operation of old liberalizing causes so strong as to be
> irresistible; men of all parties—or, at least, reasonable men of all
> parties—so carried along by the current of events . . . [that] glorious
> as would be the advent of a great political hero at any time, we could
> never better get on without one, because never before were principles
> so clearly and strongly compelling their own adoption, and working
> out their own results. They are now the masters and not the servants
> of Statesmen. [Pp. 74–75]

In the *History of the Peace* she interpreted the period according to this
necessarian concept, and instead of condemning Peel for inconsis-
tency as Disraeli did, she praised him for having the integrity to
discard worn-out opinions and for being able to accept the principle
of reform. It was this trait in Peel, a national desire to oust the
tenacious Whigs from office, and the fact that the Conservatives had
been "more attentive to registration" which accounted, in her opin-

ion, for Peel's return to Parliament with a majority of seventy-six after the election of 1841.[34]

By 1846 Martineau's friends could with justice describe her as "a sort of Peelite." Peel appeared to her to be "a statesman precisely adapted to his age;—to serve his country and his time." Her appreciation was doubtless not a little influenced by the fact that in accommodating to the times, Peel adopted those antiprotectionist principles which Martineau and the political economists held dear.[35] The Corn Laws symbolized this protection; they were the central issue of the period and their repeal was the climax of a quarter century of agitation. The question of protection was pivotal in the *History of the Peace*, and Martineau perceived it as such when she reissued the work in its expanded American edition of 1864. "Something may be learned," she said, writing to American readers not only in the throes of civil war but also a prolonged tariff debate, "of the consequences within the period of this History. It will be seen that a new vigor was infused into the whole life of society from the hour when the Protectionist system was relaxed, with or without reciprocity abroad."[36]

Martineau ascribed British prosperity in the 1860s to free trade in general and to repeal of the Corn Laws in particular. The prosperity, as we know, was temporary and the initial apparent effect of repeal was misleading. In the first twenty years after repeal of the Corn Laws, the pattern of English corn production did not materially alter. The English farmer continued to be his nations's chief provider and there was no marked difference in the scale of corn importation. The full effect of Corn Law repeal was not felt until the 1870s when large-scale cheap American grain hit the British market. But in the initial years it appeared that both the agricultural and the manufacturing sectors were reaping benefits from the now liberalized trade laws, and that Adam Smith's identity of interests theory had been proven. To Martineau, mid-century prosperity not only vindicated the hypothesis that there was "unity of interests between the agricultural and the manufacturing populations," but it also seemed to cast doubt on the pessimistic predictions of Thomas Malthus.[37]

> The repeal of the Corn Laws, with the consequent improvement in agriculture, and the prodigious increase in emigration have extinguished all present apprehension and talk of "surplus population"— that great difficulty of forty or fifty years ago. And it should be remembered, as far as I am concerned in the controversy that I advo-

cated . . . a free trade in corn, and exhibited the certainty of agricul-
tural improvement, as a consequence; and urged carefully conducted
emigration; and, above all, education without limit. It was my business
in illustrating Political Economy [abdicating her earlier espousal of
Malthusian doctrine], to exemplify Malthus's doctrine among the rest.
[*Autobiography*, 1:210]

Though the repeal of the Corn Laws did not immediately alter the
complexion of the English corn market, it had an effect on British
trade in general. The process began with the simplification of the
tariff system in 1842. In 1849 the last of the old Navigation Laws was
repealed, and by the 1860s Peel's successors on the Treasury Bench
had initiated free trade reciprocity with other countries. It was the
relaxation of the old protective system in conjunction with other fac-
tors, however, which accounted for the prosperity of the middle de-
cades of the century. British industrial productivity grew while at the
same time overseas industrialization and expansion enlarged the mar-
ket for British goods. There were, in the late 1840s, rich discoveries of
gold in Australia and the United States which acted as a stimulus to
international trade. There were increased British investments abroad.
There was rapid construction of railways, a fiercely competitive con-
struction of steamships, and a resultant decrease in freight rates. But
although apparent in retrospect, these factors were not at all obvious
to Martineau or her contemporaries, and those who had fought the
Corn Laws and the Navigation Laws appeared to have been vindi-
cated by the succeeding prosperity.

Besides Martineau's literary contributions to the repeal agitation,
and in addition to her efforts for the Anti–Corn Law League after
its formation in 1838, she had in her own private capacity played a
crucial part in reconciling personal differences between Robert Peel
and Richard Cobden. In the *History of the Peace* she praised both the
minister and the Leaguer for their parts in the removal of the re-
strictive legislation against which she had campaigned so long.[38] Sir
Robert's biographer, Norman Gash, believes that "Peel's conversion
to free trade in corn was a matter of conviction rather than an act of
concession."[39] Martineau would have agreed. She was of the firm
opinion that it had been principle rather than expediency which had
persuaded Peel. Peel himself did not consider his adoption of free
trade principles in the light of a betrayal of conservative ideals, and
Martineau quoted him to support this argument.

I cannot charge myself [Peel had said] or my colleagues with having
been unfaithful to the trust committed to us. . . . If I look to the

prerogatives of the Crown—if I look to the position of the Church—if I look to the influence of the aristocracy—I cannot charge myself with having taken any course inconsistent with Conservative principles. [*History of the Peace*, 2:684]

But to Young England and the other protectionists in the party, Peel's action was the culmination of a treachery which had had its beginnings in the 1835 Tamworth Manifesto. Peel passed the Corn Law amendment with the help of the Whigs and Radicals, but with Disraeli and two-thirds of the Tories in opposition.

Disraeli and his small elitist Young England party in Parliament were associated with all that laissez faire opposed. Young England was predicated upon what Martineau considered the

impracticable notion of restoring old conditions of protection and dependence, when the one essential thing that is now necessary for the working classes to understand is, that (food and labour being released from legal restriction) their condition is in their own hands. . . . The idea of the Young England party, in regard to the condition of the people, was that all would be well if the ancient relation between the rich and the poor could be restored—if the rich could, as formerly, take charge of the poor with a protecting benevolence, and the poor depend upon the rich in a spirit of trust and obedience. . . . This was amiable and well-intended; but it did not avail in the face of the stern truth that the great natural laws of society have dissolved the old relations between the endowed and the working classes. . . . The theory of society now is that the labouring classes are as independent as any others; that their labour is their own disposable property. [*History of the Peace*, 2:519–20]

Martineau had no doubt that the days of feudal paternalism, the days of "rural innocence," were past and that they would "give place to something better, no doubt, when the troubled stage of transition is passed."[40] This had been her conviction when she wrote the *Illustrations*; it remained her creed when she wrote the *History of the Peace*. She was as sternly opposed to factory legislation, for example, as she had ever been, and she still insisted that the worker had the right to trade in the only commodity he possessed: his labor. Nevertheless, the Harriet Martineau of the *History of the Peace* had mellowed. No longer quite as dogmatic as in the past, she was prepared to make important allowances.

There were men of opposite extremes in politics, who contended that it was the duty of government to regulate the interests of the poor, and determine the circumstance of their lives by law. Some high Conservatives contended for this on the ground of the supposed parental character of government. . . . With these high Conservatives were joined those members of the Commons who verged most towards democracy—who claimed a special protection for the poor from government because the poor were unrepresented in the legislature . . . while men of intermediate parties advocated the poor man's cause in a directly opposite manner; by contending that his labour is his only property; and that to interfere with it—to restrict its sale by law—is to infringe fatally on the poor man's rights. —The truth was (and it is the truth still) *there is much to be said on both sides. . . . It is impossible to admit that, under a representative system it is the proper business of government to regulate the private interests of any class whatever. It is impossible under the far higher constitution of humanity, to refuse attention to the case of the depressed, ignorant, and suffering, of our people. The only course seems to be to admit that, as we have not been true to our representative system (being at this day far from having carried it out), we cannot be harshly true to its theory. Having permitted a special misery and need to grow up, we must meet it with a special solace and aid . . .* [although] *nothing must be done to impair any one's right . . . under the constitution which presumes every man's condition and interests to be in his own hands.* [*History of the Peace*, 2:551–52; emphasis added]

Martineau never satisfactorily resolved this dilemma. In fact, she almost managed to bypass it by compartmentalizing societal problems into those which were the legitimate concern of government, and those which she continued emphatically to insist were not.

Martineau remained opposed to the principle of factory regulation, and impatient of Lord Ashley's perseverance on behalf of the operatives. In the *History of the Peace* she treated Ashley without pretending to objectivity. She conceded his humanitarian intentions but she clearly considered him misled and uninformed. He should, she believed, have devoted his benevolent efforts to the agricultural laborers on his ancestral estates and not to the operatives who were "the class which was actually the most enlightened, and best able to take care of itself, of any working-class in England." It was a claim not entirely unjustified for in the nineteenth century the factory workers were on the whole relatively better off than the domestic and rural members of their own class. But Martineau's observation was made without the benefit of economic analysis: it was a conclusion arrived at rather because of her personal bias than because of her research, and its intention was to invalidate Ashley's effort. She

regarded Ashley as a meddlesome Tory philanthropist who pro-
tected corn, restricted trade, and then sought to deprive "hungry
people of their only wealth—their labour." It was a formula which
she never tired of repeating. Yet even here, Harriet Martineau was
prepared to allow the exception: she could not gainsay Ashley's ef-
forts in 1842 on behalf of women and children who were being
brutally exploited in the mines. She was so genuinely shocked by the
details exposed by the Ashley Commission of Inquiry, that she
willingly conceded that in extreme cases it was better to legislate than
to permit the perpetuation of deplorable conditions such as those
existing in the collieries.[41] Although she continued to oppose efforts
to limit the hours of female and child labor in factories, she was
prepared to tolerate government intervention even here when, as in
the case of Graham's 1843 Factory Bill, education was involved.

> The voluntary principle is inapplicable to education because it is pre-
> cisely those who need education most that are least capable of de-
> manding it, desiring, and even conceiving it.[42]

Firmly believing that the "clergy of all denominations"—to whose
hands for the most part education was entrusted—were "least aware
of what education should be," she roundly condemned the narrow
sectarian motives of those who successfully opposed the bill. She was
especially critical of the Dissenters, for although she held no brief
with the Church of England, she thought it infinitely better for
"these multitudes to be Puseyites than heathens," and she castigated
the Dissenters whose selfish opposition to the bill "removed thou-
sands of children beyond the reach of education, and thus consigned
them to risks and injury immeasurably more fatal than any kind or
degree of religious error could possibly have been."[43]

Martineau succeeded in rationalizing all the exceptions which she
made to laissez faire. But the inconsistency which her dilemma
pointed up was the inconsistency and the dilemma of the age. Her
sometimes erratic deviations from the principle of laissez faire ex-
emplify the ambiguities of an era poised between the need for
administrative initiative and the desire for individual freedom and
responsibility. Jeremy Bentham, James Mill, and Edwin Chadwick
had understood the incompatibility between laissez faire and good
government, and for them the benefits of efficient administration
had superseded considerations of individual liberty. John Stuart
Mill was to come to similar conclusions. And Carlyle was not far
from the truth when he said that "the principle of *Let-alone* is no

longer possible in England these days." The Ten Hours Act, after all, was passed within a year of the repeal of the Corn Laws.

The increase of governmental responsibility notwithstanding, Victorians continued to pay extravagant lip service to laissez faire, self-help, and the work ethic, and Martineau, true to her creed, continued to believe implicitly in these dogmas: the rights of individuals to control their lives and their livelihoods were sacred concepts to her. Nevertheless she was too honest to be blind to the realities and she denounced those who claimed that "every man" had the opportunity to achieve independence and honor.

> What?—every man?—he whose early years are spent in opening and shutting a door in a coal pit; who does not know his own name, and never heard of God?—or any one of thousands of handloom weavers, who swallow opium on Saturday nights, to deaden the pains of hunger on Sundays?—or the Dorsetshire labourer, whose only prospect is that his eight shillings a week may be reduced to seven, and the seven to six, but never that his wages may rise? [*History of the Peace*, 2:31]

She had a deep well of sympathy for the less fortunate members of society and some of the contradictions in her philosophy can be accounted for by this fact. While reason dictated the principles of natural law and laissez faire, conscience addressed itself to the stark reality of the condition of England question. Her reason informed her that present charities and present ameliorations were but delays to overall recovery which perpetuated an outworn system and prevented the development of a new one. But she could always find a reason to justify the exception: the women and children in mines, the starving needlewomen thrown out of work by the invention of the sewing machine in the 1850s, and the Lancastrian operatives forced to remain idle in the 1860s.

The persistent question of Ireland punctuated the pages of the *History of the Peace* in much the same way as did the troubled refrain of the English working people. Ireland was not a problem which Martineau could neatly pigeonhole into a separate compartment like India, or Canada, or foreign affairs, or some of the other events of the period which she included within the scope of her narrative. Ireland gnawed the very vitals of English political, social, and economic life and Martineau, recognizing this fact, interwove the Irish story into the fabric of the *History of the Peace*.

The Irish question was not new to Martineau; she had first written about it in *Ireland*, one of the most effective tales in the *Political Economy* series. She had recognized even then that Ireland's problem was chiefly agrarian and she had perceived Irish peasants as the victims of selfish land policies, of misgovernment, of overpopulation, and of a church to which they did not belong but by which they were taxed. Writing in the 1830s, she had placed the blame for Irish unrest where she felt it belonged, on the economic condition of the country.

When do prosperous men plot, or contented men threaten, or those who are secure perjure themselves, or the well-governed think of treachery? Who believes that conspiracy was born in our schools instead of our cold hearths, or that violence is natural to any hands but those from which their occupation and their subsistence are wrenched together?[44]

Martineau first became aware of the Irish problem in 1831 when she visited James and Helen Martineau during the former's Dublin ministry. On her journey in the United States, where she encountered the lingering rancor of expatriate Irishmen, she became even more keenly aware of the problem. Conceding the improbability of anyone successfully undoing "the wrongs and woes of centuries, and the unreasonableness of a nation," she told Milnes in 1844:

If I had the glorious misfortune to be responsible for Irish destinies now, I believe I shd. first go faithfully through this landlord and tenant matter, and stand or fall by the remedial measures to be founded upon it. I wd. recognize the Papal Govt., help to educate the catholic clergy, exchange Judges occasionally, abolish the vice-royalty, largely modify the Poor Law, or exchange it for another system, and set about internal improvements.[45]

In the *History of the Peace* she traced the effect of Ireland on English politics and the effect of English policies on Ireland. She realized the enormous political importance of Ireland: that almost every ministry from that of Lord Grey in 1834 to that of Robert Peel in 1846 had resigned because of the Irish question; and that the issue of Irish representation had triggered Catholic emancipation, eroded the Tory Government's traditional support, and opened the floodgates to reform. Citing the litany of the debates over appropriations, disestablishment of the Church of England in Ireland, and Maynooth, she blamed a recalcitrant and prejudiced majority in Parliament for re-

fusing to realize that the Church of Ireland was the Church of Rome and not the "abstraction called the Church" which she accused of taxing without educating an ignorant and impoverished people. She was gravely aware, however, that beneath the political and religious issues lay the chief problem in Ireland: the economic question which had all but been ignored (*History of the Peace*, 2:106, 229, 232–33).

While admiring O'Connell's role in the struggle for Catholic emancipation, Martineau never really trusted his motives. She was opposed to his campaign for the repeal of Ireland's union with England; for even while admitting English culpability in the Irish tragedy, she was convinced that without the English connection poverty-ridden Ireland could not survive. In the *History of the Peace*, Martineau alternately called O'Connell the "Liberator" and the "Agitator," depending on whether she was writing about Catholic emancipation or repeal, and accused him of directing Irish energies toward the ephemeral question of independence rather than toward solving the more vital—as she saw them—problems of land tenure, evictions, taxation, and overpopulation. In an agricultural nation where the majority of the people had no security of tenure, where the soil was worn out, where half the eight million inhabitants depended solely upon the potato and where the land was unimproved and over-cultivated, the remedy, she believed, lay in land reclamation, in emigration, in the education of the people, and not in the irrelevant question of dissolving the union with England.

> Mr. O'Connell never meant that Ireland should be tranquilized; and . . . if he had wished for tranquilization ever so earnestly, he could not have effected it. A sudden change in the law could not make a permanent change in the temper of the nation;—even of a nation which knew how to reverence law. [*History of the Peace*, 2:504–5]

To ferment distrust for the law in such a nation as Ireland was to provoke violence, and this she believed O'Connell had deliberately set out to do. His successful campaign to achieve Catholic emancipation had not, therefore, led to peace and progress, but to continued evasion of the law and a seemingly unending political unrest.[46]

The vital question in Ireland, Martineau believed, was the land's chronic pauperism and not its union with England. In spite of her support for the amended Poor Law in England, however, she was uncertain about the merits of extending the new Poor Law to Ireland though English sentiment appeared to be in favor of doing so. She doubted that the English system would work

across the Irish Sea where the proportion of paupers was twice that of England and where the proportionate maintenance fund was only a third. She keenly appreciated the problems of an agrarian, high-unemployment society in which demographic and seasonal factors made some form of outdoor relief imperative. She realized that in a land where there was little alternative to peasant cultivation, the new Poor Law might be impractical. Notwithstanding substantial protests by most political economists, however, the Irish Poor Law Bill had been carried in 1838, and the machinery of the English Poor Law had been put into effect: unions and workhouses were established, and outdoor relief was curtailed. Martineau did not believe that such measures could successfully solve what was an underlying social and demographic problem. Effectual renovation, she said later in retrospect, was not in fact possible, "till a higher power than lies in human hands had cleared the way in a manner which it makes the stoutest heart tremble merely to contemplate. It is because this has happened— because the wide sweep of misery has left it clear that the maladies of Ireland are social, and not political."[47]

Martineau was sufficiently Malthusian to have seen in the Potato Famine something besides human tragedy. She had always stressed overpopulation as Ireland's chief problem, and that which compounded all the others. And when the economic condition of Ireland improved in the 1850s she was able to say that, "We are obtaining 'by the hand of God' the very conditions we have been longing for for a century."[48] It was not that she was devoid of compassion; she described the horror of the Famine and of the dysentery which came as its aftermath with great humanity when she wrote of it in the *History from the Commencement of the XIXth Century* and in the *Daily News*. But she saw in the Famine's decimation, and in the wave of emigration which followed it, an opportunity for resolving at last the problem of overpopulation which had been, she thought, at the base of Ireland's trouble. Ireland was not yet prosperous, she conceded in *History from the Commencement*; its people were still poor and ill-fed; but with a smaller population, with improvements in agricultural practice, and with a diversification of its economy by the introduction of manufactories, conditions were improving and "the growth of comfort and welfare was such as to rebuke the old prevalent despair of Ireland." She foresaw a happy conclusion to the Irish story, and completely ignored the emotional factors which centuries of subservience were bringing to the surface. She discounted entirely the claims of the Irish nationalists, and described them as "a small

and passionate deluded faction" which aimed to reject Ireland's one means of recovery, her alliance with England.[49]

The author of the *Illustrations of Political Economy* is only occasionally recognizable in the *History of the Peace*. Much of the dogmatism and the pedantry evident in the earlier work had given way to doubt, and much of the irrepressible optimism had been tempered by time and disappointment. Martineau had lost her certitude. She no longer felt sure that she knew the prescription for the greatest happiness but she still believed in the principle.

> "The greatest happiness of the greatest number" is not now talked of as the profession of a school: but the idea is in the mind of politicians and shapes their aims. The truest welfare of the largest classes has been the plea for much of our legislation; and especially for the whole grand achievement of free trade. No statesman would now dream of conducting the government on any other avowed principle than consulting the welfare of the greatest number in preference to that of any smaller class. [*History of the Peace*, 2:715]

She was still a laissez fairist but she had come to realize that there were many areas which fell into the public rather than the private sphere. Perhaps the most significant passage in this regard is in *History from the Commencement*:

> Marked advances were made in kindly legislation, meeting with no other opposition than grew out of a wholesome dread of interfering with private arrangements and personal morality by Act of Parliament. No free Legislature in the world has yet ascertained—much less observed—the proper functions and limits of State action and control; and, in England, there is no point of political philosophy on which further enlightenment and agreement are more urgently required at this hour. [4:577]

She had always supported government control of education and public health. When the railways appeared to be developing into an ominous new source of concentrated power she advocated a large measure of legislative control there too. And, in spite of her original opposition to the Ashleys and Fieldens in earlier years, she was, by the time she wrote the concluding portion of the *History of the Peace* for her American publishers, willing to concede the benefits of the

Ten Hours Act, and of the limitations set on the labor of women and children. She had not completely lost faith in the basic humanity of the employer or in the principle of worker independence, but, as always, she was able to rationalize her deviation from earlier dogmatisms. Workers, and especially women and children, she felt, "had to be protected, not so much from the hardness of employers, as from the rapacity of husbands and fathers, and the tyranny of fellow-workmen [in the unions]." Her opposition to factory legislation had been too long and too consistently maintained for her to make an about-face without offering new and compelling reasons, and, as usual, ignoring the ambiguity of her position.[50]

Martineau still believed in educating the people rather than in legislating for them, but she had learned to accept legislation, at least as an interim measure, until the condition of society made such legislation no longer necessary. She still believed in the inevitability of revolutionary political change, but she was not certain what forms these new governmental structures would take, and she was not sure how much they should govern. She regarded socialism and communism as symptoms of societal problems, not as solutions for them. But her opposition to Owenite paternalism had yielded by mid-century to a pragmatic acceptance of "the devices of domestic socialism" which "supplied the necessaries and comforts of life, on a principle independent of alms-giving, to those who could enjoy them only by means of the economy of Association." She confided privately that "we in England cannot now stop short of 'a modified communism.' " But she did not try to predict the forms which the society of the future would take, and she remained moderately optimistic that this society would be a happier one than any which had preceded it.

The material for working out a better state is before us. . . . We have science brightening around us, which may teach us to increase infinitely our supply of food. We have labourers everywhere who are as capable as any men above them of domestic solicitude, and who will not be more reckless about a provision for their families than gentlemen are, when once the natural affections of the citizen-parent are allowed free scope. We have now (by the recent repeal of the remnant of the Navigation Laws) complete liberty of commerce. We have now the best heads and hearts occupied about this great question of the Rights of Labour, with impressive warnings presented to us from abroad, that it cannot be neglected under a lighter penalty than ruin to all. Is it possible that the solution should not be found? This solution may probably be the central fact of the next period of British

history; and then, better than now, it may be seen that in preparation
for it lies the chief interest of the preceding Thirty Years' Peace.[51]

When she came to write the *History from the Commencement* a decade
and a half later, she chose to conclude the final volume with the
same cautionary paragraphs which had ended the earlier work.
"The tremendous labor question," she reiterated, "remains abso-
lutely untouched." She remained as dubious about the true extent of
Britain's progress in this area as she had been previously although
the reasons for her fear had shifted. In the preface to the American
edition she described the condition of British labor as improved and
improving but cautioned:

> The ground of fear is that popular liberty is overborne by the Trades
> Unions of our days. It seems to be so in every country where such
> combinations can take place; and the anxious questions are the same
> in all such cases; the questions how to protect the liberties of individ-
> ual workers against the dictation and tyranny of leaders and pre-
> tenders of their own class; and what are the chances of the class
> becoming informed and enlightened in regard to their legal and con-
> stitutional liberties in time to check the spirit of despotism in the few,
> and animate that of peaceful resistance to oppression in the many. At
> present, the Trades Unions of the United Kingdom are its greatest
> apparent danger.[52]

Martineau's *History of the Peace* is as valuable for its commentary
on Martineau as for its comments on her era. The style is occasion-
ally brilliant, the essential historical facts are sound, and Martineau's
contemporaneity has, perhaps, even more significance today than it
had in her own time. *The History of England during the Thirty Years'
Peace* ought not to be the neglected work it is. It should be con-
sidered a valuable resource for the modern historian of nineteenth-
century Britain, and its intrinsic merits ought to be much more
widely appreciated. It is not simply a dated historical narrative which
has been superseded by more recent and sophisticated scholarship.
Martineau's observations were astute, her research was careful, and
her opinions and even her prejudices were informed and are infor-
mative. The *History of the Peace* has stood the test of time and can still
be read with interest and profit a hundred years after its conception.

A Free Rover on the Broad, Bright Breezy Common of the Universe

In the middle decades of the nineteenth century religious orthodoxy came under the combined attack of science and higher criticism. Victorian dogmatism, as Walter Houghton notes in *The Victorian Frame of Mind*, was often less insistence based on certitude than an overriding wish to believe. In support of this contention Houghton quotes Harriet Martineau's admission that, in the 1840s, she was "unconsciously trying to gain strength of conviction by vigour of assertion."[1] But Martineau was able to make this admission only after she had found a new certitude and not at the time she was struggling to retain the old one. The need to express certitude, so characteristic of an age of uncertainty, was probably accentuated in Martineau by the insecurities she had experienced in childhood and by the vulnerabilities of deafness. She leapt, as it were, from one certitude to the next, seemingly without pause. She appeared not to suffer the crises of conscience which plagued so many of her contemporaries, and it was only in retrospect that she was willing to confess her religious doubts, and her own willing self-delusion. "I now feel pretty certain," she wrote in the *Autobiography*, "that I was not, even then, dealing truly with my own mind."[2]

Martineau's interpretation in the *Autobiography* of her own early religious views was of course colored by her later renunciation of those views. Her actual severance from Unitarianism did not come until the publication of *Eastern Life Present and Past* in 1848. But she claimed that she had ended her official connection with the Unitarian body and had become only a "nominal Christian"—even according to the limited Unitarian interpretation of Christianity—lingering

in "those regions of metaphysical fog in which most deserters from Unitarianism abide for the rest of their time" as early as 1831 and the completion of the three prize essays.

> I had already ceased to be an Unitarian in the technical sense. I was now one in the dreamy way of metaphysical accommodation, and on the ground of dissent from every other form of Christianity: the time was approaching when, if I called myself so at all, it was only in the free-thinking sense.[3]

The perspective and the phraseology of the *Autobiography* were those of Martineau the positivist, who perhaps dismissed her Unitarianism of the seventeen-year period from 1831 to 1848 a little too readily. For to outward appearances at least, the Harriet Martineau of that time had remained faithful to the creed. She dutifully attended chapel, she enjoyed reading the gospels, and she enjoyed the respect of her coreligionists for her contributions to Unitarian literature. She had of course been acclaimed by the entire sect for the three prize essays; the originally anonymous *Devotional Exercises* (1823) was reprinted under her name several times; *Traditions of Palestine* (1830) went into its third edition in 1843; and she was widely known for her articles and reviews in the *Monthly Repository* which in 1836 were republished in America in the two-volume *Miscellanies*. But after 1832 Martineau made no new major contributions to religious literature. The conventional piety expressed in *Life in the Sick-Room* and in the *Playfellow* series reflected outer conformity rather than inner faith, for by the 1840s she had surrendered most of the appurtenances of Unitarianism. She still retained a basic belief in God, revelation, and the afterlife, but the mainspring of her spiritual strength now came from her necessarianism.[4] According to Henry Crabb Robinson, she was

> . . . sustained by a very strong religious faith. I know of no orthodox sufferer who seems to be more intensely convinced of the truth of ordinary doctrines . . . than Miss M: is of her scheme of religious hope as developed by Priestley and Channing.[5]

Faith had been Harriet Martineau's earliest refuge and her chief support in the frightening days of her lonely childhood. In young adulthood she had believed that "Faith, however blind, and religious hope, however vague, afford a sufficient support to the mind under any affliction." Her achievement of personal independence had less-

ened her need to believe, but she had clung to the remnants of her faith, and in *Life in the Sick-Room*, written in 1843 when she thought herself to be dying, she still spoke of a dependence on God, "the Maker of our frame and the Ordainer of our lot." Even after her conversion from her old faith, Martineau conceded that the sentiments she had expressed in the sickroom essays had truly reflected her state of mind at that time.

> I can only now say that I am ashamed, considering my years and experience of suffering, that my state of mind was so crude, if not morbid, as I now see it to have been. . . . The fact is, as I now see, that I was lingering in the metaphysical stage of mind, because I was not perfectly emancipated from the *debris* of the theological. The day of final release was drawing nigh . . . but I had not yet ascertained my position. I had quitted the old untenable point of view, and had not yet found the one on which I was soon to take my stand. And, while attesting to the truth of the book on the whole,—its truth as a reflexion of my mind at that date,—I still can hardly reconcile with sincerity the religious remains that are found in it.[6]

She described the period of her Tynemouth confinement as one of "transition from religious inconsistency and irrationality to free-thinking." And it was, perhaps, "religious inconsistency" rather than witting hypocrisy which accounted for the seemingly calculated piety of the *Playfellow* stories. Nevertheless, it is a little difficult to avoid the suspicion that in the *Playfellow* stories, much more than in *Life in the Sick-Room*, Harriet Martineau was less than honest. Her fictional children appear to have been the offspring not of her Hartleyan philosophy but rather of her need to write in a genre which anxious parents of young readers would find acceptable. The piety of her children was therefore not a Wordsworthian "natural piety" nurtured by experience, but a formal piety bred by an orthodox faith in stern pews and dismal chapels. In *The Crofton Boys* and *Settlers at Home*, for example, she went so far as to write conventionally about children at prayer, although as a necessarian she had long since been persuaded of the irrationality of prayer: of the pointlessness of beseeching God for an intervention which in necessarian terms was impossible of achievement. Indeed, in 1842, at the very time she was writing the *Playfellow* stories, she confessed to James a conviction of "the predominance of unreality in the orthodox Christianity." But perhaps too much should not be read into this statement, for Martineau's Unitarianism was never "orthodox Christianity," and the ideological rift which was to separate her from her brother and

others of the Unitarian faith had not yet become evident. Those who knew her in the thirties and forties saw, as Maria Weston Chapman did, "no discordance between herself and our Unitarians generally on the subject of a First Cause other than the approximation to the Orthodox world occasioned by her Necessarianism."[7]

Mrs. Chapman, however, underestimated the divisiveness of necessarianism. Most Unitarians were not necessarian and in fact feared the mechanistic, impersonal, and reductionist tendencies of the necessarian philosophy. There were, in the nineteenth century, three quite distinct divisions among Unitarians: necessarians who looked to Priestley and the inevitability of natural law; conservative Unitarians who relied almost wholly on the scriptures for their inspiration; and, particularly after the third decade of the century, those Unitarians who rejected both materialism and fundamentalism, and took their philosophy from the German Romantics who perceived religion to be an "individual experience of God": a "divine consciousness" which was not assailable by either higher criticism or science because it was related to neither the scriptures nor the philosophy of the Enlightenment. To those for whom religion was a personal revelation faith could not be diminished by the proven fallibilities of the Bible, and the discoveries of science served only to increase their wonder of God.

Gotthold Ephraim Lessing (1729–81) is commonly recognized as the first of the notable German Romantics. He interpreted religion as a personal belief, a personal experience, and a personal revelation: " . . . the fact of revelation which speaks directly and with certainty to us ourselves, to our hearts. It is something, that is, which is capable of being felt and experienced."[8] Lessing's philosophy was popularized in Europe primarily by his disciple Immanuel Kant (1724–1804), and in England by Samuel Taylor Coleridge. Formerly a Unitarian and a necessarian, Coleridge came to reject necessarianism as the antithesis of faith. It led, he said, inevitably to unbelief because it abstracted and depersonalized God, and because it was predicated upon causation and the passiveness of the mind.

> If the mind be not *passive*, if it be indeed made in God's image, and that too in the sublimest sense—the Image of the *Creator*—there is ground for suspicion, that any system built on the passiveness of the mind must be false, as a system.[9]

Coleridge's rejection of materialism for spiritualism, his abandonment of necessity, his endorsement of free will, his emphasis on

individual reason, and his emergence from what he called his "*religious Twilight*," had as we know strong echoes among both Churchmen and Dissenters. Among the English Unitarians James Martineau became something of a high priest to the Romantic cult of individualized religious experience. Like Coleridge, he came to abandon necessarianism—if not Unitarianism—and by 1839 he had renounced Hartleyan ethics and had aligned himself with the proponents of free will and the individual reason. He now rejected the conception of man as the effectual object of inevitable natural laws and came instead to believe in man as the measure of all things. Although it had been James who first introduced Harriet to the logic of necessity, his doubts had been growing over a long period of years, and as early as 1833 he had intimated an increasing detachment from the necessarian school in a *Monthly Repository* essay, "On the Life, Character, and Works of Dr. Priestley."[10] He now sought "a more living spirit breathed into the outward forms of religion," and looked to "emancipated Germany" for an escape from the sterility of his dessicated faith.

> There if anywhere, will be exhibited that truly sublime state of mind, faith,—absolute faith,—in truth: and the great problem will be solved, how to combine the freest intellect with the loftiest devotion;—and while inquiring always, to love and worship still.[11]

In 1842 James severed his final links with necessarian theory. He now affirmed the efficacy of prayer and admitted that the supernatural had "power over the natural element in man." In 1848 and 1849 he went on a study tour of Germany, and later, in "Restoration of Belief," published in the *Westminster Review* in 1852—the year after his sister's renunciation of theism in *Letters on the Laws of Man's Nature and Development*—he declared that

> Religion, in its ultimate essence, is a sentiment of Reverence for a Higher than ourselves. . . . Reverence can attach itself exclusively to a *person*; it cannot direct itself on what is *im*personal. . . . All the sentiments characteristic of religion presuppose a Personal Object, and assert their power only where manhood is the type of Godhead.[12]

Because James had found himself unable to pursue the necessarian path to its mechanistic conclusions, and because he saw that he was being led away from theism, he retreated to the refuge of the personal religion of German Romantic philosophy.

Meanwhile Harriet, without relinquishing her hold on necessarian principles, had "lingered" for a time in the "metaphysical fog" of Romanticism before, in the end, rejecting the philosophy of Lessing and Kant and ultimately the last remnants of her orthodoxy: revelation, the afterlife, and an anthropomorphic deity. Harriet Martineau's belief in revelation and the resurrection, though necessary to her philosophy as a Christian, had always been hedged about by so many illogical contradictions (see chap. 2) that it is not difficult to see how she eventually came to reject them. But her belief in God had seemingly been based on the firm foundation of her personal conviction. Her God was not the omniscient deity of Judaic and Christian tradition, but a necessarian God constrained by the laws of nature. Nevertheless He was implicitly "an object of faith rather than of knowledge," and she had perceived Him in personal, Romantic terms as impregnable against higher criticism and unassailable by science: for the Scriptures were not the literal word of God, and science was the complement of faith.

> Place man on this globe with a perfect frame, and full of unperverted intelligence—what will he wish to learn? He will seek to know how he came there; and this discovered, for what purpose, and under what law. His most direct path to the first aim of his inquiries may be physical research; but he is not satisfied with it, till it leads him to the point he seeks. He may reach his theology by means of physical inquiry; but it is theology which is his aim. . . . He explores the past and the actual state of nature, and especially of man, and his inquiries again lead him back to the Fount of Being. . . . He studies for the sake of Him who made all; or, in other words, *he enriches his theology with the treasures of physical science*. [Emphasis added][13]

She placed her faith in God as a divine agent and at that time utterly rejected the concepts of ultimate materialism and atheism. Her God was the personified God of Christianity, the First Cause, the Creator. And her belief in Him as all these things temporarily outlasted her belief in organized religion, and her belief in Christianity itself.

Though anticlerical, even in the early 1830s, Martineau—as the prize essays testify—supported organized religion. Unitarianism and its propagation had then been her cause. After the essays, however, she had turned away from doctrinal arguments and had sought individual communion. She was then reading Lessing and Kant and her most Romantic views found expression in some of her *Monthly Repository* articles of this time: "Sabbath Musings" in 1831 was a paean to the devotions of the solitary: "where is there a rest, where a

home, but in communion—private communion—with the Father of the spirit?"[14] She had ceased to feel the need for chapel and community worship and had begun to see them as symbolic of the corruption of faith. She was also beginning to interpret faith as something which went beyond doctrine and even beyond worship.[15]

> Religion is, in its widest sense, "the tendency of human nature to the Infinite"; and its principle is manifested in the pursuit of perfection in any direction whatever. *It is in this widest sense that some speculative atheists have been religious men;* religious in their efforts after self-perfection; though unable to personify their conception of the Infinite. *In a somewhat narrower sense, religion is the relation which the highest human sentiments bear towards an infinitely perfect Being.* [*Society in America*, 3:224–25; emphasis added]

Harriet Martineau was moving gradually toward a renunciation of Christianity.

The brother and sister who had shared a religious faith in their young adulthood, who had been inspired Unitarians and dedicated necessarians, were now traveling to the opposite extremities of their philosophy. Religious and intellectual sympathy had provided their strongest bond, but religion was now becoming the means to their irreconcilable separation. Taking different paths, each moved irresistibly toward an inevitably different conclusion. In 1848 James went to Germany and affirmed his beliefs. In the same year Harriet published *Eastern Life Present and Past* and crossed the threshold of unbelief.[16]

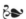

On the morning of November 20, 1846, Harriet Martineau had her first glimpse of the sandy white coast of North Africa. She and a party of friends, Mr. and Mrs. Richard V. Yates and Joseph C. Ewart, all of Liverpool, were beginning an eight month journey which was to take them to Egypt, Palestine, Syria, and Lebanon. It was winter when they began their tour, the favorite season for the numerous European and American visitors to the eastern Mediterranean. At that time of the year the temperatures were never too extreme in Egypt, rarely going above the seventies by day or dropping below forty at night. Christmas, with their Arab cook dutifully serving turkey and plum pudding, was like an English July day. But when they crossed the Sinai to Palestine and Syria after the spring

equinox the heat and the Khamsin wind combined to make the conditions barely tolerable. When it was very hot and dry, Martineau suffered from what the Victorians called the "face-ache," and she submitted to mesmeric treatment after particularly long and exhausting days on the road. Nevertheless, for one so recently an invalid, she survived the rigors of travel and the primitive conditions of desert encampments remarkably well. She rode on horseback and by donkey. She climbed to the top of the pyramids. She sat smoking a chiboque—and developed a lifelong taste for tobacco as a result—on the deck of a Nile steamer. And she traveled for endless days by camel caravan. Her journey took her up the Nile by steamer to Thebes, Nubia, the monuments of Abu-Simbel, and as far south as Wadee Halfa, where the boat almost capsized, and Karnak, where she carved her name on a rock. Her abhorrence of vandalism did not apparently extend to rocks, but she chided the tourists who wrote on monuments or stole artifacts from the sites of ancient tombs and temples; these she felt, with typical English arrogance, belonged more properly in the British Museum as they were "national property!" On the return journey to Cairo she explored the antiquities of the Nile Valley and it was then that she began to contemplate religion.

> What new and unthought of knowledge comes to one in the presence of [the] past. . . . How exceedingly limited and mistaken now appear our ordinary notions of the origen [sic], worth and tendency of our theological ideas. . . . I rode, day by day, through the glorious sterile valley which leads one among the population of the dead, feeling the same ideas and emotions *must* have been in the minds of those before whose eyes, as before mine, lay the same contrasting scenery of life and death. I do not care for, or therefore believe in, future reward and punishment as they, in their age unavoidably did: but though the interest in the unseen state has a different ground, it cannot but be of essentially the same character and strength.[17]

From Cairo the travelers followed the path the Hebrews had taken across the Sinai. They went to Jerusalem and the cities of the New Testament, to Damascus, and finally to Lebanon from which, in June, 1847, they sailed home.

The tour inspired one of the most interesting and undeservedly neglected of all Harriet Martineau's major works. *Eastern Life Present and Past*, as a portrait of the eastern Mediterranean lands and of Victorian tourism on the eve of imperialism, is probably without peer. It is impossible to conjure up in a brief paragraph the details

which Martineau brought so vibrantly to life in its pages. She succeeded, as one reviewer said, in recreating "in the minds of others the pictures which have been impressed upon her own." Her vivid images had a tactile quality. Her observant eye missed nothing either of the beauty or the harsh reality of the Middle Eastern lands and their people. She was as sensitive to the poetic magic of deserted Petra as she was to the trivial details of an Arab encampment. She listened to the "melancholy music" of the waterwheel turned by a blindfolded ox. She described the "infinity of birds" at sunset, and the "din" of the marketplace at noon. She saw the dirt, the flies, the poverty, and the blindness, but was mournfully aware that she had seen "more emaciated, and stunted, and depressed men, women and children in a single walk in England, than I observed from end to end of the land of Egypt." She was awed by the "incommunicable splendor" of the statues of Rameses at Thebes so that "nothing even in nature affected me so unspeakably." She was pleased by the natural grace of the peasants and she remarked on the lively impudence of the Arab traders. But she was utterly devastated by a visit to an Egyptian harem where the women did nothing all day but gorge themselves on sweetmeats, drink endless cups of coffee, and smoke intemperately. Her feminism was affronted by the indignity to womanhood which these pampered and mindless creatures represented. They were, in spite of the luxury of their surroundings, "the most injured human beings I have ever seen—the most studiously depressed and corrupted women whose condition I have witnessed." Almost equally shocking was the intolerance persisting among Moslem, Jew, and Christian in the Holy Land.[18]

Eastern Life conjured up the timeless atmosphere of the biblical lands, it informed the would-be tourist, and it satisfied a growing Victorian interest in exotic places. John Morley said that there were "few more delightful books of travel." But *Eastern Life* was intended as more than a book of travel: its author conceived it as a vehicle for her own religious migration. Amid the relics of ancient Egyptian beliefs, in the birthplace of "the old family of faiths," Harriet Martineau began to see Christianity within the context of all religion: as a transitional development in the evolution of religious history and as something less than the ultimate truth or the ultimate faith. Though the work made few if any important contributions to religious philosophy, though the religious theories expressed therein were neither novel nor inspired, though the conclusions were tentative and the biblical criticism unscholarly and fragmentary, and though Martineau was too poorly prepared to succeed at the larger task of

comparative religion, the three-volume work was a milestone in her own religious odyssey.

Martineau's spiritual metamorphosis took place in the vacuum of the Egyptian desert, but the germ of her conversion was rooted in the fertile soil of nineteenth-century theological dispute. Charles Hennell had challenged fundamentalist beliefs in *An Inquiry Concerning the Origin of Christianity* (1838). Charles Bray had depersonalized God according to the inevitable logic of necessarianism in *The Philosophy of Necessity* (1845). And in 1846, the year of Martineau's departure for Egypt, David Friedrich Strauss's historical analysis of the events of the Bible, *Leben Jesu* (1835–36), had been translated by Mary Ann Evans. Martineau had read Strauss. She was probably familiar with the works of Bray and of the Unitarian Hennell. In all likelihood she knew of the most significant developments in the field of higher criticism and was also fairly knowledgeable about general scientific theory. Personally acquainted with Charles Lyell, she was doubtless familiar with his seminal work, *The Principles of Geology* (1830–33). It is very possible too that she had read Robert Chambers's anonymous work, *The Vestiges of Creation* (1844). And along with most well-read Victorians she was probably familiar with the theories of evolution which were current well before the publication in 1859 of *On the Origin of Species*, which she was to greet with great enthusiasm.[19] But in spite of being well-informed, Harriet Martineau was far from accomplished as a religious thinker and she executed the philosophical aspects of *Eastern Life* without much assurance. She was in fact attempting a task which was too large for her. Her scholarship was inadequate and her method of hasty composition too incautious to comprehensively trace, as was her intention, the evolution of Christianity and Mohammedanism from Egyptian and Judaic origins.[20]

Lessing had fathered the idea of mankind's progress toward a revealed religion and a divinely ordained society, and Martineau was acquainted with his work. But she was not yet familiar with the historical perspectives of Auguste Comte, and there is no evidence to suggest that she had read Georg Friedrich Hegel with whom the idea of religious evolution is usually associated. Hegel had developed a world view of the unfolding "Spirit" of faith which he traced from the primitive magic of the natural religions to its culmination in the revelations of Christianity which he called the "Absolute Religion." Martineau's historical interpretation of Christianity, however, did not lead her to Hegelian conclusions. Her world view of religion did not lead her to an affirmation of Christianity, but rather to its nega-

tion. She came to believe that the ultimate truth and the ultimate wisdom lay not in any present creed but in mankind's future destiny, and concluded *Eastern Life* on a curiously Comtean note:

> The world and human life are, as yet, obviously very young. Human existence is, as yet, truly infantine. . . . It can hardly be but that, in its advance to maturity, new departments of strength will be developed, and the reflective and substantiating powers which characterise the Western Mind be brought into union with the Perceptive, Imaginative and Aspiring Faculty of the East, so as to originate a new order of knowledge and wisdom.[21]

Through her Egyptian experience Martineau came to believe that Judaism and Christianity owed their origins to a faith embraced by the inhabitants of the Nile Valley long before biblical creation. "The more he [the traveler] traces downwards the history and philosophy of religious worship," she wrote,

> the more astonished he will be to find to what extent this early theology originated later systems of belief and adoration. . . . Here they were, nearly two thousand years before the birth of Abraham, worshipping One Supreme God. . . . They recognised his moral government. . . . The highest objects set before these people were purity of life and rectitude of conduct. Their highest aspirations were directed to the glory and favour God in this life, and acceptance by him hereafter. Their conceptions of death were that it was a passage to an eternal existence. [*Eastern Life*, 2:85–86]

And those aspects of Christian faith which Harriet Martineau as a Unitarian had never espoused had also, she believed, been born in Egyptian legend.

> It has been a great misfortune to the . . . Christian world for many ages, that the allegories of Egypt,—the old images of miraculous birth, and the annunciation of it from heaven, should have been laid hold of . . . till at last . . . it came to be taken, with other mystic stories, for historical truth, and is to this day profanely and literally held by multitudes who should have been trained to a truer reverence. [*Eastern Life*, 3:233]

Martineau interpreted Christ's gospel to mean a recognition of God, an adherence to His moral government, a belief in the brotherhood of the human race, and the establishment of God's kingdom on earth, but she believed that encrusted upon this basic concept was

that which was "incompatible with the whole spirit of his gospel;—encumbered with a priesthood and ritual of its own, and adulterated with more or fewer of the superstitions of all the nations who ministered to the Hebrew mind."

> The old Egyptian faith deteriorated into worshipping animals; the Jewish into the Pharisaic superstitions and oppressions rebuked throughout the Gospels; and what Christianity has become, among the widest class of its professors, let the temples and congregations of the Greek and Latin churches show. [*Eastern Life*, 2:60–61]

In short, she was of the opinion that Christianity had become corrupted by the accumulated myths, fables, and superstitions which now passed for essential doctrine. The priesthood had deprived the religion of its vitality. Idolatry and bibliolatry had distorted the meaning of the faith and had substituted the symbol and the letter for the spirit, "mistaking Records of the origin of Judaism and Christianity for the messages themselves."[22]

Using the methods of higher criticism, Martineau attempted to prove the fallibility of the Hebrew and Christian records. She anticipated the arithmetical calculations of John Colenso, the Bishop of Natal, by some fifteen years when she cast doubt on the numbers and years of the biblical record. She noted the disparity between scriptural and historical accounts of Exodus, and used the recent discoveries of archaeologists and geologists to discredit Genesis.

> For our first glimpse into ancient Egyptian life we must go back upon the track of Time far further than we have been accustomed to suppose that track to extend. People who had believed all their lives that the globe and Man were created together were startled when the new science of geology revealed to them the great fact that Man is a comparatively new creation on the earth, whose oceans and swamps and jungles were aforetime inhabited by monsters never seen by human eye but in their fossil remains. People who enter Egypt with the belief that the human race has existed only six thousand years, and that at that date, the world was uninhabited by men, except within a small circuit in Asia, must undergo a somewhat similar revolution of ideas.... The differences between the dates given by legendary records and by modern research (with the help of contemporary history) are very great: but the one agrees as little as the other with the popular notion that the human race is only six thousand years old.[23]

In *Eastern Life* Martineau was groping for an elusive answer. Her religion was becoming an interpretation of universal moralities

which were not uniquely Christian, but she was not yet ready to reject Christianity for she had not yet found her new certitude. Her philosophy was as yet incompletely evolved; her methods and her purposes were unsystematically executed; and though using the tools of higher criticism and science, her technique was uncertain. *Eastern Life* added little to the arsenal of the biblical critics and little that was original to the world view of Christianity. It was primarily one woman's struggle with the awesome revelation that, beside the relics of the ancient Egyptian culture and holding many of the same verities, Christianity could claim no special divine appointment: its foundations were being undermined by geological reevaluations of the earth's age, and its spirit had been corrupted by forms and ceremonies which had for centuries replaced its essence.

Even while the philosophy and the techniques used in *Eastern Life* had been inconclusive and uncertain, Martineau's meaning had been clear. John Murray, to whom she offered the manuscript, refused to publish "a work of infidel tendency, having the obvious aim of deprecating the authority and invalidating the veracity of the Bible." Martineau was furious. She offered the rejected work to its eventual publisher, Edward Moxon, and condemned Murray's "presumption," his "immaturity," and his "censoriousness." But John Murray's personal and professional instincts proved an accurate gauge of the public's reaction to *Eastern Life*.[24] Even the hitherto loyal Henry Crabb Robinson confided in his diary:

> It is not in a book of travels that Christianity is to be attacked—and it is an attack on Christianity to imply that all miracles are untrue—that Moses derived all his philosophy from Egypt etc. These things may all be true, and no one is to blame for making them the subject of investigation, but it may be objected that these should not be smuggled into a book of travels.[25]

Most critics echoed Robinson's objections. "I should have liked it better," wrote the reviewer in *Fraser's Magazine*, "if all that Socinian trash had been extracted, to form a tit-bit for such as delight in the monstrous crudities of the dim-sighted infidel." The *British Quarterly Review* was noticeably piqued by "Miss Martineau's new and improved edition of the book of Exodus, and of the history of Moses."

> Why Miss Martineau should call herself a *Christian* at all we cannot see, for, according to her account of the matter, what Christ taught was nothing new. The doctrines which she attributes to him are actually nothing but a reproduction of what she states had already been taught

by the Essenes.... We can only express our regret, that Miss Marti-
neau should so utterly have mistaken the department best suited to
the exercise of her abilities.... if she had confined herself to the
proper object of a book of travels and not ventured beyond the sphere
of her own knowledge and experience, she might have produced a
work second to none of its class and value.[26]

But as with all her controversial decisions and publications, Marti-
neau refused to be daunted by criticism.

I am aware that very many persons,—and some who agree with me
throughout—forbid the book in their families; and that it is the policy
of the orthodox to stifle it by silence: but I have heard already quite
enough of its effects,—cheering and enlightening the minds of the
free—to make me amply satisfied that my labour is not lost.[27]

To her critics Martineau's venture into the quagmire of Victorian
theological dispute seemed precipitous and brash, but it was not
without trepidation that she had dared to publicize her newfound
convictions. She was sufficiently the journalist to have anticipated
the popular reaction to her ideas, and she was as yet more than
somewhat tentative about the philosophical foundations of these
ideas. While still at work on the manuscript of *Eastern Life* she con-
fided to Atkinson:

I am pretty confident that I am right in seeing the progression of
ideas through thousands of years,—a progression advanced by every
new form of faith (of the four great forms)—every one of these faiths
being beset by the same corruptions. But I do not know of any one
who has regarded the matter thus: and it is an awful thing to stand
alone in; for a half-learned person at least.... I could not if I tried,
communicate to any one the *feeling* that I have that the theological
belief of almost every body in the civilized world is baseless. The very
statement between you and me looks startling in its presumption. And
if I could, I dare not, till I have more assurance than I have now that
my faith is enough for my own self-government and support. I know,
as well as I ever knew any thing, that for support I really need nothing
else than a steady desire to learn the truth and abide by it ... but it
will require a long process of proof before I can be sure that these
convictions will avail me, under pressure, instead of those by which I
have lived all my life.[28]

Martineau's world had always been a Christian world, albeit a Unitarian-Christian world. She had felt secure even in her dissent for she had been supported by a consensus of other Dissenters. But now she was risking the ostracism which was certain to accompany her new declaration of unbelief. Of all her friends, only George Henry Atkinson shared her religious skepticism, and it was he who was to provide a bridge across the chasm of her doubt. She had first met Atkinson in 1845. He was a mesmerist, and she had just been cured by mesmerism.[29] He was somewhat younger than she, a man with exquisite manners, an attractive appearance, and a large enough income to indulge his philosophical dilletantism. Their correspondence began shortly after their first meeting when she had coquettishly asked him if he would write to "a lady who would promise not to fall in love with [him]."[30] The promise was kept, and the correspondence sustained—in spite of the almost total illegibility of Atkinson's writing—to the very end of Harriet Martineau's life.

Harriet Martineau held an inordinately high opinion, not generally shared by her contemporaries, of Atkinson's rather modest attainments. Because of her exalted view of Atkinson's capabilities it has been speculated that Miss Martineau's judgment may have been persuaded by a greater fondness than she was ever willing to admit. But there is no evidence to suggest that she was ever in love with Atkinson, and it is much safer to conclude that she was moved by a somewhat misplaced respect for his learning. Atkinson was an amateur scientific theorist like Herbert Spencer but without Spencer's breadth of mind and intellect. In an age when most scientific theorists were "amateurs," and when science was an embryonic study, it was not easy to challenge a pretension to knowledge. When one recalls the exaggerated esteem in which his contemporaries held Spencer, then perhaps Martineau's awe of Atkinson's scientific claims and pronouncements becomes understandable.[31] Atkinson had studied mesmerism and phrenology; Martineau was coming to these subjects as a pupil willing to be taught, and she was happy to defer to Atkinson as an expert. It was from the questions she posed and the answers she received from Atkinson in their correspondence that the idea for their joint *Letters on the Laws of Man's Nature and Development* was born.[32] The *Letters*, published in 1851, was an epistolary dialogue about the nature of man and the universe. Martineau's questions were answered by long, sententious, and frequently uninformed replies. Atkinson often lapsed into contradiction, and he carelessly used the phraseology of the religion he claimed to disbelieve. Martineau more than once corrected such lapses but she was in

no position to correct either his scientific theories or his claims for mesmerism and phrenology. She was happy to accept his answers to the fundamental questions she posed, for in them she found a new philosophy to replace the old.

The basis for Martineau's new faith was science. If her transition from Christianity was smooth, if she seemingly failed to suffer the severe crisis of conscience which characterized other Victorian conversions, then it was because she never relaxed her hold on the principles of necessarianism. The empirical aspects of necessarianism provided a substantial link with her new philosophy: empiricism was basic to her new creed. She wanted to understand man and his universe as natural rather than divine phenomena, and the *Letters* was less an attack on God and Christianity than a search for comprehension.

Atkinson's pursuit of truth was in essence little more than a restatement of the Lockean theory that all knowledge was the product of experience. But Atkinson went beyond Locke when he denied God as a first cause.

> We know nothing fundamental of nature, nor can we conceive any thing of the nature of the primary cause. We know not, nor can we know, what things really are, but only what they appear to us. [*Letters*, p. 7]

Atkinson and Martineau sought objectively for known phenomena rather than subjectively for causes. As they could only know and understand that which had been experienced, science rather than theology became their primary tool, and "Lyell a better authority than Moses." They felt no need to identify the First Cause which man in his arrogance had created in his own image.

> What a new sense of reverence awakens in us when, dismissing the image of a creator bringing the universe out of nothing, we clearly perceive that the very conception of origin is too great for us, and that deeper and deeper down in the abysses of time, farther and farther away in the vistas of the ages, all was still what we see now, —a system of ever-working forces, producing forms, uniform in certain lines and largely various in the whole, and all under the operation of immutable Law![33]

The old necessarian logic was being distilled into different containers. The old necessarian God became another name for law.

Pray tell me too, whether, in this last letter, you do not, in speaking of God, use merely another name for law? And when you speak of God as the origin of all things, what is it that you mean? Do we know anything of origin?—that it is possible? Is it conceivable to you that there was ever Nothing? and that Something came out of it? I know how we get out of our depth in speaking of these things; but I should like to be aware *where, exactly, you think our knowledge stops.* [*Letters*, p. 168]

It was, perhaps, a measure of Martineau's respect for Atkinson that she should have expected an answer to a question of such magnitude, and she was probably satisfied with the partial answer she received in reply.

I do not say, therefore, there is no God; but that it is extravagant and irreverent to imagine that cause a Person. All we know is phenomena: and that the fundamental cause is wholly beyond our conception. . . . A "Cause of causes" is an unfathomable mystery [all development is] a result of the properties of matter. If to have this conception of things is to be an Atheist, then I am an Atheist. [*Letters*, p. 246]

Actually the *Letters* went no farther than Hume had gone in his refusal to acknowledge anything beyond the human experience, and it went only a step farther in its *refusal* to acknowledge God than Joseph Priestley had gone in his *affirmation* of God.[34] "All that we can pretend to know of God is his infinite wisdom, power, and goodness," Priestley had said. "Of the nature and *existence* of this primary cause . . . we cannot have any conception."[35]

If "Man can know no more than he has perceived," and all knowledge is acquired by way of the perceptive faculties, then a study of human understanding becomes essential to a comprehension of "the laws of man's nature and development." It was the mind, and more specifically the brain which primarily claimed Atkinson's attention. Here too there were links with the necessarian school. Hartley had pioneered sensationalism, and Priestley and his willing disciple, Harriet Martineau, while never agreeing with Hartley's theory of vibrations, had accepted the theory of pain and pleasure. But in the *Letters* Atkinson and Martineau went farther than Hartley had done; they looked not to the associationist school but to phrenology.

It is astonishing to me that I could admit without question his [Hartley's] supposition that Man has two primary powers which are

enough to account for every thing: the capacity for pleasure and pain, and the principle of association.[36]

Where Hartley had generalized all sensation into pleasure and pain, the phrenologists tried to particularize sensation. Phrenology assumed that behavior was influenced directly by the physiological structure of the brain. It eliminated the spiritual attributes which had for centuries been associated with the philosophy of mind, and because of this apparent negation of the divine origin of human sensibility, it was thought to be "implicit atheism."

The founder of the phrenological school, Franz Joseph Gall (1758–1828), had originated cerebral research in an age when the functions of the brain had scarcely been thought of in physiological terms. He and his disciples dissected the brain in order to scientifically localize the seat of the different perceptions. They thought that they had identified thirty-seven (or by some counts thirty-five) separate faculties, each responsible for a different function of the mind. Each faculty was located in a separate part of the brain, and the extent to which each faculty was developed affected the shape of the brain and the contours of the skull. It was this aspect of phrenology which attracted the fortune-telling element. But serious phrenologists were interested in understanding the physical structure of the brain and in diagnosing the problems of the mind, and they had no interest in predicting personalities. Because phrenology accepted the tabula rasa theory, it placed a great deal of emphasis on environmental and educational factors, and held that the faculties could be *developed*. Phrenologists therefore treated mental disorders as the products of external or learning conditions. They thought of the mind as a function of the brain and therefore of the body, and they believed in keeping the mind healthy by means of proper nourishment and exercise. It was the materialism of phrenology which antagonized the pious, but for Martineau it had a logical appeal. Before only tangentially interested in the subject, now under the influence of Atkinson she became a devotee. She took to heart the phrenological health program, she looked to phrenology to unlock the secrets of the mind, and to this end she even willed her own brain to phrenological research.[37]

Atkinson did not doubt the verity of Gall's identification of the parts of the brain responsible for the functioning of the separate faculties. He himself was quite certain that he had discovered the locations of several faculties by his own experimentation. The techniques which he used could, however, be described as "scientific" only

by a considerable stretch of the imagination. One method which he used was to rub certain portions of a sleeper's skull and so stimulate certain muscular or mental responses; the other technique was to observe the area of the skull individuals touched when one of their faculties was excited particularly during mesmerism.[38] Harriet Martineau did not doubt the authenticity of her mentor's discoveries. She was not in a position to disagree with Atkinson's pretensions to scientific knowledge, and she never ventured to contradict his claim that in phrenology, mesmerism, and even clairvoyance—which he did not discount—lay the ultimate means of investigating "man's nature and development." Martineau and Atkinson were but two members of a small but significant group of Victorian intellectuals who chose to believe in the scientific origins and promises of phrenology.

The *Letters* is not intrinsically important. It does not deserve a special place in the hierarchy of Victorian literature or philosophy. It is long-winded, often illogical, and sometimes even arrant nonsense. But it is significant for what it tells us, and for what it told her contemporaries, about Harriet Martineau. It made her conversion from theism explicit, and it raised a roar of execration, a reception which she had wholly anticipated. "We had rather that you publish the book than any other," she told Edward Moxon, "but shall not urge it upon you.... It is ... daring to the last degree; and the public wh. certainly *is* ready for such works, may not be *your* public."[39] Moxon agreed. He turned down the manuscript, and it was eventually issued by John Chapman, the publisher of the *Westminster Review*.

Letters, threatening belief as it did, was an attack on the bastion of Victorian certitude, and the outrage which met its publication was tinged with fear.

> Such a book as this is a strange echo of ... forebodings [wrote James Anthony Froude in *Fraser's Magazine*]. We may turn away from it, affect horror of it, slight it, laugh at it; but it is a symptom of a state of things, it is the first flame of a smouldering feeling now first gaining air, and neither its writers, nor we, nor any one, well know how large material of combustion there may be lying about ready to kindle.[40]

Some grudgingly acknowledged the courage of the authors of the offending work.

> [Harriet Martineau] has at last dreamed, or sophisticated her way to plain, avowed, ostentatious Atheism [But] we willingly concede to

Miss Martineau that her moral intrepidity never shone more conspicu-
ously than now, when she has to our apprehension ignored the foun-
dation of all morality.[41]

In *The Leader*, George Lewes, while regretting that the authors of the
work had ideologically parted company with him, and pointing out
the irrationality of their mesmeric claims, nevertheless described *Let-
ters* as, perhaps, one of the "most prominent" of recent books. He
applauded the courage of the authors, and conceded that "there are
many noble and interesting passages. Whatever the conclusions, they
have been the result of honest, independent thinking." George Eliot
was privately less charitable than Lewes. She admitted to Charles
Bray that she thought the book "the boldest I have seen in the
English language." But she considered it to be "studiously offen-
sive." Other more public epithets were less discreet. It was variously
called "an overwhelming deluge of verbiage," "intolerable rubbish,"
and "daring blasphemy." But the most stinging attack of all, and the
most wounding, was the critique published by the *Prospective Review*
and written by Harriet's brother James.[42]

James mercilessly attacked the hapless Atkinson as "incompetent,"
"vacillating," and the "hierophant of the new Atheism." Athough
correct to point out Atkinson's frequent contradictions and inconsis-
tencies, James was too blinded by his private prejudices and opinions
to be objective. His own philosophical pronouncements were some-
times questionable, and his too literal interpretations were fre-
quently less than logical. He refused, for example, to perceive time
and space as phenomena because "they are not objects accessible to
us by perception." He denied any attempt to conceive of the mind in
materialistic terms, and he denied an empiricism which reduced all
knowledge to experience. His own religious belief and the inductive
science which was Atkinson's article of faith could find no meeting
ground. "So far as Science has effected the 'exorcism of the spirit'
from nature, has science produced, we believe only a delusion,"
wrote James.

> To reconcile science and theism . . . the inquirer must evidently pass
> out beyond the canons of induction into a higher philosophy, which
> limits the pretensions of physical investigation, and restores authority
> to the original instincts of causation. He rights himself, not by shutting
> himself up more closely than before in his habits of thinking as a
> chemist, astronomer, or physiologist, but by freeing himself from
> these at the upper end, and looking down upon them as only provi-
> sional assumptions. In effecting this emancipation, he finds that he

has emerged again into the region of his earliest faith: and he looks forth once more . . . through the childlike eye to which nature and life are astir and breathe with the hidden thought of God.[43]

The authors of the *Letters* denied all that James had come to believe: they denied that the First Cause was God; they denied freedom of will; and they assumed that the ultimate truth lay not "*within us*," but with external actions. Although James may have been profoundly disturbed by the extent of his sister's unbelief, and personally "mortified" by her "exceptional submission to an inferior mind," his decision to write a deliberately critical, harsh, and supercilious review of her publication is difficult to understand.[44] He claimed that the task had naturally fallen to him as one of the editors of the *Prospective Review*, but according to his biographer, Drummond, the other editors recalled somewhat differently the occasion on which James undertook the task of reviewing the *Letters*. It appears that the decision to write the review had been made solely by James. His fellow editors did not urge the task upon him, and indeed would not have permitted him to undertake the assignment had he been reluctant to accept it. This claim by the other editors appears to be borne out by the fact that in 1853 James again volunteered to write a review of his sister's work— her translation of Comte—but his offer was turned down "as the editor was of the opinion that the work would be criticised by Dr. Martineau in a thoroughly hostile spirit."[45]

The fact that James wrote a review which he knew would deeply hurt Harriet says something about his attitude toward his more famous sibling. His action cannot simply be ascribed to tactlessness, and it is unlikely that he was motivated solely by the ideological differences separating him from his sister. There was something very purposeful and personal about his attack, and although he directed his criticism chiefly at Atkinson, Harriet, who had taken responsibility for the publication, appeared to be the target of his unnecessary virulence. Harriet—though always claiming the contrary—minded literary criticism very much, and coming from James it was especially hurtful. But she did not consider a literary rebuttal. "People do not answer reviews," she cuttingly told James's wife Helen, "and especially where the circulation is so insignificant as that of the 'Prospective.'" In spite of Helen Martineau's pleas for a reconciliation, Harriet and James never saw or spoke to each other again. Harriet shut her brother out of her life as completely as she had so many years earlier shut out the painful memory of John Worthington. It was her way of protecting herself. But though she

barely acknowledged James's review and gave no details of the quarrel in the *Autobiography*, she was unable to completely efface the bitterness of her resentment, and it surfaced from time to time in her conversations and in correspondence with her closest friends.[46]

Martineau's relationship with her brother was not the only old association affected by the religious doubts which had been so openly expressed in the *Letters*. Julia Smith and Elizabeth Reid, two of her closest female friends, were both offended by the publication. Philip and Mary Carpenter, the son and daughter of Harriet's old teacher, the Reverend Lant Carpenter, were severe in their criticism. Charles Knight refused to publish the conclusion to her *History of the Peace* "because he knows no-one would have purchased." Edward Moxon expected to lose on the second edition of *Eastern Life*. Her Lake District neighbors were horrified. Mrs. Arnold for a time broke off acquaintance with her. Edward Quillinan told Henry Crabb Robinson

> I have not met her [Harriet Martineau] since my return home; and it will be an embarrassing meeting when I do see her; for, after her publication of such a book, I cannot cordially enjoy her society, much as I valued it on many accounts before. If I were a bachelor or had no daughters, it might not be so difficult to keep up such neighbourly intercourse as I have been accustomed to with her: and even as matters stand, it is not that I have the least fear for me and mine; for I never heard her *say* anything that was offensive; but I should not like my daughters subjected to the censures that would be sure to follow them if we kept up intimacy after her announcement of such opinions as that book contains.[47]

Crabb Robinson confided in his diary: "I am not sorry that my intimacy with Miss M: has of late so much declined. I shall make no *sacrifice* if I break with her entirely." His visits to the Lake District had become less frequent since the death the previous year of his friend William Wordsworth, but Robinson kept in touch with his many other acquaintances in the district, and it is largely through this correspondence that we know not only of Harriet Martineau's social ostracism when the *Letters* first appeared, but also of her reinstatement not long thereafter.

> I hear that Miss Martineau is as well received now as ever in the Lake society. Her bad *doctrine* seems merged in her *every day deeds of kindness*, which people have before their eyes and ears—while the *book* is out of sight.[48]

Some of Harriet Martineau's friendships were undisturbed by theological differences of opinion. William Lloyd Garrison told her

> I know what you have dared to be brave, what you have suffered, by the frank avowal of what a hireling priesthood and a corrupt church have branded atheistical sentiments. Though my belief in immortality is without peradventure, I desire to tell you that your skepticism, in lack of evidence, on that point, has never altered my confidence in the goodness of your heart and the nobleness of your character. . . . I respect and admire conscientious dissent and doubt. . . . Heresy is the only thing that will redeem mankind.[49]

Sara Hennell disagreed with Martineau's conclusions but acquiesced "in cases like your own where a station has been reached which can be maintained with moral dignity." Henry William Wilberforce, son of the abolitionist and a convert to Catholicism just a year before the appearance of the *Letters,* told Martineau, "I cannot but honour a person who has never hesitated to defend and avow any thing known or believed to be truth." The Reverend Perceval Graves, with whom Martineau carried on a long correspondence dating from 1848 to 1867, expressed his continued regard for her in spite of the pain their differences gave him, and his hopes for her "moral reconciliation with our Divine Creator." Dr. Samuel Brown described her as "my beautiful enemy in theory, my noble friend in life." Florence Nightingale, who corresponded with Harriet Martineau from the 1850s, regarded her as having the "truest and deepest religious feeling I have ever known . . . contradictory as it may seem." When Harriet Martineau died, Nightingale chose to disregard her friend's unorthodoxy: "She is gone to our Lord and her Lord," she wrote, "She is in another room of our Father's house. . . . I do not grudge her to God."[50]

Martineau was, said John Chapman, "A perfect zealot in her new faith."[51] She was acquiring a new certitude and was seemingly undaunted by the disapproval of those who clung to what she believed were the dogmas of outworn beliefs. She told the Secularist George Jacob Holyoake that

> within a few days, it seems that indications have appeared of the tide turning. At least those who are willing to allow us liberty of thought and speech, are now, at last asserting our rights. On their account and for the sake of the principle, we are glad. For ourselves,—the truth is,—we don't care.[52]

Martineau's bravura may have been as much an indication of her need to believe as it was of her belief, and she may well have been "unconsciously trying to gain strength of conviction by vigour of assertion." She needed a faith, and she needed an intellectual replacement for the theological interpretation of the universe. But her confident proclamation of a new faith which flew in the face of public opinion was as much an indication of the strength of her new conviction as it was of her personal sense of security. She had traveled a long way since the uncertain, frightening days of her hapless childhood. She was not afraid to stand alone.

In groping for a scientific explanation of her world and her species, Harriet Martineau was approaching the positivist theories of Auguste Comte. She had been exposed to Saint-Simonianism when Gustave D'Eichtal, a Saint-Simonian emissary and an acquaintance of William Johnson Fox, came to England in the 1830s. As early as 1831 Harriet was enthusiastically writing to James extolling the philosophy which D'Eichtal purveyed.[53] Comte had been a student of Henri de Saint-Simon at the Ecole Polytechnique in Paris, but he had broken away from his teacher in 1826. Each claimed authorship of the same basic philosophy, but it is not our purpose to discuss the merits of their respective claims, or to discover whether and how much the teacher influenced the student, or if indeed the reverse was actually true. Both men espoused the theory that the old order of society was disappearing and that its old chiefly theocratic leadership would be replaced by a new scientific-industrial elite. They both believed that societies passed through three basic stages of development: the theological, which evolved from fetishism to polytheism and monotheism; the metaphysical, in which men sought for causes; and the positive, which was based on empirical fact or law. Comte elaborated on the theory, and systematically examined the evolution of the basic sciences which were the very foundation of the final positive state of society in his six-volume work, *Cours de Philosophie Positive*, which was published between 1830 and 1842. It was read in the original in England by a few intellectuals, and the first volumes were reviewed in the *Edinburgh Review* in 1838.[54] But for all its limited circulation in England, the philosophy had an impact on English thought. John Stuart Mill acknowledged that his *System of Logic* owed much to Comtean theory and that his aim, like Comte's, had been to "raise all knowledge to the level of sciences based on,

and codified according to, that which was observable." George Henry Lewes published a *Biographical History of Philosophy* in 1845 and 1846 in which he outlined Comtean theory. Herbert Spencer commented on Comte's positivism mainly in order to proclaim the independence of his own philosophy: in *Social Statics* published in 1850, he systematized knowledge into a hierarchy of the sciences from basic physics to biology, psychology, and finally sociology. His aim was to understand society as a biological organism which was progressing toward perfection. Comte's purpose on the other hand was political rather than biological; he worked toward the creation of the ultimate polity. There were other notable English commentators on the philosophy of Comte: John Morley in the *Encyclopædia Britannica*, the scientist Thomas Henry Huxley, Comte's chief English disciple Frederic Harrison, and, in 1865, John Stuart Mill's final estimate in *Auguste Comte and Positivism.*[55]

Before 1852 Harriet Martineau's knowledge of Comte's work had been largely secondhand. She had read Lewes's commentary, and Emile Littre's French summary, but she did not begin to read *Cours de Philosophie Positive* for herself until after the publication of *Letters.* She sensed a growing interest in Comte in England, and with her unerring timing she conceived the idea of translating and condensing the rambling six-volume work. John Chapman agreed to publish her translation. Comte concurred in the enterprise and was to receive a share of its profits. And to ensure completion of the project in the event of Martineau's own inability to do so, Henry Atkinson and Marian (Mary Ann) Evans were named as trustees. Having thus prepared the groundwork, on June 1, 1852, Harriet Martineau embarked upon "the greatest literary engagement of my life."[56]

In its original form the work of Comte was difficult to read. It had been composed as a series of lectures delivered orally over a long period of time and as a result was often repetitive: even Frederic Harrison admitted that it made "very irksome reading to any but a patient student." It was because of this that Martineau felt the need to translate and abridge the *Philosophie Positive* in order to bring it "before the minds of many who would be deterred from the study of it by its bulk." She hoped too, that by popularizing Comte she would help to provide a "rallying point" for the "scattered speculations" of those who had become alienated from traditional religion. As she stated without further elaboration in the preface, she did not agree with all aspects of Comte's philosophy, but she chose not to make her translation a forum for her criticisms, and one is left to

draw one's own conclusions about those areas of Comtean theory with which she disagreed.[57]

Comte's primary aim in the *Philosophie* was to establish sociology as a science based on historical and empirical criteria: to study all aspects of the phenomena of society which constituted "a vast social unit." His secondary aim was to review all the sciences "in order to show that they are not radically separate, but all branches from the same truth." He thought that the sum of human knowledge formed a complete scientific hierarchy which he divided into the inorganic sciences (astronomy, physics, and chemistry), the organic sciences (biology or physiology), and finally "the most complex of all," that of "humanity in a state of association." He called this ultimate science social physics or sociology and he attempted to formulate a theory in which all of natural philosophy was integrated in order to contemplate the evolution of human development. Unlike Atkinson and Martineau in the *Letters*, Comte did not stop with the study of "man" but went on to contemplate "man in society." The first five volumes of *Positive Philosophy* (to use Martineau's English title), summarizing the state of existing scientific knowledge, are of interest here only because they revealed Martineau's ability to master and translate difficult concepts in a variety of fields. But the final volume, "Social Physics," was less an exposition than an interpretation, for it was in this portion of his work that Comte purposed to understand and reorganize society.[58]

Comte noted two basic elements in society: order and progress. Order, or social statics, was the constitution of society: its structure and its social groupings. Progress, or social dynamics, was society in a state of change: its evolution through the theological and metaphysical stages toward the positive state. Order and progress while appearing to be apparently paradoxical were according to Comte compatible in the positive state because "no progress can be accomplished if it does not tend to the consolidation of order." The old feudal, Catholic society of Western Europe in its theological stage was an *ordered* political world. In its metaphysical stage, the later revolutionary period, order and progress coexisted. The society retained some of its old elements of order while admitting the anarchic ideas of *progress*. The anarchy of the metaphysical polity was essential to the development of the positive stage. "The metaphysical spirit was necessary to direct the formation of the critical and anti-theological doctrine . . . to overthrow the great ancient system." The chief ideas or "dogmas" of the metaphysical stage through which Europe was then passing were essential to the breakup of the old theological static system, but an

obstacle to the consolidation of progress, and they would be replaced by a new unifying concept when the disintegration of the old society was complete. These dogmas were: individual reason, liberty of conscience, equality, sovereignty of the people, nationalism, and laissez faire.[59] Comte considered laissez faire, for example, to be anarchic in the extreme. It sanctioned, he said, "the spirit of individualism and the state of no-government." He did not believe in leaving the direction of the new industrial state to the "negative" influences of a metaphysical theory. He was similarly opposed to sovereignty of the people because he did not agree to placing the government of a society in the hands of "the incapable multitude."

> The great social rules which should become customary cannot be abandoned to the blind and arbitrary decision of an incompetent public without losing all their efficacy. The requisite convergence of the best minds cannot be obtained without the voluntary renunciation, on the part of most of them, of their sovereign right of free inquiry, which they will doubtless be willing to abdicate, as soon as they have found organs worthy to exercise appropriately their vain provisional supremacy.[60]

Comte therefore brought into question all the tenets of the democratic-individualist philosophy which Martineau had always held. Comte's authoritarianism affronted Martineau's republicanism; his denial of laissez faire struck at the roots of her political and economic creeds; and his denial of equality was an attack on an even more basic conviction: for his antiegalitarianism struck not only at the relationship between man and man, in a generic sense, but also extended itself to race and sex. Comte believed that the white race was superior to all others.

> Why is Europe the scene, and why is the white race the agent, of the highest civilization? This question must have often excited the curiosity of philosophers and statesmen; yet it must remain premature, and incapable of settlement by any ingenuity, till the fundamental laws of social development are ascertained. . . . No doubt, we are beginning to see, in the organization of the whites, and especially in their cerebral constitution, some positive germ of superiority we observe certain physical, chemical, and biological conditions which must have contributed to render European countries peculiarly fit to be the scene of high civilization.[61]

And Comte as firmly believed that females were inferior to males, and that their subordination was both natural and practical.

Biological analysis presents the female sex, in the human species especially, as constitutionally in a state of perpetual infancy, in comparison with the other; and therefore more remote, in all important aspects, from the ideal type of the race. Sociology will prove that the equality of the sexes, of which so much is said, is incompatible with all social existence, by showing that each sex has special and permanent functions which it must fulfill in the natural economy of the human family.[62]

As a phrenologist, Comte based his ideas not only on his social observation of the pattern of existing male dominance, but also on what he considered indisputable proof: the smaller size of the female brain.[63] Comte's insistence on the inequality of the races and the sexes could not but have disagreed with Martineau's long, firm stand on these issues. And in general Comte's antilibertarianism so contradicted Martineau's political philosophy that it is regrettable she did not annotate her translation or at least fully document elsewhere her objections to the aspects of Comte's work with which she felt out of step.

Comte's view of reconstructed society was Catholic and monarchical rather than Protestant and egalitarian. He admired the authoritarian structure and the spiritual leadership which Catholicism had given Europe in the theological age. He wanted the leaders of the new positive state to reassume the spiritual and intellectual leadership which he believed had lapsed during the revolutionary metaphysical period. His new leaders would be neither theologians as in the theological era, nor lawyers as in the metaphysical era, but instead would be trained in the positive philosophy of the sciences and able to contemplate the more complex problems of social science. Comte proposed to separate—as it had been in old Catholic Europe—the corporate intellectual-spiritual leadership of the positive state from its temporal authority. He proposed to lodge temporal control in the hands of the industrialists, and to make the scientist-leaders of the new state responsible only for the education and moral welfare of the people. All citizens would be trained in the positive sciences, but they would occupy in the society only those positions for which they were best suited, and they would have no share in the governmental process.[64]

In his first great work Comte did not detail his concept for the reconstruction of Europe. But in his final multivolume work the *Système de Politique Positive,* published between 1851 and 1854, he created an elaborate intellectual oligarchy to replace the old theo-

metaphysical one, and he himself, in John Stuart Mill's words, was "transfigured as the High Priest of the Religion of Humanity."[65] As Nietzsche phrased it, "that most intelligent of Jesuits, Auguste Comte, . . . wished to lead his compatriots back to Rome by the circuitous route of science."[66] Therefore, as Comte conceived it in its final form, positivism did not merely supersede religion, it replaced it as a new faith with its own priestly hierarchy. It was a secular religion owing its devotions to humanity and taking its teachings from science, but it came garbed in the ritual robes of the theistical religion which it purported to displace.

Martineau considered Comte's final treatise an aberration.[67] She would never agree to a doctrine built upon the scaffold of ecclesiastical authority—whatever its professions. She had rejected sacerdotal dominion long before she rejected theism and she would never have submitted to the kind of pontifical dictatorship which Comte envisioned. She was too much the republican to submit to dictatorship of any kind. Before she had read Comte she had described Saint-Simon's similar political solution in volume two of her *History of the Peace* as that which promised to become "an intolerable despotism— a locked frame-work, in which individual freedom might become impossible."[68] Nevertheless while rejecting the more outrageous aspects of Comte's philosophy, she seized hold of its main elements: that humankind should seek to understand only the phenomena of the knowable; that the West should be liberated from anachronistic theologians and anarchic metaphysicians in order to constitute "a true sociocracy"; and that society should assume the responsibility for its own education. She adopted the language of positivism, and used it particularly in her *Autobiography* where she described her own "theological" and "metaphysical" periods from the long perspective of her new certitude. Now at last she was able to replace her old discarded theistical creed with the principles of positivism. She explained exactly what positivism meant to her in an 1856 letter to Maria Weston Chapman.

> By positive philosophy I mean not any particular scheme by any one author, but the philosophy of fact, as arising from the earliest true science positive philosophy is at the opposite pole to scepticism. . . . it issues in the most affirmative (not dogmatical) faith in the world, and excludes unbelief as absolutely as mathematical principles do; . . . there is no "darkness" in it, but all clear light, up to the well-defined line which separates knowledge from ignorance; . . . positive philosophy is, in short, the brightest, clearest, strongest, and only irrefragable state of conviction that the human mind has ever at-

tained. . . . Scepticism is doubt; and the positive philosopher is in a position of direct antagonism to it. . . . While the disciples of dogma are living in a magic cavern painted with wonderful shows, . . . the positive philosophers have emerged upon the broad airy, sunny common of nature, with firm ground underfoot and unfathomable light overhead. [*Autobiography*, 3:323-30]

Martineau, as we have seen, could tailor her philosophy to suit her needs. She was able to hold onto certain of her old beliefs while accepting new ones; she was able to ignore those aspects of Comtean theory which were not congenial and to derive strength and satisfaction from those elements of the philosophy which answered her purpose. She accused Unitarians of "taking any liberties they please with the revelation they profess to receive," but if the trait was Unitarian then it died hard in Harriet Martineau. It was almost as if she was able to listen *or not* to the voices of reason as she did or not to the voices of life through her ear trumpet. She had an uncanny knack of being able to close her mind to the most insistent logic. If she had ever permitted herself to carry all her arguments to their inevitable conclusions then she would have been forced to admit the contradictions in her philosophy, but Martineau did not permit her conflicting opinions to disturb each other; and her contradictions and discrepancies notwithstanding, there was, paradoxically enough, a basic consistency in her philosophy. Her positivism was at heart nothing more than necessarianism altered to conform to a new secular faith. She still rested as she had in the past on "laws which cannot be broken by human will." The main difference between her new philosophy and her old was that she could now distinguish between the knowable and the unknowable, and was able to dismiss the latter from her consciousness: there was no First Cause in her new universe. The empiricism of Comtean thought was the foundation of her new creed, and the more disquieting details of positivism neither altered her faith in it nor disturbed her old liberal convictions. Though she rejected her "metaphysical" religious dogmas, she held onto her "metaphysical" political principles. And she forebore to comment on those aspects of Comte which she must have found difficult to translate objectively. George Lewes acknowledged her literary honesty in his review of her work.

Comte's views are there without suppression of important considerations, with only such omissions as the very fact of abridgment implies. Indeed, in the whole range of philosophy, we know of no such successful abridgment.[69]

Lewes, Spencer, and Huxley all thought that Martineau's translation and abridgment were "admirable." Frederic Harrison had some reservations about the omissions but acknowledged the value of the work, and quoted George Grote's comment in her praise: "Not only is it extremely well done, but it could not be better done." Comte himself was so delighted with Martineau's condensation that he authorized a French translation of her version of his work. And when a new edition of her translation was published in 1875, the *Daily News* noted that since the appearance of her translation "the study of Comte's writings has been greatly extended." But John Stuart Mill was conspicuously silent. When Chapman asked him to do the review for the *Westminster,* Mill refused. His reason for declining the offer was partly because he had changed his favorable view of Comte and desired to "atone for the overpraise" he had given him, and partly because he and Harriet Taylor Mill could not forgive Martineau for gossiping about their early friendship in those distant London days. Harriet Taylor Mill feared that a review would have to make a flattering reference to Harriet Martineau, and Mill himself declared, "I don't like to have anything to do with the name or with any publication of H. Martineau."[70]

The Mills notwithstanding, Martineau had reason to be very satisfied with the results of her arduous effort. After the acrimony which had greeted the *Letters,* the praise with which the translation was met must have been most gratifying. But apart from the success of the translation itself, she had acquired a new faith: "a faith . . . not an infidelity."[71] And for Martineau, as for the era itself, faith was imperative. For this reason she had clung to the conventional pieties almost to the threshold of her conversion. Like someone swinging from branch to precarious branch she did not let go until she had securely transferred her grasp. She did not surrender her old certitudes until she firmly held her new ones. Now she felt that she had arrived; she was secure in her new conviction; and surrounded by the disparaging unconverted, she felt herself to be "standing on a bit of firm ground, with a whole environment of hollowness; and nobody wants a helping hand to get upon the rock."[72]

"A Gentleman of the Press"

In 1854, respiratory difficulties, occasional spells of dizziness and "odd sensations at the heart" marked the end for Harriet Martineau of a decade of unprecedented good health. She consulted two London physicians and came away from the consultations convinced that her heart was failing and that her illness was mortal. One of her doctors, Dr. Thomas Watson, later recalled that although he had sought to reassure her, it had been impossible to dissuade her from "the impression that her heart was incurably diseased, and that she had not long to live. . . . She plainly distrusted, or rather she disbelieved my reassurances, looking upon them, I fancy, as well-meant and amiable attempts to soothe and tranquilise a doomed patient." In recording her symptoms, Dr. Watson noted that their possible cause was a large pear-shaped abdominal tumor which reached as high as the epigastrium—the area over the stomach. This was undoubtedly the same tumor which had caused her earlier illness, and, according to the opinion of doctors after her death, it had probably shifted position in 1844, and by doing so had given her ten untroubled years. But now, grown to a great size—at her death it measured twelve inches in diameter—it once again affected the abdominal organs and also, because of pressure on the diaphragm, the action of the heart and lungs.[1] Except confidentially to John Chapman, Harriet Martineau did not generally acknowledge the presence of the tumor. "It is *certainly not,*" she told Chapman with emphasis, "of the same nature as the Tynemouth disease."[2] Harriet Martineau could not admit even to herself that her mesmeric cure had been a delusion. She had doggedly and publicly insisted then on the efficacy of her cure, and with her customary obstinacy, she refused now to lose face. She would not for an instant entertain the idea of giving the skeptics, and especially James, the opportunity to say "I told you so!" Although she continued to profess belief in mesmerism, it is signifi-

cant that in connection with her last illness there was little mention of it, and that she turned again to opiates for relief.[3]

She returned to Ambleside in the invalid carriage of the North Western Railway and for a second time prepared to face death. The prospect did not make her self-pitying or maudlin as it had done during her first protracted illness. Undaunted she told George Jacob Holyoake

> I really *can't* care about what lies behind my own curtain (while entirely conceiving that there is nothing) while the world is in such a state as I see it in,—with so much to be done. . . . This hourly increasing indifference about one's own share is much more than a compensation for any natural regrets about leaving one [*sic*] blessings; but those regrets are surprisingly less trying than I could have supposed possible.[4]

As a positivist Martineau no longer believed in the afterlife. On a personal and a professional level she felt fulfilled. She could therefore endure the prospect of her own end with resignation and a sense of adequacy. "I feel very, very old, through the varied experience that I have had," she wrote, "and I am so thoroughly content with my share of life and its blessings that I feel I have had enough, and am very easy about going, whenever the moment may come."[5] So she calmly went about the business of dying. She made her will. She considerately inquired about burial places lest her heretical beliefs cause her survivors untoward awkwardness.[6] And then she began the task of recording her life for posterity.

Martineau had made two earlier attempts at autobiography—one in 1831 and another at Tynemouth. Now, with the destruction of most of her correspondence by interdict in 1843, the work seemed imperative. She also felt a need to explain her religious conversion. "The most important part [of the *Autobiography*] was" she told George Jacob Holyoake, "the true account of my conscious transition from the Xn faith to my present philosophy."[7] It was, therefore, almost as much with an apologia in mind as with a desire to leave an account of her personal history and achievements that Harriet Martineau began what she thought would be her final literary task. The *Autobiography* is a revealing work, especially about her childhood—it was easier to describe those fears and failings she had outgrown than it was to contemplate those she still possessed—but it is more concerned with the life of the mind and with the author's development as a writer and a celebrity than it is with the growth of the psyche. It

is less a confessional than a memoir and less an analysis than a narrative. Her dearest friendships were not described in detail, and her most intimate thoughts and feelings were seldom revealed. The description of her religious conversion was intellectual rather than emotional except insofar as her emotional dependence on religious faith diminished with age and assurance.

When the *Autobiography* was completed, she permitted John Chapman, Richard Monckton Milnes, and Henry George Atkinson to read it in manuscript, and she asked Maria Weston Chapman to write a concluding volume of *Memorials* (vol. 3).[8] She next had the first two volumes privately printed so that they would be issued unaltered after her death. Then, with her nieces and her faithful maids in attendance, Harriet Martineau prepared to spend her remaining days in retirement.

It took twenty long, increasingly debilitating and painful years for Harriet Martineau to die, but she continued to write until about 1866 in spite of her progressive incapacity. For Harriet Martineau retirement did not mean idleness. She revised old works for republication. She updated her *History of the Peace* for its American edition. And she devoted herself extensively to journalism. She had been making substantial contributions to both *Household Words* and the *Westminster Review* prior to her last illness. The *Westminster* connection had begun after visit to America, but it had intensified after 1851 when John Chapman became the proprietor and editor. Chapman was a friend, a confidante, and an ally. It was he who published both the controversial *Letters on the Laws of Man's Nature and Development* and the Comte translation. She had gone with him to the theater and the opera and, in his home in the Strand, had met the contemporary avant garde. Thomas Huxley, Herbert Spencer, Marian Evans, George Lewes, Ralph Waldo Emerson, Francis Newman, Barbara Leigh Smith, and Bessie Raynor Parkes were all his guests at one time or another. When the *Westminster* faltered financially in 1854, Harriet Martineau offered to assume a five hundred pound mortgage. "I have long felt grateful to you for your aims and aids in behalf of free thought and speech," she told the beleaguered Chapman.[9] But although her gesture was generous, Martineau's motive may not have been one of unmixed altruism. Her brother James was one of Chapman's creditors. He did not like Chapman's philosophical bias and he hoped to use the publisher's financial straits to wrest the journal from his control and secure it as "an organ of a serious and free theology." When Harriet learned that James planned to undermine Chapman's control of the *Westminster,* she immediately

sent the publisher the full amount of his debt to her brother, and with George Grote and some of Chapman's other supporters undertook to keep the *Westminster* out of the hands of Chapman's enemies. James's chagrin when the journal fell, in his words, "into the hands of a Comtist coterie," doubtless gave his sister a good deal of secret satisfaction.[10]

Martineau tried to bolster the circulation of the *Westminster* by writing reviews of it in the *Daily News,* and she continued her contributions to the *Westminster* even after the onset of her illness. Her connection with the journal survived Chapman's refusal to publish her article, "The Factory Controversy: A Warning against Meddling Legislation."[11] But it did not long outlive her discovery in 1858 that at the very time Chapman was assuring her of the *Westminster's* solvency he was secretly taking out a second mortgage. Martineau's outrage when she discovered Chapman's duplicity was unbounded. She not only felt betrayed herself, but also felt responsible for having persuaded others to join with her in underwriting the journal. Her friendship with Chapman, and with it her connection with the *Westminster,* came very abruptly to an end.[12]

Three years earlier she had similarly dissolved her ties with *Household Words.* She had long been one of the journal's chief contributors, writing the occasional story, but mainly providing factual accounts of Britain's industries and crafts. Her connection with *Household Words* was reminiscent of her early association with the *Monthly Repository,* and when work on the Comte translation necessitated a temporary suspension of her contributions, Charles Dickens, the editor, expressed sincere regrets. "I require a good deal," he wrote, "to counterbalance your total abstinence from *Household Words* for so long a time."[13] Nevertheless, for some time ideological differences had been separating Martineau and Dickens. For one thing, she thought that Dickens's views on women were too often demeaning. She challenged him with ignoring the fact that "nineteen-twentieths of the women in England earn their own bread," and she accused him of thinking that woman's only function was "to dress well and look pretty, as an adornment to the homes of men." She objected as emphatically to Dickens's views on political economy, and it was his endorsement of factory legislation that motivated her to write "The Factory Controversy" in 1855. Earlier in the same year the final breaking point had come when she had criticized Dickens's "anti-papist" attitude. She told the assistant editor of *Household Words,* William Henry Wills, that as an "advocate of religious liberty" and a "lover of fair play" she could no longer write for an anti-Catholic

publication. Instead she began sending articles to *Once a Week,* to *The Leader* and, from 1859, to the American *Anti-Slavery Standard* and the *Edinburgh Review.*[14] This was her first connection with the *Edinburgh Review,* for despite an association in the 1830s with the *Edinburgh* reviewers Brougham, Empson, Jeffrey, and Sidney Smith, Martineau had not contributed to the then chief organ of Whiggery. By mid-century, when Whiggism was being transformed into liberalism, she probably no longer had any great conscientious objection. The editor, Henry Reeve, was a cousin, and she quite happily transferred her loyalty from Chapman to Reeve, and her more important articles from the *Westminster* to the *Edinburgh.*[15]

Martineau's chief literary commitment from mid-century was not, however, to the journals but to the press. In 1852 she had become a leader writer on the London *Daily News.* So earnest was the devotion with which she served the *Daily News,* that at the onset of her illness she told Maria Weston Chapman that she intended at all costs "to work to the last in the Daily News." The *Daily News* was a liberal daily begun under the editorial direction of Charles Dickens in 1846. After seventeen issues Dickens was succeeded as editor by his friend, and later biographer, John Forster. Frederick Knight Hunt became editor in 1851 and it was he who conferred upon Harriet Martineau the opportunity to become "a gentleman of the press." In her opinion the *Daily News* was "the next paper to the Times in circulation, and high above it in character." She soon developed the same easy friendly relationship with Hunt and his successors as that which she had enjoyed with Chapman before 1858. Her letters to Hunt, like her letters to Chapman, were charming, insouciant, and fondly impertinent. Hunt's premature death in 1854—leaving Martineau and the rest of his staff at the *Daily News* "in a state of suspense and orphanhood"—came as an immense personal blow.[16]

Beginning with an occasional leader in 1852, Harriet Martineau eventually contributed more than sixteen hundred leaders, letters, and obituaries to the *Daily News* over the fourteen-year period of her association with the newspaper. "Doing pretty well for a dying person," she was writing, at her peak, as many as four, five, and even six leaders a week. Illness did not diminish her lively interest in the world, nor her sense of duty, and, if inclined to be polemical, her articles were nonetheless pertinent and crisply written. She felt herself to be too far from London and the center of events to write "hot and hot" news. She was dissatisfied with both the cost and the speed of the postal service, as she repeatedly informed a sorely tried Rowland Hill, but it nevertheless took only two days from the time

she received the mails for her rapidly dispatched articles to appear in print.[17] Her subjects ranged over a wide field of foreign and domestic affairs. She gave her opinion on political, social, and economic conditions. She wrote about war in Crimea and about imperial policy in Ireland, India, and the colonies. She expressed her continued concern for education at all levels of society. She argued for public health, political, legal, and prison reform. She kept the question of slavery in America before the consciences of her English readers. And she used the pages of the *Daily News* as well as those of the *Edinburgh Review* to vent her opinions on the rights of women. Some of these themes were new because circumstances made them so, but many were old abiding interests, and in the journalism of her later years, Martineau summed up the opinions of a lifetime. It would be almost impossible to summarize Martineau's views on all the questions which preoccupied her in her final years, but we shall sample her attitudes on some of the more important of these: the Crimean War, India and the Mutiny of 1857, abolition and civil war in the United States, questions concerning the working class, and the rights and roles of women.

The Crimean War

Harriet Martineau was born during the Napoleonic era, and her earliest memories were of a nation at war. Perhaps her abhorrence of war had its origins in those early recollections. In 1823, when her writing career was just beginning, she told James that she was thinking of writing a "condemnation even of defensive war." Later her pacific inclinations were reinforced by political economy arguments which opposed the disruptiveness of international conflict and favored peaceful trading relationships and by the Garrisonians who similarly stressed the qualities of peace. In the first volume of the *History of the Peace*, written in 1849, she described war as a season when "the great natural laws of society are obscured and temporarily lost": a time when the solitary benefit to be reaped was "a national idea . . . for the people's heart and mind to work up to."[18]

The "national idea" which caused Harriet Martineau to abandon pacifism in the years immediately following was loyalty to the principle of democratic representative government. Europe had been balanced between the promise of democracy and the menace of despotism since 1815. To Martineau the archetypal symbol of despotism was Russia, and she feared the threat of Russian tyranny more than she feared war itself. She had acquired a firsthand knowledge of

Russian despotism from the Polish refugees whom she had met and aided in the 1830s, and at that time she had so angered the Czar by her denunciation of Russian despotism in the *Illustrations of Political Economy* tale *The Charmed Sea* that he ordered every copy in his empire to be destroyed and denied Harriet Martineau the right to cross his borders. In 1838 Martineau met the arch-Russophobe David Urquart, and his "ferocious discontent" may well have further influenced her. By 1849 she clearly had come to consider that war between Russian despotism and western self-government was already begun. In the *History of the Peace* she warned that "it would be a treachery to the cause of Freedom to forget that from Russia will proceed, sooner or later, the most perilous attacks she has yet to sustain."[19] When Russia's threatening gestures became explicit, she told her *Daily News* readers that there could be no accommodation between the democracies of the West—however flawed and incomplete—and the autocracy of the East. "There can be no possible amalgamation between the two systems—no truce between the two principles:"

> We wish most heartily for peace: but it must be that peace, as heroic as war, which will not sacrifice good faith or social duty to its own preservation. [*Daily News*, July 20, 1853]

In her own mind there was clearly no question of compromise. When the war of opinion ended and the battle began in earnest with the Russian attack on Turkey in October, 1853, she believed it to be Britain's duty to act. Russian tyranny had to be confined within its own boundaries not so much in defense of Turkey as in defense of liberty.[20]

Martineau was not motivated by an imperialist desire to see an extension of British influence. Hers was a genuine fear of Russian oppression, and her Russophobia was symptomatic of that which swept England at the time of Crimea. Her relentless leaders on the subject undoubtedly contributed to the general hysteria, and in this she was sharply at odds with those of her erstwhile liberal colleagues who joined the Peace party. Both Cobden and Bright remained true to the principles of the free trade philosophy and denounced the war, but Martineau believed that the cause of liberty was at stake. "We have to do what is morally right at all cost." Although she was more idealistic than chauvinistic, her pronouncements, for one so recently pacific, were surprisingly warlike: she embraced her new cause with as much enthusiasm and belligerence as she did all her

causes. When Britain's participation in the war still seemed uncertain she upbraided Lord Aberdeen for being "the wetblanket which is turning the national fire into smoke." A few weeks later when Britain finally committed herself to the conflict she urged, ". . . we have now a military and political reputation to uphold, which is, and must be, second to no other." She appeared confident that the British with their "added knowledge, expanded sympathies, purified politics and morals, and confirmed industrial habits," would overthrow the tyrant. And she confided to Milnes

> I rejoice in the war, more than ever. My History (vol. II, p. 517) shows that I, for one, anticipated just the present chaos: and I think that the good principle of the war, and the noble temper of our people in it are just the finest force we could have to carry us through to a regenerate state.[21]

But for all her enthusiasm, Martineau was deeply skeptical of the competence of the British establishment to successfully wage a military campaign. She had been a critic of the government for many years, and even her patriotism could not erase her lack of confidence in an administration still almost wholly aristocratic in its composition. She was afraid that for all the courage of the ordinary English soldier, and for all the righteousness of his cause, he might be "baulked and disgusted by folly in Downing-street." She was quite aware of the fact that four decades of peace may have dulled the British sword.

> It is nearly forty years since we were at war [and] we cannot at all tell how able we are to fight. We mean, of course, that the doubt is as to the ability of our officers, and not the strength and courage, physical and moral, of our soldiers and sailors.... warfare after so long a peace, must be an anxious experiment.[22]

It was not long before her fears were justified. Inadequately equipped, poorly led, and unprepared, the British army was soon reeling, and Martineau, appalled by the hardships inflicted on the British soldiers and by the tragic neglect of the sick and wounded, was quick to blame mismanagement at home: "Our soldiers have gone out against the tyrant with citizen ideas in their minds, and citizen feelings in their hearts; and therefore do we owe them citizen treatment."[23] The armies in the field had suffered needlessly, it seemed, under the incompetent leadership of an aristocratic officer

corps, and except for the valiant efforts of Florence Nightingale, the injured and fever-ridden casualties of the campaign had been callously neglected.

"Our aristocracy have received their rebuke in their proved incapacity to manage our army," she proclaimed. ". . . . the results of our political tendencies have told disastrously on our organization and management." The aristocratic system which Martineau had so long opposed had become one of the casualties of the war. Martineau could draw solace from the fact that at least at home the conflict had struck a blow for liberty and against privilege, even if it had failed to strike a blow for liberty and against tyranny in eastern Europe. At war's end, its chief object, in Martineau's view, had not been achieved. Russia had merely been contained and freedom was still in jeopardy.[24] She did not recommend that Britain resort to arms again even to defend freedom. When in 1859 the Italian battle of liberation against Austria began, she hailed the "inevitable struggle" between democracy and autocracy; she praised the "honest, intrepid, devoted Garibaldi"; and she applauded the "fine spirit" of the Italians; but she did not suggest that British troops be committed in support of the struggle. She suspected that Louis Napoleon's intervention on the Italian side was motivated by his imperial ambitions, and although her intense personal dislike of the "French usurper" made her a less than impartial observer, the perfidy of Villa Franca seemed to bear out her suspicions and to justify her conviction that British neutrality had been wise.[25] The lesson of Crimea was not easily forgotten, and Harriet Martineau's brief flirtation with "jingoism" was over.

India and the Mutiny of 1857

Martineau had viewed Crimea as an ideological and not as an acquisitive war. At the start of the Crimean campaign she had warned

> We must take care . . . that no diplomatist or military leader in our service shall be permitted to harbour the idea of *our* planting ourselves down, on any pretext whatever, in any country abroad, for other purposes than preparation for finishing the business that sent us there. [*Daily News*, August 3, 1854]

Her attitude toward empire had always been that of the ripe-fruit school. She believed that "the time is come for aiding our dependencies to establish themselves as communities . . . independent in those particulars in which each is the best judge of its own interests."[26] She

criticized deliberate imperialist aggressions such as the Opium War, generally opposed territorial conquests unless they were the only alternative to war, and in the *History of the Peace* had written:

> Future generations are subjected by those who first established a footing by force in a barbaric quarter of the globe. Such men little know what they do—to what an interminable series of future wars they pledge their country; what an embarrassment of territory, and burden of responsibility, and crowds of quarrelsome and irrational neighbours, they bring upon her; and how they implicate her in the obligation to superintend half a continent—or perhaps half the globe.[27]

She had been influenced by the Durhamites Buller and Wakefield—in spite of her moral disapproval of the latter—to think of England's colonial empire in terms of consolidation and improvement rather than in terms of aggrandisement and expansion. England, she argued, should not seek greater conquests but should concentrate on the efficient administration of those territories which she already possessed. She recognized—forty years before Joseph Chamberlain and new imperialism—the essential importance of the underrated, poorly staffed, and impermanently officered Colonial Ministry. Appreciating the complexity of Britain's empire, she pointed out the folly of placing such a vital and complex department under the leadership of political appointees who needed to consult a map in order to discover where Her Majesty's territories lay.

As a ripe-fruit theorist, Martineau believed that all Britain's dependencies should eventually achieve independence. A personal friend of the Lambtons, she had been intimately concerned with Lord Durham's Canadian ordeal in 1838.[28] And it is surely no coincidence that in *How to Observe Morals and Manners,* written in that year, she should have said:

> The moral progression of a people can scarcely begin till they are independent. Their morals are overruled by the mother country; by the government and legislation she imposes; by the rulers she sends out; by the nature of the advantages she grants and the tribute she requires; by the population she pours in from home, and by her own example. Accordingly, the colonies of a powerful country exhibit an exaggeration of the national faults, with only infant virtues of their own, which wait for freedom to grow to maturity.[29]

But the Whig government had failed to appreciate Durham's advice, in her view, and continued to ignore "the desire of our colonies for participation in the best privileges of the British Constitution."

With this attitude toward empire it is not at all surprising to find that Martineau was a severe critic of Britain's India policy. Her opposition to the exploitation of native populations extended back to the *Illustrations of Political Economy* tale *Cinnamon and Pearls,* and forward to Governor Eyre of Jamaica's "... flogging, hanging and shooting of nonresisting victims without trial [which] can never be reconciled with the professed principles and practice of English govt."[30] She did not entirely object to the British presence in India, for like most of her contemporaries she feared that chaos might ensue if the British withdrew precipitously. Yet she was painfully aware that British rule had not brought peace. Britain's expenditures in India, she noted, were forty-two times greater on war than they were on public works. Native law and custom as well as community organization had been undermined. Indians played a diminishing rather than an increasing role in the government of their own land. And instead of the growth of indigenous industry, the old arts and manufactures of India had been allowed to fall into decay.[31]

At the time of the Mutiny of 1857 India was still under the administrative control of the East India Company. The Company had lost its trading monopoly in 1833 and had come under increased government review, but it was still responsible for the revenue, administration, and defense of the subcontinent. Company attitudes and policies in India were not consistent, for each of the three presidencies was governed independently, the Company had a different relationship with each of the principalities, and each pro-consul brought his own idiosyncracies and his own prejudices to the job. There were, however, two recognizable and powerful influences on the Indian administrators: the influence of Evangelicalism which sought to Christianize and Anglicize; and the influence of utilitarianism, represented by James Mill at India House, which sought to centralize and codify. James Mill believed that India should be ruled by authoritarian fiat and not by means of representative institutions. Believing the Indian social structure and culture to be inferior, he sought improvement by reforming and codifying the laws, simplifying the tax structure, and centralizing the government. The Evangelicals, for their part, wanted to convert India to the Christian religion, the European civilization, and the English language. The effect of both Evangelicalism and utilitarianism was to discredit Indian custom, and to impose the legal, religious, and moral mores of an alien culture upon the inhabitants of a vast and diversified land.[32] Although this policy did not ultimately achieve its goal, it nevertheless succeeded in eroding the indigenous systems of politics, land

tenure, and taxation, and until the ethnic revival at the end of the nineteenth century, even to some extent the native culture.

When the Indian Mutiny occurred, Martineau, with her unerring sense of timing, was ready to cater to the public's aroused attention. She wrote about India in the *Daily News,* and she published *The History of British Rule in India* in 1857, and *Suggestions Towards the Future Government of India* in 1858.[33] In general she accepted the fact of the British presence in India but believed that India should be ruled according to Indian ideas, with the assistance of the Indians themselves, and with the aim of developing India for the Indian. It was an attitude consistent with the political economy ideas of the *Illustrations* and compatible with her respect for native society. As *How to Observe Morals and Manners* and *Eastern Life* all too emphatically showed, Martineau esteemed native culture too much to favor a policy of Anglicization. Not only did she recognize the difficulty of achieving Anglicization, but she also perceived the impossibility of trying to lure Indians into the Christian fold. She appreciated the folly of undermining the traditional systems of land tenure, tax collection, and economy, and she was distressed by the blatant bias against appointing Indians to administrative positions. She was too much the democrat to approve of government by authoritarian and alien administration, whether it issued from the Company's offices on Leadenhall Street or from Whitehall. Martineau also had the sensitivity to realize that clumsy British attempts to tamper with inheritance, succession, ancestral worship, and even such practices as infanticide and the suttee were cursed by those "whom they have unconsciously doomed to excommunication here and perfidy hereafter." In her opinion, instead of drawing closer together over the years, Briton and Indian had grown further apart. And as a Comtean she realized the futility of attempting to alter a part of a society before the whole of it had undergone a metamorphosis; she appreciated that reforms thus superimposed would "make eternal enemies of the subject people, or break their hearts."[34]

Martineau believed that Britain's maladministration had made mutiny almost inevitable and certainly predictable. She consequently denounced the stupidity of British officialdom as the cause of the outbreak, and she deplored the vindictiveness with which the British press now castigated "a hundred millions of our fellow subjects in the East." Far from blaming the Indians, Britain, she told her *Daily News* readers, should have anticipated the atrocities of 1857 for "where is cruelty to be expected if not among a depressed people?"

> We cannot innocently proceed to settle the future destiny of the people of Hindostan while under the influence of such sweeping denunciations of them, and while so ignorantly astonished at their vices. [*Daily News*, February 1, 1858]

Vengeance was not the answer.

> We must do nothing in a temper of mere wrath at an outbreak of spirit which we have not understood; and we must omit nothing in the way of retribution and future control which is enjoined by the strict justice that alone binds people to us.[35]

She regarded the mutineers as "a helpless multitude" which had been victimized as much by the incitement of the old Moslem hierarchy as by the ignorance of British officials. Nevertheless she saw the British presence in India as a duty and was convinced that without the protection of Britain, the "helpless multitude" would, if anything, be more oppressed under the historically callous control of the native aristocracy. For all its faults, British administration, she thought, brought a degree of justice and order to India, and she hoped that as a result of the Mutiny there would be a much greater understanding between the governors and the governed. Her hopes were not realized, however, and British rule in India remained authoritarian. When the Company was dissolved in 1858 and Parliament became the arbiter of Indian affairs, the Indians played a diminishing rather than an increasing role in their own government. Instead of the development of a greater sympathy for Indian culture, the converse actually became true. To Martineau the substitution of the British government for the East India Company appeared to be a regression rather than an improvement, for during its tenure the Company had acquired at least some knowledge of Indian character and had gleaned some wisdom from years of experience in the area. Ironically, Harriet Martineau, the old critic of the Company, became its champion in its waning days.[36] She continued to plead for a greater degree of comprehension and sympathy in the governing of India, for the participation of Indians in their own administration, and for the Indianization of the civil service.[37]

> A good government is not at liberty to refuse the advantages of the traditional association of the most cultivated class of natives. . . . The upper class natives have pride of tradition and they should be allowed to use this pride to stimulate future generations instead of ignoring and disaffecting them. [*Daily News*, April 19, 1861]

But her advice—sound as it now seems in retrospect—went unheard and in her time the lines between the conqueror and the conquered became more rigidly drawn than ever.

Abolition and Civil War in America

On the other side of the world battle lines of a different kind were being drawn, and in the crucial decade which was to see the extinction of slavery in America, Harriet Martineau's was to be one of the most influential voices in the English press. "It was Harriet Martineau alone," said William Edward Forster, "who was keeping English public opinion about America on the right side through the press." Having battled slavery for a quarter of a century, Martineau saw herself as a keeper of the English conscience on the question. "I think the state of the world keeps me alive,—especially the American part of it," she told Philip Carpenter. "There is so much work to be done!" At the onset of her final illness when she did not expect to live long enough to see the resolution of the slavery issue, she wrote what she expected to be her last letter to William Lloyd Garrison.

> Twenty years ago, I considered the Abolition question in your country the most important concern of the century; and my sense of its importance has deepened with every passing year. . . . If your countrymen permit your republic to decline into dark despotism for the sake of its one despotic institution, they will have perpetuated the most desperate crime, and created the most intolerable woe, ever wrought by an association of human beings.[38]

But Harriet Martineau was destined to witness emancipation, and in the final struggle her voice did not remain mute. As a longtime observer of American affairs, she continued to inform the public as she had always done in the past. She kept her *Daily News* readers up to date with political and constitutional developments in the United States, and she explained for them the significance of the territorial struggle between the free and slave states. Slavery, she reasoned, had always been protected by a congressional balance in favor of the South. Southern representation in Washington was, she said, "out of all proportion to the population," and in order to maintain its proportional preponderance, the South was "driven to territorial aggression and encroachment on the Constitution." She watched free states and slave states battle to extend their influence as the nation expanded westward, and she

indignantly observed that the free states too easily permitted "all
this ravage."

> With the numbers, the industry, the wealth in their own hands, why
> have they allowed the slave-power to over-ride all other interests, and
> determine the entire policy of the United States for so long a course of
> years? . . . the South poor and half-peopled . . . has overborne all the
> rest. It has impressed a retrograde character on the whole policy and
> government of the nation . . . and jeopardized free institutions all over
> the world.[39]

The purpose of the Missouri Compromise of 1820 had been to con-
tain slavery in the South, but Martineau saw that even this partial
measure was eroding in the 1850s. She made note of the Fugitive
Slave Bill and the Compromises of 1850 which traded concessions
between the free and the slave states. She deplored the Nebraska Act
of 1854 which made possible the extension of slavery north of the
Mason and Dixon line and into the area which should have been free
by reason of the Missouri Compromise. She recognized as the portent
of a great crisis the Dred Scott decision of 1857 which, in effect,
legalized slavery throughout the federal territory by condemning
slaves to bondage in perpetuity no matter where they resided.

For Harriet Martineau the slave question was the axis about which
American destiny turned.

> Every public movement in the United States is, and long has been,
> determined by the immediate condition of the slavery question; and
> that question supplies the whole group of tests by which the political
> conduct of every public man will necessarily be tried till the contro-
> versy is extinguished in one way or another.[40]

Although apolitical, as were the other Garrisonian abolitionists, Mar-
tineau had welcomed the prospect of a Republican victory in the
election of 1860 as an omen of change.

> The struggle has come at last, after being long foreseen as inevitable—
> the struggle to overthrow or to maintain slavery as a national institu-
> tion in a democratic republic.[41]

But though Martineau had nurtured the hope that the Lincoln ad-
ministration would at last achieve emancipation, the new president
had initially disappointed her. In order to propitiate the large
unionist faction in the North, he had at first tried to compromise
and conciliate. Instead of proclaiming the freedom of the slaves, he

even—anathema to the Garrisonians who had so ardently and long opposed the Colonization Society—suggested a "monstrous" scheme for colonizing freed blacks. Thus, when emancipation eventually came in 1863, it seemed to Martineau that the President had dragged his feet too long.[42]

Martineau, following the lead of William Lloyd Garrison, had regarded an "Idolatry of Union" as one of the chief obstacles to abolition. Because the North was bartering its own morality as well as the freedom of the slave in order to preserve the union, the abolitionists had begun to talk about dissolution of that union in the late 1830s. Martineau eventually joined the anti-union chorus when it appeared to her that northern liberty and southern slaveholding could no longer be reconciled. She did not think that by seceding, the North would be abandoning its responsibilities toward those still shackled in the South, for she was certain that the slaveholding minority would be unable to prevail in the event of the inevitable "servile war."

When the Fugitive Slave Law and the Dred Scott decision placed the rights of blacks living in the free states in jeopardy, it seemed to Martineau that the very essence of the American Constitution was being sullied by legislative compromise. She therefore welcomed the proliferation of Disunion Associations in the northeastern states, for it appeared that secession by the free states was by far the most honorable course.

> The old Constitution laden with new corruptions, cannot serve and sustain the Republic. We believe that if a radical reconstruction is not immediately agreed upon, there must be a dissolution of the Union.[43]

But the American Civil War was fought to prevent a *southern* secession and to preserve the very union of which Martineau and the abolitionists had despaired, and when the war began, she rejoiced because she saw it as an opportunity to end slavery at last and rewrite the Constitution without compromise or evasion. She still opposed war in principle, but as with Crimea, she was prepared to accept the cost of conflict when principle was at stake. She championed the North unequivocally, and was confidently assured that with its greater manpower, its more sophisticated financial structure, and its superior cause, it would prevail. Emancipation so long sought after was, she felt certain, at last at hand.

> I did not expect to see America cease to be a slaveholding *nation*. . . . My quarter of a century's work is over. . . . There is a good deal to be

done still in America; but as a State institution slavery must soon go out.[44]

≥∾

For Martineau and Britain, the American Civil War raised many issues besides those associated with slavery.[45] Although Martineau never permitted these to detract—either in her mind or in her writing—from the essential question of abolition, she nevertheless reviewed these matters with a candor which sometimes brought her into opposition with the very states she was supporting in the conflict. One of these was the question of free trade. By 1860, Britain had become in essence a free trade nation. The British were antagonized by the tariff system maintained by the northern states, and Harriet Martineau, a longtime antiprotectionist, opposed the tariff both because of the principle involved, and because she feared that the North's policy would drive the British into the arms of the free-trading, cotton-producing South. She made her opposition to the North's trading practices quite clear, but she never permitted her disapproval to obscure the slavery question: "It is not true that I think a Protectionist policy worse than slavery," she protested, when her criticism of the North's commercial system caused an immediate and angry response from some of the readers of the *Anti-Slavery Standard*. But Martineau's fears were not unfounded. Britain was so antagonized by northern trading restrictions and so dependent on southern cotton, that it looked for a time as if she might rally to the support of the South. The *Trent* affair further estranged the British and even Martineau was upset by the boarding of a neutral British vessel at sea. She chided the North about the *Trent*'s violated sovereignty. "Your government has outraged your best friend. . . . Retraction is the only alternative to war." Nevertheless, in the pages of the *Daily News* she sought to placate ruffled British pride rather than to further inflame it. She nervously watched the growth of a sentiment favoring the South, and did what she could to keep the slave question in the forefront and to minimize the impact of northern impudence. Martineau blamed *The Times*, which she called the voice of the "old planter interest," for encouraging a prosouthern sympathy. She told Milnes that "If war between us and the United States were possible (which I am confident it is not) it *wd* be a duty and a necessity to remember to publish how far The Times is answerable for it." *The Times* spoke for many in England who not only feared the impact of the Civil War on British commerce but who also— until emancipation in 1863 made slavery an explicit issue in the campaign—championed the South's right to self-determination.

There always appeared to be the danger that the British government might be persuaded by popular sentiment to run the northern blockade and thus sustain the South. To thus risk British involvement in hostilities and prolong the war would thwart the prospects of emancipation.

> It is of serious consequence to us that our trade is injured, and that our chief manufacture is paralyzed for a time; but it is of graver consequence still that civilization should not be set back by the establishment in this century of a retrograde . . . society in place of the free progressive republic.[46]

The cotton famine which stopped the factories of Lancashire and caused the destitution of thousands of mill workers was to Martineau especially poignant as it must have seemed so needless. Besides arguing the immorality of purchasing a slave-grown product and thereby perpetuating the need for slave labor, she had for years been pointing out the danger of Britain's dependence on southern cotton.

> England is far too dependent on America for her cotton. There is too much risk in relying on any one country . . . when the country . . . has been at war with us more than once, and might possibly some day be so again. . . . When we add the consideration that cotton in the United States is raised by slave labour, and that the only certainty about slave labour is that it will sooner or later become free, it is evident that we cannot too soon set about providing ourselves with cotton-fields in various parts of the world, and especially, if possible, within our own dominions.[47]

But her farsighted suggestion went unheeded and during the American Civil War the Lancashire factory workers paid a very bitter price.

For all their hardships, the Lancashire operatives did not turn to violence, leading Bright and the other political reformers, including Martineau, to argue for the enfranchisement of a working class which had shown its worthiness of political responsibility by enduring privation rather than rioting in support of the cotton-producing, slaveholding South. It is a theory recently challenged by Mary Ellison in *Support for Secession: Lancashire and the American Civil War* (1972).[48] The Free Traders, Ellison says, created a deliberate myth and knowingly misrepresented what was a large actual support for the South, especially in Lancashire's more depressed areas. Using

selected journalistic evidence, Ellison demonstrates that a substantial prosouthern sentiment existed in the cotton manufacturing county. Her evidence is persuasive, but nevertheless, the facts remain unchanged: the workers did *not* rise in rebellion or attempt in any way to coerce the British government to intervene on the side of the South. If indeed the workers' support for emancipation and their willingness to suffer for it *was* a deliberately contrived myth, then Martineau's role in helping to create and perpetuate that myth in the pages of the *Daily News* becomes difficult to explain. As a Free Trader and colleague Martineau could not have been the unwitting instrument of Bright's supposed scheme. She must have been a knowing coconspirator if a conspiracy ever existed. But her letters give no indication that a plot to delude Parliament into extending the franchise existed, and it is rather doubtful that she would have lent herself to such a purpose. Her basic honesty and journalistic integrity would have rebelled at such duplicity. Her intimate connection with the Free Traders precludes the possibility that she was a victim of the so-called deliberate misconception, and her behavior seems to indicate that she truly believed in both the loyalty and the emancipationist sympathies of the cotton operatives. She assuredly would not have encouraged the drive to relieve the distressed Lancastrians if she had suspected them of southern sympathies. For Harriet Martineau, the emancipation question came first.

Martineau lived to see the end of the internecine war, to grieve over the assassination of Abraham Lincoln, and to witness the disasters of Reconstruction.[49] But her task as an abolitionist was at last ended, and there was hope that finally the promise of the American Constitution would be fulfilled: the promise which in *Society in America* she had thought such a mockery, that "all men are created equal; that they are endowed by their Creator with certain inalienable rights; that among them are life, liberty, and the pursuit of happiness."

Some Questions Concerning the Working Class

During the cotton famine, Harriet Martineau had helped to organize relief for the unemployed Lancashire operatives. She had advised relief committees on the provision of clothing and the installation of soup kitchens; she had advocated facilitating labor migration from the stricken areas by providing living accommodation in those places where work was available; and she had even suggested the apportionment of temporary plots to the unemployed although still in principle "unable to countenance permanent schemes of spade

husbandry, workhouse farms, &c." But she considered the "suffering operatives" to be a "national charge," and so in this instance she became an unlikely advocate of charity. Seemingly unaware of the irony of her accusation, she chided the Manchester Chamber of Commerce for their "pedantry in political economy" when they argued against the government procurement of cotton from alternative sources abroad for the depressed industry because, they said, it would "paralyse private enterprise!" Martineau as we have seen was able to pick and choose the exceptions to her general principles, for she was still a proponent of the self-help philosophy herself.

> Every man must owe his true welfare to himself.... he cannot cast his burden upon others without suffering something worse than poverty; and all dependence on Government for any of the essentials of private life is a delusion as enslaving to the spirit of man as disappointing to his hope. As for the present suffering of the unemployed, everybody is grieved at it; but, if the men themselves could not manage to escape it, nobody could help them to do so.[50]

During the temporary slump of 1857 she nevertheless went so far as to recommend that kitchens be set up for the sale—not the free donation—of cheap food, and that the unemployed be put to work on such worthwhile public projects as road building, parks and gardens for the people, and sanitary drainage. Using an argument still heard in many quarters today, she said that by providing work instead of outright charity, society would spare "the honest pride of good working men ... [and] would keep off the encroachment of the idle and the debased." Even this limited endorsement of government-sponsored work projects and soup kitchens made a major exception to the laissez faire rule for one who was still fundamentally opposed to charity because it encouraged improvidence, discouraged frugality, and created a dependence on alms. However, after the Lancashire experience and perhaps because of it, she became much less dogmatic on this point. She admitted that the individual might not always be able to master his or her circumstances, and she urged that society owed it to posterity to "investigate the causes of an apparently boundless pauperism." This was a major concession from one who remained a supporter of the new Poor Law and in essence a liberal, but her optimism had receded before the realities. Although she retained a faith in the individual and in the individual's right and ability to forge his or her own destiny without the interference of the state, the number of exceptions which she made to this

rule increased as time went on. Her hopes for the industrial age had
become tempered by the realization that hers was not the best of all
possible worlds. And although she hoped that it could still become
so, she was forced at the end of her long literary career to relinquish
her utopian expectations and to admit that, "The elder generation
among us have [*sic*] proved to be as short-sighted as other mortals."[51]

ও

Martineau said that she was opposed to the government regulation
of industry because she believed that it threatened the individual's
right to labor. "If there is a right more sacred and indisputable than
any other ... it is a man's disposal of his own industry." But her
opposition to labor regulation was based more on personal bias than
on principle. Martineau's middle-class manufacturing background
inclined her to view matters from the perspective of the factory
owners, who regarded government regulation as harassment of the
employers rather than as protection of the workers. In 1855, ignor-
ing the disquieting evidence of the factory inspectors, she rose in
defense of the factory owners in *The Factory Controversy: A Warning
against Meddling Legislation.* John Chapman refused to publish it as
an article in the *Westminster Review* and warned her of a tendency "to
speak of masters as a band of enlightened well wishers."[52] It was
essentially this faith in the ultimate fair-mindedness and benevolence
of middle-class employers rather than a callous disregard of worker
suffering that underlay Martineau's fidelity to the laissez faire prin-
ciple in industry.

Before mid-century, numerous factory bills had been introduced
to Parliament for the regulation of child and female employment.
The Ten Hours Act of 1847 was limited to the labor of women and
children in the textile industry, and although the act was later ex-
tended to other industries, by and large most industries were un-
regulated and where the law did apply it was systematically evaded.
Long hours and appallingly dangerous and unhealthy conditions
were the rule rather than the exception, and as the evidence of the
parliamentary commissioners began to build—especially between
1860 and 1863—the conscience of Parliament and the nation was
stirred to enlarge the scope and effectiveness of the Factory Act.
This evidence clearly had a sobering effect on Harriet Martineau,
and it is more than coincidence that in 1860 the erstwhile opponent
of factory legislation at last admitted the fallibility of human nature
and conceded that perhaps all employers were *not* indeed "a band of
enlightened well wishers." She still clung to the principle of laissez
faire and insisted that "men ought to be able to guard their own

commodity of labour," but she was at last regretfully forced to admit that in the nineteenth-century world of industrial relations the ideal of laissez faire was more often than not illusory.

> We must consider ourselves under a kind of disgrace in our own eyes and those of others—as, in fact unfit to be trusted in those relations of industrial compact which should need no interference of law if we were wise and strong enough to live in accordance with the highest principles of government—we should not need, nor endure, the interference of penal law in the relation between the buyers and sellers of labour. . . . It ought not to be an office of law to protect the operative from being overworked, deprived of sleep, and of time for meals, and of education; *but it was worse to see operatives oppressed, as they too often were before the protection of the law was provided for them. . . . We have to extend this protection beyond its present range.* [*Daily News*, March 15, 1860; emphasis added]

She urged that the provisions of the Ten Hours Act be extended to cover female and child laborers in the hitherto unregulated industries, and she insisted that "Principles" not be permitted to intervene! True to character, Martineau's embracement of a conviction led her to champion it, and she became an ardent advocate of factory reform for those industries where child labor was still unprotected. It was thirty years since she had opposed the efforts of Lord Shaftesbury. Then she had insisted that "legislation *cannot* interfere effectually between parents and children in the present state of the labour-market."[53]

Martineau still believed in Adam Smith's identity of interests principle, and she still contended that workers and their employers should arrive at a mutual understanding of their problems by means of peaceful negotiation.[54] Although she paid lip service to the workers' right to combine, she regarded industrial labor unions with suspicion and was vigorously opposed to strike action. She preached the wage-fund theory to prove the folly of those workers who believed that "the wages fund is inexhaustible." And she noted that it was in any case usually "the least distressed of the working classes who have struck, for the obvious reason that they alone have resources to begin upon. . . ."[55] She pleaded the main nineteenth-century middle-class argument against unions—that they tyrannized and intimidated the operatives—but it was chiefly her sympathy for the manufacturing class, her fear of the disruption of the economy, and her continued adherence to the identity of interest principle which inspired her opposition. She really had very little understanding of employer-

employee relations in the impersonal world of large industry. Her information about unions came mainly from the masters, and her insistence on individual contract was based on her knowledge of industry as it existed in the "multitude of garrets and small shops" of places like her brother Robert's Birmingham. There, as her nephew Robert F. Martineau informed her, the workers were called "workmen" and not "hands" as in Manchester.[56] In the smaller industries where owner and worker collaborated in close liaison they could far more easily understand each other's viewpoint and could much more readily compromise than could their counterparts in the large factories. Martineau was unable to appreciate that unionization and strike action were the only means of persuasion available to the thousands of operatives in the major industries. She did not realize the ambiguity posed by her support for compact and self-help, on the one hand, and her opposition to unions and strikes, on the other.

Martineau believed that the hope of the working class lay in the prospect of its enlightenment. Because she placed her faith in the individual's right and ability to control his or her own destiny and because of her Hartlean-Benthamite-Comtean belief in the educational process, she remained a life-long champion of national education. Unlike Adam Smith and the other laissez fairists she believed that, except at the upper levels of society where individuals were better able to provide for themselves, education should be the responsibility of the state: for "those most needing education, are most helplessly out of the way of it, under the voluntary system."[57] In 1832 she had called for national education in the *Monthly Repository* articles, "National Education" and "Prison Discipline."

> The moral and religious education of the people is an object too vast in its importance to the well-being of the State, to be left to the voluntary exertions of benevolent individuals and charitable associations. An Education Act, framed on broad and liberal principles, and securing the concurrence of all sects and parties, would be one of the greatest blessings which the legislature could confer.[58]

In the *Illustrations of Political Economy* tale *The Three Ages* she pleaded that national education should be the chief item in the national budget. And in *How to Observe Morals and Manners* she said that without popular education a society could not be called "free."

> The universality of education is inseparably connected with a lofty idea of liberty; and until the idea is realized in a constantly-expanding

system of national education, the education of the less privileged will be distinguishable from the education of the privileged.[59]

When she began writing her *Daily News* leaders her hopes for public education were still unrealized, and she used her position as an editorialist to reiterate the importance of education, "the birthright of every child born into a civilised society."

In the *Daily News* Martineau covered the educational spectrum. She criticized the inadequate schooling available to upper class children and she mourned the educational neglect suffered by their poorer counterparts. She described the "operation of the snobbish spirit which is too often the vice and disgrace of English society in our time," in the prestigious public schools—originally intended for "humbler scholars," but become the preserves of the aristocracy and the wealthier members of the middle class. She privately chided Matthew Arnold for his elitist attitude toward class and education in his report as inspector of schools. She publicly mourned the inadequacy of middle-class education, especially that of middle-class girls. She criticized the poorly administered charitable trusts which frittered away "millions" while "tens of thousands of the youth of the nation are growing up in brutal ignorance, through the neglect of the State." She expressed her disappointment in the ragged schools—she did not like the stigma attached to the name—because they catered to a "somewhat higher class" than those for which they were intended, and left those most helplessly in need of education still in "the outer darkness of irredeemable ignorance." Most of all she continued to call the churches to account for their neglect of education and for the sectarian rivalry which had frustrated national education for more than half a century since the formation of the National, and the British and Foreign societies.[60]

Martineau was concerned about curricula and especially about the differentiation between subjects taught at different levels of society. "Our division of classes, our spirit of caste, is quite broad enough, without being extended into the kingdom of knowledge," she said. She wanted students to learn modern languages in addition to or instead of the traditional classical ones. She made a special plea for the teaching of history, ". . . how we came by our liberties, civil and religious, and how we propose to preserve them." And she believed that all classes should become acquainted with "the implements and employments of everyday life." The upper classes should learn to

respect the manual arts and the working classes should learn to master them.[61]

ह०

In *Introduction to the History of the Thirty Years' Peace,* Martineau had observed that a society ought to be judged by the condition of its laboring class. She was painfully aware that in England the vast majority of that class lived in abject poverty and ignorance, under the most appalling physical conditions, and without representation in the councils of the state. Paying the largest share of the taxes, and with the greatest interest in social welfare, the bulk of the population remained without spokesmen in government.[62] The ruling minority had proved its incapacity to rule, Martineau thought, during the Crimean War. And the voiceless majority, by its "quiet patience" throughout the cotton crisis, were "winning for themselves that political position in their country which it will never be long possible to withold from intelligence and desert proved as theirs is now." She rebuked *The Times* for saying that the "multitude" was "virtually represented" by its "rulers and paymasters." And she demanded that all "intelligent" men be given a share in political action. In answer to members of the ruling minority who feared the revolutionary consequences which an extension of the franchise seemed to imply, Martineau—with a perspicacity which anticipated Walter Bagehot—pointed out:

> We are a nation in the world which need least fear that an enlargement of the electoral body will result in the spread of democratic opinion among us. The truth is, we are the most aristocratic people in Christendom, in our inmost feelings and prejudices; and there is no more prospect of our becoming perilously democratic than there was a century or two centuries ago. No doubt there is some good in our conservative tendencies. They preclude the danger of too sudden changes, and give time for education to keep up with the expansion of popular power. . . . There is mischief, and even danger, in setting up an alarm about the extension of the suffrage, when the impediments to our welfare lie in a directly opposite quarter. [*Daily News,* December 9, 1859]

The democratic spirit, she continued, was totally wanting among the lower classes.

> The whole process is founded on the worship of station, wealth and authority prevalent in the class which is least independent in its politi-

cal action. Every fresh admission to the franchise is an addition of force to the conservative sentiment of the country . . . [And] turns out a reinforcement of the principles and old elements of the polity under which we live. . . . The admiration and reverence are quite strong enough to preserve the constitution.[63]

The Position of Women

Although she was an advocate of franchise reform, and although she believed that the franchise should be extended to women, Martineau did not confuse the two issues. Because she knew that the latter would jeopardize the former she preferred to keep the questions separate. Barbara Leigh Smith Bodichon, visiting Lucretia Mott in America in the 1850s, told her hostess that in England the advocates of women's rights "only wait to claim the suffrage because it would be useless to try for it now."[64] And thus it was that Martineau asked for the extension of the suffrage to those "intelligent and educated *men* [emphasis added] who happen to live elsewhere than in ten-pound houses," while at the same time she believed that

> certain powers as well as rights of citizenship reside in every woman in civilized society; and in proportion to her use of those powers and her exercise of her corresponding duties are her privileges likely to be enlarged, and her wrongs or restrictions redressed.[65]

Martineau believed that the franchise belonged as rightfully to women as it did to men, but she did not see the franchise as a panacea. The main difficulties facing English womanhood as she perceived them were educational and economic discrimination, marital subjection, and the duplicity of the social, legal, and sexual double standard. She herself had managed to overcome the handicap of her sex educationally and professionally, and undoubtedly her experience helped to convince her that equality of education and economic opportunity would enable women to achieve social as well as legal equality and that they would thereby naturally acquire political representation as well.

> It seemed to me from the earliest time when I could think on the subject of Women's Rights and condition, that the first requisite to advancement is the self-reliance which results from self-discipline. Women who would improve the condition and chances of their sex

must, I am certain be . . . rational and dispassionate, with the devoted-
ness of benevolence, and not merely of personal love. [*Autobiography,*
1:400]

It was a testament to the radicalism of the Martineau household
that the young Harriet had grown up with an admiration of Mary
Wollstonecraft. But although she owned a "disposition" to honor
Wollstonecraft as she did "all promoters of the welfare and improve-
ment of Woman," she did not think those women acceptable advo-
cates of woman's cause who argued out of their own personal frus-
trations. It was Martineau's ardent conviction that the advancement
of her sex would best be served by those whose pleas were rational
rather than emotional, and whose lives exemplified woman's right to
equality.

Nobody can be further than I am from being satisfied with the condi-
tion of my own sex, under the law and custom of my own country; but
I decline all fellowship and co-operation with women of genius or
otherwise favourable position, who injure the cause by their personal
tendencies. . . . The best friends of that cause are women who are
morally as well as intellectually competent to the most serious business
of life, and who must be clearly seen to speak from conviction of the
truth, and not from personal unhappiness. The best friends of the
cause are the happy wives and the busy, cheerful, satisfied single
women, who have no injuries of their own to avenge, and no painful
vacuity or mortification to relieve. The best advocates are yet to
come,—in the persons of women who are obtaining access to real
social business,—the female physicians and other professors in Amer-
ica, the women of business and the female artists of France; and the
hospital administrators, the nurses, the educators, and substantially
successful authors of our own country. . . . Women, like men, can
obtain whatever they show themselves fit for. Let them be educated,—
let their powers be cultivated to the extent for which the means are
already provided, and all that is wanted or ought to be desired will
follow of course. Whatever a woman proves herself able to do, society
will be thankful to see her do,—just as if she were a man. . . . The time
has not come which certainly will come, when women who are practi-
cally concerned in political life will have a voice in making the laws
which they have to obey. . . . I have no vote at elections, though I am a
tax-paying housekeeper and responsible citizen; and I regard the dis-
ability as an absurdity, seeing that I have for a long course of years
influenced public affairs to an extent not professed or attempted by
many men. But I do not see that I could do much good by personal
complaints, which always have some suspicion of reality in them. I

think the better way is for us all to learn and to try to the utmost what we can do, and thus to win for ourselves the consideration which alone can secure us rational treatment. [*Autobiography,* 1:400–402]

Martineau's argument against "the Wollstonecraft order" was inspired less by prudery than by concern for woman's cause. She felt that the Victorian woman had a sufficiently uphill race to run without adding to it the handicap of moral disapprobation, and she believed that those advocates of woman's rights who inspired such disapprobation were more a hindrance than an asset to the cause. She did not understand passion herself and had little sympathy for those who allowed it to rule, or overrule, their lives.

Still influenced by the habitual optimism which characterized the laissez fairist, Martineau placed her faith in that natural law which, given half a chance, would enable women to attain their rightful place in society. To achieve this end, the ancient debris of social and economic prejudice had to be cleared away, and Martineau doggedly set herself to the task of publicizing this need. She was confident that the democratization and the industrialization of England would end sex-role discrimination as it "happily" seemed to be ending "much of the peculiar kind of observance which was the remarkable feature of the chivalrous age." She dismissed as "a mere waste of words" all argument about male and female innate superiority, not bothering to challenge Comte's thesis. Instead she pleaded that all individuals be allowed to be "as good as they are capable of being."[66]

ॐ

Both sex-role differentiation and individual accomplishment had their beginnings in the learning process, and Martineau had been decrying the one and pleading the other ever since her 1822 *Monthly Repository* article, "On Female Education." She had begged the divisive and illusive question of whether sexual difference influenced mental capacity even then and had concentrated instead on the importance of education in determining not only the level of female accomplishment but also the lack thereof. "If the soul be early contracted," she had written, "by too great attention to trifles, if it be taught that ignorance is to be its portion, no later endeavours will be of any avail to ennoble it."[67] It was the same argument which Mary Wollstonecraft had used in *A Vindication of the Rights of Woman* in 1792, and yet at mid-century, when Martineau assumed her editorial position, the plea remained unacknowledged. Some male educators, like Matthew Arnold, were more inclined to shrug off the question of women's education than to attack it, ". . . the matter," Arnold told

Martineau, "is as yet too obscure to me, for me to try and grapple with it."[68]

As we have noted, education in nineteenth-century England was divided along class lines. In the lower strata of society illiteracy was the lot of both sexes. Few had the leisure to acquire even the rudiments of knowledge. There was little educational discrimination on the basis of sex in that element of the population which, irrespective of gender, worked for a bare subsistence from its youngest days.[69] Sex discrimination in education occurred in England mainly in that rank of society which could afford to be educated, and the women's education movement of the nineteenth century focused its energies primarily on the quality of secondary and higher education for girls of the middle class. When Martineau wrote about the inequality of girls' education she was addressing herself specifically to the education of girls of her own class. In an article in the *Cornhill Magazine* at the time of the Schools Inquiry Commission in 1864, she was still complaining, as she had some forty years earlier, that middle-class parents were not prepared to go beyond a general commitment to teach their daughters "to read and write, and to practice [*sic*] whatever accomplishment may be the fashion of the time." The middle class, emulating the nobility, were training their daughters to idleness. "Ladies Seminaries" were a byword "for false pretension, vulgarity and cant," governesses were generally too ill-taught themselves to be satisfactory as teachers, and according to the findings of the Schools Commission, only one tenth of the pupils attending grammar schools were girls.[70]

Martineau blamed well-to-do parents who sent their sons to the public schools and universities but who refused their daughters similar advantages. Queen's College in Harley Street and Ladies' College in Bedford Square had been founded in 1848 and 1849, and Martineau had great hopes for the "new order of superior female teachers—issuing from these colleges to sustain their high credit and open the way to a general elevation of female education."[71] But the majority of middle-class parents did not send their daughters to one or the other of these new institutions of female learning, and the number of educators which the two colleges supplied was small. Most girls were still instructed by those who were wholly unqualified to teach, and if taught at all were given a curriculum which differed dramatically from that of their brothers. Martineau had always pleaded for equality in, as well as of, education. If boys were taught mathematics and the classics to "improve the quality of the mind," then girls ought also to be so taught. In *Household Education* Marti-

neau had tried to counter the old argument that education distracted women from their housewifely chores.

> Men do not attend the less to their professional business, their counting-house or their shop, for having their minds enlarged and enriched, and their faculties strengthened by sound and various knowledge; nor do women on that account neglect the work-basket, the market, the dairy and the kitchen.[72]

Martineau never denied that housekeeping was a woman's duty; even the most ardent feminists did not then question this aspect of sex-role differentiation. Mary Wollstonecraft in *Thoughts on the Education of Daughters* (1787) had used an almost identical argument. "No employment of the mind," she had said, "is a sufficient excuse for neglecting domestic duties, and I cannot conceive that they are incompatible. A woman may fit herself to be the companion and friend of a man of sense, and yet know how to take care of his family."[73] And Martineau in asking for equality of education nevertheless accepted the fact of women's domestic responsibilities. She never quite resolved the problem which the additional burden of household duties and domestic training placed on pupils of her own sex.

> Boys have two things to divide their days between,—study and play. Girls have three,—study, the domestic arts and play. At boarding-school the domestic training is dropped out of the life altogether: and at home life without school at all nullifies study. Here is the dilemma.[74]

She did not think that domestic work—in an age when most women still made and mended the clothes of the household and pickled and preserved and baked—should be sacrificed by the intellectual woman; nor did she want to see girls thrust perforce into lives of narrow domesticity and deprived of the instruction their brothers received. It was a dilemma which she was unable to resolve.

Girls were not only mentally confined by an exclusively domestic regimen but were also functionally crippled as far as life in the outside world was concerned. While their brothers were trained for independence, girls were vouchsafed no training at all. The middle-class girl who was unable to rely on a father or husband for her support was usually too ill prepared to maintain herself. Though the

myth of female dependency persisted, as Harriet Martineau pointed out, the reality was slowly changing. The usefulness of the unmarried female relative was waning in the no longer self-sufficient family of industrial England. Few women were as able as Martineau herself had been to face the world unaided and alone. In retrospect she was, in fact, grateful for the opportunity for independence which the impoverishment of her own family in 1829 had given her. But for that financial setback, she acknowledged, she and her sisters might have

> . . . lived on in the ordinary provincial method of ladies with small means, sewing, and economizing, and growing narrower every year: whereas being thrown, while it was yet time, on our own resources, we have worked hard and usefully, won friends, reputation and independence, seen the world abundantly, abroad and at home, and, in short, have truly lived instead of vegetated.[75]

But Harriet Martineau and her sisters had been better educated than most girls, and in spite of her mother's initial insistence that she confine herself to sewing, Harriet's literary ambitions had received positive reinforcement from the family. "Now dear," her oldest brother Thomas had said on reading her first article, "leave it to other women to make shirts and darn stockings; and do you devote yourself to this."[76] But the Martineau family was radical, and its attitude was by no means usual. In 1838, the then poet laureate, Robert Southey had told Charlotte Brontë, "Literature cannot be the business of a woman's life, and ought not to be. The more she is engaged in her proper duties the less leisure will she have for it, even as an accomplishment and recreation." Even Mrs. Jameson had expostulated in the same vein: "All this business of *woman's work* seems to me in a strange state and out of joint. They cannot and will not do their own work, and they want to do other people's." "Mrs. Jameson," Henry Crabb Robinson commented in his Diary of May 1838

> . . . disapproves of Miss Martineau's notion about the sex and their rights—She [Mrs. Jameson] says and it is conclusive—to bear children is the great privilege of women—They must forego that or decline public duties—for the most important part of their life during three quarters of the year they are incapacitated by their condition as wives or their duties as mothers from public life, and to be married is the natural condition of women. If they remain single their character is soured and injured.[77]

But some few women thought otherwise. Florence Nightingale, though admittedly "indifferent to the wrongs and rights of my sex," opposed the "unnecessary division of men's and women's work." And though Martineau was far from indifferent to "the wrongs and rights" of her sex, she like Nightingale took a firm stand against discrimination in employment. She believed that only when women's labor was recognized and encouraged would "our hereditary notions of the dependence and amiable helplessness of women" cease. For the fact was that more and more women were forced by circumstances to earn their own keep. They were paid less than men for "the same kind and degree of work," and they were kept out of certain skilled employments by prejudice and "ancient jealousy." It was time, she said, for the principle of free trade to be applied to the labor market, and for careers to be open to members of the labor force according to ability and regardless of sex. In the *Daily News* she warned that

> if the natural laws of society are not permitted free play among us, we may look for more beating of wives and selling of orphans into perdition; and more sacrifice of women to brutal and degrading employments, precisely in proportion to their exclusion from such as befit their social position and natural abilities.[78]

She peppered the pages of the *Daily News* with her pleas for governesses, nurses, and female doctors and she personally petitioned Parliament in 1870 to admit women into the medical profession on terms of equality. Her pleas for working-class women—for seamstresses and domestic servants in particular—were equally vociferous. Her article "On Female Industry," in the *Edinburgh Review* of 1859, was a classic restatement of her views on women in employment.[79] She hammered again at the need to recognize that a majority of Englishwomen either contributed to or independently provided their own support. Using figures from the census of 1851, she pointed out that of the six million women of working age in England, two million wholly supported themselves and another three million did work of some kind. The vast majority was underpaid and exploited. They worked mainly in domestic service and in the factories and sweated trades. And even when they performed the same tasks and worked the same hours, they were paid less than were their male counterparts. She was pleased to see that women were no longer permitted to work in the coalpits, but apart from this exception she wanted equality of employment opportunity for her sex. She wanted to see women paid like men, and

included in those professions and crafts which traditionally excluded them. She did not permit her optimism to entirely desert her in spite of the generally dismal picture which female labor and opportunity presented in nineteenth-century England. She believed that, in the end, industrialization would emancipate women by relieving them of the drudgery of having to produce all their own needs and by enabling them to occupy those positions which they were entitled to share with men. For, she argued, had not women like Florence Nightingale, Mary Carpenter, and Mrs. Somerville—as well as Martineau herself—already proved "that the field of action is open to women as well as men?"

ð➤

Meanwhile, work was still considered déclassé by members of the wealthier classes, and it was only the working-class and less endowed middle-class women who earned the dubious privilege of supporting themselves. Marriage continued to be the young middle-class woman's only avowed vocation. As the ward of either a father or husband, she was by law and by custom a perpetual minor. Her role at home became more secondary and undemanding as industrialization simplified her housekeeping task. Some few exceptional men and women achieved a marital partnership, but the vast majority of wives claimed no such equality within the family. Most wives believed that they owed their husbands obedience, and even the Queen humbled herself as a wife.

Before its gradual reform in the nineteenth century, the law of the land reinforced women's subjection in marriage. When they married, women surrendered their property to their husbands; they were unable to claim title to their earnings; they were not permitted to petition for divorce or even to defend themselves if their husbands sued to divorce them; they could not give evidence against their husbands even in cases of brutality; and if divorced, they lost all—even visiting—rights to their children. Martineau had long been a vigorous opponent of this legal double standard. Over the years she had commented on the inequities of the law and had drawn attention to its grudging and gradual amendment. In the *History of the Peace* she lauded Lord Brougham's efforts on behalf of women in the Infant's Custody Act of 1839—"the first blow struck at the oppression of English legislation in relation to women" (2:421–25). In the *Daily News* she persistently sniped at the injustice which made divorce impossible for the poor of both sexes, not legally obtainable by women in all ranks of society, and which assumed as a matter of course "that the sin of conjugal infidelity is immeasurably

greater in the wife than the husband" (March 25, 1853; June 28, 1854). When Barbara Leigh Smith Bodichon petitioned Parliament in 1856 to alter the marriage law, Martineau was naturally one of the signatories—along with, among other notables, George Eliot, Elizabeth Barrett Browning, Jane Welsh Carlyle, Elizabeth Reid, and Elizabeth Gaskell. Martineau meanwhile was telling her *Daily News* readers about "the unprotected condition of women under the law of England, and . . . the liability of women to have their property wasted by their husbands and their earnings appropriated by him." She drew attention to police-blotter reports of "wife-beating," a new term, she noted, which illustrated "the present prevalence of ill-usage of wives." Although pleased with passage of the Marriage Law Amendment Act of 1857, which replaced the cumbersome legislative divorce procedure by establishing a divorce court and which permitted women the right to seek a legal separation from their husbands in cases of gross abuse, she was far from complacent about the extent of the new law's achievement. It left, she said, "some things to be peremptorily desired."[80]

Martineau did not analyze marriage as systematically as Engels was to do in *The Origin of the Family* (1884), but her conclusions about the materialism of middle-class marriage were remarkably similar. It was her opinion that marital unions in her society were based primarily on economic considerations.

> The necessity of thinking of a maintenance before thinking of a wife has led to requiring a certain style of living before taking a wife; and then, alas! to taking a wife for the sake of securing a certain style of living. [*Society in America*, 3:127]

She described the average loveless and mercenary marriage as a "legal prostitution," and she recognized the effect which such marriages had on the morals of the society: "if men and women marry those they do not love, they must love those whom they do not marry."

> In a society where pride and ostentation prevail, where rank and wealth are regarded as prime objects of pursuit, marriage comes to be regarded as a means of obtaining these. Wives are selected for their connexions and their fortunes, and the love is placed elsewhere.[81]

Without condoning marital infidelity, Martineau understood its causes. She called attention to the double standard which winked at

a husband's indiscretions while at the same time it imposed a false chastity on wives—even within marriage. She understood the dangers implicit in the Victorian insistence on asceticism: "Wherever artificial restraints are imposed on the passions," she wrote, ". . . there must be licentiousness precisely proportioned to the severity of the restraint." It was, she said, largely because of the limits placed on conjugal relations that "a large proportion of the girlhood of England is plunged into sin and shame, and then excluded from justice and mercy."[82]

Martineau thought of prostitution as the inevitable result of the society's distorted values, and she was therefore disinclined either to judge or blame the prostitute. In her view, prostitutes were the exploited victims of a system which promoted loveless marriages; which insisted on false female chastity, especially in the upper ranks; and which placed women in a social and legal position of inferiority: "If women were not helpless, men would find it far less easy to be vicious . . . the inferior condition of women has ever exposed those of them who were not protected by birth and wealth to the profligacy of men."[83] These sentiments were unusually liberal and candid in one of her sex, rank, and period, but she, typically, did not hesitate to express them.

Parliament began considering its first Contagious Diseases Bill in 1864. The bill was designed to protect men in the armed forces from contracting venereal disease, and it proposed that in the garrison towns and ports policemen should be empowered to arrest, detain, and examine any woman who was a suspected prostitute. Such women were permitted no legal defense, no proof of prostitution was required, no man was called upon to testify against them, and no appeal was allowed. Martineau immediately understood that the proposed legislation would have wide implications on the already restricted rights of women. In the *Daily News* of July 2, 1864, she fired the first shot in the contagious diseases campaign. She pointed out that the rights of all female citizens were being threatened, that no woman would be legally protected if the bill became law, and that the innocent would be subjected to the same inequities as the "guilty." Apologizing for the awkwardness of the subject but doing her duty as always, Martineau went on: "The awkwardness and difficulty, however, are no justification to journalists for permitting the slightest risk of bad legislation which they may preclude by timely warning."

Despite this brave protest, the bill was passed. It applied only to the garrison towns and because of this received little attention and

aroused only minor opposition. However, in 1869, legislation was introduced to widen the scope of the Contagious Diseases Act so that it would include the rest of the country. Once again, Harriet Martineau was in the vanguard of the opposition. Ill health had forced her retirement from the *Daily News* three years earlier, but her fidelity to duty would not permit her to be silent when her conscience was roused. The subject itself still outraged her modesty. "It was sickening to think of such work," she told Maria Weston Chapman, "but who should do it if not an old woman, dying and in seclusion."[84] On December 28, 1869, she therefore published another letter in the *Daily News*. Englishwomen, she said, would now be forced "to undergo the outrage and heartbreak . . . of personal violation under sanction of law and the agency of the police," in order to safeguard men "from the worst consequences of their own licence." In a second letter published the next day she went on in the same vein.

> Up to the date and the passage of these Bills every woman in the country had the same rights as men over her own person. . . . Now it is so no longer. Any woman of whom a policeman swears that he has reason to believe that she is a prostitute is helpless in the hands of the administrators of the new law. She is subject to the extremity of outrage . . . for the protection of the sex which is the cause of the sin. [*Daily News*, December 29, 1869]

She did not deny the importance of containing the disease, but she feared that the proposed method of containment would endanger and abridge the personal rights of women everywhere. "We cannot, will not, must not, surrender any of the personal liberty which is our birthright" (*Daily News*, December 30, 1869). In all Martineau wrote three letters. They appeared in the *Daily News* on December 28, 29, and 30, 1869. On December 31, the *Daily News* published a fourth letter from the Ladies' National Association for the repeal of the Contagious Diseases Acts. It was signed by one hundred twenty-eight women including, among others, Josephine Butler, Florence Nightingale, and Jessie Boucherette: Harriet Martineau's name headed the list.[85] It was Harriet Martineau, Josephine Butler acknowledged in her *Reminiscences of a Great Crusade*, who had "fired the first round" in the contagious diseases campaign.[86] And Harriet Martineau, in spite of her increasing infirmity, continued to support the cause. She presented the Ladies' Association with fancy-work so that they could raise money, but she considered this "the very lowest

method of assisting the movement," and adopted it only because her "state of health" precluded a more vigorous participation. She wrote addresses for pamphlets and posters when repealers ran in elections in Colchester and North Nottinghamshire. She added her name to petitions. She supported Josephine Butler's National Association for the Promotion of Social Purity which aimed to elevate the morals of the society by elevating the morality of its male members. Now become an almost legendary symbol of the feminist cause, she was asked to lend her aid to many branches of the burgeoning feminist struggle. She supported the Woman's Suffrage Society. She encouraged the effort to obtain recognized qualification for female doctors. She was asked to write an address by the Women's Peace Society in 1873. Her name was placed on the executive committee of the Social Science Congress. And women in the university extension movement, educators in the colleges, and the new female professionals in journalism acknowledged her influence and kept her abreast of their progress in the field in which she had labored so long.

Meanwhile the agitation to repeal the Contagious Diseases Acts had proved effective. In the 1871 bye-election at Colchester the incumbent Liberals lost their seat. The party was forced to revise its attitude toward the acts, and Gladstone initiated a royal commission to examine the question. When the commission voted thirteen to six for amendment the repealers were jubilant, and none more so than Harriet Martineau.

> We never could have dreamed of such a victory. *As* victory no matter. But what a prospect is opened for the whole sex in Old England! For the stronger and safer sort of woman will be elevated in proportion as the helpless or exposed are protected.[87]

"You have done more than anyone else, I really believe," wrote Sir John Richard Robinson, manager of the *Daily News*, "to defeat the plans of the military."[88] But with her characteristic honesty, Martineau penciled the margin of Robinson's letter with the single comment, "No, Mrs. Butler." As it happened, the amendment to the Contagious Diseases Acts was not passed before the end of the parliamentary session and it was subsequently dropped. The last of the Contagious Diseases Acts was not repealed until 1886, fully a decade after Martineau's death. But the movement to defeat the contagious diseases legislation and to protect their rights gave women a greater national stature and provided momentum to a developing feminist consciousness. Few had done more toward this achievement than Harriet Martineau.

In the journalism of the years 1852 to 1866 Harriet Martineau covered everything from postfamine Ireland to the tyranny of the crinoline; touched the nation's conscience on matters ranging from prison reform to sanitation and working-class housing; and discussed every aspect of government from foreign affairs to domestic politics.[89] Concerned always about the welfare of the people, her influence was chiefly extended in support of the minorities and the oppressed: the poor, the Irish, the colonial natives, the American slaves, the women, and the children. She opposed those things which denied natural liberty: the negation of individual rights, monopolies in the economy, oligarchies in government, authoritarianism in the religious establishment, social prejudice, and sexual inequity. Generally humane and almost always in advance of public opinion, her advice too often fell on stony ground. Nevertheless, her influence for good or ill was far from negligible. She stirred the new feminists of the mid-nineteenth century with her views on employment and with her opposition to the Contagious Diseases Acts; she helped keep public opinion on the side of the North in the American Civil War; she fanned the flames of war at the time of Crimea; she insistently drew attention to the inadequacy of national education and to the plight of the unemployed, the exploited, and the unrepresented. In her way, and according to her lights, she played the part of a national conscience.

Epilogue

By 1866 Harriet Martineau had become so ill that she was at last forced to lay down the pen. She ended her fourteen-year connection with the *Daily News,* and with it a forty-five year literary career.[1] She lingered for another decade, debilitated by immense suffering, and sinking for longer and longer periods of the day into the hazy relief which the opiates brought. The pain was unremitting, and she disliked the mental incapacity and disorientation which the drugs induced, but she remained cheerful and busy to the end. She retained a lively awareness of what was happening in the world and was kept informed about events by those interest groups she had served in the past. She still directed the household. She got up and dressed every day. And she continued to do the fancy-work which had always delighted her. Her correspondence, however, dropped off considerably in the last years. Her hand was sometimes less than firm, and she often resorted to dictation. Old friends like Julia Smith and Elizabeth Reid kept a distant and anxious eye on her through mutual acquaintances. She saw only occasional visitors like her neighbors the Arnolds, now become "as intimate as possible."[2] Her niece and companion Maria, the daughter of Robert, had died of typhoid in 1864, and her place was taken by her sister Jane.[3] When Jane's health became frail in 1873 she was moved to a warmer climate and Miss Goodwin came to live with Harriet Martineau in her stead. Harriet's ties with Robert, Rachel, and Ellen remained affectionate, but the breach with the Greenhows and with James was never healed.

Her income was small now that she was no longer able to earn money by her writing, and she was forced to economize. She was receiving modest sums from some investments, from new editions of her works, and from the publication in 1869 of *Biographical Sketches,* a reprinting of her *Daily News* obituaries compiled by the staff of that

publication. But she again refused a pension when Prime Minister Gladstone offered one in 1873: "I have a competence; and there would be no excuse for touching the public money."[4]

Unafraid of death as she had been unafraid of life, Harriet Martineau refused to the last to acknowledge or seek comfort in a belief in the hereafter. In June of 1876 she caught bronchitis, and in her weakened condition lapsed into a final coma. She died on June 27, 1876, and was buried by her family in Birmingham.

Two days after Harriet Martineau's death the *Daily News* published an obituary which Martineau had—characteristically—written herself in 1855 when she thought her death imminent.

> Her original power was nothing more than was due to earnestness and intellectual clearness within a certain range. With small imaginative and suggestive powers, and therefore nothing approaching to genius, she could see clearly what she did see, and give a clear expression to what she had to say. In short, she could popularise, while she could neither discover nor invent. She could sympathise in other people's views and was too facile in doing so; and she could obtain and keep a firm grasp of her own, and, moreover, she could make them understood. The function of her life was to do this, and, inasfar as it was done diligently and honestly, her life was of use, however far its achievements may have fallen short of expectations less moderate than her own. Her duties and her business were sufficient for the peace and the desires of her mind. She saw the human race, as she believed, advancing under the law of progress; she enjoyed her share of the experience, and had no ambition for a larger endowment, or reluctance or anxiety about leaving the enjoyment of such as she had.[5]

It was a mark of Harriet Martineau's candor and her lack of self-delusion that she could evaluate her own career so honestly and dispassionately. "There is no education like authorship," she had once written, "for ascertaining one's knowledge and one's ignorance."[6] For all her dogged confidence in her own convictions, Harriet Martineau seldom had any illusions about her own capacity.

Reviewing the *Autobiography* in 1877, a friend and fellow Lake District resident William Rathbone Greg said of her that she was

> . . . a singularly happy person; and continued to grow happier and happier, illness notwithstanding, till near the end. Her unflinching belief in herself, her singular exemption from the sore torment of doubt or hesitation, helped to make her so. . . . Misgiving seems, indeed, to have been a sensation that was alien to her constitution. . . .

> She never *reconsidered* her opinions, or mused over her judgments. They were instantaneous insights, not deliberate or gradual deductions. . . . [Yet] her confidence in her own opinions was not an irrational conceit in her own powers; on the contrary, her estimate of these was not at all inordinate, but, as may be seen especially in her last obituary notice of herself in the *Daily News,* rather below the truth, not to say wide of it.[7]

Even when they disagreed with Harriet Martineau's opinions, her contemporaries never thought of her as inconsiderable. George Eliot described her as "the only English woman that possesses thoroughly the art of writing," and as "quite one of those great people whom one does not venerate the less for having seen."[8] Matthew Arnold, although dissenting strongly from Harriet Martineau's creed, could not but "praise a person whose one effort seems to have been to deal perfectly honestly and sincerely with herself."[9] Charlotte Brontë had borne similar testimony.

> Without adopting her theories, I yet find a worth and greatness in herself, and a consistency, benevolence, perseverance in her practice, such as wins the sincerest esteem and affection. She is not a person to be judged by her writings alone, but rather by her own deeds and life, than which nothing can be more exemplary and noble.[10]

In the *National Reformer,* a secularist organ, her friend George Jacob Holyoake paid her tribute too: "No woman more brave, or wise, or untiring in the public service has lived this century."

> Her glory was that she not only sympathised with progress, she took trouble to advance it, she worked for it by the labour of her genius.[11]

Martineau's dedication to her duty as she saw it was as much a feature of her personality as it was of the Victorian character. Her dedication to progress had its origins in the dissent and radicalism of her middle-class beginnings. The independence of her temper, born as it was out of the loneliness of her childhood and the isolation of her deafness, further inclined her to radical causes. She possessed, as she herself realized, "too facile" a sympathy for the ideas of others: Unitarianism, necessarianism, laissez fairism, egalitarianism, abolitionism, feminism, mesmerism, empiricism, positivism, and "agnosticism" all impressed themselves on her receptive mind, and once being impressed became articles of faith. W. R. Greg described her mind as "wax to receive and marble to retain."[12] It is true that she

embraced new ideas with a too ready and often unconsidered enthusiasm, and that she held on to them with a too dogged fidelity. Lord Brougham recognized this trait in her as early as 1834, and *The Times* reminded its readers of the late Chancellor's comment in its own obituary notice.

> I fear . . . that it is the character of her mind to adopt extreme opinions upon most subjects, without much examination. [June 29, 1876]

The haste with which Martineau arrived at her conclusions and rushed them into print backed her into many an untenable corner, marred her composition, and flawed her judgment. Once having made up her mind on a subject she refused to listen to countervailing arguments, and she yielded her position only when the decision to do so was her own. In conversation she would sometimes put down her ear trumpet when the discussion began to move in an unwelcome direction.[13] She refused to see beyond the limits she had set on her own horizon, or to listen to voices she did not wish to hear. She could shut out the arguments of a Shaftesbury in much the same way as she shut out her brother James or the memory of John Worthington. This trait distorted her perspective and immured her within the confines of her own conviction. Like a kaleidoscope her mind was directed into a myriad facets, but like a kaleidoscope too, her vision was tunneled, and in spite of her intellectual versatility, her overall view was correspondingly narrowed. It was her singular deafness to certain facts, and her unwillingness to concede her own fallibility, which accounted in large measure for her dogmatism. Nevertheless, it would be a mistake to suppose that her devotion to principle was unvarying, or that she *never* yielded her persuasions. Her early fundamentalism gave way to necessarianism, her Unitarianism surrendered to positivism, and even her laissez fairism was eventually subject to substantial qualification. She was, after all, living at a time when principle and practice could not but be at odds; when radical theory and humanitarian sympathy were in conflict; in a paradoxical age of which she was, in a sense, a paradigm.

Martineau's optimism was as naive as her enthusiasm was precipitous. Utopia seemed possible to the adherents of political economy in the early part of the nineteenth century, and Martineau saw it as her duty to show the way. She had an earnest faith in the virtues of the individual and in the values of the educative process. The greatest happiness of the greatest number seemed achievable if the debris

of ancient privilege could be swept away and if only society could be taught the principles of utility. It was to this end that she dedicated her life, and although utopia was still an unrealized ideal by the time of her death, it appeared to her contemporaries that her efforts toward achieving progress had met with a considerable measure of success. Even *The Times,* which had so often been the object of her criticism in politics and principle, said of her passing:

> If any lady of the 19th century, in England or abroad, may be allowed to put in a claim for the credit of not having lived in vain, that woman, we honestly believe, was Harriet Martineau. [June 29, 1876]

By the time of her death most of Harriet Martineau's more immediate causes had become facts of British life. Her writings had lost their polemical immediacy and the purpose which had made them important. They now seemed to be little more than heavy-handed didacticism and had become literary works of the second rank already declining into obscurity. It was now only Harriet Martineau's personal reputation, that "generous purpose" and those "large thoughts" which had inspired her work, which still drew applause from a new generation of Englishmen. John Morley, speaking for this new generation, described Martineau's literary performance as having "acquired . . . little of permanent value," yet

> behind the books and opinions was a remarkable personality, a sure eye for social realities, a moral courage that never flinched; a strong judgment within its limits; a vigorous self-reliance both in opinion and act, which yet did not prevent a habit of the most neutral self-judgment; the commonplace virtues of industry and energy devoted to aims too elevated, and too large and generous to be commonplace; a splendid sincerity, a magnificent love of truth. And that all these fine qualities, which would mostly be described as manly, should exist not in a man but a woman, and in a woman who discharged admirably such feminine duties as fell to her, fills up the measure of interest in such a character.[14]

Martineau's personal reputation seemed to have outlived her work. She had apparently become little more than a phenomenon: a woman who in defying the conventions had achieved a stature seldom attained by members of her sex.

But the quality which made Martineau seem almost irrelevant by the time of her death was the very quality which had made her important during her lifetime and which makes her important to-

day: her contemporaneity is for the modern historian her most interesting and enduring feature. Martineau was an astute observer of her own era. She seized upon the vital issues of the day, and with that dispatch and fluency which made her such a considerable journalist, she informed her public. She wrote much as she lived, energetically, simply, and as honestly as she knew how: "Yielding a glad obedience from hour to hour."[15]

Harriet Martineau had grown to maturity as a woman and a writer in a nascent era, and change had always been the imperative order of the day. "If we attempt to frame moral systems," she had written in 1832, "we must make them for the present only. We must provide for their being modified as the condition of society changes, or we shall do more harm than good."[16] She was fully aware that she lived in an age of transition—a positivist could not but be thus aware. As one of the nation's radical reformers she had long heralded change, and being without personal ambition, she would have been pleased rather than otherwise to think that her works had become neglected because their objects had been achieved.[17] Although she had marched ahead of most of her contemporaries, and had often been considered reprehensibly out of line by many of them, she was seldom seriously out of step with the more advanced opinions and trends of her day. She was, as John Stuart Mill had said, "a sign of this country and Time."[18] And it is herein that her immortality resides.

Abbreviations

Bodleian	Bodleian Library, Oxford
B. Mus.	British Museum, London
Boston P. Lib.	Boston Public Library, Boston, Massachusetts
B.U. Lib.	Harriet Martineau Papers, University of Birmingham Library, Birmingham
DN	*Daily News*
DW Lib.	Dr. Williams's Library, London
ER	*Edinburgh Review*
Fawcett Lib.	Fawcett Library, City of London Polytechnic, London
Harvard	Houghton Library, Harvard University, Cambridge, Massachusetts
M. Coll.	James Martineau Papers, Manchester College, Oxford
MR	*Monthly Repository*
Tr. Coll.	Houghton Papers, Trinity College Library, Cambridge
University Coll.	University College Library, London
WR	*Westminster Review*
Yale	Beineke Library, Yale University, New Haven, Connecticut

Notes

Chapter I

1. Harriet Martineau, *Household Education* (1849; American ed., Philadelphia: Lea Blanchard, 1849), p. 49 (hereafter cited in text as *Household Education*). See also Harriet Martineau, *Society in America*, 3 vols. (1837; 2d ed., London: Saunders and Otley, 1839), 3:169–70.
2. Harriet Martineau, *Autobiography with Memorials by Maria Weston Chapman*, 3 vols. (London: Smith, Elder, and Co., 1877), 1:9–11, 15–16, 29, 43 (hereafter cited in text as *Autobiography*).
3. Harriet Martineau, "Amelia Opie," in *Biographical Sketches* (1869; American ed., New York: Leypoldt and Holt, 1869), p. 20.
4. Theodora Bosanquet advances this theory in *Harriet Martineau: An Essay in Comprehension* (1927; reprint ed., St. Clair Shores, Mich.: Scholarly Press, Inc., 1971), p. 5.
5. From the notebook of a Norwich neighbor, James Martineau Papers, Manchester College, Oxford. Hereafter references to the James Martineau Papers will be cited as M. Coll. See also James Drummond and C. B. Upton, *Life and Letters of James Martineau*, 2 vols. (London: J. Nisbet and Co., 1902), 1:3–4.
6. Harriet Martineau, *Miscellanies*, 2 vols. (Boston: Hilliard Gray and Company, 1836), 1:182; *Autobiography*, 1:21, 22; see also, for example, *Society in America*, 1:134; *Household Education*, p. 2; *The Crofton Boys* (1842) in *The Playfellow* (London: George Routledge and Sons, 1895), p. 114.
7. *Autobiography*, 1:13–14, 17–18, 58–59; Drummond and Upton, *James Martineau*, 1:9; Harriet Martineau, *Life in the Sick-Room* (1844; 2d American ed., Boston: William Crosby, 1845), pp. 111–12.
8. *Autobiography*, 1:51–52; see also 1:53; *Household Education*, p. 37.
9. *Autobiography*, 1:19, 85–87.
10. See, for example, Erik Erikson, who, in *Childhood and Society* (1950; New York: Norton, 1963), p. 256, describes shame as the product of "foreign over-control" and loss of self-control, and relates the loss of self-control specifically to the functioning of the bowels.
11. *Autobiography*, 1:10.

12. J. E. Amoore, "Olfactory Genetics and Anosmia," in *Handbook of Sensory Physiology*, vol. 4, *Chemical Senses*, pt. 1, ed. L. M. Biedler (New York: Springer Verlag, 1971). I am indebted for this citation to Professor Howard Gadlin, Department of Psychology, University of Massachusetts at Amherst.

13. Henry George Atkinson and Harriet Martineau, *Letters on the Laws of Man's Nature and Development* (1851; American ed., Boston: Josiah P. Mendum, 1851), pp. 124–25, 164.

14. *Autobiography*, 1:39; 3:7, 11, 21.

15. As Erikson states in *Childhood and Society*, p. 249, trust and its corollary faith are fundamental in the maternal administration of children. Trust, he says, "forms the basis in the child for a sense of identity which will later combine a sense of being 'all right', of being oneself, and of becoming what other people trust one will become."

16. *Autobiography*, 1:18–19, 22, 35–36, 45. She also used the carving-knife incident in her novel *Deerbrook*, 3 vols. (London: Edward Moxon, 1839), 2:58. Harriet Martineau to Henry Crabb Robinson, October 29, 1842, Dr. Williams's Library (hereafter cited as DW Lib.).

 In Stephen Kern, "Explosive Intimacy: Psycho-dynamics of the Victorian Family," *History of Childhood Quarterly* 1 (1974):437–61, Kern notes (pp. 456–57) the frequency of nineteenth-century child suicide and cites an 1879 study by Enrico Morselli which suggested shame and fear as the most frequent causes.

17. *Life in the Sick-Room*, pp. 177–78.

18. *Autobiography*, 1:53–54.

19. *Autobiography*, 1:162–69; *Household Education*, p. 154.

20. *Autobiography*, 1:53–56; *Household Education*, pp. 145–47; "An Autobiographic Memoir," *Daily News*, June 29, 1876 (*Daily News* hereafter cited as *DN*).

21. *Autobiography*, 1:72, 124; 2:150; "An Autobiographic Memoir," *DN*, June 29, 1876.

22. *Autobiography*, 1:72–78.

23. *Autobiography*, 1:83, 95–96, 190–94; 2:13; 3:13–14.

24. John Locke, *An Essay Concerning Human Understanding* (1690), ed. Alexander Campbell Fraser, 2 vols. (1894; reprint ed., New York: Dover, 1959), 1:121–22; see also 2:305 ff.

25. "Characteristics of the Genius of Scott," in *Miscellanies*, 1:12; "On the Agency of Feelings in the Formation of Habits," in *Miscellanies*, 1:203 (originally published in *Monthly Repository* 3 [1829]:102–6); "Essays in the Art of Thinking," in *Miscellanies*, 1:99 (originally in *Monthly Repository* 3 [1829]). All identification of Martineau's *Monthly Repository* (hereafter cited as *MR*) articles is from Francis E. Mineka, *The Dissidence of Dissent: The Monthly Repository 1806–1838* (Chapel Hill, N.C.: University of North Carolina Press, 1944). *Household Education*, pp. 13, 16–17, 19, 39, 123–33, 136–37, 148, 159, 164; see also Harriet Martineau, *Retro-*

spect of Western Travel, 2 vols. (London: Saunders and Otley, 1838), 2:132.

26. *Practical Education* was retitled *Essays in Practical Education* in 1801. See Marilyn Butler, *Maria Edgeworth: A Literary Biography* (Oxford: The Clarendon Press, 1972). The Reverend Lant Carpenter, *Principles of Education* (London: Longman, Hurst, Rees, Orme and Brown, 1820), originally in *The New Cyclopedia* (1802–20) ed. Abraham Rees. See also *Autobiography* 1:44, 103 ff., 171 ff., 185; *Household Education,* pp. 62–65.

27. *Autobiography,* 1:100–103, 142, 185; "On Female Education," *MR,* 1st ser., 18 (1823): 79.

28. James Martineau, "Biographical Memoranda," M. Coll.; Drummond and Upton, *James Martineau,* 1:39; *Autobiography,* 1:118; see also Harriet Martineau to James Martineau, Transcript Letters, M. Coll.

29. [Discipulus] "Female Writers on Practical Divinity," *MR,* 1st ser., 17 (1822): 593–96.

30. [Discipulus] "On Female Education," *MR,* 1st ser., 18 (1823): 77–81.

31. Mary Wollstonecraft, *A Vindication of the Rights of Woman* (1792; reprint ed., New York: W. W. Norton and Company, 1967), p. 258; see also p. 286.

32. "On Female Education," p. 80. She wrote these lines twenty-five years before Tennyson wrote *The Princess,* but the sentiment had changed remarkably little in that time. See John Killham, *Tennyson and The Princess: Reflections of an Age* (London: University of London Athlone Press, 1958).

33. Harriet Martineau to James Martineau, October 13, 1822; March 2, 1823, Transcript Letters, M. Coll.

34. Harriet Martineau to James Martineau, October 12, 1825; December 22, 1825; January 12, 1826; February 7, 1826, Transcript Letters, M. Coll.

35. Manchester New College was founded in Manchester in 1786 as a Unitarian educational institution. In 1803 it was moved to York, but it returned to Manchester in 1840. See Drummond and Upton, *James Martineau,* 1:25–26.

36. *Autobiography,* 1:130 ff.; James Martineau, "The Early Days of Harriet Martineau," *DN,* December 30, 1884; Harriet Martineau to James Martineau, October 1, 1825; August 18, 1826; August 22, 1826; December 2, 1826; May 14, 1827, Transcript Letters, M. Coll.

37. Harriet Martineau to James Martineau, February 2, 1824, Transcript Letters, M. Coll.; *Autobiography,* 1:127. For her description of continuing digestive problems and attempts to improve her hearing see Harriet Martineau to James Martineau, August 31, 1827; September 27, 1827; November 16, 1828, Transcript Letters, M. Coll.

38. *Autobiography,* 2:324. Charlotte Brontë did not, of course, ever read the *Autobiography.* Brontë died in 1855; the *Autobiography* was published in 1877.

Chapter II

1. From "Stanzas," in Harriet Martineau, *Miscellanies*, 2 vols. (Boston: Hilliard Gray and Company, 1836), 1:345 ("Harvests of All Time," originally published in *MR* 8 [1834]: 533).
2. "Sabbath Musings," in *Miscellanies*, 1:163 (originally published in *MR* 5 [1831]:684–90); see also Harriet Martineau, *Autobiography with Memorials by Maria Weston Chapman*, 3 vols. (London: Smith, Elder and Co., 1877), 1:44–45, 103–4, 108–9; Harriet Martineau, *Household Education* (1849; American ed., Philadelphia: Lea Blanchard, 1849), p. 151.
3. "On Nature and Providence to Communities," in *Miscellanies*, 2:273 (originally published in *MR* 6 [1832]:248–57); see also *Autobiography*, 1:110–11.
4. Quoted from *History of English Thought* (1876) in Francis E. Mineka, *The Dissidence of Dissent: The Monthly Repository 1806–1838* (Chapel Hill, N.C.: The University of North Carolina Press, 1944), p. 20.
5. Owen Chadwick, *The Victorian Church* (1966–70, reprinted in 2 vols., London: Adam and Charles Black, 1971), 1:396–97.
6. *Autobiography*, 1:39.
7. Harriet Martineau to James Martineau, March 17, 1822; December 7, 1823; December 22, 1825, Transcript Letters, M. Coll.
8. Harriet Martineau, *The Essential Faith of the Universal Church* (1830; American ed., Boston: Leonard C. Bowles, 1833); *The Faith as Unfolded by Many Prophets* (1831; American ed., Boston: Leonard C. Bowles, 1833); *The Faith as Manifested through Israel* (1831; American ed., Boston: Leonard C. Bowles, 1833).
9. *The Essential Faith*, p. 29; see also pp. 15–17, 33, 48–49, 51, 53–55.
10. "Lessing's Hundred Thoughts on the Education of the Human Race," in *Miscellanies*, 2:333 (originally published in *MR* 4 [1830]: 511–17); see also *Autobiography*, 1:153.
11. "Physical Considerations connected with Man's Ultimate Destiny," in *Miscellanies*, 2:212 (originally published in *MR* 5 [1831]: 217–29).
12. Harriet Martineau to James Martineau, October 21, 1830, Transcript Letters, M. Coll.
13. "Sabbath Musings III," in *Miscellanies*, 1:145, 155 (originally published in *MR* 5 [1831]: 139–46).
14. Quoted from Newman's *Oxford Sermons* in Bernard M. G. Reardon, *From Coleridge to Gore: A Century of Religious Thought in Britain* (1961; reprint ed., London: Longman, 1971), p. 134.
15. "Crombie's Natural Theology," in *Miscellanies*, 2:267 (originally published in *MR* 4 [1830]: 145–54, 223–30); see also "Lessing's Hundred Thoughts," in *Miscellanies*, 2:338; "Theology, Politics, and Literature," in *Miscellanies*, 1:191–201 (originally published in *MR* 6 [1832]: 73–79).
16. *Autobiography*, 3:32–34 (from a private memo of June, 1829); and 1:141–43. Harriet Martineau to James Martineau, January 2, 1829;

July 9, 1829; July 17, 1829; August 18, 1829, Transcript Letters, M. Coll.

17. *Autobiography,* 1:149; Harriet Martineau to James Martineau, January 26, 1830, Transcript Letters, M. Coll.

18. Richard Garnett and Edward Garnett, *The Life of William Johnson Fox: Public Teacher and Social Reformer 1786–1864* (London and New York: John Lane, 1910), p. 94 (hereafter cited as *Fox*); Mineka, *The Dissidence of Dissent,* pp. 22, 144 ff., 163–64.

19. Mineka, *The Dissidence of Dissent,* pp. 170, 247, 249n.

20. Garnett and Garnett, *Fox,* p. 80.

21. *Five Years of Youth; or Sense and Sentiment* (London: Harvey and Dalton, 1831).

22. *Traditions of Palestine* (London: Longman, Rees, Orme, Brown and Green, 1830). Note: the first tale in *Traditions of Palestine* was published in *MR* 4 (1830): 101–8.

23. Garnett and Garnett, *Fox,* p. 134; Mineka, *The Dissidence of Dissent,* pp. 207, 241; *Autobiography,* 1:154.

24. Harriet Martineau to James Martineau, January 26, 1830; May 5, 1830, Transcript Letters, M. Coll; see also *Autobiography,* 1:140, 148.

25. Garnett and Garnett, *Fox,* p. 81.

26. Garnett and Garnett, *Fox,* p. 75; see also Harriet Martineau to James Martineau, January 26, 1830. This differed slightly from the account she gave of her daily routine in *Autobiography,* 1:146–47.

27. Garnett and Garnett, *Fox,* p. 81. According to R. K. Webb, *Harriet Martineau: A Radical Victorian* (New York: Columbia University Press; London: William Heinemann, 1960), p. 99, this correspondence has been destroyed.

28. Quoted in Maisie Ward, *Robert Browning and His World,* 2 vols. (New York: Holt, Rinehart and Winston, 1967), 1:29.

29. Quoted in Garnett and Garnett, *Fox,* pp. 43–44.

30. Ibid., p. 112.

31. Garnett and Garnett, *Fox,* pp. 131, 158–59, 169–70, 296–98. Not all Unitarian ministers joined their London colleagues. In fact, a group outside London censured the latter for their action. Among these was James Martineau who had no sympathy for Fox's "obnoxious opinion on the subject of marriage," but who deplored the fact that the London Unitarian ministry had not given Fox the opportunity to defend himself. (Fox became M.P. for Oldham in 1847.)

32. Quoted in Garnett and Garnett, *Fox,* p. 189.

33. Betty Miller, *Robert Browning: A Portrait* (New York: Charles Scribner's Sons, 1952), p. 48.

34. Harriet Martineau to Richard Monckton Milnes, April 21, 1844, Houghton Papers, Trinity College, Cambridge (hereafter cited as Tr. Coll.).

35. Quoted in Garnett and Garnett, *Fox,* p. 189; see also Harriet Martineau to James Martineau, March 6, 1838, Transcript Letters, M. Coll.

36. *Five Years of Youth;* "Liese; or, The Progress of Worship," in *Miscellanies*, 2:1–42 (originally published in *MR* 6 [1832]: 153–61, 239–48, 324–33); *Deerbrook*, 3 vols. (London: Edward Moxon, 1839).
37. *Five Years of Youth*, pp. 62, 114, 150–52.
38. "Liese," in *Miscellanies*, 2:2, 11.
39. "Liese," in *Miscellanies*, 2:27; see also 35–36.
40. "Liese," in *Miscellanies*, 2:14, 28–29, 38; *Autobiography*, 1:149; 3:32.
41. "On the Agency of Habits in the Regeneration of Feelings," in *Miscellanies*, 1:214 (originally published in *MR* 3 [1829]: 159–62).
42. "Sabbath Musings I," in *Miscellanies*, 1:122–23 (originally published in *MR* 5 [1831]: 73–77).
43. "Sabbath Musings II," in *Miscellanies*, 1:130 (originally published in *MR* 5 [1831]: 235–39).
44. Matthew Arnold, "Stanzas from the Grande Chartreuse," (1855).
45. *Miscellanies*, 1:viii; "Sabbath Musings VI," in *Miscellanies*, 1:168 (originally published in *MR* 6 [1831]: 763–70).
46. "Solitude and Society," in *Miscellanies*, 2:56 (originally published in *MR* 4 [1830]: 442–9); see also "On Moral Independence," in *Miscellanies*, 1:182 (not listed in Mineka); also *Briery Creek*, in *Illustrations of Political Economy*, 25 vols. (London: Charles Fox, 1832–34).
47. "On Moral Independence," in *Miscellanies*, 1:182.
48. Thomas Carlyle, *Sartor Resartus: The Life and Opinions of Herr Teufelsdröckh*, ed. Charles Frederick Harrold (New York: The Odyssey Press, 1937), pp. 196–97.
49. "On the Agency of Feelings in the Formation of Habits," in *Miscellanies*, 1:207 (originally published in *MR* 3 [1829]: 102–6).

Chapter III

1. Both Francis Hutcheson (1694–1746) at Glasgow University, and John Gay (1699–1745) at Cambridge had written on the subject before Bentham or Priestley.
2. John Stuart Mill, *Utilitarianism* (1863; 9th ed., London: Longman's Green and Co., 1885), pp. 9–10, 16, 25 (originally published in *Fraser's Magazine*, October–December, 1848).
3. "On the Duty of Studying Political Economy," in Harriet Martineau, *Miscellanies*, 2 vols. (Boston: Hilliard Gray and Company, 1836), 1:281 (originally published in *MR* 6 [1832]: 24–34).
4. R. K. Webb, *Harriet Martineau: A Radical Victorian* (New York: Columbia University Press; London: William Heinemann, 1960), pp. 88–90.
5. See for example Harriet Martineau to Henry Crabb Robinson, January 8, 1841, DW Lib.
6. Harriet Martineau, *The History of England from the Commencement of the XIXth Century to the Crimean War*, 4 vols. (Philadelphia: Porter and Coates, 1864), 1:449–50 (hereafter cited as *History from the Commencement*); Har-

riet Martineau, *The History of England during the Thirty Years' Peace 1816–1846*, 2 vols. (London: Charles Knight, 1849–50), 2:715 (hereafter cited as *History of the Peace*).

7. John Stuart Mill, *Collected Works*, 13 vols., ed. F. E. L. Priestley and J. M. Robson (Toronto: University of Toronto Press, 1963–72), 4:225–28.

8. Mark Blaug, *Ricardian Economics: A Historical Study* (New Haven: Yale University Press, 1958), pp. 138–39.

9. *Illustrations of Political Economy*, 25 vols. (London: Charles Fox, 1832–34), *Life in the Wilds*, p. vi. In addition during the period 1832 to 1834 she wrote *Illustrations of Taxation*, 5 vols. (London: Charles Fox, 1834) and *Poor Laws and Paupers*, 4 vols. (London: Charles Fox, 1833–34), under the superintendence of the Society for the Diffusion of Useful Knowledge (SDUK).

10. *Illustrations of Political Economy, The Moral of Many Fables*, p. vi; Harriet Martineau to Lord Broughan, n.d., University College Library, London (hereafter cited as University Coll.).

11. John Stuart Mill to Walter Coulson, November 22, 1850 in Lord Robbins, *The Evolution of Modern Economic Theory* (London: Macmillan & Co., 1970), p. 125.

12. Blaug, *Ricardian Economics*, p. 139; see also p. 129n.

13. Harriet Martineau, *Autobiography with Memorials by Maria Weston Chapman*, 3 vols. (London: Smith, Elder, and Co., 1877), 1:258.

14. Harriet Martineau to William Tait, August 29, 1833; September 14, 1833, MS. Ogden 101, University Coll.

15. *Autobiography*, 1:70, 138; see also Harriet Martineau, *Biographical Sketches* (1869; American ed., New York: Leypoldt and Holt, 1869) for Martineau's obituary notice of Mrs. Marcet who died June 28, 1858.

16. Jane Haldimand Marcet, *Conversations on Political Economy: In Which the Elements of that Science are Familiarly Explained* (1816; 6th ed., London: Longman, 1827), p. 25; see also James Mill, *Elements of Political Economy* (1821; 3d edition 1844; reprint ed., New York: Augustus M. Kelley, 1963).

17. *Illustrations of Political Economy, Life in the Wilds*, pp. viii, xiv.

18. Ibid., p. xiv.

19. *Autobiography*, 1:161 ff.; Richard Garnett and Edward Garnett, *The Life of William Johnson Fox: Public Teacher and Social Reformer 1786–1864* (London and New York: John Lane, 1910), pp. 83–84; Harriet Martineau to James Martineau, November 1, 1831; December 13, 1831, Transcript Letters, M. Coll. For her agreement with Charles Fox see December 16, 1831, Harriet Martineau Papers, Birmingham University Library (hereafter cited as B.U. Lib), 1048.

20. Harriet Martineau to James Martineau, November 18, 1832, Transcript Letters, M. Coll.

21. Harriet Martineau to Brougham, [1832?] University Coll.; Harriet Martineau to Francis Place, March 29, 1832, British Museum, Add. MS.

35149/145 (hereafter cited as B. Mus.); April 7, 1832, B. Mus., Add. MS. 35149/146; Harriet Martineau to William Tait, August 29, 1833; September 14, 1833; February, 1834, MS. Ogden 101, University Coll.

22. *Autobiography*, 1:193–95.

23. Jane Welsh Carlyle to Helen Welsh, December, 1843, in Leonard Huxley, ed., *Jane Welsh Carlyle: Letters to her Family 1839–1863* (New York: Doubleday, Page and Co., 1924), p. 164.

24. *Edinburgh Review* 57 (April, 1833): 1–39 [William Empson: *The Wellesley Index to Victorian Periodicals* (hereafter cited as *Wellesley Index*)].

25. *Illustrations of Political Economy, For Each and for All*, p. 127.

26. *History of the Peace*, 2:154.

27. There have been some attempts to summarize *Illustrations* but they have not been very successful: Elizabeth Escher, "Harriet Martineaus social-politische Novellen" (Ph.D. diss., Zurich University, 1925); Narola Elizabeth Rivenburgh, "Harriet Martineau: An Example of Victorian Conflict" (Ph.D. diss., Columbia University, 1932); and more recently a chapter in Dorothy L. Thomson, *Adam Smith's Daughters* (Hicksville, New York: Exposition, 1973).

28. Quoted in Blaug, *Ricardian Economics*, pp. 10, 13.

29. In *Illustrations of Political Economy, For Each and for All*, pp. 82–83, 131; *Ella of Garveloch*, p. 144; *Sowers not Reapers*, p. 145.

30. "A Summers Dialogue between an Englishman and a Pole," in *Miscellanies*, 1:290, 294.

31. *Illustrations of Political Economy, The Hill and the Valley*, p. 140; *Sowers not Reapers*, pp. 120 ff.; *The Loom and the Lugger*, 2:82.

32. *Illustrations of Political Economy, The Hill and the Valley*, pp. 139–40; see also *How to Observe Morals and Manners* (1838; American ed., New York: Harper Brothers, 1838), passim.

33. *Illustrations of Political Economy, For Each and for All*, pp. 58–59, 126; *The Moral of Many Fables*, pp. 40–41.

34. *Illustrations of Political Economy, The Three Ages*, p. 115 and pp. 59, 111, 103, 115.

35. *Illustrations of Political Economy, The Three Ages*, p. 41; and *The Moral of Many Fables*, pp. 133 ff.; *The Farrers of Budge-Row*, p. 135; *Illustrations of Taxation, The Park and the Paddock*, p. 53.

36. Harriet Martineau to Mrs. Martineau (n.d.), *Autobiography*, 3:87–88; see also *Illustrations of Political Economy, A Manchester Strike*, pp. 64–65. Note: because of its education clause she supported Graham's Factory Act:See Henry Crabb Robinson to Thomas Robinson, December 4, 1843, DW Lib.; Harriet Martineau to Brougham, [1832?], two letters recommending Dr. Southwood Smith to investigate the condition of child operatives, University Coll. For her position on the employment of women later in the century see "Female Industry," in *Edinburgh Review* 109 (April, 1859): 151–73. Though an advocate of equal employment, Martineau in spite of her laissez fairism and her feminism supported legisla-

tion in the case of women in the mines and the sweated industries (see chap. 8).

37. *History of the Peace,* 2:90–91.

38. Mark Blaug, "The Classical Economists and the Factory Acts Re-Examined," *Quarterly Journal of Economics* 63 (May, 1958): 211–26; J. T. Ward, *The Factory System,* 2 vols. (Newton Abbott: David and Charles, 1970), 2:149.

39. Francis Place to Harriet Martineau, September 8, 1832, B. Mus., Add. MS. 35149/189; see also Harriet Martineau to Francis Place, March 29, 1832, B. Mus., Add. MS. 35149/145.

40. Harriet Martineau to Crabb Robinson, May 11, 1844, DW Lib; see also Harriet Martineau to Milnes, June 12, [1844?], Tr. Coll.; *History from the Commencement,* 1:26.

41. Blaug, *Ricardian Economics,* pp. 65–73; see also John Stuart Mill, *Principles of Political Economy,* p. 715.

42. *Illustrations of Political Economy, Life in the Wilds,* pp. 116–18; *Briery Creek,* pp. 80 ff.; *The Hill and the Valley,* p. 140; *History of the Peace,* 1:368, 508.

43. *The tendency of strikes and sticks to produce low wages, and of union between masters and men to ensure good wages* (Durham: J. H. Veitch [1834]), p. 11. Note: "sticks" is a north country word meaning combinations.

44. *Illustrations of Political Economy, A Manchester Strike,* p. 49, see also pp. 60, 75, 97–99.

45. James Mill, *Elements of Political Economy,* pp. 41 ff.

46. *Illustrations of Taxation, The Scholars of Arneside,* pp. 35 ff.; *History of the Peace,* 1:369; 2:154–55, 179–80, 408; *History from the Commencement,* 1:9.

47. *History of the Peace,* 2:468; see also R. M. Hartwell in *The Long Debate on Poverty,* ed. Arthur Seldon (London: Institute of Economic Affairs, 1972), pp. 17, 20.

48. Harriet Martineau to James Martineau, June 11, 1832, Transcript Letters, M. Coll.

49. *Illustrations of Political Economy, Weal and Woe in Garveloch,* pp. 96–99, 102.

50. *Edinburgh Review* 57 (April, 1833): 27 [William Empson: *Wellesley Index*].

51. Francis Place to Harriet Martineau, September 8, 1832, B. Mus., Add. MS. 35149/189.

52. *Quarterly Review* 49 (April, 1833): 139, 141 [George Poulett Scrope: *Wellesley Index*].

53. Harriet Martineau to James Martineau, April 25, 1833, Transcript Letters, M. Coll; Harriet Martineau to Frederick Knight Hunt [1854?], 483 B.U. Lib. She writes of doing Lockhart's obituary, "I did not personally know him because I declined it; in the wickedest days of the Quarterly, when he and Croker deserved ill of honest people. . . . I will be as gentle as possible. It is impossible to rank him with the earnest, and pure and good-natured. But his deserts are in some respects great; and he shall have his due." In Croker's case, however, "one must be outspoken, as to

untruth and malice, or be silent altogether about him." The *Daily News* obituaries are reprinted in *Biographical Sketches*, pp. 29 ff., 60 ff.

54. *Illustrations of Political Economy, Homes Abroad*, pp. 14, 125–25; *Ireland: A Tale*, pp. 58–59.

55. *Illustrations of Political Economy, Cinnamon and Pearls*, pp. 21–23, 77, 114, 124; *The Moral of Many Fables*, pp. 79–81; *History of the Peace*, 1:371.

56. John Stuart Mill, *Principles of Political Economy*, p. 66.

57. *Illustrations of Political Economy, Cousin Marshall*, p. 52; and see also pp. 47–54, 88, 111, 119; and *Ireland*, p. 54.

58. *Illustrations of Political Economy, The Moral of Many Fables*, pp. 66–67; *History of the Peace*, 2:84.

59. John Stuart Mill, *Principles of Political Economy*, p. 968.

60. Norman Longmate, *The Workhouse* (London: Temple Smith, 1974), quoted p. 62.

61. For her correspondence with the SDUK see Brougham Papers, University Coll. and SDUK Papers, University Coll.

62. Mark Blaug, "The Myth of the Old Poor Law and the Making of the New," *Journal of Economic History* 23 (June, 1963): 151–84; and "The Poor Law Report Re-examined," *Journal of Economic History* 24 (June, 1964): 229–45.

63. Brougham to Macvey Napier [June?], 1832, B. Mus., Add. MS. 34615/443.

64. Harriet Martineau to James Martineau, October 13, 1832; January 2, 1834, Transcript Letters, M. Coll.; Harriet Martineau to Francis Place, March 24, 1834, B. Mus., Add. MS. 35149/276; Garnett and Garnett, *Fox*, p. 88.

65. Mrs. John [Elizabeth] Farrar, *Recollections of Seventy Years* (Boston: Ticknor and Fields, 1866), p. 260.

66. The SDUK paid Martineau its share for *Poor Laws and Paupers*, but the amount promised from Brougham was not forthcoming.

67. *Edinburgh Review* 57 (April, 1833): 1–39 [William Empson: *Wellesley Index*].

68. *Fraser's Magazine* 6 (November, 1832): 403–13 [William Maginn: *Wellesley Index*]; see also *Fraser's Magazine* 8 (November, 1833); *New Monthly Magazine* 37 (January-February, 1833): 146–51 [Edward Bulwer-Lytton: *Wellesley Index*].

69. *Quarterly Review* 49 (April, 1833): 136–152; and on political economy 44 (January, 1831) [Both by George Poulett Scrope: *Wellesley Index*]. See also *Autobiography*, 1:199, 205 ff.

70. "Miss Martineau's Summary of Political Economy," in John Stuart Mill, *Collected Works*, 4:225–28 (originally published in *MR* 8 (May, 1834): 318–22).

71. Francis Place to Harriet Martineau, September 9, 1832, B. Mus., Add. MS. 35149/192; see also March 4, 1834, B. Mus., Add. MS. 35149/276; March 31, 1834, B. Mus., Add. MS. 35149/278.

72. *Illustrations of Political Economy, The Moral of Many Fables*, pp. 4, 8.

73. "On the Duty of Studying Political Economy," in *Miscellanies*, 1:276.
74. John Stuart Mill to Thomas Carlyle, November 22, 1833 in Mill, *Collected Works*, 12:152.

Chapter IV

1. Harriet Martineau, *Autobiography with Memorials by Maria Weston Chapman*, 3 vols. (London: Smith, Elder, and Co., 1877), 2:app. B, "A Month at Sea" (originally in the *Penny Magazine*, October-November, 1837), recalls the voyage to the United States. Note: Her views on prison reform owed a great deal to Howard, Fry, Bentham, and the Hartleyan theory of causation.
2. *Autobiography*, 2:2–3.
3. Harriet Martineau to William Tait, August 29, 1833, MS. Ogden 101, University Coll.
4. Alice Rossi refers to Harriet Martineau as "the first woman sociologist," in Alice Rossi, ed., *The Feminist Papers* (1973; reprint ed., New York: Bantam Books, 1974), p. 124.
5. *How to Observe Morals and Manners* (1838; American ed., New York: Harper Brothers, 1838).
6. Frances Trollope, *Domestic Manners of the Americans*, 2 vols. (1832; New York: Dodd, Mead and Co., 1894), 2:304; cf. 1:64; 2:9.
7. *Retrospect of Western Travel*, 2 vols. (London: Saunders and Otley, 1838), 1:34. See also Alexis de Tocqueville, *Democracy in America*, 2 vols. (1835 and 1840; New York: Alfred A. Knopf, 1945), 1:3. Henry Crabb Robinson noted in his Diary, "Miss M. gave an amusing account of Mrs. Trollope who she says was admitted to no decent society in Cincinnati." (October 22, 1837, DW Lib.)
8. *Retrospect of Western Travel*, 1:72.
9. *Society in America*, 3 vols. (1837; 2d ed., London: Saunders and Otley, 1839), 1:x.
10. *How to Observe Morals and Manners*, p. 62; *Society in America*, 2:178; 3:xvii–xviii.
11. "An Autobiographic Memoir," *DN*, June 29, 1876.
12. Harriet Martineau to James Martineau, February 7, 1838, Transcript Letters, M. Coll.
13. John Morley, *Critical Miscellanies* (1886–1908), 4 vols. (London: Macmillan & Co., 1909), 3:193.
14. *Retrospect of Western Travel*, 2:26; see also *Society in America*, 1:209–13.
15. *How to Observe Morals and Manners*, p. 105.
16. *Society in America*, 1:viii, 2–8, 40–41, 26–29, 87–88; 2:27; 3:29–30, 36–37; *Retrospect of Western Travel*, 2:104; Trollope, *Domestic Manners*, 1:61–62, 64, 96, 138–39, 171; 2:159–60, 296.
17. *Society in America*, 3:37–39; see also 2:54 ff., 360–61, 365.
18. Harriet Martineau to the Reverend William Ware, April 6, 1837, Boston Public Library, MS. Eng. 244 (1—16) (hereafter cited as Boston P. Lib.).

19. *Society in America,* 3:8; 2:7–8; *How to Observe Morals and Manners,* p. 42.
20. Tocqueville, *Democracy in America,* 1:257; see also 1:263.
21. *Society in America,* 1:32–33, 117, 118.
22. "West India Slavery," in Harriet Martineau, *Miscellanies,* 2 vols. (Boston: Hilliard Gray and Company, 1836), 2:375–89 (originally published as "Negro Slavery," *MR* 4 [1830]: 4–9); "Liberia," *MR* 5 (1831): 758–61. "Liberia" was not reprinted in *Miscellanies* in 1836 because it endorsed the American Colonization Society of which she had by then become critical.
23. "West India Slavery," in *Miscellanies,* 2:378.
24. *Retrospect of Western Travel,* 1:33.
25. *Society in America,* 1:193–94; 2:103 ff., 109 ff.
26. Tocqueville, *Democracy in America,* 1:357–58.
27. *Retrospect of Western Travel,* 1:191 ff.; *Society in America,* 2:153–54 ff.
28. *Society in America,* 3:277 ff.
29. Harriet Martineau to Henry Crabb Robinson, November 27, 1843, DW Lib.; *Society in America,* 3:277 ff., 226 ff.
30. *The Martyr Age of the United States* (Boston: Weeks, Jordan and Co.; Otis; Broaders and Co., 1839). Originally published in *Westminster Review* 32 (December, 1838). *Westminster Review* hereafter cited as *WR.*
31. *Society in America,* 3:231; "An Autobiographic Memoir," *DN,* June 29, 1876.
32. *Autobiography,* 3:109 ff.; *Retrospect of Western Travel,* 1:237–38; *Society in America,* 2:144 ff., 152–53.
33. *Retrospect of Western Travel,* 1:242–43 ff.; see also 1:235; *Society in America,* 1:302; 2:53.
34. *Retrospect of Western Travel,* 1:142.
35. Harriet Martineau to James Martineau, July 29, 1838, Transcript Letters, M. Coll.; *Autobiography,* 2:143–44; see also for her attitude on the treatment of blacks, *Autobiography,* 2:14–15; *Society in America,* 2:328–30; 3:98–99; *Retrospect of Western Travel,* 2:38.
36. *Retrospect of Western Travel,* 2:159 ff. It was on this occasion that Maria Weston Chapman, who became Martineau's close friend, refused to retreat before the mob. "If this is the last bulwark of freedom, we may as well die here as anywhere," she said. Quoted in Louis Filler, *The Crusade Against Slavery* (New York: Harper and Row, 1960), pp. 76–77.
37. "An Autobiographic Memoir," *DN,* June, 1876.
38. Harriet Martineau to Brougham, November 21, 1858 [copy], B.U. Lib., Let. Add.; *Retrospect of Western Travel,* 2:26 ff.; *Society in America,* 1:106–7.
39. *Society in America,* 1:108.
40. *Autobiography,* 3:223, Harriet Martineau to Abby (Kelly) Foster, June 20, 1838; see also Aileen S. Kraditor, *Means and Ends in American Abolitionism* (New York: Pantheon Books, 1967), pp. 12–13, 20; *Retrospect of Western Travel,* 1:240–41.

41. William Lloyd Garrison to Harriet Martineau, December, 1855, B.U. Lib., 349.

42. Harriet Martineau to William Tait, December 28, 1832, MS. Ogden 101, University Coll.

43. Harriet Martineau to Francis Place, May 12, 1832, B. Mus., Add. MS. 35149/147.

44. Quoted in *The Martyr Age of the United States*, p. 54. Cf. John L. Thomas, *The Liberator: William Lloyd Garrison* (Boston: Little, Brown and Co., 1963), p. 294.

45. *Society in America*, 3:268; For similar sentiments see Trollope, *Domestic Manners*, 1:102–4.

46. See Harriet Martineau's introduction to Charles Knight, ed., *Mind Amongst the Spindles: The Lowell Offering: A Miscellany Wholly Composed by the Factory Girls of an American City* (London: Knight, 1844), pp. xvii, xix; "Female Industry," *Edinburgh Review* 109 (April, 1859): 186–87 (hereafter cited as *ER*); Barbara Leigh Smith Bodichon, *An American Diary 1857–58*, ed. Joseph W. Reed (London: Routledge and Kegan Paul, 1972); Alice Felt Tyler, *Freedom's Ferment* (Minneapolis: University of Minnesota Press, 1944), p. 212; the Reverend William Wood to Harriet Martineau, February 19, 1856, B.U. Lib. 1031–35.

47. *Society in America*, 1:206–7; see also Margaret Fuller's comment that "what a woman needs is not as a woman to act and rule, but as a nature to grow, as an intellect to discern, as a soul to live freely and unimpeded, to unfold such powers as were given her when we left our common home." Quoted in Tyler, *Freedom's Ferment*, p. 430; Margaret Fuller Ossoli, *Memoirs*, 2 vols. (Boston: Phillips, Sampson and Co., 1857), in which she described meeting Harriet Martineau in Massachusetts.

48. Tocqueville, *Democracy in America*, 2:211–12, 214.

49. *The Princess*, section vii, lines 263–70.

50. Mary Wollstonecraft, *A Vindication of the Rights of Woman* (1792; reprint ed. New York: W. W. Norton and Company, 1967), p. 97.

51. *Autobiography*, 2:163–65; Harriet Martineau to the Reverend William Ware, April 6, 1837, Boston P. Lib., MS. Eng. 244 (1–16); also September 15, 1837, Boston P. Lib., MS. Eng. 244 (1–16).

52. *Liberator* 7 (July 28, 1837):124, reprinted from the *Daily Advocate;* and *Liberator* 7 (June 30 and July 14, 1837). The *Liberator* did not generally do book reviews. See also Dr. Sprague (Albany, New York) to Henry Crabb Robinson, June 1838, DW Lib.; *Autobiography*, 3:165–84.

53. *American Quarterly Review* 22 (September, 1837): 21–53.

54. *New York Review* 3 (July, 1838): 129–49; *The American Monthly Magazine* n.s. 4 (July, 1837): 80–94, and 4 (August, 1837): 190–93; *A Review of Miss Martineau's Work on "Society in America,"* (Boston: Marsh, Capen, and Lyon, 1837), p. 3; *Autobiography*, 3:183.

55. Harriet Martineau to William Tait, July 16 [1837], MS. Ogden 101, University Coll.

56. *Fraser's Magazine* 19 (May, 1839): 557–92 [unidentified: *Wellesley Index*]; see also *London and Westminster Review* 27 (July, 1837): 94; 30 (October, 1837): 470–502; *ER* 67 (April, 1838): 180–97 [unidentified: *Wellesley Index*]; Garnett and Garnett, *Fox*, p. 189.
57. *The Times*, May 30, 1837, p. 5.
58. For the Indians whom she described as "the injured and exasperated red men of the wilderness," see *Society in America*, 1:127, 244, 353; 2:18, 25; *Retrospect of Western Travel*, 1:81.

Chapter V

1. For a discussion of the psychological implications of deafness see: Edna Simon Levine, *The Psychology of Deafness* (New York and London: Columbia University Press, 1960), pp. 60–67; D. A. Ramsdell, "The Psychology of the Hard-of-Hearing and Deafened Adult," in *Hearing and Deafness*, ed. Hallowell Davis and S. Richard Silverman (1947; reprint ed., New York: Holt, Rinehart and Winston, 1960), pp. 469, 471–72; Helmer R. Myklebust, *The Psychology of Deafness* (1960; reprint ed., New York and London: Grune and Stratton, 1964), pp. 29–43, 117 ff., 131; Richard E. Hardy and John C. Cull, *Educational and Psychosocial Aspects of Deafness* (Springfield, Illinois: Charles C. Thomas, 1974), pp. 160–61, 179–80.
2. "Letter to the Deaf," in Harriet Martineau, *Miscellanies*, 2 vols. (Boston: Hilliard Gray and Company, 1836), 1:248–65 (originally published in *Tait's Magazine*, 1834).
3. For Harriet Martineau's comments on her hearing deficiency see: Harriet Martineau to Henry Crabb Robinson (extract copied in Robinson's hand), February 8, 1846, DW Lib.; Harriet Martineau to James Martineau, August 31, 1827, Transcript Letters, M. Coll; "Letter to the Deaf," in *Miscellanies*, 1:260; Harriet Martineau to Edward Moxon, November 21, 1844, Fawcett Library, London (hereafter cited as Fawcett Lib.); Harriet Martineau to Milnes, n.d., Tr. Coll., in which she speaks of hearing with the ear "totally deaf for twenty years" after mesmeric treatment; Harriet Martineau to [Joseph] Toynbee, n.d., Beineke Library, Yale University (hereinafter cited as Yale), MS. Vault File 15/4; Harriet Martineau, *Autobiography with Memorials by Maria Weston Chapman*, 3 vols. (London: Smith, Elder, and Co., 1877), 1:327; 2:236; 3:126; Henry George Atkinson and Harriet Martineau, *Letters on the Laws of Man's Nature and Development* (1851; American ed., Boston: Josiah P. Mendum, 1851), pp. 166–67; *Retrospect of Western Travel*, 2 vols. (London: Saunders and Otley, 1838), 2:140; *Eastern Life Present and Past*, 3 vols. (London: Edward Moxon, 1848), 2:64–65; Gordon S. Haight, *George Eliot and John Chapman: With Chapman's Diaries* (New Haven: Yale University Press, 1940), p. 146, from Chapman's diary of March 15, 1851.
4. Henry Crabb Robinson, Diary, October 27, 1837, DW Lib.
5. Gordon S. Haight, ed., *The George Eliot Letters*, 6 vols. (New Haven: Yale University Press, 1954), 2:180.

6. R. K. Webb, *Harriet Martineau: A Radical Victorian* (New York: Columbia University Press; London: William Heinemann, 1960), p. 13.

7. Henry Crabb Robinson told Harriet Martineau that "he did not care if he never saw Carlyle again," *Autobiography*, 2:201; Diary, October 25, 1837; and in 1849 Henry Reeve described Carlyle as "so offensive I never made it up with him," Reeve Diary, December 19, 1849, in John Knox Laughton, ed., *Memoirs of the Life and Correspondence of Henry Reeve*, 2 vols. (London and New York: Longmans, Green and Co., 1898), 2:216–17.

8. James Anthony Froude, ed., *Letters and Memorials of Jane Welsh Carlyle*, 2 vols. in 1 (New York: Charles Scribner's Sons, 1883), 1:50; Jane Welsh Carlyle to John Sterling, February 1, 1837, and see 1:52; Trudy Bliss, ed., *Jane Welsh Carlyle: A New Selection of her Letters* (New York: Macmillan Co., 1950), pp. 61–62 (Jane Welsh Carlyle to Eliza Aitken, March 6, 1837), p. 206 (Jane Welsh Carlyle to Thomas Carlyle, September 14, 1849); Alexander Carlyle, ed., *New Letters and Memorials of Jane Welsh Carlyle*, 2 vols. (London and New York: John Lane, 1903), 2:4; Theodora Bosanquet, *Harriet Martineau: an Essay in Comprehension* (1927; reprint ed., Saint Clair Shores, Mich.: Scholarly Press Inc., 1971), p. 133; see also Harriet Martineau to Emerson, February 25, 1852, Houghton Library, Harvard (hereafter cited as Harvard), b MS AM 1280 in which Martineau described sitting next to the Carlyles at a Thackeray lecture in London. They invited her to return to Chelsea with them but she was unable to do so.

9. Michael St. John Packe, *The Life of John Stuart Mill* (London: Secker and Warburg, 1954), pp. 321 ff.

10. Friedrich A. Hayek, *John Stuart Mill and Harriet Taylor: Their Correspondence and Subsequent Marriage* (Chicago: University of Chicago Press, 1951), pp. 79–80, 88–90, 103; Packe, *John Stuart Mill*, pp. 128, 236; Harriet Martineau to the Reverend William Ware, July 14, September 15, 1837, Boston P. Lib., MS. Eng. 244 (1–16); Harriet Martineau to James Martineau, December 21, 1837, Transcript Letters, M. Coll. Note: two of the more important articles of this period were: "The Martyr Age of the United States," *WR* 31 (December, 1838); and "Literary Lionism," *WR* 32 (April, 1839).

11. See for example Eliza Bostock to Harriet Martineau, April 24, 1866, B.U. Lib., 80; Henry Crabb Robinson to Thomas Robinson, September 8, 1841; Henry Crabb Robinson, Diary, October 16, 1839, DW Lib.

12. R. K. Webb, *Harriet Martineau*, p. 51.

13. William Lloyd Garrison to Harriet Martineau, December 4, 1853, B.U. Lib; see Louis Filler, *Abolition and Social Justice in the Era of Reform* (New York: Harper and Row, 1972), pp. 55, 76–77 for a modern appraisal of Chapman. R. K. Webb considers both Garrison and Chapman to have been "as securely second-rate as Harriet Martineau herself" (Webb, *Harriet Martineau*, p. 23).

14. Weston Papers [Notes], Boston P. Lib., MS. A. 9. 2. vol. 6, p. 4; Harriet Martineau to the Reverend William Ware, July 8 [?], Boston P. Lib., MS. Eng. 244 (1–16).

15. See Harriet Martineau to the Reverend William Ware, June 21, [1840?], Boston P. Lib., MS. Eng. 244 (1–16), in which Martineau told Ware that Fludyer Street was being torn down to make way for government offices. The site is now occupied by Whitehall offices and the Horseguards' Parade.

16. *Autobiography*, 1:249; see also Harriet Martineau to James Martineau, July 10, 1832; March 14, 1833, Transcript Letters, M. Coll.

17. Webb, *Harriet Martineau*, p. 192.

18. *The Guide to Service* published by Charles Knight (London) consisted of: *The Housemaid* (1839); *The Lady's Maid* (1838); *The Maid-of-all-work* (1838).

19. *Autobiography*, 2:111; Harriet Martineau to James Martineau, December 12, December 21 [?], DW Lib. James's reasons for discouraging Harriet from accepting the editorial position are nowhere clearly stated.

20. *Deerbrook*, 3 vols. (London: Edward Moxon, 1839).

21. Harriet Martineau to James Martineau, July 14, 1830; June 6, 1832; March 6 and August 4, 1838; January 10 or 17 and December 5, 1839, Transcript Letters, M. Coll.

22. "Literary Lionism," *WR* 32 (April, 1839): 261–81.

23. Harriet Martineau to the Reverend William Ware, October 11, [1836?], Boston P. Lib., MS. Eng. 244 (1–16).

24. Harriet Martineau to William Tait, June 3, 1834, MS. Ogden 101, University Coll.; *Autobiography*, 2:196 from Macready's journal; 3:201–2, 207, Diary, 1837; Betty Miller, *Robert Browning: A Portrait* (New York: Scribner's Sons, 1952), 58 ff. (hereafter cited as *Robert Browning*).

25. Robert Lee Wolff, *Strange Stories and other Explorations in Victorian Fiction* (Boston: Gambit, 1971), p. 86.

26. The plot was based on Catherine Sedgwick's "Old Maids," which in turn was based on a true incident (*Autobiography*, 2:111), and the character of the hero was probably Dr. Follen, an American friend (*Autobiography*, 1:50).

27. *Athenaeum* 597 (April 6, 1839): 254–56.

28. *WR* 34 (June-September, 1840): 502–4 [P.M.Y.]; *ER* 69 (July, 1839): 494–502 [T. H. Lister: *Wellesley Index*]; *Blackwood's* 47 (February, 1840): 180 [G. S. Venables: *Wellesley Index*].

29. The *WR*, however, applauded this aspect of her novel. It said she had "daring for anything, and a talent to make her enterprise successful" (34 [June-September, 1840]: 502).

30. *WR* 34 (June-September, 1840): 503–4; *Blackwood's* 47 (February, 1840): 118; *ER* 69 (July, 1839): 495.

31. *Deerbrook*, 1:303–10.

32. *Deerbrook*, 3:166; see also *Autobiography*, 3:189.

33. *Deerbrook,* 1:67.
34. *Deerbrook,* 1:115.
35. Martineau's review of *Villette* appeared in *DN,* February 3, 1853.
36. Vineta Colby, *Yesterday's Woman: Domestic Realism in the English novel* (Princeton: Princeton University Press, 1974), p. 256.
37. John Morley, *Critical Miscellanies,* 4 vols. (London: Macmillan & Co., 1909), 3:195.
38. Currer Bell to Harriet Martineau, November 7, 1849 in *Autobiography,* 2:323; *Athenaeum* 597 (April 6, 1839): 254–56; Harriet Martineau to James Martineau, April 18, 1839, DW Lib.; *Autobiography,* 3:221.
39. Thomas M. Greenhow, *A Medical Report of the Case of Miss H— M—,* 2d ed. (London: Samuel Highley, 1845), pp. 9 ff., 21–22.
40. Frederick G. Kenyon, ed., *The Letters of Elizabeth Barrett Browning* (New York: Macmillan Co., 1899), p. 151 (Elizabeth Barrett to Mrs. Martin, September 4 and 5, 1843).
41. Harriet Martineau to Henry Crabb Robinson, January 8, 1841, DW Lib.; Harriet Martineau to the Reverend William Ware, June, 1840(?), Boston P. Lib., MS. Eng. 244 (1–16).
42. Webb, *Harriet Martineau,* pp. 7, 196, 312; Cecil Woodham-Smith, "They Stayed in Bed," *Listener* 55 (February 16, 1956): 245–46; see also Narola Elizabeth Rivenburg, "Harriet Martineau: An Example of Victorian Conflict" (Ph.D. Diss., Columbia University, 1932), pp. 3–4.
43. *British Medical Journal* (July 8, 1876): 64; (April 14, 1877): 449–50; (April 21, 1877): 496; (May 5, 1877): 543, 550.
44. Carroll Smith-Rosenberg, "The Hysterical Woman: Sex Roles and Sex Conflict in 19th Century America," *Social Research* 39 (Winter, 1972): 652–78; see also Ann Douglass Wood, "The Fashionable Diseases: Women's Complaints and Their Treatment in Nineteenth-Century America," *Journal of Inter-Disciplinary History* 4 (Summer, 1973): 25–52.
45. Harriet Martineau to Milnes, August 28 [1843], Tr. Coll.; Harriet Martineau to Henry Crabb Robinson, January 8, 1841, DW Lib.; *Life in the Sick-Room* (1844; 2d American ed., Boston: William Crosby, 1845), pp. 52–53.
46. Henry Crabb Robinson to Thomas Robinson, July 15, 1842, Mrs. Reid to Henry Crabb Robinson, August, 1842, DW Lib.; Harriet Martineau to the Reverend William Ware, June 21[1840?], Boston P. Lib., MS. Eng. 244 (1–16); Julia Smith to Milnes [1842?], Tr. Coll.
47. *Life in the Sick-Room,* pp. 125–26, 40–42; Harriet Martineau to Mrs. Marshall, September 29 [?], Yale, MS. Vault File 15/4; Henry Crabb Robinson to Thomas Robinson, July 7, 1842, DW Lib.; Leonard Huxley, ed., *Jane Welsh Carlyle: Letters to her Family 1839–1863* (New York: Doubleday, Page and Co., 1924), Jane Welsh Carlyle to Helen Welsh, October, 1841.
48. Harriet Martineau to James Martineau, April 15, 1843, Transcript Let-

ters, M. Coll.; Greenhow, *Medical Report*, passim; *Letters on the Laws of Man's Nature and Development*, p. 69.

49. Harriet Martineau to Henry Crabb Robinson, October 29, 1842; see also November 27, 1843, DW Lib.

50. Erasmus Darwin to Henry Crabb Robinson, March 15, 1843, DW Lib.; Harriet Martineau to James Martineau, August 6, 1843, Transcript Letters, M. Coll.; Carlyle, *Jane Welsh Carlyle*, pp. 119–20 (Jane Welsh Carlyle to Thomas Carlyle, July 17, 1843).

51. On this subject see: Harriet Martineau to James Martineau, November 14, 1832; December 3, 1832; September, 1833; August, 1833, Transcript Letters, M. Coll.; *Illustrations of Political Economy*, 25 vols. (London: Charles Fox, 1832–1834), *The Three Ages*, pp. 112–13, 126; Harriet Martineau to Brougham [1832], University Coll.; *The History of England during the Thirty Years' Peace 1816–1846*, 2 vols. (London: Charles Knight, 1849 and 1850), 2:80–81; Harriet Martineau to Milnes [1843], Tr. Coll.; Thomas Robinson to Henry Crabb Robinson, November 9, 1842, DW Lib.; *Autobiography*, 2:177, 500, 544; 3:445, 447.

52. Edward Quillinan to Henry Crabb Robinson, November 28, 1842, DW Lib.

53. Harriet Martineau to Henry Crabb Robinson, April 27, 1843; July 7, 1842; March 8, 1844; DW Lib.; Harriet Martineau to Mrs. Marshall, September 29 [?], Yale, MS. Vault File 15/4; Harriet Martineau to James Martineau, January, 1844, Transcript Letters, M. Coll.; Harriet Martineau to Milnes, December 22 [1843?], Tr. Coll.; Harriet Martineau to the Reverend William Ware, February 3, 1841, Boston P. Lib., MS. Eng. 244 (1–16).

54. *The Hour and the Man*, 3 vols. (London: Edward Moxon, 1841), in which see her sources and bibliography, 3:256, 263 ff.; cf. *Autobiography*, 2:145, 157; 3:216; *Liberator* 7 (June 30, 1837): 108.

55. Harriet Martineau to Henry Crabb Robinson, January 8, 1841, DW Lib.; see also *The Hour and the Man*, 2:248; 3:166.

56. *Athenaeum* 684 (December 5, 1840): 958–59; *Autobiography*, 2:156–9.

57. *Principle and Practice: or, the Orphan Family* (Wellington: Houlston, 1827), p. 126; see also *Sequel* (London: Houlston, 1831).

58. *Life in the Sick-Room*, pp. x, 22–23.

59. Edward Quillinan to Henry Crabb Robinson, December 9, 1843; Henry Crabb Robinson to William Wordsworth, December 16, 1843; January 27, 1844, DW Lib.; also Thomas Sadler, ed. *Diary, reminiscences and correspondence of Henry Crabb Robinson*, 3 vols. (London: Macmillan & Co., 1869), 3:235.

60. Kenyon, *Letters of Elizabeth Barrett Browning*, 1:227–28, Elizabeth Barrett to Mrs. Jameson [fragment, December, 1844].

61. Paul Landis, ed., *Letters of the Brownings to George Barrett* (Urbana: University of Illinois Press, 1958), Elizabeth Barrett to George Barrett, December 21, 1843; Kenyon, *Letters of Elizabeth Barrett Browning*, 1:225

(Elizabeth Barrett to H. S. Boyd, December 24, 1844); 1:196 (Elizabeth Barrett to Mrs. Martin, September, 1844); Elvan Kintner, ed., *The Letters of Robert Browning and Elizabeth Barrett Barrett 1845–1846*, 2 vols. (Cambridge, Mass.: Harvard University Press, 1969), 1:306 (hereafter cited as *Browning Letters*); see also Weston Papers [Notes], Boston P. Lib., MS. A. 9. 2. vol. 5. p. 108; Harriet Martineau to Henry Crabb Robinson, January 3, 1844, DW Lib.

62. Harriet Martineau to Henry Crabb Robinson, April 27, July 20, November 27, 1843, DW Lib.

63. Greenhow, *Medical Report*, p. 18.

64. "Mesmeric Mountebanks," *Blackwood's* 60 (August, 1846): 223–37.

65. Harriet Martineau to Milnes, July 2, 1844, Tr. Coll.; "Letters on Mesmerism," *Athenaeum* 891 (November 23, 1844): 1071 ff.; 892 (November 30, 1844): 1093 ff.; 895 (December 21, 1844): 1174–75; *Autobiography*, 2:191 ff. Note: Except in the case of ill health it was unusual for a social inferior to mesmerize a social superior, see Eric J. Dingwall, *Abnormal Hypnotic Phenomena*, 4 vols. (London: J. and A. Churchill, 1967–68), 4:119, 84 ff.

66. Harriet Martineau to Milnes, May 23 [1845]; October 27, 1844, Tr. Coll.; Harriet Martineau to Henry Crabb Robinson, October 6, 1844, DW Lib.; Harriet Martineau to Lord Advocate Murray, February 13, 1845, Yale, MS. Vault File; "Letters on Mesmerism," *Athenaeum* 891 (November 23, 1844): 1071.

67. Henry Crabb Robinson to Miss Fenwick, January 27, 1845; Harriet Martineau to Henry Crabb Robinson, June 24, 1845, DW Lib.

68. Kintner, *Browning Letters*, 1:349–50 (Elizabeth Barrett to Robert Browning, December 30, 1845).

69. *Athenaeum* 896 (December 28, 1844): 1198–99; 897 (January 4, 1845): 14; 908 (March 22, 1845): 200–291; 909 (March 29, 1845): 310–11; see also *Blackwood's* 70 (July, 1851): 70–85 [John Eagles: *Wellesley Index*]; Harriet Martineau to Henry Crabb Robinson, October 6, 1844, DW Lib. Jane was not the maid who mesmerized Harriet Martineau.

70. Henry Crabb Robinson to Thomas Robinson, December 6, 1844; October 5, 1844; Thomas Robinson to Henry Crabb Robinson, December 25, 1845; Henry Crabb Robinson to Miss Fenwick, January 27, 1845; Mrs. Arnold to Henry Crabb Robinson, October 11, 1844, DW Lib.

71. Kintner, *Browning Letters*, 1:424 (Robert Browning to Elizabeth Barrett, January 27, 1846); Kenyon, *Letters of Elizabeth Barrett Browning*, 1:217 (Elizabeth Barrett to Mrs. Martin [September, 1844]); 1:196–97 (Elizabeth Barrett to Mrs. Martin, November 26, 1844); 1:219–20 (Elizabeth Barrett to James Martin, December 10, 1844); 1:255–58 (Elizabeth Barrett to Mr. Chorley, April 28, 1845); 1:212 (Elizabeth Barrett to John Kenyon, November 8, 1844); Miller, *Robert Browning*, pp. 233–34 (Elizabeth Barrett to Miss Mitford, January 15 [1845]).

72. Carlyle, *Jane Welsh Carlyle*, 1:158 (Jane Welsh Carlyle to Mrs. Russell,

December 27 [1844]); Froude, *Jane Welsh Carlyle*, 1:309–312 (Jane Welsh Carlyle to John Welsh, December 13, 1847).

73. Richard Garnett and Edward Garnett, *The Life of William Johnson Fox: Public Teacher and Social Reformer 1786–1864* (London and New York: John Lane, 1910), p. 75 (hereafter cited as *Fox*).

74. William Wordsworth to Henry Crabb Robinson, February 2, 1845; August 7, 1845; Miss Fenwick to Henry Crabb Robinson, July 1, 1845, DW Lib.

75. Greenhow, *Medical Report*, p. 23.

76. Spencer T. Hall, *Mesmeric Experiences* (London: H. Balliere, 1845), p. 68.

77. *Autobiography*, 3:238; Greenhow, *Medical Report*, pp. 14, 15; Harriet Martineau to Henry Crabb Robinson, April 27, 1843, DW Lib.

78. Webb's quotation is from "Essays on the Art of Thinking," *MR* 3 (1829), and his references are to Greenhow, *Medical Report*, p. 23.

79. Harriet Martineau to Edward Moxon [dated 1841 but probably 1844 or 1845], Oxford, Bodleian Library, MS. Eng. Lett. d2 86 (hereafter cited as Bodleian); Henry Crabb Robinson to Thomas Robinson, January 24, 1845, DW Lib.; Harriet Martineau to Milnes, n.d., Tr. Coll.; Harriet Martineau to James Martineau, 1845, Transcript Letters, M. Coll.; Weston Papers [Notes], Boston P. Lib., MS. A. 9. 2. vol. 16, p. 13; *Autobiography*, 2:198 n.

80. Harriet Martineau to the Reverend William Ware, July 14, 1837; July 8, 1838, Boston P. Lib., MS. Eng. 244 (1–16); Harriet Martineau to Henry Crabb Robinson, June 24, 1845, DW Lib.; James Martineau, "The Early Days of Harriet Martineau," *DN*, December 30, 1884; Weston Papers [Notes], Boston P. Lib., MS. A. 9. 2. vol. 16, p. 3; Haight, *George Eliot Letters*, 6:371 (George Eliot to Sara Sophia Hennell, May 15, 1877). Note: Richard Garnett, the biographer of William Johnson Fox, had read her letters and thought that "no one would gain so much from their publication as the writer" (*Fox*, pp. 80–81).

81. "An Autobiographic Memoir," *DN*, June 29, 1876; *Autobiography*, 2:205.

82. Mrs. Wordsworth to Henry Crabb Robinson, September 16, 1845, DW Lib.; Harriet Martineau to Henry Crabb Robinson, June 24, 1845, DW Lib.; Harriet Martineau to Lord Advocate Murray, February 13, 1845, Yale, MS. Vault File 15/4; Harriet Martineau to Milnes, February 28 [1845], Tr. Coll.

83. Kintner, *Browning Letters*, 1:459–63 (Harriet Martineau to Elizabeth Barrett, February 8, 1846); see also 1:464, Robert Browning's comment to Elizabeth Barrett, February 15, 1846; *Autobiography*, 2:225 ff.

84. See *A Complete Guide to the English Lakes* (1855; 2d ed., Windermere: John Garnett, 1855); *Autobiography*, 3:262; *Our Farm of Two Acres* (New York: Bunce and Huntington, 1865), pp. 8, 13 (published originally in *Once a Week);* Harriet Martineau to Arthur Allen, October 19 [1852], Yale, MS. Vault File; Harriet Martineau to Florence Nightingale, September 6, 1867, B. Mus., 45788/314; Kintner, *Browning Letters*, 1:459–

63 (Harriet Martineau to Elizabeth Barrett, February 8, 1846); Henry Crabb Robinson to Miss Fenwick, January 15, 1848, DW Lib. The original plans for "The Knoll" are among the Martineau Papers, B.U. Lib.

85. Henry Crabb Robinson to Miss Fenwick, July 16, 1845; Harriet Martineau to Henry Crabb Robinson, February 8, 1846; William Wordsworth to Henry Crabb Robinson, August 7, 1845, DW Lib.

86. *Autobiography*, 3:289–90, Charlotte Brontë to Emily Brontë.

87. Haight, *George Eliot Letters*, 2:62 (George Eliot to Mr. and Mrs. Bray, October 21, 1852); see also 1:188–89, 192, 361; 2:4–5, 27, 32, 65, 80, 86, 88, 96, 122, 229, 258.

88. Webb, *Harriet Martineau*, p. 262; *Autobiography*, 2:306–8; Agreement of Rent, May 12, 1852, B.U. Lib., HM 1312.

89. Mrs. Wordsworth to Henry Crabb Robinson, November 7, 1845, DW Lib.

90. Harriet Martineau to Emerson, July 2 [1845], Harvard, b MS AM 1280.

91. Edward Quillinan to Henry Crabb Robinson, June 6, 1848; August 17, 1849, DW Lib.

92. Harriet Martineau to Emerson, February 25 [1852], Harvard, b MS AM 1280; *Autobiography*, 3:110–12 (Mr. Gilman to E. G. Loring [1835]).

93. Harriet Martineau to Arthur Allen, December 16 [?], Yale, MS Vault File 15/4.

Chapter VI

1. Harriet Martineau, *The History of England during the Thirty Years' Peace 1816–1846*, 2 vols. (London: Charles Knight, 1849–50) (hereafter cited as *History of the Peace*). *Athenaeum*, 1118 (March 31, 1849): 317–19; 1119 (April 7, 1849): 353; 1163 (February 9, 1850): 149–51; 1164 (February 16, 1850): 177–79, passim.

2. Harriet Martineau to Henry Crabb Robinson, June 8, 1848, DW Lib.

3. George M. Young, *Portrait of an Age* (1936; reprint ed., New York: Oxford University Press, 1964), p. 8.

4. For Martineau's opinion of Macaulay's *History* see Harriet Martineau, *Autobiography with Memorials by Maria Weston Chapman*, 3 vols. (London: Smith, Elder, and Co., 1877), 1:348–49.

5. Elie Halévy, *A History of the English People in the Nineteenth Century*, 6 vols. (vols. 1–4, 1923–48; 2d rev. ed., London: Ernest Benn, 1949–51), 4:256.

6. *Life in the Sick-Room* (1844; 2d American ed., Boston: William Crosby, 1845), pp. 79–80; see also Harriet Martineau to Henry Crabb Robinson, November 27, 1843, DW Lib.

7. Among Charles Knight's publications were: *The Penny Cyclopedia, The British Almanac and Companion, The Penny Magazine, The Library of Entertaining Knowledge, The Journal of Education,* and *The Gallery of Portraits.*

8. *History of the Peace*, 1:iii–iv; Preface to *The History of England from the Commencement of the XIXth Century to the Crimean War*, 4 vols. (Philadel-

phia: Porter and Coates, 1864), 1:1–2 (hereafter cited as *History from the Commencement);* Harriet Martineau to Milnes, June 4, 1848, Tr. Coll.; Harriet Martineau to Henry Crabb Robinson, June 8, 1848, DW Lib.; *Autobiography,* 2:301, 318; 3:334, 336, 468; "An Autobiographic Memoir," *DN,* June 29, 1876.

9. Harriet Martineau to Henry Crabb Robinson, July 6, 1850, DW Lib.; Gordon S. Haight, *George Eliot and John Chapman: With Chapman's Diaries* (New Haven: Yale University Press, 1940), p. 151.

10. *Introduction to the History of the Peace: from 1800 to 1815* (London: Charles Knight, 1851).

11. *History of the Peace,* 1:345; 2:700; "Results of the Census of 1851," *WR* 120 (April, 1854): 171–89.

12. *British Quarterly Review* 11 (February and May, 1850): 355–71.

13. Ibid.

14. *History of the Peace,* 1:286, 292.

15. Benjamin Disraeli, *Coningsby* (1844, London: John Lane, 1905), p. 93.

16. *History of the Peace,* 1:426–27; 2:458–59; Harriet Martineau to William Tait, July 16 [1837], MS. Ogden 101, University Coll.

17. *Autobiography,* 2:127; see also Harriet Martineau to the Reverend William Ware, July 14, 1837, Boston P. Lib., MS. Eng. 244 (1–16); *History of the Peace,* 2:398–401; 1:321,538,554. Also cf. *The Peasant and the Prince* (1841) in *The Playfellow,* 4 vols. (London: George Routledge and Sons, 1895), pp. 557, 571, 580, 660.

18. Quoted in Francis E. Mineka, *The Dissidence of Dissent: The Monthly Repository 1806–1838* (Chapel Hill, N.C.: University of North Carolina Press, 1944), pp. 356–57; see also Harriet Martineau to James Martineau, November 23, 1831; June 6, 1832, Transcript Letters, M. Coll; *Autobiography,* 3:82.

19. Harriet Martineau to Milnes, June 22, [1842?], Tr. Coll.

20. *History of the Peace,* 2:20–21, 70, 152–53.

21. *History of the Peace,* 2:25, 30, 32; see also Joseph Hamburger, *James Mill and the Art of Revolution* (New Haven: Yale University Press, 1963), pp. 23, 152, 267.

22. *History of the Peace,* 2:33; Halévy, *History,* 3:3 ff.

23. Norman Gash, "English Reform and French Revolution in the Election of 1830," in Richard Pares and A. J. P. Taylor, eds., *Essays Presented to Sir Lewis Namier* (London: Macmillan & Co.; New York: St. Martin's Press, 1956); Michael Brock, *The Great Reform Act* (London: Hutchinson University Library, 1973).

24. *History of the Peace,* 1:542–43, 549–51; 2:4–6.

25. *History of the Peace,* 2:263, 264, 405–14, 521–25; *Life in the Sick-Room,* p. 73; Harriet Martineau to Helen Martineau, June 12 [1848?], M. Coll.; cf. *History of the Peace,* 2:180, 457, 688–89; *Autobiography,* 3:241.

26. *History of the Peace,* 2: 262–63; see also Harriet Martineau to Henry Crabb Robinson, July 20, 1843, DW Lib.

27. *History from the Commencement,* 4:571–76.

28. For Martineau's comments on the exclusion of Jews from participation in the political process see: *History of the Peace*, 1:546–47.

29. Elvan Kintner, ed., *The Letters of Robert Browning and Elizabeth Barrett Barrett 1845–1846*, 2 vols. (Cambridge, Mass.: Harvard University Press, 1969), 2:826 (Robert Browning to Elizabeth Barrett, June 30, 1846).

30. *History of the Peace*, 2:78; see also pp. 146, 223–24, 351, 415, 420, 437; *Autobiography*, 1:260, 263–65, 336–37, 340–41; Harriet Martineau to James Martineau, March 6, 1838, Transcript Letters, M. Coll.

31. Harriet Grote, *The Philosophic Radicals of 1832* (1866; reprint ed., New York: Burt Franklin, 1970), pp. 25, 33, 41 (Molesworth to Harriet Grote, October 15, 1836; George Grote to John Austin, February, 1838); see also Donald Southgate, *The Passing of the Whigs 1832–1886* (London: Macmillan & Co., 1962), pp. 69–70.

32. Undated MS., B.U. Lib., 1406.

33. Ibid.

34. *History of the Peace*, 2:207–8 in which she discussed the 1835 Tamworth Manifesto without relating its significance for the rest of the Tory party. See Disraeli, *Coningsby*, p. 135; *History of the Peace*, 2:472–73.

35. See Henry Crabb Robinson to Thomas Robinson, January 2, 1846, DW Lib.; *History of the Peace*, 1:491–92; 2:516–18, 667–68, 683.

36. *History from the Commencement*, 1:4–7; see also the *National Anti-Slavery Standard*, June 1, 1861, in which Martineau wrote of the "blessed effects" of free trade and of the increased general prosperity.

37. *History of the Peace*, 2:518–19; see also Betty Kemp, "Reflections on the Repeal of the Corn Laws," *Victorian Studies* 5 (March, 1962): 189–204.

38. *History of the Peace*, 2:73, 150, 414–16, 606 ff., 667 ff.; Harriet Martineau to Milnes, June 12 [1844?], Tr. Coll.; *Autobiography*, 2:260–62; Harriet Martineau to Peel, February 22, 1846; Peel to Harriet Martineau, February 23, 1846, B. Mus., 40585/287 and /291; Norman Gash, *Sir Robert Peel: The Life of Sir Robert Peel after 1830* (London: Longman, 1972), pp. 576–77.

39. Gash, *The Life of Sir Robert Peel after 1830*, p. 531.

40. *Illustrations of Political Economy*, 25 vols. (London: Charles Fox, 1832–34), *The Moral of Many Fables*, p. 24.

41. *History of the Peace*, 2:553, 555; Harriet Martineau to Milnes, April 21 [1844(?)], Tr. Coll.

42. *History of the Peace*, 2:557–59; see also pp. 90–91, 408.

43. *History of the Peace*, 2:556–58; see also Henry Crabb Robinson to Thomas Robinson, December 4, 1843, DW Lib.; Harriet Martineau to Milnes, December 22 [1843?]; May, 1843, Tr. Coll.

44. *Illustrations of Political Economy, Ireland*, p. 126; see also *Moral of Many Fables*, p. 75.

45. Harriet Martineau to Milnes, November 21 [1844?], Tr. Coll.; see also Harriet Martineau, *Retrospect of Western Travel*, 2 vols. (London: Saunders and Otley, 1838), 1:157.

46. *History of the Peace,* 2:7 ff., 158, 292, 569–75.
47. *History of the Peace,* 2:315, 316, 576 ff.
48. Harriet Martineau to Frederick Knight Hunt, April 28 [1853?], B.U. Lib., 523.
49. *History from the Commencement,* 4:547 ff., 552–53, 576.
50. *History from the Commencement,* 4:577; see also *History of the Peace,* 2:629–30.
51. *History of the Peace,* 2:716; see also *History from the Commencement,* 4:622, which ends with the identical paragraph except for the word "forty" being substituted for "thirty." Cf. also *History of the Peace,* 2:444, 561; *Autobiography,* 2:447 ff., 453 (Letter to a friend, October 1, 1849).
52. *History from the Commencement,* 1:8–9.

Chapter VII

1. Walter Houghton, *The Victorian Frame of Mind 1830–70* (1957, New Haven and London: Yale University Press, 1972), p. 156.
2. Chapter title comes from Harriet Martineau, *Autobiography with Memorials by Maria Weston Chapman,* 3 vols. (London: Smith, Elder, and Co., 1877), 1:116; quotation from *Autobiography,* 2:186–87.
3. *Autobiography,* 1:36, 40, 156–58; see also 3:201 (Martineau's Diary, October 25, 1837).
4. She contributed to the Unitarian journal, *The Christian Teacher,* in the 1830s. See *Autobiography,* 3:201, and Francis E. Mineka, *The Dissidence of Dissent: The Monthly Repository 1806–1838* (Chapel Hill, N.C.: University of North Carolina Press, 1944), p. 246.
5. Henry Crabb Robinson to Thomas Robinson, July 7, 1842, DW Lib. Crabb Robinson is here referring to both the necessarian (Priestley) and the Romantic (Channing) elements in Martineau's religion at that time.
6. *Autobiography,* 2:172–73, 182; see also "Essays on the Art of Thinking," in Harriet Martineau, *Miscellanies,* 2 vols. (Boston: Hilliard Gray and Co., 1836), 1:119–20 (originally published in *MR* 3 [1829]: 521–26, 599–606, 707–12, 745–57, 817–22); Harriet Martineau, *Life in the Sick-Room* (1844; 2d American ed., Boston: William Crosby, 1845), pp. 117, 125, 156–57.
7. Harriet Martineau to James Martineau, January 17, 1842, Transcript Letters, M. Coll.; *Autobiography,* 3:141–42.
8. Karl Barth, *Protestant Theology in the Nineteenth Century* (1946; 1st English trans. 1972, Valley Forge: Judson Press, 1977), pp. 255–56 quoted from *Theological Writings.* The earliest English translation of Lessing's *Education of the Human Race* was made by Henry Crabb Robinson and published in the *Monthly Repository,* 1st ser., 1 (1806): 412–20, 467–73. See also Mineka, *The Dissidence of Dissent,* pp. 116, 212, 242, 245; Richard Garnett and Edward Garnett, *The Life of William Johnson Fox: Public Teacher and Social Reformer 1786–1864* (London and New York: John Lane, 1910), p. 80 (hereafter cited as *Fox*);

Harriet Martineau, "Lessing's Hundred Thoughts," in *Miscellanies,* 2:337–38 (originally published in *MR* 4 [1830]: 300–306, 367–73, 453–58, 511–17).

9. Quoted in Basil Willey, *Samuel Taylor Coleridge* (London: Chatto and Windus, 1972), p. 88; also see chap. 1 of this book, "A Human Mind from the Very Beginning."

10. *MR* 7 (1833): 19–30, 84–88, 231–41.

11. Quoted from *The Rationale of Religious Enquiry* (1836) in James Drummond and C. B. Upton, *Life and Letters of James Martineau,* 2 vols. (London: J. Nisbet and Co., 1902), 1:92; see also Bernard M. G. Reardon, *From Coleridge to Gore: A Century of Religious Thought in Britain* (1961; reprint ed., London: Longman, 1971), pp. 312–13.

12. Quoted in Drummond and Upton, *James Martineau,* 1:240–41; see also 1:169, 122; Garnett and Garnett, *Fox,* p. 92.

13. "Theology, Politics, and Literature," in *Miscellanies,* 1:195 (originally published in *MR* 6 [1832]: 73–79); see also "Essays on the Art of Thinking," in *Miscellanies,* 1:67; "Crombie's Natural Theology," in *Miscellanies,* 2:236–68 (originally published in *MR* 4 [1830]: 145–54, 223–30). And Mrs. John (Elizabeth) Farrar in *Recollections of Seventy Years* (Boston: Ticknor and Fields, 1866), pp. 261–62 recalled that Harriet Martineau had lectured on the philosophy of Kant to her fellow passengers en route from New York to England in 1836.

14. "Sabbath Musings," in *Miscellanies,* 1:132 (originally published in *MR* 5 [1831]: 73–77, 235–39, 369–73, 601–7, 684–90, 763–70).

15. See *Deerbrook,* 3 vols. (London: Edward Moxon, 1839), 1:85 in which religion, reason and philosophy are all identified as "faith." Cf. also *How to Observe Morals and Manners* (1838; American ed., New York: Harper Brothers, 1838), pp. 60–67, 81.

16. *Eastern Life Present and Past,* 3 vols. (London: Edward Moxon, 1848) (hereafter cited as *Eastern Life*).

17. Harriet Martineau to Milnes, January 31, 1847, Tr. Coll.; see also John Morley, *Critical Miscellanies,* 4 vols. (London: Macmillan & Co., 1909), 3:199; Weston Papers [Notes], Boston P. Lib., MS. A. 9. 2. vol. 5, p. 111; *Eastern Life,* 1:v, 2:39, 81; *Autobiography,* 2:270–71.

18. *Eastern Life,* 1:9–10, 82–84; 2:155 ff., 170 ff.; 3:120–21. See *British Quarterly Review* 8 (November, 1848): 436, for a review of *Eastern Life* which praised Martineau's descriptive talents. Note: Martineau's friend Milnes had visited Egypt in 1843 and had written favorably about the harem in *Palm Leaves* (1844); see also "The Rights of Women," *Quarterly Review* 75 (December, 1844): 94–125 [A. W. Kinglake: *Wellesley Index*].

19. See for example Harriet Martineau to Henry Crabb Robinson, July 6, 1850, DW Lib.; Harriet Martineau to Milnes, April 2 [1855], Tr. Coll.; Harriet Martineau to George Jacob Holyoake [1859?], B. Mus., Add. MS. 42726/26; *Autobiography,* 1:355.

20. Martineau's chief references were: Herodotus, Plutarch, Josephus, Sir

John Gardner Wilkinson (1797–1875), Samuel Sharpe (1799–1881), and Bartholemew Eliot George Warburton; see also *Autobiography,* 2:282.
21. *Eastern Life,* 3:332.
22. *Eastern Life,* 1:201, 247–48, 310, 331, 336; 3:69–70, 151, 262–63, 265–66. She believed that the strength of Mohammedanism lay in its lack of a priesthood (3:294–95).
23. *Eastern Life,* 1:150, 161 n; 2:84–85, 241; 3:100–2, 227–30.
24. John Murray to Harriet Martineau, February 25, February 29, 1848, B.U. Lib., 1187, 1190; Harriet Martineau to John Murray, March 3 [1848], B.U. Lib., 1191; Harriet Martineau to Edward Moxon, March 1, 1848, B.U. Lib., 1143; June 1 [1848], Bodleian, MS. Eng. Lett. d2 135; Harriet Martineau to Ralph Waldo Emerson, April 5 [1848], Harvard, b MS AM 1280; *Autobiography,* 2:294–95.
25. Henry Crabb Robinson Diary, November 22, 1848, DW Lib.
26. "Fuss in a Book-Club; as related by a copy of Miss Martineau's 'Eastern Life,' " *Fraser's* 38 (December, 1848): 628–34 [author unidentified: *Wellesley Index*]; *British Quarterly Review* 8 (November, 1848): 471–72.
27. Harriet Martineau to Henry Crabb Robinson, June 8, 1848, DW Lib.
28. Harriet Martineau to Henry George Atkinson, November 7, 1847, *Autobiography,* 2:282–84.
29. Mesmerism was based on a materialist philosophy, and although there is no evident connection the near coincidence of Martineau's mesmeric cure and her rejection of Christianity should not go unremarked. See Henry Crabb Robinson to Mrs. Wordsworth, September 5, 1845, DW Lib.: "In H:M: it would seems [*sic*] as if Mesmerism had driven Unitarianism out of the field. And it is quite certain that if she ever suffers martyrdom it will be for her physiological not her theological beliefs."
30. Henry George Atkinson to Maria Martineau, June 22, 1855, B.U. Lib.; see also *Autobiography,* 2:213; Harriet Martineau to Philip Carpenter, March 3, 1856, M. Coll.
31. Harriet Martineau to Philip Carpenter [March, 1856], M. Coll.; *Autobiography,* 2:213, 215, 335.
32. Henry George Atkinson and Harriet Martineau, *Letters on the Laws of Man's Nature and Development* (1851; American ed., Boston: Josiah P. Mendum, 1851) (hereafter cited as *Letters*).
33. *Letters,* pp. 1, 15, 149, 174, 176–77, 222–23, 225, 245; *Autobiography,* 2:334.
34. Martineau refused to admit atheism. See her letters to Patrick Brontë, November 5, November 13, 1857, B.U. Lib., 89, 90; *Autobiography,* 2:370.
35. Quoted in Anne Holt, *A Life of Joseph Priestley* (1931; reprint ed., Westport, Conn.: Greenwood Press, 1970), p. 116.
36. *Letters,* p. 145; see also pp. 130, 6, 121–22.
37. Harriet Martineau to James Martineau, March 2, 1833, Transcript Letters, M. Coll.; *Autobiography,* 1:392 ff.; Harriet Martineau, *Society in America,* 3 vols. (1837; London: Saunders and Otley, 1839), 3:174–75.

38. See for example *Letters*, pp. 35, 41, 198.

39. Harriet Martineau to Edward Moxon, November 6, 1850, Fitzwilliam Museum, Cambridge; see also *Autobiography*, 2:329 ff., 351.

40. James Anthony Froude, "Materialism.—Miss Martineau and Mr. Atkinson," *Fraser's* 43 (April, 1851): 418–34. Froude rejected orthodoxy in *Nemesis of Faith* (1849).

41. *Weekly Dispatch* [n.d.] from a clipping in the Holyoake Papers, B. Mus., Add. MS. 42726/33.

42. *Leader*, February 22, 1851, 178; March 8, 1851, 227; March 15, 1851, 256, letter signed "No disciple of Miss Martineau"; Gordon S. Haight, ed., *The George Eliot Letters*, 6 vols. (New Haven: Yale University Press, 1954), 1:364 (George Eliot to Charles Bray, October 4, 1851); Henry Crabb Robinson Diary, February 8, 1851, DW Lib.; *The Atlas* (1851), Holyoake Papers, B. Mus., Add. MS. 42726/34; John Stevenson Bushnan, "Miss Martineau and her Master," pamphlet (London: John Churchill, 1851). James Martineau's review was "Mesmeric Atheism," *Prospective Review* 7 (May, 1851): 224–62.

43. "Mesmeric Atheism," pp. 256, 257, 236.

44. James Martineau, "Biographical Memoranda," pp. 38, 39, M. Coll.; see also Drummond and Upton, *James Martineau*, 2:321 ff. (James Martineau to Francis W. Newman, May 14, 1852).

45. Drummond and Upton, *James Martineau*, 1:222 ff.; 2:347–48 n. In 1851 James praised an article on Niebuhr in the *Westminster Review*. He attributed it to Francis Newman but it was actually written by his sister; see Haight, *George Eliot Letters*, 2:46 (George Eliot to John Chapman, July 24–25, 1852).

46. Harriet Martineau to Helen Martineau, July 1, July 14 [1851], B.U. Lib., 631, 632; Helen Martineau to Harriet Martineau, [n.d.], 634, 635, 636; *Autobiography*, 2:217 ff., 354, 355; 3:280; "An Autobiographic Memoir," *DN*, June 29, 1876; see also Harriet Martineau to George Jacob Holyoake March 17, 1857, B. Mus., Add. MS. 42726/19, /23.

47. Edward Quillinan to Henry Crabb Robinson, March 14, April 28, 1851; Henry Crabb Robinson Diary, February 14, March 1, March 11, March 28, April 2, 1851; Henry Crabb Robinson to Thomas Robinson, March 15, 1851, DW Lib. The break in Martineau's friendship with Mrs. Arnold was brief and when Mrs. Arnold died in 1873, Martineau described her as a "dear kind friend," and "comrade"—see Harriet Martineau to Milnes, October 13, 1873, Tr. Coll. (her last extant letter to Milnes). See also John Chapman to Harriet Martineau, January 6, 1856, B.U. Lib., 199; Harriet Martineau to Philip Carpenter, January 1, January 9, January 11, 1856, M. Coll.

48. Sara [Mrs. Hartley] Coleridge to Henry Crabb Robinson, February 4, 1852, DW Lib.; see also Henry Crabb Robinson Diary, March 4, March 9, 1851; Henry Crabb Robinson to Thomas Robinson, September 22, 1851, DW Lib.; the Reverend Thomas Sadler to Harriet Martineau, March 6, 1869, B.U. Lib., 782.

49. William Lloyd Garrison to Harriet Martineau, December 4, 1855, B.U. Lib., 349.

50. Sara Hennell to Harriet Martineau, April 13, June 24, 1860, B.U. Lib.; Henry William Wilberforce to Harriet Martineau, October 3, 1864, B.U. Lib., 1017; the Reverend Robert Perceval Graves to Harriet Martineau, January 11, 1853, B.U. Lib., Add. 12; *Autobiography*, 3:275, 475–76.

51. Gordon S. Haight, *George Eliot and John Chapman: With Chapman's Diaries* (New Haven: Yale University Press, 1940), p. 189, Chapman Diary, July 4, 1851.

52. Harriet Martineau to George Jacob Holyoake, October 6 [1851], B. Mus., Add. MS. 42726/1.

53. Harriet Martineau to James Martineau, March 24, 1831, Transcript Letters, M. Coll.

54. *Edinburgh Review* 67 (July, 1838): 271–308 [Sir David Brewster: *Wellesley Index*].

55. Thomas Huxley favorably reviewed Martineau's Comte translation in *Westminster Review* 42 (July, 1854): 92–103; see also Lewes's favorable review in the *Leader*, December 3, 1853, pp. 1171–72.

56. *Autobiography*, 2:371 ff.; see also Haight, *George Eliot and John Chapman*, pp. 55–56, 199–200, 205, 206, 214, 215; Harriet Martineau to George Jacob Holyoake, October 6 [1851], April 9, November 4, 1853, B. Mus., Add. MS. 42726/1, /9, /11.

57. *The Positive Philosophy of Auguste Comte*, trans. Harriet Martineau, first published in 1853; with introduction by Frederic Harrison, 3 vols. (1896; London: G. Bell and Sons, 1965) (hereafter cited as *Positive Philosophy*). See 1:xvii, xxiii, xxiv, xxvi.

58. *Positive Philosophy*, 1:3–4, 8, 9; 2:137, 183–84, 240–41; 3:402. For Comte's belief in and reliance upon phrenology see also 2:113–17, 122, 136.

59. *Positive Philosophy*, 2:140–45, 150, 152.

60. *Positive Philosophy*, 2:170; see also 2:206–7; 3:196, 272.

61. *Positive Philosophy*, 3:5.

62. *Positive Philosophy*, 2:284–85.

63. See John Stuart Mill's arguments against Comte's theory of female inferiority: *Auguste Comte and Positivism* (1865; reprint ed., Ann Arbor: University of Michigan Press, 1961), pp. 63–67; Iris Mueller, *John Stuart Mill and French Thought* (Urbana: University of Illinois Press, 1956), pp. 113 ff.; Michael St. John Packe, *The Life of John Stuart Mill* (London: Secker and Warburg, 1954), pp. 276–77.

64. *Positive Philosophy*, 2:168, 173, 179, 187; 3:133, 277, 311–15, 319, 328, 332–34.

65. John Stuart Mill, *Comte*, p. 125.

66. Friedrich Wilhelm Nietzsche, *Twilight of the Idols*, in *Works* (1909–11; reprint ed., New York: Russell and Russell, 1964), 16:62.

67. *Autobiography*, 3:312.

68. Harriet Martineau, *The History of England during the Thirty Years' Peace 1816–1846,* 2 vols. (London: Charles Knight, 1849–50), 2:141; *How to Observe Morals and Manners,* pp. 158 ff. in which she stated her objection to "blind, ignorant obedience to any ruling power which the subjects had no hand in constituting."

69. *Leader,* December 3, 1853, pp. 1171–72.

70. Haight, *George Eliot Letters,* 2:127 (George Eliot to Sara Hennell, November 25, 1853); 140 (George Eliot to Charles Bray, February 6, 1854); Frederic Harrison in the Introduction to *Positive Philosophy,* 1:xiii, xvii; *Autobiography,* 3:310–12; *Daily News,* August 19, 1875; Friedrich A. Hayek, *The Life of John Stuart Mill* (London: Secker and Warburg, 1954), pp. 188, 189; Packe, *John Stuart Mill,* p. 310.

71. *Autobiography,* 2:288–92.

72. Harriet Martineau to George Jacob Holyoake, May 17 [1854?], B. Mus., Add. MS. 42726/13.

Chapter VIII

1. Harriet Martineau, *Autobiography with Memorials by Maria Weston Chapman,* 3 vols. (London: Smith, Elder, and Co., 1877), 1:2; 2:424, 430, 431; Maria Martineau to Arthur Allen, July 20, 1855, Yale, MS. Vault File 15/4; *British Medical Journal* 2 (July 8, 1876): 64; (April 14, 1877): 449–50; (April 21, 1877): 496; (May 5, 1877): 545.

2. Harriet Martineau to John Chapman, September 16, 1855, Bodleian, MS. Eng. Lett. d2 186.

3. Florence Fenwick Miller, *Harriet Martineau* (London: W. H. Allen, 1884), p. 131 (Harriet Martineau to Henry Atkinson, July 6, 1874). For her continued faith in mesmerism see Harriet Martineau to Mary Carpenter, April 17, 1866 (copy), Brougham Papers, University Coll.; Richard Garnett and Edward Garnett, *The Life of William Johnson Fox: Public Teacher and Social Reformer 1786–1864* (London and New York: John Lane, 1910), p. 310.

4. Harriet Martineau to George Jacob Holyoake, February 15 [1855?], B. Mus., Add. MS. 42726/14. In the same letter she suggested composing a secularist burial service. See also George Jacob Holyoake to Harriet Martineau [n.d.], B. Mus., Add. MS. 42726/15.

5. Harriet Martineau to Mrs. Frederick Knight Hunt, February 15 [1855], B.U. Lib.; see also *Autobiography,* 3:2–3 (Harriet Martineau to Maria Weston Chapman, January 24, 1855); 3:450 (January 25, 1876); 3:454 (Harriet Martineau's last letter to Henry George Atkinson, May 19, 1876); also cf. 2:438; Henry George Atkinson and Harriet Martineau, *Letters on the Laws of Man's Nature and Development* (1851; American ed., Boston: Josiah P. Mendum, 1851), pp. 143, 168, 190.

6. Harriet Martineau to Philip Carpenter, February 11 [1855], M. Coll.

7. Harriet Martineau to George Jacob Holyoake, Feburary 15 [1855], B. Mus., Add. MS. 42726/14. Holyoake suggested that Francis W. Newman would be the best person to complete the *Autobiography* if Martineau did not live to do so. See also Harriet Martineau to Philip Carpenter, January 11, 1856, M. Coll.

For an additional comment on the *Autobiography* see "A Note on Sources."

8. John Chapman to Harriet Martineau, September 27, 1855, B.U. Lib., 189; Harriet Martineau to John Chapman, September 16, 1855, Bodleian, MS. Eng. Lett. d2 187; Milnes to Harriet Martineau [1855], B.U. Lib., 693; Harriet Martineau to Milnes, April 20, September 5, November 21 [1855], Tr. Coll.; Thomas Martineau (Harriet's nephew and executor, son of Robert) to Milnes, October 12, 1876, Tr. Coll.

9. Harriet Martineau to John Chapman, September 16, 1855, Bodleian, MS. Eng. Lett. d2 188; John Chapman to Harriet Martineau, September 13, 1855, B.U. Lib., 189; see also Gordon S. Haight, ed., *The George Eliot Letters*, 6 vols. (New Haven: Yale University Press, 1954), 1:xliv; Gordon S. Haight, *George Eliot and John Chapman: With Chapman's Diaries* (New Haven: Yale University Press, 1940), p. 75; *Autobiography*, 2:425.

10. James Drummond and C. B. Upton, *Life and Letters of James Martineau*, 2 vols. (London: J. Nisbet and Co., 1902), 1:269; *Autobiography*, 3:394; Haight, *George Eliot and John Chapman*, p. 76.

11. John Chapman to Harriet Martineau, November 6, 1855; January 6, 1856, B.U. Lib., 193 and 199; Haight, *George Eliot Letters*, 2:225–26 (George Eliot to Sara Hennell, January 18, 1856).

12. Harriet Martineau to George Grote, April 2, 1858, B.U. Lib., 385; Samuel Courtauld to George Grote, June 7, 1858 (copy), B.U. Lib., 392; John Chapman to Harriet Martineau, July 29, 1858; August 8, 1858 (copy), B.U. Lib., 236 and 204; Maria Martineau to John Chapman, July 31, 1858, B.U. Lib., 237; Harriet Martineau to John Chapman, June 1, 1858 (copy), July 4, 1858, B.U. Lib., 222 and 230; Undated note in Harriet Martineau's hand, B.U. Lib., 242; Harriet Martineau to John Chapman, July 16, 1858, August 6, 1858, Bodleian, MS. Eng. Lett. d2 230, 232, 235; Haight, *George Eliot Letters*, 2:490 (George Eliot to Charles Bray, October 13 [1858]).

13. Charles Dickens to Harriet Martineau, April 19, 1853, B.U. Lib., 279.

14. *Autobiography*, 2:417–23; Harriet Martineau to W. H. Wills, September 26, 1855 (copy), B.U. Lib., 1025. Her correspondence with Samuel Lucas of *Once a Week*, 1859–1864, B.U. Lib., 596–610. For her association with the *Anti-Slavery Standard* see *Autobiography*, 3:369 ff.

15. See the Harriet Martineau-Henry Reeve letters, 1858–1863, B.U. Lib., 725–30; see also John Knox Laughton, ed., *Memoirs of the Life and Correspondence of Henry Reeve*, 2 vols. (London and New York: Longmans, Green and Co., 1898), 1:396; 2:87, 107.

16. *Autobiography*, 3:3 (Harriet Martineau to Maria Weston Chapman, Janu-

ary 24, 1855); 2:429; 3:337 ff., 342–43, 422 ff.; Harriet Martineau to Frederick Knight Hunt, April 28 [1853?], B.U. Lib., 492; Harriet Martineau to William Lloyd Garrison, November 1 [1853?], Boston P. Lib., MS. A. 1. 2. vol. 21, p. 116; Harriet Martineau to Philip Carpenter, November 23 [1854], M. Coll.; Harriet Martineau to William Weir (editor of the *Daily News* 1854–58), B.U. Lib., 937–69; Harriet Martineau to Thomas Walker (editor of the *Daily News* 1858–66), B.U. Lib., 926–31; Harriet Martineau to Sir John Richard Robinson (manager of the *Daily News* 1868–1901), B.U. Lib., 736–40. Weir described Harriet Martineau as "no Miss Martineau, but a benevolent indefatigable fairy, who knows instinctively what is wanted, and how it should be done" (quoted in *Autobiography*, 3:340). Robinson prepared Martineau's *Daily News* obituaries for publication in 1869 as *Biographical Sketches*—see *Autobiography*, 3:425.

17. An unpublished list compiled by R. K. Webb of Martineau's *Daily News* articles is available in the Library of Congress, the Boston Public Library, and the British Museum Newspaper Library. See *Autobiography*, 3:405–6, 343; Harriet Martineau to Frederick Knight Hunt, June 25 [1853(?)], B.U. Lib., 492; Harriet Martineau to [Philip Carpenter], September 29, 1856, M. Coll.; Harriet Martineau to Rowland Hill [1853], B. Mus., Add. MS. 31978/ 290, 294, 296.

Testifying to her continued interest in the world: Maria Martineau to Arthur Allen, December 26 [1856], Yale, MS. Vault File 15/4; Jane Martineau to George Jacob Holyoake, [misdated 1876], B. Mus., 42726/27; Thomas Sadler, ed., *Diary, reminiscences and correspondence of Henry Crabb Robinson*, 3 vols. (London: Macmillan & Co., 1869), 3:449 (Henry Crabb Robinson to Thomas Robinson, October 1, 1856).

18. Harriet Martineau, *The History of England during the Thirty Years' Peace 1816–1846*, 2 vols. (London: Charles Knight, 1849–50), 1:268, 317 (hereafter cited as *History of the Peace*); Harriet Martineau to James Martineau, October 23, 1823, Transcript Letters, M. Coll.

19. Martineau expressed opinions on Russia in *Autobiography*, 1:236–37, 414; 2:450–52 (letter to an American friend, October 1, 1849); 3:213; and *History of the Peace*, 2:368.

20. *Daily News* (hereafter cited as *DN*), November 19, 1852; June 15, July 13, October 8, 1853; February 24, 1854.

21. Harriet Martineau to Milnes, July 1 [1854?], Tr. Coll.; see also Harriet Martineau to Frederick Knight Hunt [1854?], B.U. Lib. 484; "England's Foreign Policy," *WR*, n.s. 7 (January, 1854); *DN*, October 20, December 19, 1853; January 28, 1854, letter signed, "One who remembers George the Third"; November 18, 27, 30, December 27, 1854; *Anti-Slavery Standard*, June 18, 1859; *The Factory Controversy: A Warning against Meddling Legislation* (Manchester: National Association of Factory Occupiers, 1855), p. 5.

Martineau regretted that Bright and Gibson, "the brave men of the

League," had been lost to Manchester as M.P.s on account of their pacifism.

22. *DN*, January 20, 1854; see also January 2, November 2, 1854; May 24, December 18, 1855; January 22, 1856; "Lord Herbert of Lea," and "The Duke of Newcastle," in *Biographical Sketches* (1869; American ed., New York: Leypoldt and Holt, 1869). For Martineau's voluminous correspondence with Florence Nightingale see B. Mus., Add. MS. 45788. On the subject of army reform see George Smith to Harriet Martineau, January 18, 1859, B.U. Lib., 813; Harriet Martineau to George Smith, January 19, 1859, B.U. Lib., 814.

23. *DN*, November 2, 1854; May 24, 1855.

24. *DN*, December 6, 1855.

25. *DN*, June 24, 1852; May 6, December 31, 1859; *Anti-Slavery Standard*, June 18, June 25, July 9, August 20, December 17, 1859; *Autobiography*, 3:410–13 (Harriet Martineau to Maria Weston Chapman, July 22, 1862); Miller, *Harriet Martineau*, pp. 201–3 (Harriet Martineau to Atkinson, October 18, 1870).

26. *DN*, July 29, August 29, October 2, October 7, 1854; April 8, 1856; see also January 3, 1853; August 3, 1854.

27. *History of the Peace*, 1:311, 371–72. See *British Rule in India: a Historical Sketch* (London: Smith, Elder, and Co., 1857), pp. 321 ff.; *DN*, January 3, 1853. Although she expressed the fear that emigration of too many skilled workers might be detrimental to the English economy (*DN*, June 28, 1853), she still recommended emigration—see her *DN* leaders May 10, 15, 21, 31, June 5, 8, 1852, etc.

28. She remained in close contact with the Lambtons even after the death of Lord Durham in 1840. Members of the family visited her at Ambleside in 1866.

29. *How to Observe Morals and Manners* (1838; American ed., New York: Harper Brothers, 1838), pp. 179–80. See also *History of the Peace*, 2:377, 382–90, 661.

30. "The Year 1865," MS., B.U. Lib., 1404.

31. *British Rule in India*, p. 333; *DN*, May 12, June 7, 1853.

32. See Eric Stokes, *The English Utilitarians in India* (Oxford: Clarendon Press, 1959), pp. 27, 35–36, 57, 63–69, 242, 251–52, 255–56, 298, 320–21.

33. *Suggestions Towards the Future Government of India* (London: Smith, Elder, and Co., 1858); see also Harriet Martineau to George Jacob Holyoake, December 27, 1857, B. Mus., Add. MS. 42726/24.

34. *British Rule in India*, pp. 124–35, 173–78, 180–83, 287, 296, 297, 337, 338; *Autobiography*, 3:350–53.

35. *DN*, November 2, 1857; see also August 27, September 12, 1857; *British Rule in India*, pp. 187, 341.

36. *DN*, February 19, 22, 26, March 8, 13, 26, December 31, 1858; July 30, 1860.

37. For the Indianization of the India Army officer corps see *DN*, July 28, 1857.

38. Harriet Martineau to William Lloyd Garrison, February 16, 1859 (possibly a copy), M. Coll.; see her comment in the *Anti-Slavery Standard*, June 25, 1859 about the incongruity of permitting slavery in a democratic republic. See also, Miller, *Harriet Martineau*, p. 100; *DN*, October 20, 1852. Martineau commended W. E. Forster's understanding of and efforts in behalf of the American question in *DN*, November 27, 1862. She also paid tribute to the efforts of the *Daily News* editor, Thomas Walker, in Harriet Martineau to William Lloyd Garrison, July 7, 1867, Boston P. Lib., MS. A. 1. 2. vol. 35, p. 72A. And see Harriet Martineau to [Philip Carpenter], July 7 [1856?], M. Coll.

39. *A History of the American Compromises*, reprinted from *DN* (London: Chapman, 1856), pp. 31–32; see also pp. 6, 26 ff.; "The United States under the Presidentship of Mr. Buchanan," *ER* 112 (October, 1860): 278–97; *DN*, June 18, 1857.

40. "The United States under the Presidentship of Mr. Buchanan," p. 288.

41. *DN*, December 31, 1861.

42. Ibid. p. 296. *DN*, May 14, November 22, 1860; March 4, December 21, 1861; February 15, March 1, 23, 28, 1862; *Anti-Slavery Standard*, April 13, 1861; "The Negro Race in America," *ER* 119 (January, 1864): 102–23; Harriet Martineau to William Lloyd Garrison, August 10, 1864, Boston P. Lib., MS. A. 1. 2. vol. 33, p. 77A.

43. *The "Manifest Destiny" of the American Union*, reprinted from *WR*, July, 1857 (New York: American Anti-Slavery Society, 1857), p. 64; see also pp. 25, 38, 44–45, 53; *A History of the American Compromises*, pp. 19–20; *Anti-Slavery Standard*, June 1, 1861; *DN*, January 23, February 2, September 18, 1856; *Autobiography*, 3:245 (Harriet Martineau to Mrs. Henry G. Chapman, March 15, 1845).

44. Harriet Martineau to Milnes, May 9, 1862, Tr. Coll.; see also *DN*, November 2, 9, 1859; January 3, 1860; January 29, February 23, May 16, July 20, October 11, 1861; "The United States under Mr. Buchanan," p. 292; *Autobiography*, 3:376, 403; *Anti-Slavery Standard*, June 1, 1861.

45. For Martineau's concern about the exploitation of liberated blacks see "The Negro Race in America," *ER* 119 (January, 1864): 110, 113, 118.

46. *DN*, June 20, 1862; see also September 18, 24, 1856; January 14, August 30, 1862; *Anti-Slavery Standard*, August 20, 1859; April 13, June 29, August 3, October 5, December 28, 1861; *Autobiography*, 3:386, 406–7 (Harriet Martineau to Maria Weston Chapman, October 31, 1861); 3:410 (Harriet Martineau to Maria Weston Chapman, July 8, 1862); Harriet Martineau to Milnes, August 11, 1862, Tr. Coll.; Harriet Martineau to [Philip Carpenter], September 19, 1856, M. Coll.

47. *DN*, August 2, 1852; August 13, 1856; *History of the Peace*, 2:96, 446.

48. Mary Ellison, *Support for Secession: Lancashire and the American Civil War* (Chicago and London: University of Chicago Press, 1972).

49. William E. Forster to Harriet Martineau, March 25, 1869, B.U. Lib., 312.
50. *DN*, January 19, 1857; see also July 17, 21, 1862; November 11, 21, 1863.
51. "The Year 1865," undated MS., B.U. Lib., 1404; *DN*, November 10, 20, 1852; November 24, December 1, 1857; January 5, 1859; January 26, October 8, 1861.
52. John Chapman to Harriet Martineau, November 10, 1855, B.U. Lib., 195. See also *The Factory Controversy;* see her correspondence with Henry Whitworth of Liverpool, Secretary of the National Association of Factory Occupiers, B.U. Lib., 976–1015; also note *DN*, February 12, 1856; January 20, 1857; August 3, September 10, 1859; February 27, 1860.
53. See chap. 3, and cf. *DN*, August 4, 11, 1863.
54. See for example Harriet Martineau to Milnes, July 20 [1844], Tr. Coll.
55. *DN*, February 17, March 26, June 16, October 21, November 1, 1853; March 17, 1854; January 30, 1857; September 19, October 3, 1859; August 20, 1860; April 5, December 8, 1864; January 18, 1865.
56. Robert F. Martineau to Harriet Martineau, August 7, 1859, B.U. Lib., 1321. She also received information from Charles Bray, and she read letters to the press by Trade Unionists, and pamphlets by workers opposed to strikes, B.U. Lib., 1319–37. See and compare with Charles Dickens in *Hard Times.*
57. *DN*, April 30, 1853; January 28, September 24, 1861.
58. "Prison Discipline," in Harriet Martineau, *Miscellanies,* 2 vols. (Boston: Hilliard Gray and Co., 1836), 2:287 (originally published in *MR* 6 [1832]: 577–86). See also "National Education," *MR* 6 (1832): 689–94.
59. *How to Observe Morals and Manners,* p. 171; see also *DN*, April 14, 21, 1857.
60. Matthew Arnold to Harriet Martineau, April 11, July 24, 30, 1860; July 7, 1864, B.U. Lib., 17–20; also see *DN*, June 18, 1852; March 22, April 7, May 25, 1853; September 9, 1854; October 13, November 29, 1856; June 25, September 7, December 7, 1864; *History of the Peace,* 2:250–51, 441–43, 555–56, 595. She believed that Forster's Education Bill was marred by its concessions to religious interests: Josephine Butler to Harriet Martineau, December 21 [?], B.U. Lib., 118; W. E. Forster to Harriet Martineau, February 26, 1870, B.U. Lib., 313; Miller, *Harriet Martineau,* pp. 207–8 (Harriet Martineau to Atkinson, December, 1871).
61. *DN*, May 5, 1853; November 5, 1855; April 14, 21, 1857. Martineau also supported adult education actively by teaching in Ambleside, encouraging Mechanics' Institutes, and working with Charles Knight and the SDUK to publish cheaper books.
62. *DN*, June 20, 1855; August 10, 1853; January 14, 1854 (letter signed "A Reformer"); May 28, June 15, 19, 1855; April 9, 1857; Harriet Martineau,

The History of England from the Commencement of the XIXth Century to the Crimean War, 4 vols. (Philadelphia: Porter and Coates, 1864), 1:7.

63. *DN,* December 9, 1859; see also March 17, 25, April 22, 1859; July 4, 1862. Like almost every other liberal in the country, she had opposed Lord John Russell's abortive Reform Bill of 1860 because of its "poor timing." See Harriet Martineau to [Philip Carpenter], June 2 [1860?], M. Coll.; "The Year 1865," undated MS., B.U. Lib., 1404.

64. Barbara Leigh Smith Bodichon, *An American Diary,* ed. Joseph W. Reed (London: Routledge and Kegan Paul, 1972).

65. *DN,* July 17, 1856; April 9, 1857.

66. *How to Observe Morals and Manners,* p. 152; *DN,* October 21, 1856.

67. "On Female Education," *MR,* 1st ser. 18 (1823), p. 79.

68. Matthew Arnold to Harriet Martineau, July 7, 1864, B.U. Lib., 20.

69. *DN,* February 18, 1864, on working women's colleges.

70. "Middle Class Education. *Girls,*" *The Cornhill Magazine* 10 (November 1, 1864): 549–68. The manuscript is in the Harvard University Library.

71. *DN,* November 23, 1859.

72. Harriet Martineau, *Household Education* (1849; American ed., Philadelphia: Lea Blanchard, 1849), pp. 155–56. Martineau never neglected and rather enjoyed her own domestic accomplishments. See for example Holyoake's comment: "In spite of the vigour and grasp of her [Martineau's] intellect, she is a true woman, and proclaims Home a peculiarly female sphere of action." B. Mus., Add. MS. 42726/35. See also *Autobiography,* 3:289–91, Charlotte to Emily Brontë: "All she [Martineau] does is well done, from the writing of history down to the quietest feminine occupation." And Lady Henrietta Maria Stanley of Alderley to Harriet Martineau, January 4, 1872, B.U. Lib., 864.

73. Quoted in Eleanor Flexner, *Mary Wollstonecraft: A Biography* (New York: Coward, McCann and Geoghegan, 1972), p. 60.

74. "Middle Class Education. *Girls,*" pp. 31–32.

75. *Autobiography,* 1:142. Both Ellen and Rachel became teachers, the former only until her marriage to Alfred Higginson. Rachel never married.

76. *Autobiography,* 1:120.

77. Henry Crabb Robinson, Diary, May 14, 1838, DW Lib. See also Florence Nightingale to Harriet Martineau, November 30, 1858, B. Mus., Add. MS. 45788/1; Harriet Martineau, *Society in America,* 3 vols. (1837; London: Saunders and Otley, 1839), 3:118, 147; M. Phillips and W. S. Tomkinson, *English Women in Life and Letters* (Oxford: Oxford University Press, 1926), p. 350; Amy Cruse, *Victorians and Their Reading* (Boston: Houghton Mifflin, 1935), p. 342.

78. *DN,* November 17, 1859; see also February 29, April 2, 1856; December 9, 1859. On women in the professions refer to *DN,* August 31, 1853; July 5, 1854; October 21, 1856; January 13, 1857; March 25, November 25, 1859; July 9, 1863; February 18, 1864. See also George F. W. Robin-

son, 3d Earl de Grey (later Marquess of Ripon) to Harriet Martineau, May 10, 1870, B.U. Lib., 276.

79. "On Female Industry," *ER* 109 (April, 1859): 151–73; see also *DN*, February 18, 1864.

80. *DN*, February 29, March 26, 1856; December 31, 1857; May 28, 1858.

81. *How to Observe Morals and Manners*, p. 147; *Society in America*, 3:128.

82. *Household Education*, p. 23.

83. *How to Observe Morals and Manners*, pp. 146, 148, 154.

84. *Autobiography*, 3:438.

85. *DN*, December 31, 1869; see also *Autobiography*, 3:427 ff.

86. The Josephine Butler Papers in the Fawcett Library, London were being catalogued at the time this research was done, and additional letters may be found in this collection. There are other letters in the Birmingham University and Boston Public libraries. See also *Autobiography*, 3:436–37; A. S. G. Butler, *Portrait of Josephine Butler* (London: Faber and Faber, 1954), p. 71.

87. *Autobiography*, 3:436; see also George Warr to Harriet Martineau, March 27, April 1, 1873, B.U. Lib., 933 and 934; Harriet Martineau to Mary J. Herford, May 23, 1873 (copy), B.U. Lib., 426; Josephine Butler to Harriet Martineau, December 22, 1872, B.U. Lib., 119. See also, for example, Anne Jemima Clough to Harriet Martineau, 1852 to 1862, Fawcett Lib.; Lady Henrietta Maria Stanley of Alderley to Harriet Martineau, several letters 1872, B.U. Lib., 855–66; Emily Faithfull to Harriet Martineau, March 14, 1863, B.U. Lib., 294; Josephine Kamm, *Hope Deferred* (London: Methuen, 1965), p. 181.

88. Sir John Richard Robinson to Harriet Martineau, May 22, 1871, B.U. Lib., 758.

89. For her views on the Whig administration see, for example, *DN*, May 31, 1855; August 14, 1856; August 1, 1860; Harriet Martineau to Frederick Knight Hunt [1852–54?], B.U. Lib., 494–99; "Lord Palmerston," in *Biographical Sketches*, pp. 390–91; Harriet Martineau to Florence Nightingale, May 13, 1867, B. Mus., Add. MS. 45788/310.

Epilogue

1. Thomas Walker (editor, *Daily News*) to Harriet Martineau, April 26, 1866, B.U. Lib., 931; Harriet Martineau to the Reverend Robert Graves, July 5, 1866, B.U. Lib., Add. 29; James Anthony Froude to Harriet Martineau, October 26, 1866, B.U. Lib., 315, asking her to contribute to *Fraser's*, an invitation which she was forced to decline on account of her health; and Harriet Martineau, *Autobiography with Memorials by Maria Weston Chapman*, 3 vols. (London: Smith, Elder, and Co., 1877), 3:424.

2. Harriet Martineau to Florence Nightingale, June 25, 1860; November

2, 1861; May 13, September 6, 1867, B. Mus., Add. MS. 45788/59, /86, /170, /309, /312; *Autobiography*, 3:444, 451–56, 418, 481; *British Medical Journal* (July 8, 1876): 64; (April 14, 1877): 449–50; (April 21, 1877): 496; (May 5, 1877): 545; Maria Martineau to Arthur Allen, July 22, 1855; December 26 [1856], Yale, MS. Vault File 15/4; Harriet Martineau to [Philip Carpenter], December 12, 1854; January 7, 1856; June 26, 1865, M. Coll.; Harriet Martineau to Milnes, May 9, 1862, Tr. Coll.; Julia Smith to [Maria or Jane] Martineau, March 23, [n.d.], B.U. Lib., 837.

3. Martineau had made Maria her heir in 1858. See John Chapman to Harriet Martineau, March 8, 1858, B.U. Lib., 216.

4. Harriet Martineau to Florence Nightingale, May 13, September 6, 1867, B. Mus., Add. MS. 45788/308 and /314; Harriet Martineau to [Philip Carpenter], May 28, 1864, M. Coll.; W. E. Gladstone to James Martineau (copy), June 6, 1873, B.U. Lib., 356; Harriet Martineau to W. E. Gladstone, June 8, 1873, B.U. Lib., 358; W. E. Gladstone to Harriet Martineau [June 9, 1873], B.U. Lib., 359; *Autobiography*, 3:445–47. Note: Gladstone's offer of a pension was made through James because he was unaware of the rift between brother and sister. James forwarded a copy of the Prime Minister's letter (not the original) to his sister.

5. "An Autobiographic Memoir," *DN*, June 29, 1876.

6. *Autobiography*, 3:197, from her diary (1838).

7. W. R. Greg, "Harriet Martineau," *Nineteenth Century* 2 (August, 1877): 100–102.

8. Gordon S. Haight, ed., *The George Eliot Letters*, 6 vols. (New Haven: Yale University Press, 1954), 2:32 (George Eliot to Mr. and Mrs. Charles Bray and S. Hennell, June 2, 1852); 1:189 (George Eliot to Martha Jackson, April 21, 1845); 2:229–30, 258; 6:354.

9. Matthew Arnold, *Letters 1848–1888*, 2 vols., ed. George W. E. Russell (1895; reprint ed., Grosse Pointe, Mich.: Scholarly Press, 1968), 1:51.

10. Quoted in John Morley, *Critical Miscellanies*, 4 vols. (London: Macmillan & Co., 1909), 3:175.

11. *The National Reformer*, n.s. 27 (July 9, 1876); see also Holyoake's obituary notice in the *Index* (December 28, 1876), p. 619.

12. Greg, "Harriet Martineau," p. 102.

13. Greg, "Harriet Martineau," p. 103.

14. Morley, *Critical Miscellanies*, 3:176–77.

15. *Deerbrook*, 3 vols. (London: Edward Moxon, 1839), 1:278–79; see also Harriet Martineau to Arthur Allen, November 8 [?], December 31 [?], Yale, MS Vault File 15/4.

16. "On the Duty of Studying Political Economy," in Harriet Martineau, *Miscellanies*, 2 vols. (Boston: Hilliard Gray and Co., 1836), 1:20 (originally published in *MR* 6 [1832]: 24–34).

17. ". . . of posthumous fame I have not the slightest expectation or desire.

To be useful in my day and generation is enough for me" (*Autobiography,* 3:33 from a memo dated June 1829 [see chap. 2]). See also Harriet Martineau to Milnes, May 9, 1862, Tr. Coll., in which she told Milnes that she did not care for fame herself and was frightened and alienated by ambition in others.

18. John Stuart Mill, *Collected Works,* 13 vols., ed. F. E. L. Priestley and J. M. Robson (Toronto: University of Toronto Press, 1963–72), 12:152 (John Stuart Mill to Thomas Carlyle, November 22, 1833).

A Note on Sources

Harriet Martineau's *Autobiography,* written in 1855 but published in 1877, the year of her death, is still the single most useful source for a study of her life. Along with *Household Education* (1849), it is especially useful for the early years for which there is no existing correspondence. Like most such works, however, Martineau's *Autobiography* has serious limitations. She wrote in large part to explain her conversion from religious orthodoxy, and the representation of her early beliefs is distorted by her later attitude. She also wrote because she felt it was a duty incumbent on a famous personage, and, as a result, her *Autobiography* is written not in the spirit of self-exploration but rather of public explanation. She did not dwell on the more personal details of her life: her closest friends were "too near and dear to me to be described in detail"; her engagement to John Hugh Worthington was not dwelt on (on the advice of Henry Atkinson); and her later relationship with James was discreetly passed over. Because the *Autobiography* was completed more than two decades before Harriet Martineau's death, it fails to account for the final years. Maria Weston Chapman's *Memorials* which make up the concluding volume only partially supply the deficiency. Mrs. Chapman's *Memorials* were damned with faint praise when the *Autobiography* was published in 1877, and they have received short shrift ever since. It is true, as R. K. Webb says, that they are "wretchedly edited and completely eulogistic," but they nevertheless contain much valuable information, and cannot be ignored. As the work of a friend of nearly forty years, Maria Weston Chapman's reminiscences are invaluable in spite of their bias. She was also in possession of documents which are no longer available. Unfortunately she censored her material, and, in compliance with her friend's wishes, destroyed the originals.

Martineau herself was aware of the difficulty of honest self-appraisal and therefore of the limitations of autobiography. In 1830 she made the following observation, and it is well to keep it in mind when reading the *Autobiography:*

> It is painful enough to fix our gaze steadily on any foul stain or festering sore within, which is hidden from every other human eye; it is difficult enough to

detect every slight obliquity, and to acknowledge to ourselves the permanence of any deformity which we have long labored to rectify: and how can we summon courage to stand the examination of the public, to invite the careless observation of those who cannot feel with us, or the rigid scrutiny of some who will not spare us? The best parts of ourselves it is yet more difficult to expose, as the most exalted virtues are the most modest, and the most refined parts of the human machine are the most sensitive. ["Dodderidge's Correspondence and Diary," *Miscellanies*, 2:348]

Martineau's friends certainly thought that the *Autobiography* did her less than justice. It was in her personal correspondence, they felt, that the virtues of her character were most evident.

The only extant family letters are those which she wrote to James between August 9, 1819, and August 6, 1843. James condensed and transcribed these into shorthand and, unfortunately, the reader cannot be sure how great a reinterpretation was made in the transcription. Scholars are indebted to R. K. Webb who commissioned a longhand translation of James's shorthand in 1958. The transcript letters, together with letters to Helen Martineau and Philip Carpenter, are located in the Manchester College Library, Oxford. Martineau's letters to such intimate acquaintances as Julia Smith, Mrs. Bellenden Ker, Mrs. Elizabeth Reid, and others have not survived, but fortunately not all Martineau's correspondents obeyed her 1843 injunction to destroy her letters. Important collections of Martineau letters are to be found in the following locations: 1417 items and some additional letters in the University of Birmingham Library were presented to the library by Sir Wilfrid and John Martineau in 1961, and were catalogued by D. W. Evans in 1969. The Martineau-Henry Crabb Robinson correspondence is in the Dr. Williams's Library, London. The Martineau–Richard Monckton Milnes (Lord Houghton) correspondence is to be found in the Trinity College Library, Cambridge. The Brougham and SDUK collections are in the University College Library, London. The Francis Place, Florence Nightingale, Sir Robert Peel, John Bright, Rowland Hill, and George Jacob Holyoake papers are in the British Museum. The Weston and Anti-Slavery Society papers are in the Boston Public Library. Additional letters can be located in several other libraries in England and the United States, including: the Cambridge University Library; the Bodleian, Oxford; the Fawcett Library, London; the Beineke Library, Yale; and the Houghton Library, Harvard.

The most important of Harriet Martineau's publications have been cited in the text and documented in the notes. A comprehensive list of the most important of Martineau's publications cited in the text is appended. A complete bibliography of Harriet Martineau's works has been published by Joseph B. Rivlin, "Harriet Martineau: A Bibliography of her Separately Printed Works," *Bulletin of the New York Public Library* 50 (1946); 51 (1947). There is a great need for a similar indexing of Harriet Martineau's journal articles. Her *Monthly Repository* articles, reproduced for the most part in

Miscellanies (1836) which has recently been reprinted by AMS Press, have been identified and catalogued by Francis E. Mineka in *The Dissidence of Dissent: The Monthly Repository 1806–1838* (Chapel Hill, N.C.: University of North Carolina Press, 1944). There is no available index for the period covering Martineau's contributions to the *Westminster Review*. The *Wellesley Index to Victorian Periodicals* is valuable for identifying Martineau's articles in the *Edinburgh Review*, and for reviews of her work in other journals. It should be noted that the American editions of both the *Edinburgh* and the *Westminster* were used in this work and that the pagination therefore differs from that in English editions. R. K. Webb has catalogued almost all Martineau's *Daily News* leaders and has made the list available at the Library of Congress, the Boston Public Library, and the British Museum Newspaper Library at Colindale. Martineau's *Daily News* obituaries were republished in *Biographical Sketches* (1869), and her Irish letters to the *Daily News* in *Letters from Ireland* (1852). Her articles to the *People's Journal* became the basis for *Household Education* (1849); her articles to *Household Words* appeared in *Health, Husbandry and Handicraft* (1861); and her stories to the *Leader* were reprinted in *Sketches from Life* (1856). There were additional articles and letters in the *Penny Magazine, Once a Week,* and the *National Anti-Slavery Standard.* Some of Martineau's more important articles were reprinted as pamphlets, for example: "The Martyr Age of the United States," originally in the *Westminster Review,* was republished in Boston in 1839; "Letters on Mesmerism" in the *Athenaeum* were separately issued by Edward Moxon in 1845; "A History of the American Compromises" in the *Daily News* was republished by John Chapman in 1856; and "The 'Manifest Destiny' of the American Union" in the *Westminster Review* was reprinted by the American Anti-Slavery Society in 1857.

There have been several biographies and studies of Martineau. The first, by Mrs. Florence Fenwick Miller, *Harriet Martineau* (London: W. H. Allen, 1884), is uncritically appreciative but it remains interesting because Mrs. Miller was a feminist of the eighties who was inspired by Harriet Martineau's example. It was her characterization of Harriet's mother as a harsh and domineering woman which brought forth James Martineau's rebuttal: "The Early Days of Harriet Martineau," *Daily News,* December 30, 1884. In 1927 Theodora Bosanquet wrote *Harriet Martineau: An Essay in Comprehension* (reprint ed., Saint Clair Shores, Mich.: Scholarly Press, 1971) which was much more objective and insightful than Mrs. Miller's work, but which added little to what the *Autobiography* could tell readers. Also adding little to Martineau studies were John C. Neville, *Harriet Martineau* (London: F. Muller, 1943), and Vera Wheatley, *The Life and Work of Harriet Martineau* (London: Secker and Warburg, 1957). The best researched work on Martineau has been R. K. Webb's *Harriet Martineau: A Radical Victorian* (New York: Columbia University Press; London: William Heinemann, 1960). Webb's scholarship is sound but some of his more debatable conclusions have unfortunately been very influential. Later commentators like Robert

Lee Wolff in *Strange Stories and Other Explorations in Victorian Fiction* (Boston: Gambit, 1971), and Vineta Colby in *Yesterday's Woman: Domestic Realism in the English Novel* (Princeton: Princeton University Press, 1974) have relied almost exclusively on Webb and have uncritically reproduced his assumptions without checking primary sources. Published dissertations on Martineau include Narola Elizabeth Rivenberg, "Harriet Martineau: An Example of Victorian Conflict" (Columbia University, 1932) which sets out to do more than it accomplishes; and Elizabeth Escher, "Harriet Martineaus socialpolitische Novellen" (Zurich University, 1925), which attempts without much success to analyze Martineau's *Illustrations of Political Economy*. There were some nineteenth-century chapter-length considerations of Martineau: Richard Hengist Horne, ed. *A New Spirit of the Age* (1844; London: Oxford University Press, 1907); and John Morley, *Critical Miscellanies,* 4 vols. (London: Macmillan & Co., 1909), vol. 3. A recent, but not notably successful, attempt to analyze Martineau's economic writings has been made by Dorothy Lampen Thomson in *Adam Smith's Daughters* (Hicksville, N.Y.: Exposition, 1973).

The lives and letters of Martineau's contemporaries have provided a rich source of information. See particularly:

Arnold, Matthew. *Letters 1848–1888.* Edited by George W. E. Russell. 2 vols. 1895. Reprint. Grosse Pointe, Mich.: Scholarly Press, 1968.

Bliss, Trudy, ed. *Jane Welsh Carlyle: A New Selection of Her Letters.* New York: Macmillan Co., 1950.

Carlyle, Alexander, ed. *Letters of Thomas Carlyle to John Stuart Mill, John Sterling, and Robert Browning.* 1923. Reprint. New York: Haskell House, 1970.

———. *New Letters and Memorials of Jane Welsh Carlyle.* 2 vols. London: John Lane, 1903.

Drummond, James, and Upton, C. B. *Life and Letters of James Martineau.* 2 vols. London: J. Nisbet and Co., 1902.

Froude, James Anthony. *Letters and Memorials of Jane Welsh Carlyle.* 2 vols. in 1. New York: Charles Scribner's Sons, 1883.

———. *Thomas Carlyle: A History of His Life in London 1834–1881.* 2 vols. 1884. Reprint. New York: Scribner, 1910.

———. *Thomas Carlyle: A History of the First Forty Years.* 2 vols. American ed. New York: Charles Scribner's Sons, 1882.

Garnett, Richard, and Garnett, Edward. *The Life of William Johnson Fox: Public Teacher and Social Reformer 1786–1864.* London and New York: John Lane, 1910.

Haight, Gordon S. *George Eliot and John Chapman: With Chapman's Diaries.* New Haven: Yale University Press, 1940.

————, ed. *The George Eliot Letters*. 6 vols. New Haven: Yale University Press, 1954.

Holyoake, George Jacob. *Sixty Years of an Agitator's Life*. 2 vols. London: T. F. Unwin, 1892.

Huxley, Leonard, ed. *Jane Welsh Carlyle: Letters to Her Family 1839–1863*. New York: Doubleday, Page and Co., 1924.

Jackson, Abraham Willard. *James Martineau: A Biography and Study*. Boston: Little, Brown and Co., 1901.

Kenyon, Frederic G., ed. *The Letters of Elizabeth Barrett Browning*. New York: Macmillan Co., 1899.

Kintner, Elvan, ed. *The Letters of Robert Browning and Elizabeth Barrett Barrett 1845–1846*. 2 vols. Cambridge, Mass.: Harvard University Press, 1969.

Landis, Paul, ed. *Letters of the Brownings to George Barrett*. Urbana: University of Illinois Press, 1958.

Laughton, John Knox, ed. *Memoirs of the Life and Correspondence of Henry Reeve*. 2 vols. London and New York: Longmans, Green and Co., 1898.

McCabe, Joseph. *George Jacob Holyoake*. 2 vols. London: Watts and Co., 1922.

————. *Life and Letters of George Jacob Holyoake*. 2 vols. London: Watts and Co., 1908.

Mill, John Stuart. *Collected Works*. Edited by F. E. L. Priestley and J. M. Robson. 13 vols. Toronto: University of Toronto Press, 1963–72.

Miller, Betty. *Elizabeth Barrett and Miss Mitford*. London: John Murray, 1954.

————. *Robert Browning: A Portrait*. New York: Charles Scribner's Sons, 1952.

Milnes, Richard Monckton, Lord Houghton. *Monographs, Personal and Social*. New York: Holt and Williams, 1873.

Morley, Edith. *The Life and Times of Henry Crabb Robinson*. London: J. M. Dent, 1935.

————, ed. *Henry Crabb Robinson on Books and Their Writers*. 3 vols. London: J. M. Dent and Sons, 1938.

Norton, Charles Eliot, ed. *The Correspondence of Thomas Carlyle and Ralph Waldo Emerson 1834–1872*. 2 vols. Boston: Osgood, 1883.

Reid, Stuart J. *Life and Letters of Lord Durham*. 2 vols. London and New York: Longmans, Green and Co., 1890.

Reid, T. Wemyss. *The Life of Richard Monckton Milnes, First Lord Houghton*. 2 vols. London: Cassell and Co., 1890.

Sadler, Thomas, ed. *Diary, reminiscences and correspondence of Henry Crabb Robinson*. 3 vols. London: Macmillan & Co., 1869.

Thomas, John L. *The Liberator: William Lloyd Garrison*. Boston: Little, Brown and Co., 1963.

Wallas, Graham. *William Johnson Fox 1786–1864*. London: Watts and Co., 1924.

Ward, Maisie. *Robert Browning and His World*. 2 vols. New York: Holt, Rinehart and Winston, 1967.

A comprehensive list of the editions of Martineau's separately published works cited in the text:

Autobiography with Memorials by Maria Weston Chapman. 3 vols. London: Smith, Elder, and Co., 1877.

Biographical Sketches. 1869. American ed. New York: Leypoldt and Holt, 1869.

British Rule in India: a Historical Sketch. London: Smith, Elder, and Co., 1857.

A Complete Guide to the English Lakes. 1855. 2d ed. Windermere: John Garnett, 1855.

Dawn Island: a Tale. Manchester: Gadsby, 1845.

Deerbrook. 3 vols. London: Edward Moxon, 1839.

Eastern Life Present and Past. 3 vols. London: Edward Moxon, 1848.

The Essential Faith of the Universal Church. 1830. *The Faith as Unfolded by Many Prophets.* 1831. *The Faith as Manifested through Israel.* 1831. American ed. Boston: Leonard C. Bowles, 1833.

The Factory Controversy: A Warning against Meddling Legislation. Manchester: National Association of Factory Occupiers, 1855.

Five Years of Youth; or Sense and Sentiment. London: Harvey and Dalton, 1831.

Forest and Game Law Tales. 3 pts. London: Edward Moxon, 1845.

The Guide to Service. London: Charles Knight, 1838–39.

The History of England from the Commencement of the XIXth Century to the Crimean War. 4 vols. Philadelphia: Porter and Coates, 1864.

A History of the American Compromises. London: Chapman, 1856.

The History of England during the Thirty Years' Peace 1816–1846. 2 vols. London: Charles Knight, 1849–50.

The Hour and the Man. 3 vols. London: Edward Moxon, 1841.

Household Education. 1849. American ed. Philadelphia: Lea Blanchard, 1849.

How to Observe Morals and Manners. 1838. American ed. New York: Harper Brothers, 1838.

Illustrations of Political Economy. 25 vols. London: Charles Fox, 1832–34.

Illustrations of Taxation. 5 vols. London: Charles Fox, 1834.

Introduction to the History of the Peace: from 1800 to 1815. London: Charles Knight, 1851.

Letters on the Laws of Man's Nature and Development. With Henry George Atkinson. 1851. American ed. Boston: Josiah P. Mendum, 1851.

Life in the Sick-Room. 1844. 2d American ed. Boston: William Crosby, 1845.

The "Manifest Destiny" of the American Union. New York: American Anti-Slavery Society, 1857.

The Martyr Age of the United States. Boston: Weeks, Jordan and Co.; Otis; Broaders and Co., 1839.

Miscellanies. 2 vols. Boston: Hilliard Gray and Co., 1836.

Our Farm of Two Acres. New York: Bunce and Huntington, 1865.

The Playfellow. 4 vols. 1841–43. London: George Routledge and Sons, 1895.

Poor Laws and Paupers. 4 vols. London: Charles Fox, 1833–34.

The Positive Philosophy of Auguste Comte. Translated by Harriet Martineau.

1853. 3 vols. Introduction by Frederick Harrison. 1896. London: G. Bell and Sons, 1965.

Principle and Practice; or, the Orphan Family. Wellington: Houlston, 1827.

Retrospect of Western Travel. 2 vols. London: Saunders and Otley, 1838.

Society in America. 3 vols. 1837. 2d ed. London: Saunders and Otley, 1839.

Suggestions Towards the Future Government of India. London: Smith, Elder, and Co., 1858.

The tendency of strikes and sticks to produce low wages, and of union between masters and men to ensure good wages. Durham: J. H. Veitch [1834].

Index

Q5